PAUL SMITH'S
CYCLING SCRAPBOOK

First published in the United Kingdom in 2016 by
Thames & Hudson Ltd, 181A High Holborn, London WC1V 7QX

Paul Smith's Cycling Scrapbook © 2016 Thames & Hudson Ltd, London

Edited by Richard Williams

Art Direction and Design: Alan Aboud & Jo Woolhead, at ABOUD + ABOUD

British Library Cataloguing-in-Publication Data
A catalogue record for this book is available from the British Library

ISBN 978-0-500-29236-5

Printed and bound in China by C & C Offset Printing Co. Ltd

To find out about all our publications, please visit **www.thamesandhudson.com**.
There you can subscribe to our e-newsletter, browse or download our current catalogue, and buy any titles that are in print.

PAUL SMITH'S
CYCLING SCRAPBOOK

PAUL SMITH WITH RICHARD WILLIAMS
With 553 illustrations

Thames & Hudson

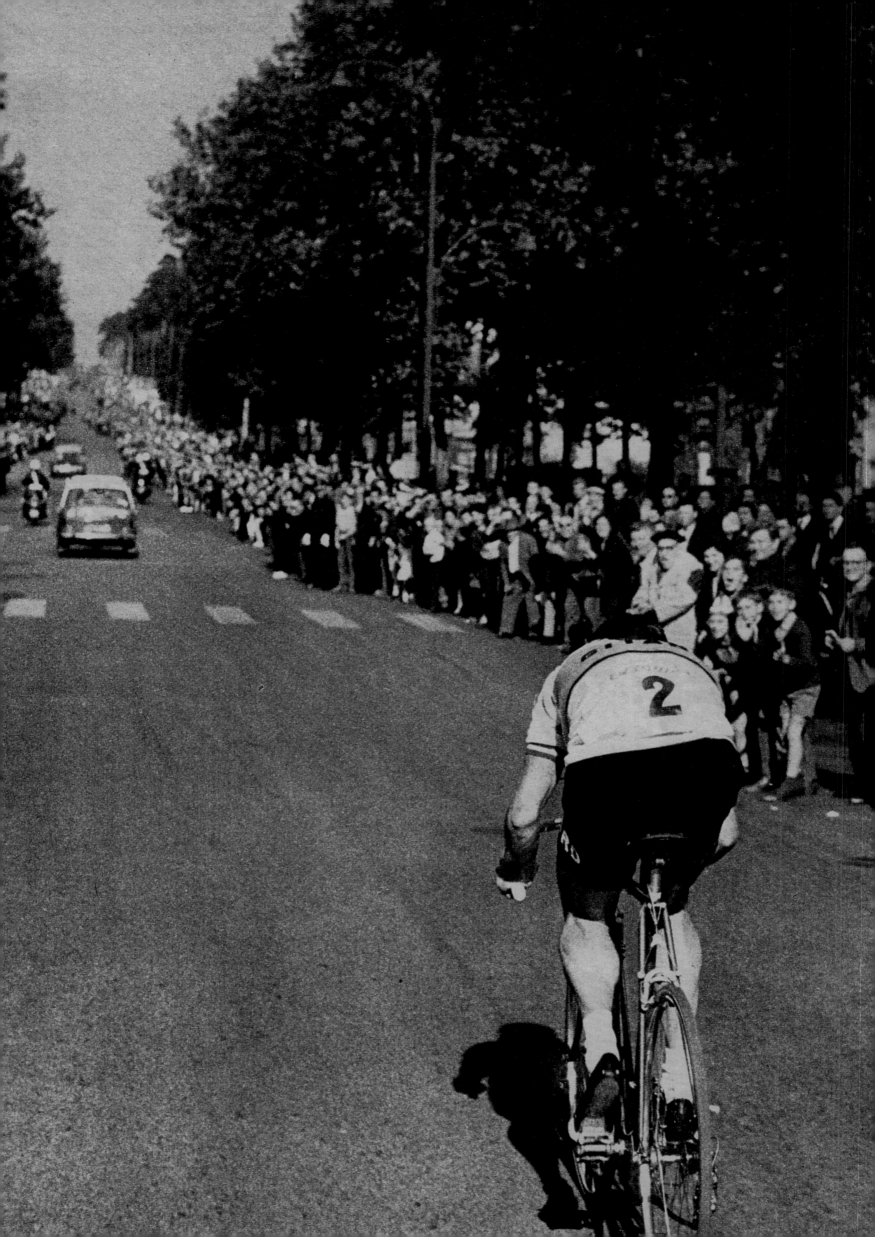

CONTENTS

Paul wore a Raleigh top and rode his Harry Hall bike – which he still owns – when ATV, which was making a programme about his fashion show, filmed him setting off from his house in Nottingham one winter's day in the 1970s.

FOREWORD
BY DAVID MILLAR

When I became a professional cyclist in 1997, cycling wasn't a popular sport in the English-speaking world. You had to know about it, and to know about it you had to love riding a bike. That love would make you want to know more about it, and that's when the most curious thing happened: the more you got to know it, the less you realized you knew.

This happened to me when I was a teenager living in Hong Kong. I'd played football, tennis and squash, raced BMXs, skated, wake-boarded, and raced mountain bikes before finally being introduced to the existence of the Tour de France, after which I dropped all of them for road bikes. That's how fascinated I became by the world I'd discovered. I wanted to be part of it.

Through all this my favourite subject at school was art, something that allowed me to appreciate the beauty of the sport but did not necessarily prepare me for the hardness of it. I turned down my place at art college in order to pursue my dream of becoming a Tour de France racer.

Paul didn't get the same chance as I did. He broke his leg as a teenager, ending his Tour de France dreams. Instead, after meeting a group of art students, he set off on a different path. Our lives have had nothing in common since that fork in the road, except the fact that he has kept his love of cycling as I have kept my love of art and fashion.

No doubt some people have thought Paul mad for holding on to his love of cycling through thick and thin. Now that many more are beginning to understand, I hope they will see why he has. This book is his love-letter to cycling.

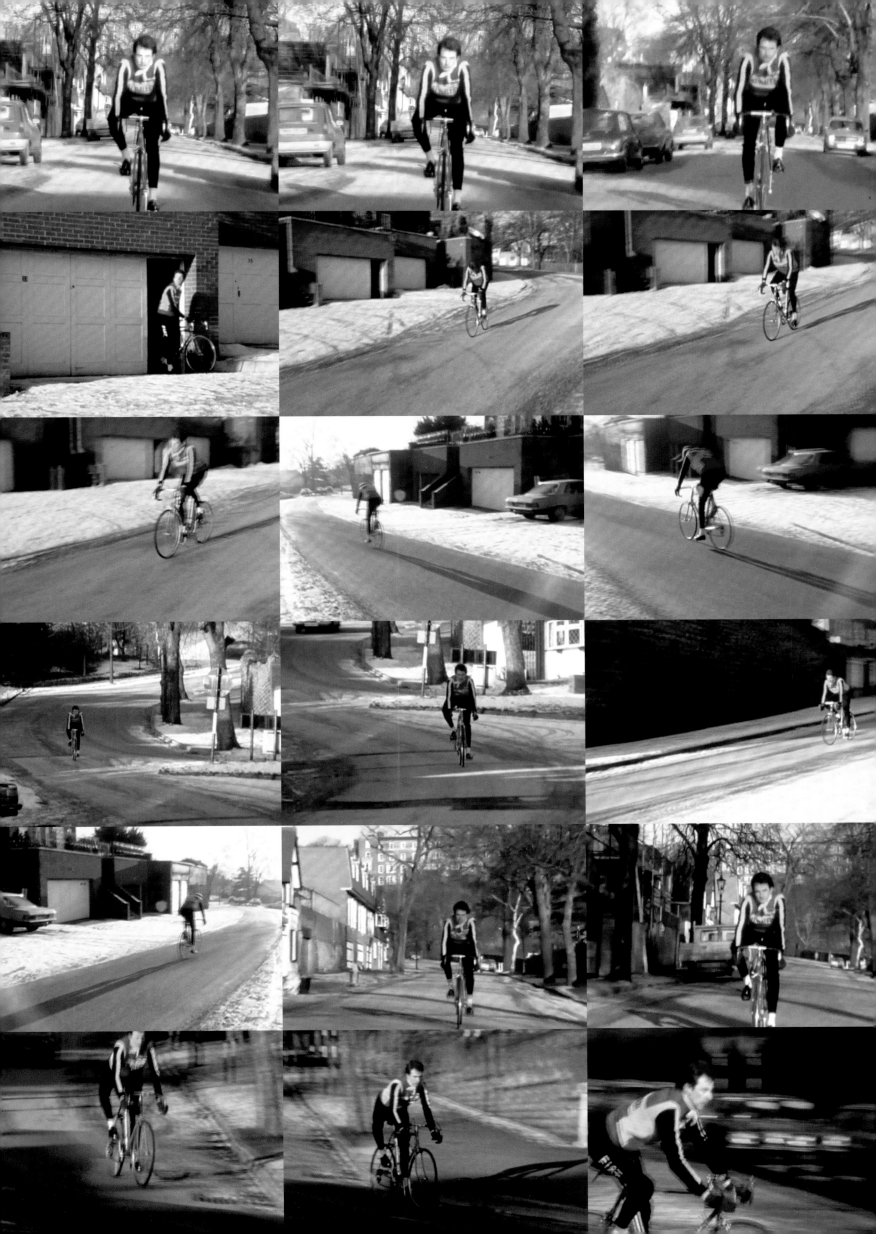

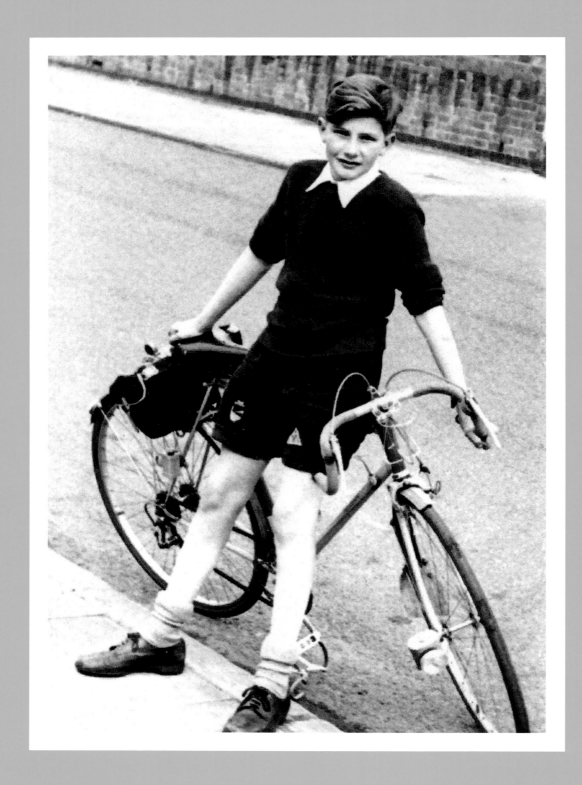

PROLOGUE
BY PAUL SMITH

Cycling has always been the sport for me. You probably won't be surprised to learn that I was attracted by its sense of style: things like Fausto Coppi's sunglasses, Jacques Anquetil's jerseys and the beautiful graphics on a piece of Campagnolo kit have provided a regular source of inspiration in my work.

But there's much more to it than that. As a child I loved the feeling of being on a bike so much that my first serious ambition was to be a professional rider. I probably wouldn't have been good enough, even if an accident when I was seventeen hadn't removed that possibility. But for most of my life I've admired the skill and courage of the great riders of successive generations,

from Coppi and Anquetil – whom I was too young to see at first hand, and could only read about – to Britain's current generation of Tour de France and Olympic champions, some of whom I'm lucky enough to have as friends.

I hope this book reflects my love of a sport that is as simple or as complicated as you want it to be. You can be thrilled by a bunch sprint in which the fastest man wins, or you can spend three weeks watching the subtle tactics at work as the riders go up and down the mountains in one of the three Grand Tours that provide the summer's peak moments. Sometimes its complexities are hard to follow, but they're worth the trouble.

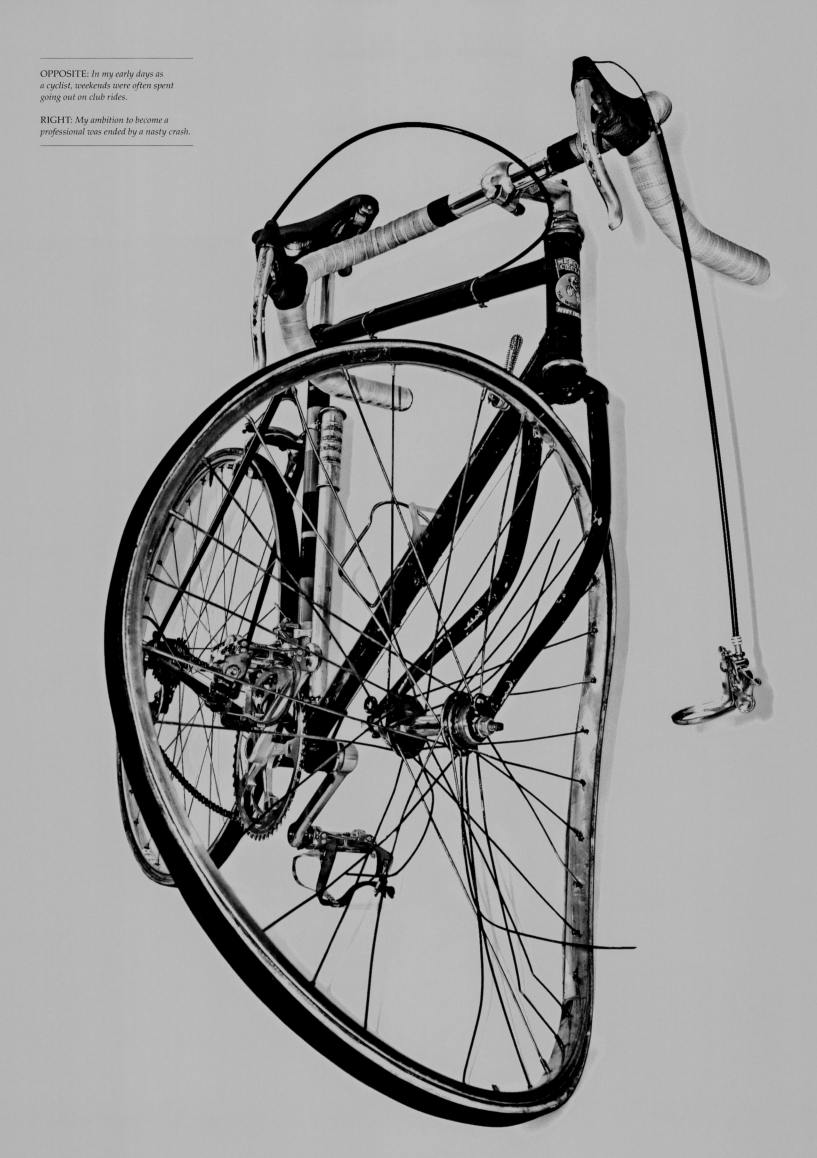

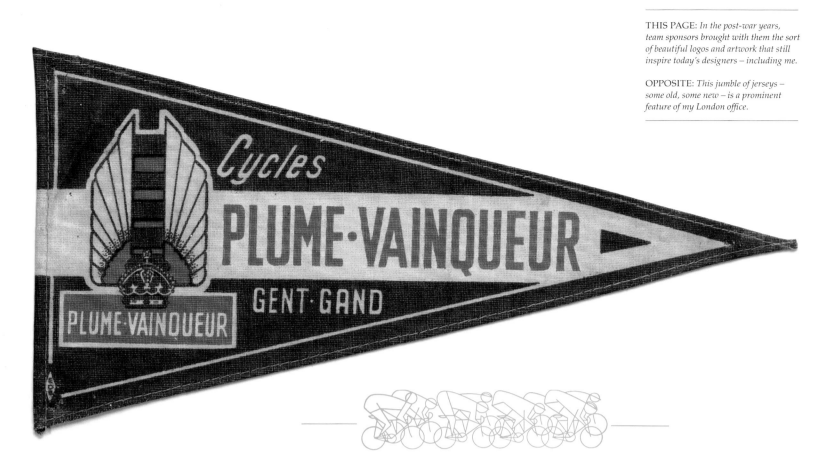

THIS PAGE: *In the post-war years, team sponsors brought with them the sort of beautiful logos and artwork that still inspire today's designers – including me.*

OPPOSITE: *This jumble of jerseys – some old, some new – is a prominent feature of my London office.*

You'll find all sorts of things here, including my thoughts about the classic races and the great riders from my youth to the present day, the collection of jerseys I've been building up for many years, and my involvement in projects with bike manufacturers and clothing companies.

There's also a sprinkling of the cycling ephemera to be found in my office at the Paul Smith headquarters in London – a room that always astonishes people visiting it for the first time, and which some of my colleagues claim resembles the inside of my head. It always contains a few bikes – one of Mark Cavendish's bikes, for instance, or my own lovingly restored steel-framed Harry Hall racing bike from the 1960s, or the beautiful all-black fixie that Mercian made specially for me, or an extraordinary Soviet-era Russian machine that a lady brought all the way from Moscow to give me.

Over the last few years it's been very exciting to see the British public getting to grips with the nuances of a sport that for many years was a minority interest. Throughout my teenage years I was a member of that minority. I got my first racing bike for my eleventh birthday, back in 1957. My dad bought it from a friend of his who was a member of a local cycling club. I went along, and by the time I was twelve I'd started racing in the jersey of the Beeston Road Club, competing on a road circuit near the centre of Nottingham and in time trials over 10 and later 25 miles. We also raced at a velodrome not far from my home. At the weekends there were club runs out into the Derbyshire dales.

It was at the club nights, held in a British Legion hut every Thursday, that I found myself becoming immersed in the detail and the history of the sport. We'd go along and chat and look at each other's bikes. The older guys smoked like chimneys and were great storytellers.

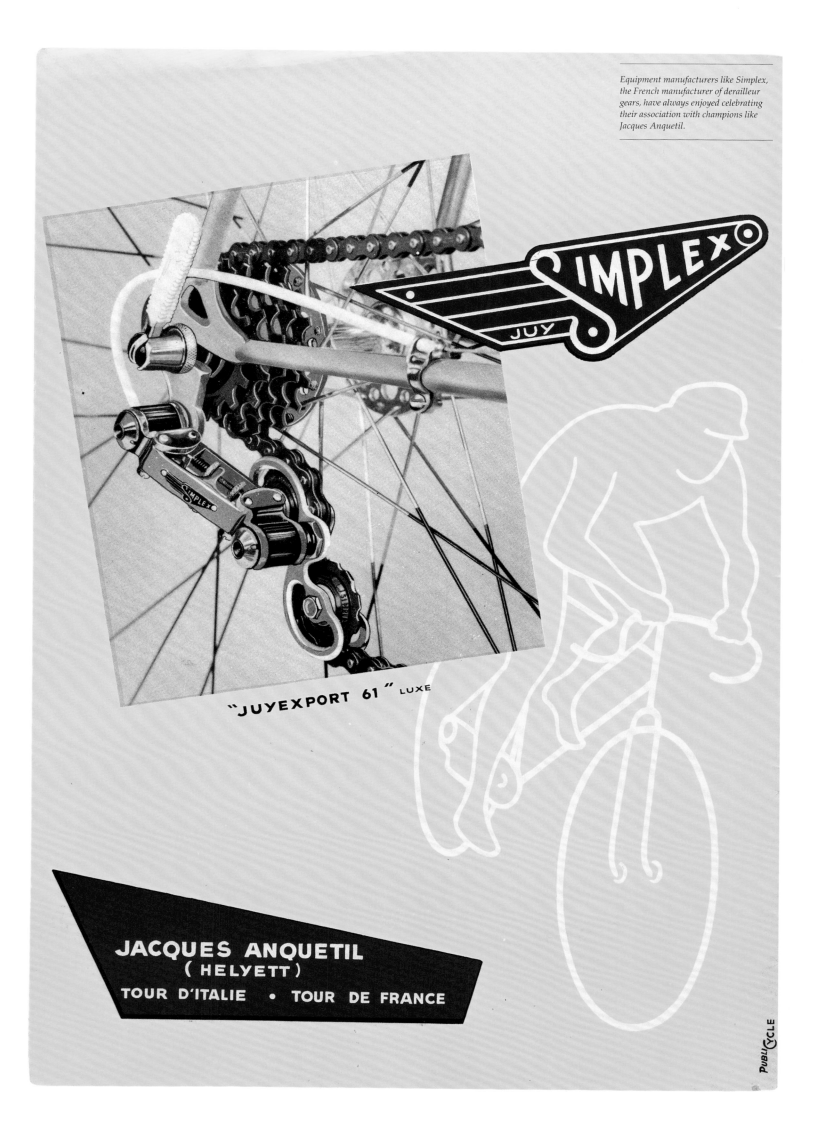

Equipment manufacturers like Simplex, the French manufacturer of derailleur gears, have always enjoyed celebrating their association with champions like Jacques Anquetil.

"JUYEXPORT 61" LUXE

JACQUES ANQUETIL
(HELYETT)
TOUR D'ITALIE • TOUR DE FRANCE

PUBLI CYCLE

THEY CAME OUT WITH THESE STRANGE FOREIGN PHRASES: 'MAILLOT JAUNE', 'BIDON', 'MUSETTE'. GRADUALLY YOU STARTED TO LEARN WHAT THEY MEANT. AND I BEGAN HEARING THE NAMES OF THE CONTINENTAL HEROES OF THE TIME.

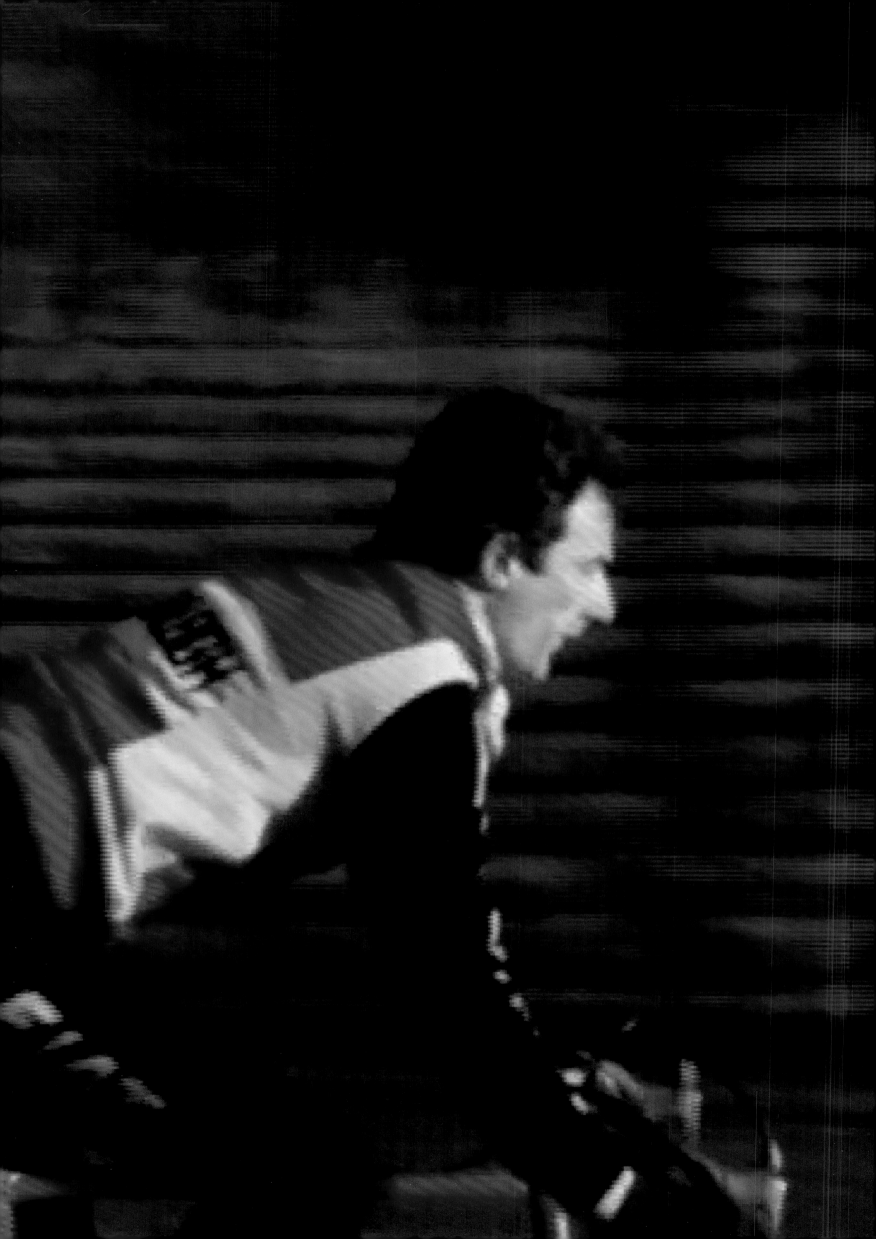

I suppose Anquetil was my hero. He was good-looking and he was often on the cover of those French cycling magazines that one of the older members used to bring in, and which we passed around with as much awe as if they'd been gold bars. I started to spend some of my pocket money on those newspapers and magazines, such as *L'Équipe* and *Miroir des Sports*. The rest of it went on new kit to improve my bike: something like a set of Mafac centre-pull brakes, perhaps, or an alloy Campagnolo seat pillar to replace the standard one. I saved the Campag box because it had the world championship stripes on it, and the magic name in that lovely script.

It was all very exotic and romantic. Very stylish, too. I'm not going to pretend that the look of the sport wasn't an important factor. But this was also the time when I learned about the importance of looking further than appearances. In the club there was a boy of about my age whose bike and kit were always immaculate, but who wasn't very good at riding. There was another boy who always looked scruffy, whose hair was dishevelled, and who wore black socks – which really wasn't done in those days – and he always won. He showed me that success in life isn't just about making sure that you look great.

I've learned a lot from cycling along the way, and it played a vital – although unplanned and extremely painful – role in the most important turning point of my life. When I told my father one day that I wanted to be a professional cyclist, he said, 'I'm sorry, son, but that's not a real job.' He was absolutely correct, in a way.

But in any case, a crash on my bike put me in hospital for several months, destroying that initial ambition to ride professionally and setting me on the path to a very different career.

Those club nights with my fellow members of Beeston RC gave way to evenings in the pub with a bunch of art students who were to reshape my view of the world and the possibilities it offered. But I've always retained a close interest and involvement in cycling that I hope are reflected in this book, which looks at some of my heroes, my favourite races, the beauty of some of the design that surrounds bike racing, and some of the collaborations in which I've been involved over the years with names like Mercian, Rapha and Pinarello. In 2013 the organizers of the Giro d'Italia invited me to design the jerseys for that year's race, including the *maglia rosa*, the pink jersey worn by the leader in the overall classification. It was taken to the Vatican to be blessed by the Pope before the start of the race, which isn't something that happens to all the clothes I design.

That opportunity was a source of great pride and satisfaction, something I could trace all the way back to the day when I was given my first racing bike. So this scrapbook is an attempt to reflect how I feel about the sport: about its past and present, its great riders and the challenges against which they measured themselves, its sense of style and its rich traditions. Those are some of the reasons why I fell in love with it in the first place, and why I see no reason to fall out. Enjoy the book; enjoy the sport.

Du super-Poulidor dans le Ventoux !...

FACE A MORVAN, ANQUETIL ET BALDINI
conservent le bénéfice du doute

MANCHE-OCEAN dimanche dernier, a ouvert la série des courses contre la montre qui se poursuivra avec le Grand Prix Martini (8 septembre), Les Nations (22 septembre), Grand Prix de Lugano (13 octobre) et le Trophée Baracchi (14 novembre).

Cette «première» à laquelle participaient Rivière, Gaul, Bouvet, Ruby, Rohrbach, Barbotin vit l'écrasante victoire du régional de Colpo, Morvan.

accepta de se montrer sur le plan national en disputant le Grand Prix des Nations.

Morvan aurait pu être un de nos grands cracks mais l'apprentissage des courses internationales exige un sacrifice financier alors qu'en Bretagne les nombreuses «kermesses» sont lucratives. La «Grande Semaine Bretonne» du 22-9 au 1-10 (cinq épreuves entre 120 km. et 150 km. dotées de trois millions de prix) vient à l'appui de cette thèse qui s'explique d'ailleurs quand on sait que l'élite bretonne

REG. HARRIS
World's Professional Cycling Sprint Champion

FAUSTO COPPI

BAHAMONTES A-T-IL GAGNE UN TOUR

BERYL BURTON : UNE MÈRE DE FAMILLE PÉDALANTE

TOM SIMPSON
qu'il a engagé une " course à la célébrité " ...avec se frère aîné, footballeur à Bournemouth

par François Terbeen

EDDY MERCKX: UN "SUPER" ENCORE

Beryl Burton quelque 52 heures d'un effort qui aurait rebuté un solide gaillard.

C'est cette même fille aux che-

MENACE CHARLY GAUL

Un rival devenu un ami : GINO BARTALI

RIVIERE
le de 22 ans

quille » un jour de septembre 1958, j'avais eu le temps de faire amplement la connaissance du Stéphanois.

J'ai beaucoup de solides amis, parmi les champions cyclistes, des amis sincères qui m'ont souvent confié leurs joies et leurs déceptions.

Il m'est arrivé — bien que j'y veille — d'être partial par sentiment ou amitié.

Et pourtant jamais — et je m'excuse auprès de mon vieux compagnon de route Raphaël Géminiani — jamais je n'avoue je n'ai été autant ébranlé que par

Je l'imagine volontiers champion de billard, annonçant à l'avance les coups difficiles...

Et le plus beau c'est qu'il n'est ni fanfaron ni prétentieux. Il se connaît bien, un point c'est tout. Quand il dit : « Et pourquoi ne gagnerai-je pas le Tour de France ? », c'est parce qu'il s'est déjà posé la question ! Et y a répondu !

Rivière c'est avant tout un phénomène d'équilibre, physique et moral. Il est sérieux, mais ce n'est pas un ascète, il est serviable et bon copain, mais il ne

THE HEROES

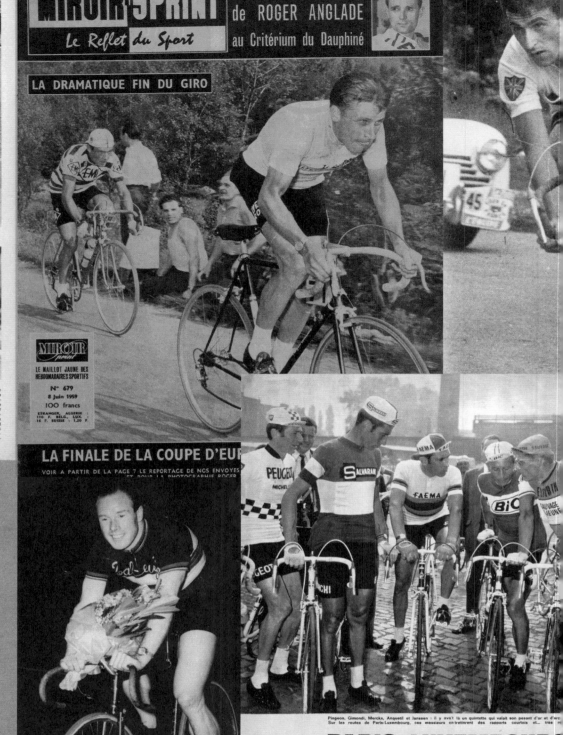

LA DRAMATIQUE FIN DU GIRO

MIROIR
sprint
LE MAILLOT JAUNE DES HEBDOMADAIRES SPORTIFS
N° 679
8 Juin 1959
100 francs
ETRANGER, ALGÉRIE :
BELG., LUX. :
F. SUISSE : 1,20 F

LA FINALE DE LA COUPE D'EUROPE

VOIR A PARTIR DE LA PAGE 7 LE REPORTAGE DE NOS ENVOYÉS

Reginald HARRIS

Pingeon, Gimondi, Merckx, Anquetil et Janssen : il y avait là un quintette qui valait son pesant d'or et d'arc. Sur les routes de Paris-Luxembourg, ces messieurs entretinrent des rapports courtois et... très

PARIS - LUXEMBOURG
RÉPETITION GÉNÉRA
AVANT LE CHAMPIONNAT DU MON

DUBLE
ANNIQUE

WEBB :
A
ME

venir un professionnel, il lui fallait s'entraîner durement, constamment, et surtout se heurter à meilleur que lui. Comme Tom Simpson.

Marié à 21 ans à Karen, une jeune bureaucrate, il était parvenu à lui inculquer son amour du vélo et à lui faire miroiter l'espoir d'une carrière.

— J'ai compris, lui dit-elle un jour. Partons sur le continent. Je travaillerai et tu apprendras le métier de coureur cycliste.

Ce fut en Hollande, à Hilversum, que les deux réfugièrent se réfugièrent. Mais de travail de bureau, point. Il eût fallu connaître le néerlandais.

Tout ce que Karen se vit offrir fut une place de femme de ménage dans une banque. Début du travail : 5 heures du matin.

Grâce à Karen, la marmite bouillait. Chichement, mais elle bouillait tout de même. Karen n'avait pas même un regret pour sa vie de jeune fille, lorsqu'elle comptait les meilleures écuyères d'obstacles des Midlands. Ce qui comptait, c'était que Graham devienne un vrai coureur cycliste, résistant et connaissant les succès dont il rêvait.

C'est maintenant fait en partie. Si Graham est professionnel, s'il a son maillot arc-en-ciel, c'est à la totalité du A une histoire e jolie.

Saint-Etienne deux épreuves ne coupes et mé des polices d'as Webb se prenait du regretté Tom

t bon pédaleur ppe que pour de

R. d. L.

BERYL BURTON : UNE MÈRE DE FAMILLE PÉDALANTE

Dans une ferme du Yorkshire dont les habitants passent pour être les plus têtus de toute l'Angleterre, une jeune femme, dernièrement, maniait ferme la fourche pour rentrer un champ entier de rhubarbe.

En trois jours, il fut demandé à Beryl Burton quelque 52 heures d'un effort qui aurait rebuté un solide gaillard.

C'est cette même fille aux yeux courts et bouclée et au regard souriant qui ridiculisa, sur le circuit de Heerlen, les redoutables pédaleuses russes à la musculature trapue et à la volonté tendue vers un maillot arc-en-ciel.

— Je ne pédale que pour mon plaisir, assure-t-elle. Je me moque des maillots et des médailles et j'aime autant l'atmosphère des sorties hebdomadaires de mon club que toute cette agitation des Championnats. Et si j'y viens, c'est uniquement parce que je pense que ces résultats sont une bonne propagande pour amener les filles d'Angleterre à venir se promener avec moi au lieu d'aller danser le jerk.

Burton est une pédaleuse d'une rare efficacité et son exemple est à citer. Socialement, elle tient doublement sa place puisque mère de famille (une fille de onze ans) et ouvrière agricole. Une ouvrière agricole qui a délaissé classements de bureau et sténo pour vivre au grand air. Au grand air, elle l'était samedi en roulant seule à 40 à l'heure, irrattrapable même par les dures athlètes moscovites.

Il n'en est pas moins vrai que Beryl

R. d. L.

LES PYRÉNÉES, DERNIÈRE CHANCE POUR CHARLY GAUL

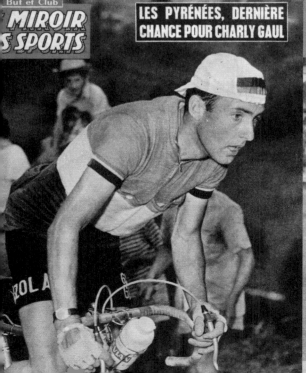

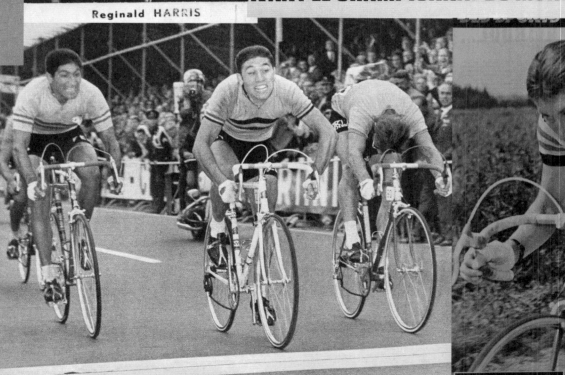

avait décidé de se venger : c'est fait !

DANS l'ascension du Puy-de-Dôme, contre la montre, on avait noté la résurrection de Charly Gaul. Il l'a confirmée à la faveur de l'étape Saint-Étienne-Grenoble. Décidé à prendre sa revanche sur le sort, il l'a fait avec éclat : en enlevant la victoire devant Bahamontes.

MOLA, MERCKX OU MOI !

S'il est un routier qui attend impatiemment le 1er septembre, c'est bien l'Italien Felice Gimondi.

« Ce que ce jour-là, il compte non se venger des graves accusations qui faillirent lui faire abandonner le cyclisme, après dernier Tour d'Italie où il fut de la rentre » des suspendus pour usage de dopi mais seulement se justifier aux yeux de se.

« Que je gagne ou non, je serai le premier à me rendre au contrôle, d'où je suis certain de sortir blanc comme neige. Et pourtant je ne me serais pas conformé autrement au Giro où je m'étais contenté de suivre les indications de mon médecin, le docteur Garenghi. C'est un homme habitué aux sports et qui ne pouvait se tromper en m'indiquant un reconstituant n'entrant nullement dans la liste des produits interdits. »

Depuis cette suspension, et malgré le riche lot de champion d'Italie qu'il acquit en cette année d'efforts, comme dans Paris-Roubaix il y a deux ans, Felice, malgré son prénom, n'est pas un homme vraiment heureux.

« C'est un peu comme si l'on m'avait traité de voleur, dit-il. Et si le ministre italien de la Santé m'a rendu en partie raison en m'omettant que certains produits aux intérêts pouvaient, à l'analyse, donner graphique accusateur, j'ai quand même vu dans l'esprit d'une partie du public, un effet. Et cela m'a fait tellement mal malgré les manifestations de sympathie la grande majorité de mes supporters.

— Est-il vrai que vous avez failli abandonner le cyclisme ?

— Sur le coup, oui. J'étais si profondément démoralisé que je ne voyais pas d'autre réponse à cette injustice. Très à peu du heureusement. L'esprit mon vélo et prendant vingt et un jours j'ai roulé, seul, ruminant ma rancœur. Pendant le Tour de France surtout, j'en ai bavé, comme vous êtes. Petit à petit, j'ai pensé que la meilleure réponse à faire à ceux qui m'avaient mis en doute était de retrouver le plus rapidement possible ma forme et mon ambition, lesquelles étaient tombées à zéro. Comme je n'avais pas dérogé à la vie saine et active qui est à la base de ma préparation, c'est revenu assez vite. »

EDDY PEUT FLANCHER

Felice Gimondi, qui se connaît bien, croit à deux doigts de sa meilleure condition c'est-à-dire de cet état de grâce qu'un ri peut décrypter et qui fédie le surentraînement.

« Je crois que cette superforme, luxu je la devais, pour durer deux mois, affirme-t-il. Ce, t suffisant pour que je meuble de palmarès de fin de saison

— Avec quoi ?

— Avec la course d'Imola, si possible, connais bien ce circuit si j'estime qu'il plus dur que le Nurburgring, mon épouvantail. Là-bas, il y a deux on pouvait souffler dans chaque descente se vant une bosse. Et Dieu sait s'il y en A Imola, les temps morts seront inexistant sur les descentes sont en pente douce faut continuer à y pédaler. »

Gimondi n'ignore pas que pour être champion du monde il faudra, avant tout, battre Eddy Merckx.

Ce projet ne lui paraît pas irréalisable.

« Non que je me sente plus fort que ou sur sol égal, mais une course est souple farcie d'imponderables. Merckx peut connaître une erreur de tactique ou, tout bonnement, se trouver dans un mauvais jour comme cela arrive à tous les coureurs, aux valeureux soient-il. Il saura, du fait de notoriété, le poids de la course. C'est lourd fardeau. Eddy peut flancher. »

René de LA TOUR

LES 26,700 KM DE CHA-TEAULIN : UNE PÉRIPÉTIE

ON attendait avec grande impatience l'épreuve contre la montre qui, le samedi 26 juin dans l'après-midi, devait être disputée sur le circuit de Châteaulin. Il suffit, en effet, de parler de course contre le chrono pour que tout le monde entre en transes dans la caravane, comme si ses effets devaient être décisifs. En réalité, pour ce qui est de l'épreuve de Châteaulin, cette heure de vérité ne se prolongea guère plus... d'une demi-heure ! La distance était très courte (26,700 km) : elle ne pouvait provoquer de gros écarts. Comme prévu, Raymond Poulidor se montra le meilleur rouleur du lot, mais sans, pour autant, affirmer une suprématie éclatante, puisqu'il ne prit que 7" à Felice Gimondi et 19" à Gianni Motta. Et l'on ne pouvait pas penser, décemment, que cette poignée de secondes pèserait lourd finalement dans la balance. En somme, Châteaulin n'avait été qu'une péripétie. Une péripétie, cependant, qui confirmait que Poulidor aurait à compter avec les deux Italiens. Une péripétie qui, également, semblait écarter Bahamontes de la course au maillot jaune, puisqu'il avait tout de même perdu 2' 16" sur Raymond Poulidor.

SAINT-ÉTIENNE-GRENOBLE PAR LES COLS DES GRANDS BOIS ET DE ROMEYÈRE : GAUL ET BAHAMONTES ONT PRIS LE LARG

(210,5

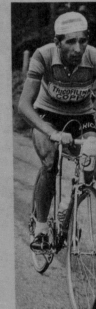

BAH

voulait le m jaune : il l'a

BAHAMONTES çoit à Depuis le Pu voulait le m à Grenoble, meyère devan rejoint dans Son premier l'Espagnol ment accroch

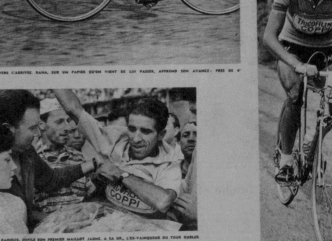

ILS FONCENT VERS L'ARRIVÉE. BAHA, SUR UN PAPIER QU'ON VIENT DE LUI PASSER, APPREND SON AVANCE : PRÈS DE 4'

BAHAMONTES, RADIEUX, ENFILE SON PREMIER MAILLOT JAUNE. A SA DR., L'EX-VAINQUEUR DU TOUR KUBLER

58

Momenti dei trionfo di Coppi ai campionati mondiali dell'inseguimento a Parigi. Famoso in batteria superò nell'ordine Lanz e Ridant. In semifinale si incontrò col famoso olandese Schulte e lo battè di 160 metri. Nell'altra semifinale Bevilacqua batteva Kobler. La finale fu tutta italiana. Nella foto 58: Coppi si portava in trionfo; nella foto 59: l'abbraccio tra Bevilacqua e Coppi; nella foto 60: il giro d'onore; Coppi, Bevilacqua in testa.

OUR OU PAS TOUR

il à l'heure du choix

1 FR. 20

AIT FALLU IPE BOBET... IL Y A UNE E BARTALI

s envoyés spéciaux

AKER D'ISY

LE COL DES ARRAVIS N'A FAVORISÉ L'ÉCHAPPÉE D'AUCUN GRIMPEUR. LE PELOTON DONN LIMITER SES EFFORTS ET, SI PEU AVANT CHAMONIX, L'ITALIEN LAMBERTINI ET PIOT HENENI, TION D'ACCÉLÉRER LA COURSE. SUBIRAIT-ON LA LOI DE BARTALI AU POINT D'ÊTRE BATTU

Silhouettes de la Caravane

LES "MOTARDS"

LES hommes avant tout... car outre les qualités de coup d'œil, de maîtrise, de sang-froid, de souplesse, la fonction de motocycliste réclame un goût du risque et l'état d'un de cette particularité assimile son « motards » aux coureurs plutôt qu'aux caravaniers.

On rapporte que l'un de ces « risque-tout » auquel on faisait remarquer sa forte tendance à appuyer démesurément sur la manette, répondit froidement :

— Que m'importe ! J'ai eu un accident dernièrement auquel je n'aurais pas dû survivre. Je considère donc que tout ce que je fais maintenant, c'est du rabiot.

Fichu métier... mais métier exal

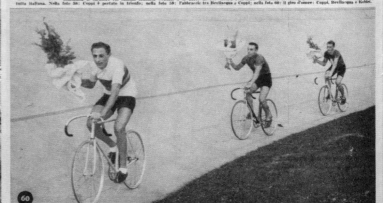

60

FAUSTO COPPI AND GINO BARTALI

When I was racing, in my early teens, I didn't really know much about Fausto Coppi. It was a name mentioned by older riders, but since he was no longer active I didn't pay much attention. A lot later, maybe only twenty years ago, when I started visiting Italy quite regularly, I'd go into a café and there would always be a photograph of Coppi on the wall, sometimes alongside one of his great rival, Gino Bartali. It was obvious that they occupied a special place in the hierarchy of Italian life.

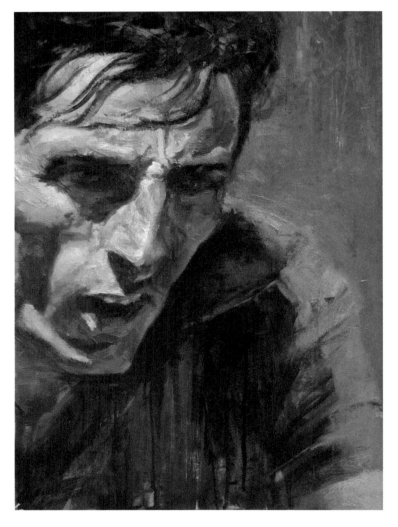

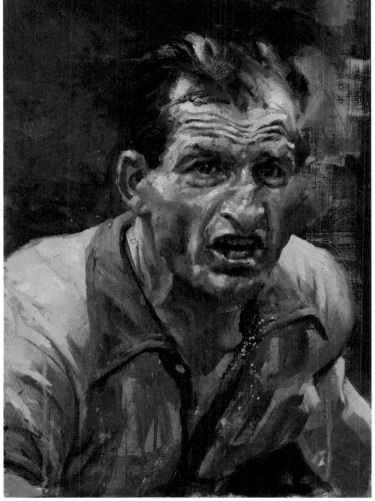

ABOVE: *My friend Karl Kopinski's oil paintings capture the soul and commitment of the two great Italian rivals Fausto Coppi, left, and Gino Bartali.*

OPPOSITE: *When Bartali's retirement meant that they'd finished hunting each other down on mountain roads, the pair joined forces to go after other game.*

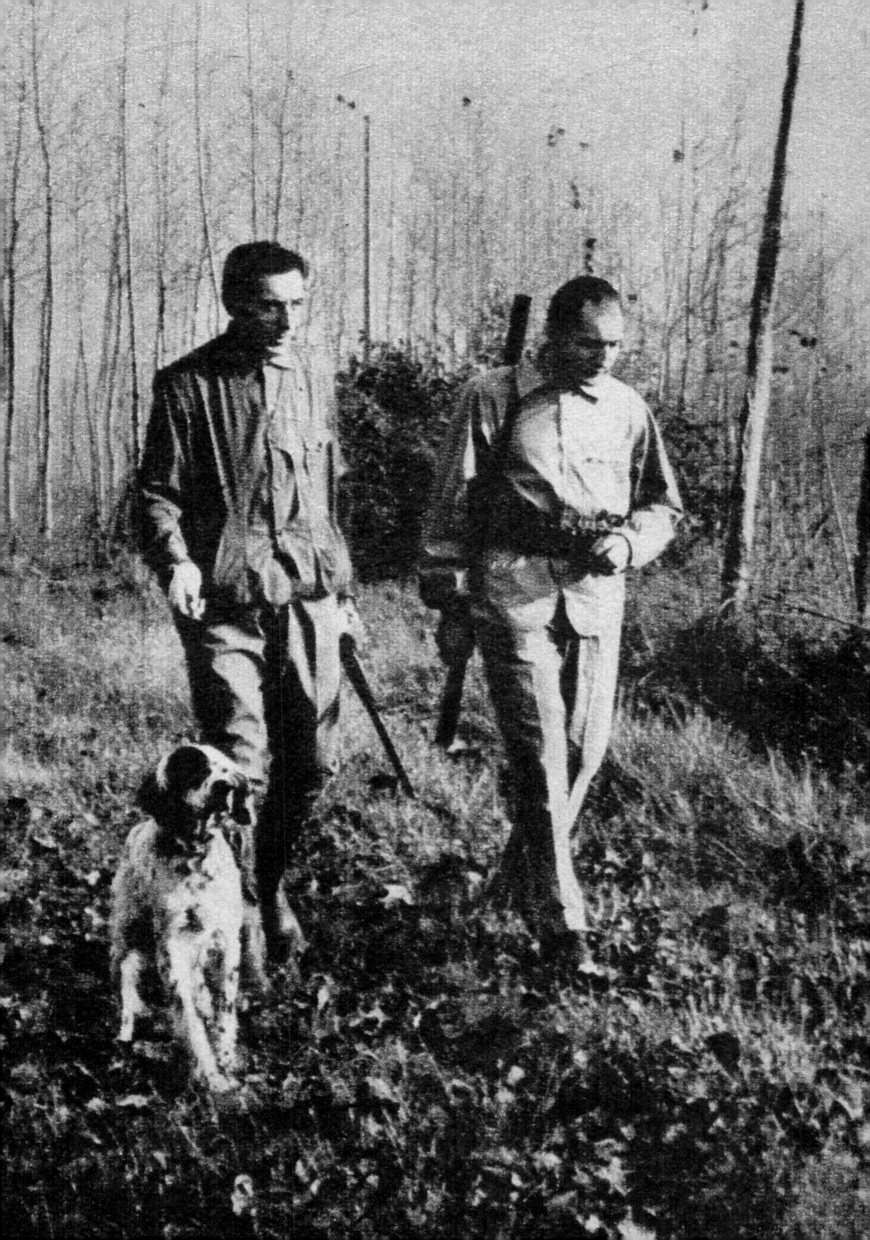

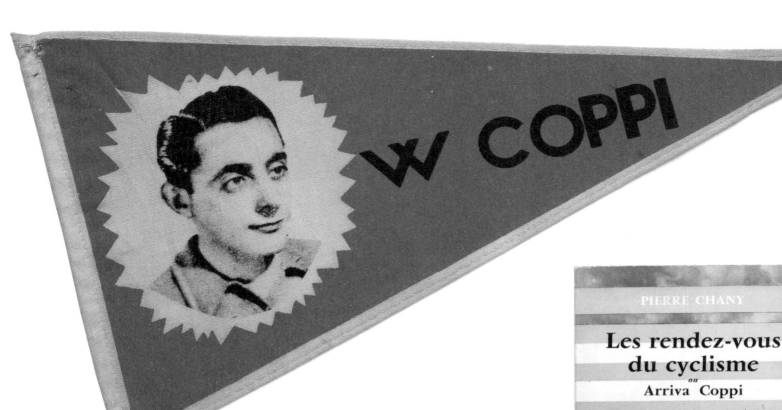

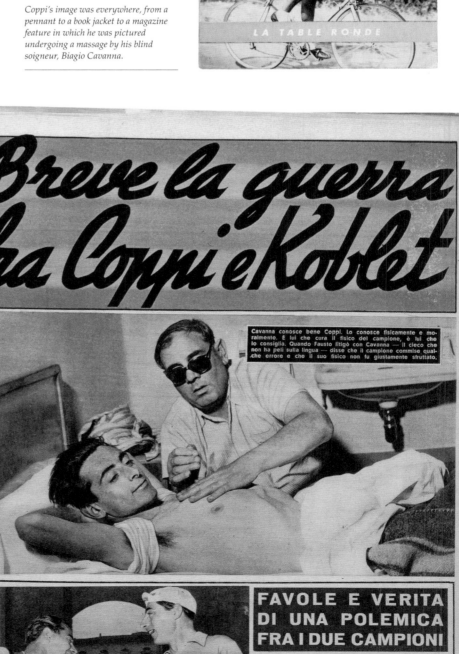

Coppi's image was everywhere, from a pennant to a book jacket to a magazine feature in which he was pictured undergoing a massage by his blind soigneur, Biagio Cavanna.

Today, even young cyclists talk about Coppi. They discuss his famous lung capacity, his distinctive pigeon chest, his personal style, the way he was as handsome off the bike as on it, and the beautiful married woman – known to the Italian tabloids as La Dama in Bianco, or the Lady in White – with whom he had a famous affair. A designer like me would notice that he often wore a beautiful double-breasted overcoat and that his hair was always combed back in a very stylish way. And there were always lots of rumours about him, like the one – true or not – about how he used to drink fourteen espressos before a mountain stage.

Coppi was so famous that the general public even knew the name of his blind soigneur, Biagio Cavanna. Most people had seen newspaper pictures of him being massaged by Cavanna or sitting in the bath at the end of a hard day's racing. You couldn't help being struck by the pure-white body and really dark arms from just above the elbow down. There was something magical about that. My parents and my brother and sister and I had never been anywhere hot. We'd always had our holidays in England. I wasn't aware of suntan because I'd never really sat on a beach.

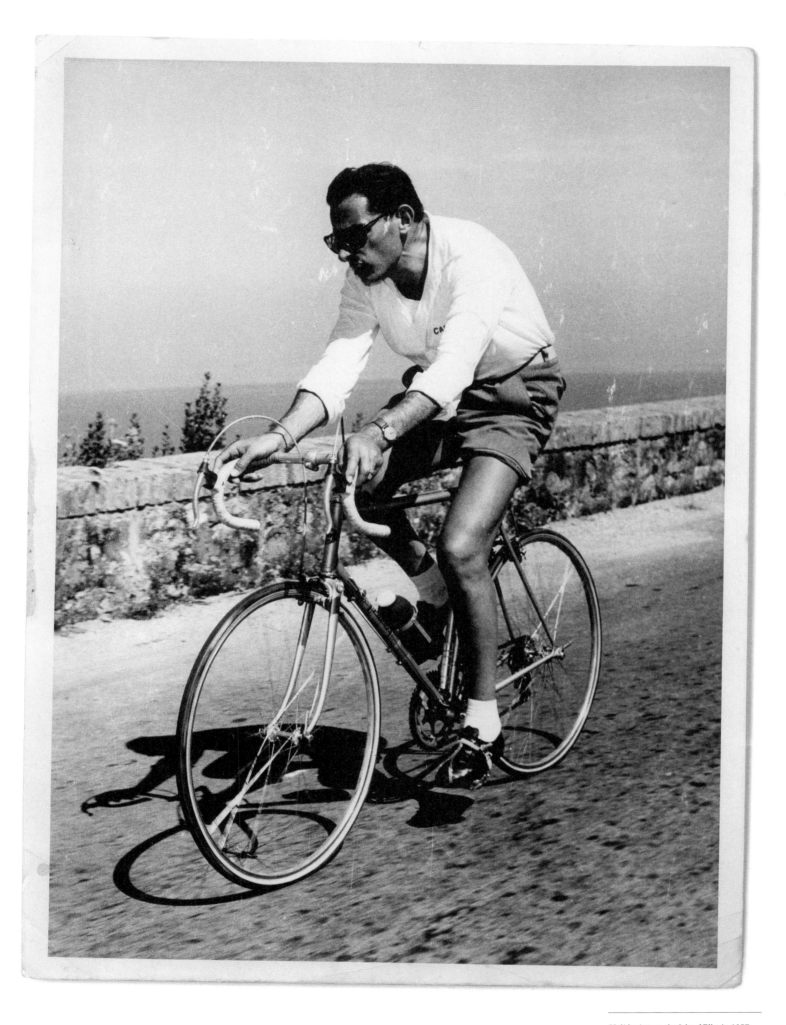

*Holidaying on the Isle of Elba in 1957,
but never letting his standards slip,
Coppi gets everything – shirt, shorts,
socks, shoes, sunglasses, haircut,
watch – exactly right.*

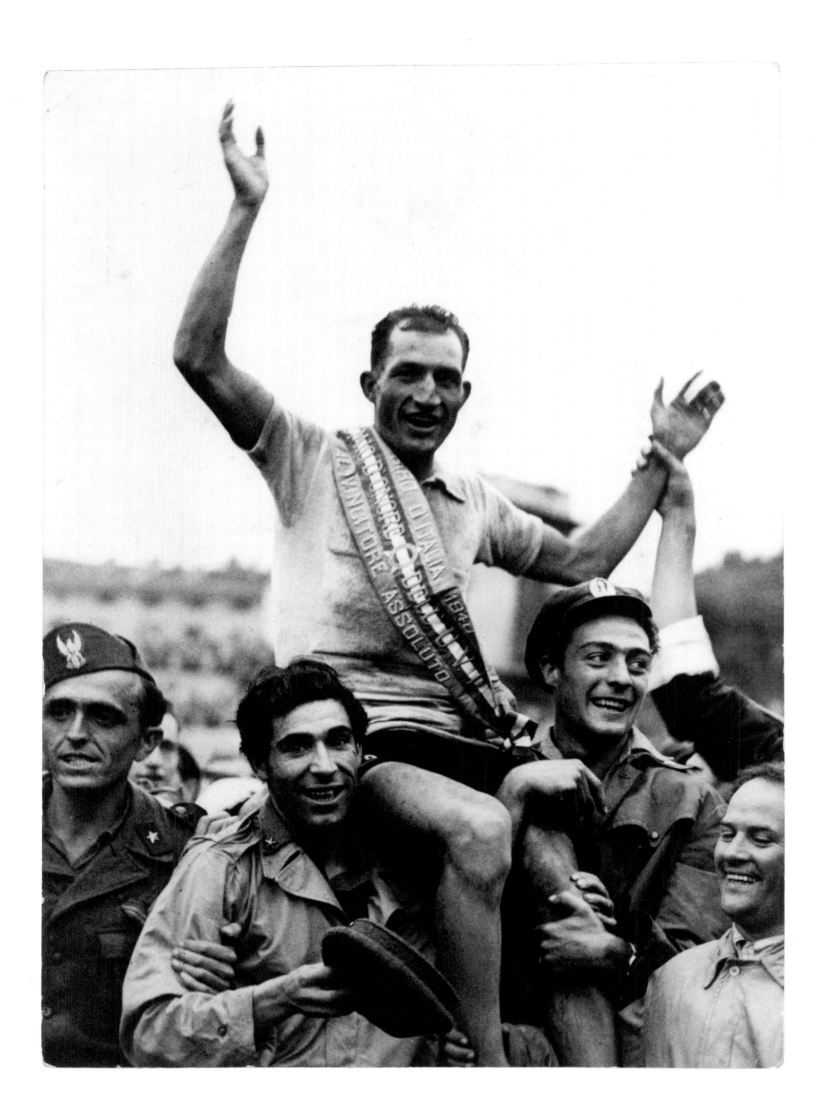

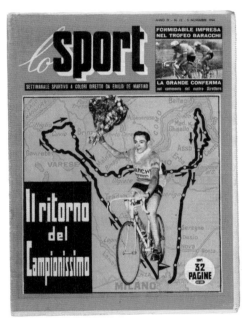

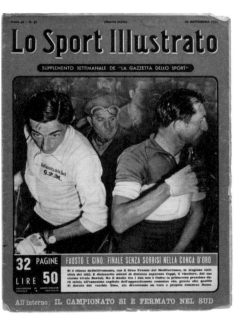

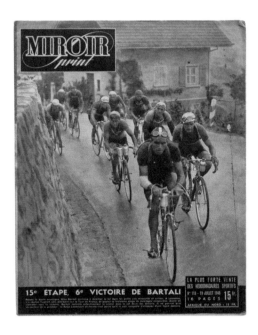

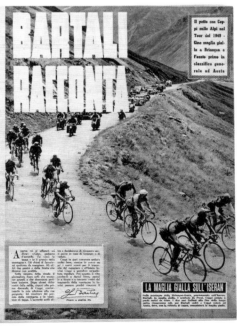

Bartali, born in 1914 in a village outside Florence, was five years older than Coppi, and it showed. He was a very different type, more like a teacher or even a priest than a sporting hero. There was something calm about his face, a more grown-up kind of dignity, even with his boxer's broken nose. Coppi was more like the farmer's son who'd made it to international acclaim; in fact, after suffering poor health as a child, he acquired his love of riding a bike while delivering meat for a local butcher in Castellania, his home village in the Piedmont, which I visited in 2015 while on a trip to Turin.

The rivalry between the two was amazing. Bartali won the Giro d'Italia twice before the Second World War, in 1936 and 1937, and won the Tour de France in 1938, but he was then beaten by the up-and-coming Coppi in the Giro of 1940. The younger man also took the hour record at the Vigorelli velodrome in Milan in 1942.

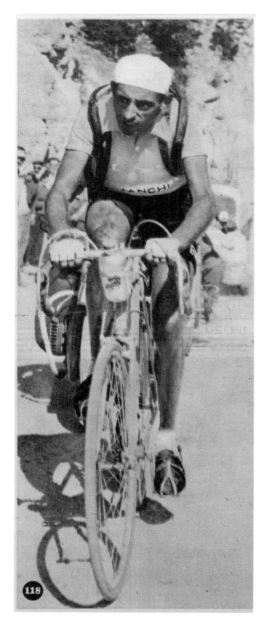

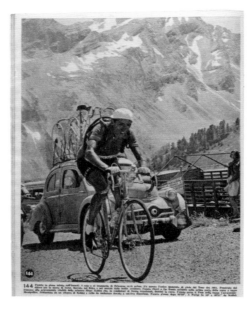

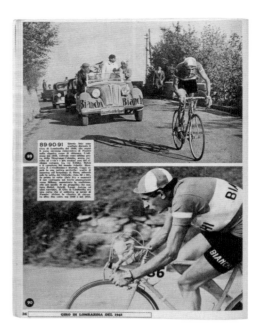

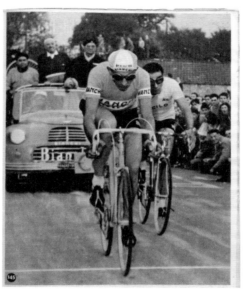

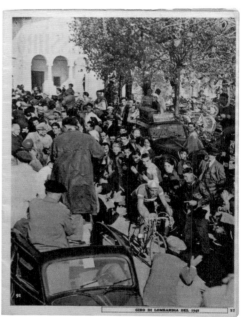

During the war, while Coppi was serving – probably without great enthusiasm – in an infantry regiment of the Italian army, Bartali helped Jewish refugees to escape to Switzerland and used his bicycle to carry messages for the Italian Resistance. Coppi was eventually captured by British forces in North Africa and held as a prisoner of war for two years. Not many of his captors recognized him or knew of the exploits of the dark-haired man who occasionally cut their hair.

The two men were back in competitive action as soon as possible. Coppi won the first post-war Milan–San Remo in 1946, while Bartali won that year's Giro. Coppi won the Giro in 1947 and again in 1949 (when Bartali played an unselfish and important supporting role). Those triumphs were separated by the scandal that erupted across Italy after Coppi left his wife and child and began seeing the wife of a doctor who was one of his biggest fans. Even though the Vatican issued a public condemnation of their relationship, Coppi and his new partner settled down happily together. But the contrast with the abstemious lifestyle of the highly devout Bartali – who was blessed by three popes during the course of his career – became even more marked.

Anno 41 - N. 43 (Nuova serie) 23 OTTOBRE 1952

Lo Sport Illustrato

SUPPLEMENTO SETTIMANALE DE "LA GAZZETTA DELLO SPORT"

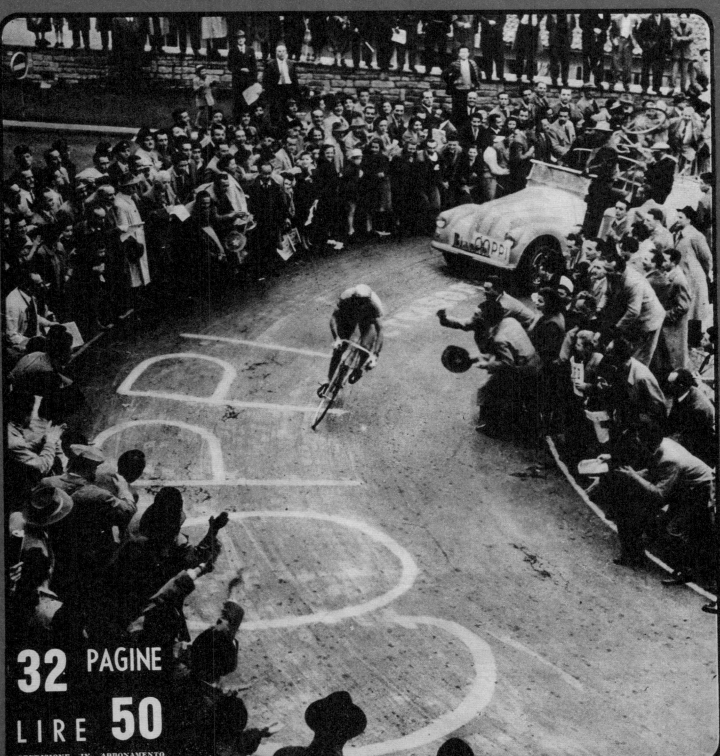

32 PAGINE

LIRE **50**

SPEDIZIONE IN ABBONAMENTO
POSTALE • GRUPPO II

AL GRAN PREMIO VANINI "COPPI ULTRASONICO„

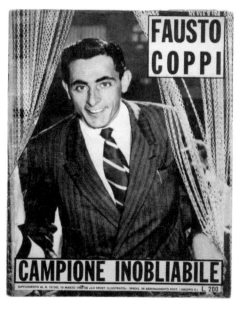

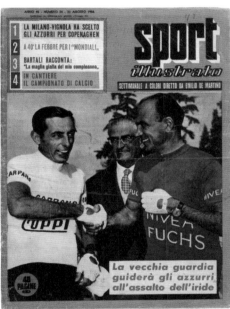

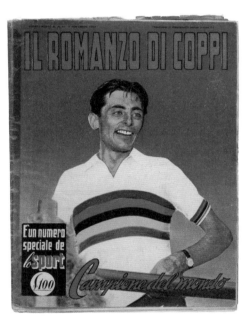

Coppi won Milan–San Remo again in 1948, Paris–Roubaix in 1950, the Tour for a third time in 1952, and the world road championship in Lugano in 1953 – a distinction that would elude his great rival. Bartali triumphed in Milan–San Remo in 1947 and 1950, either side of a third Tour win in 1948 – in which he won mountain stages on three consecutive days, a feat never matched – before his career began to wind down towards his retirement in 1954.

Coppi's performances deteriorated after the death of his younger brother and teammate, Serse, from head injuries suffered in a crash in the Giro del Piemonte in 1951. And in December 1959,

long past his best, he was one of a small group of top riders invited on a hunting and riding visit to Burkina Faso. Bitten by mosquitoes, he contracted malaria and died in Italy on 2 January 1960, aged forty.

Bartali lived into old age, long enough to teach Pope John XXIII – one of the three who blessed him – how to ride a bicycle. In 2000, after suffering a heart attack, he died at his home in Florence at the age of eighty-five. The rivalry between these two great and supremely charismatic Italian riders continues to provoke awed discussion to this day.

ONE REASON FOR REMEMBERING CHARLY GAUL IS THAT HE HAD THE MOST BEAUTIFUL OF CYCLING NICKNAMES: IN HIS HEYDAY IN THE 1950s HE WAS KNOWN AS THE ANGEL OF THE MOUNTAINS.

Karl Kopinski's painting shows Charly Gaul, one of the greatest climbers, with his gaze fixed on some distant summit finish.

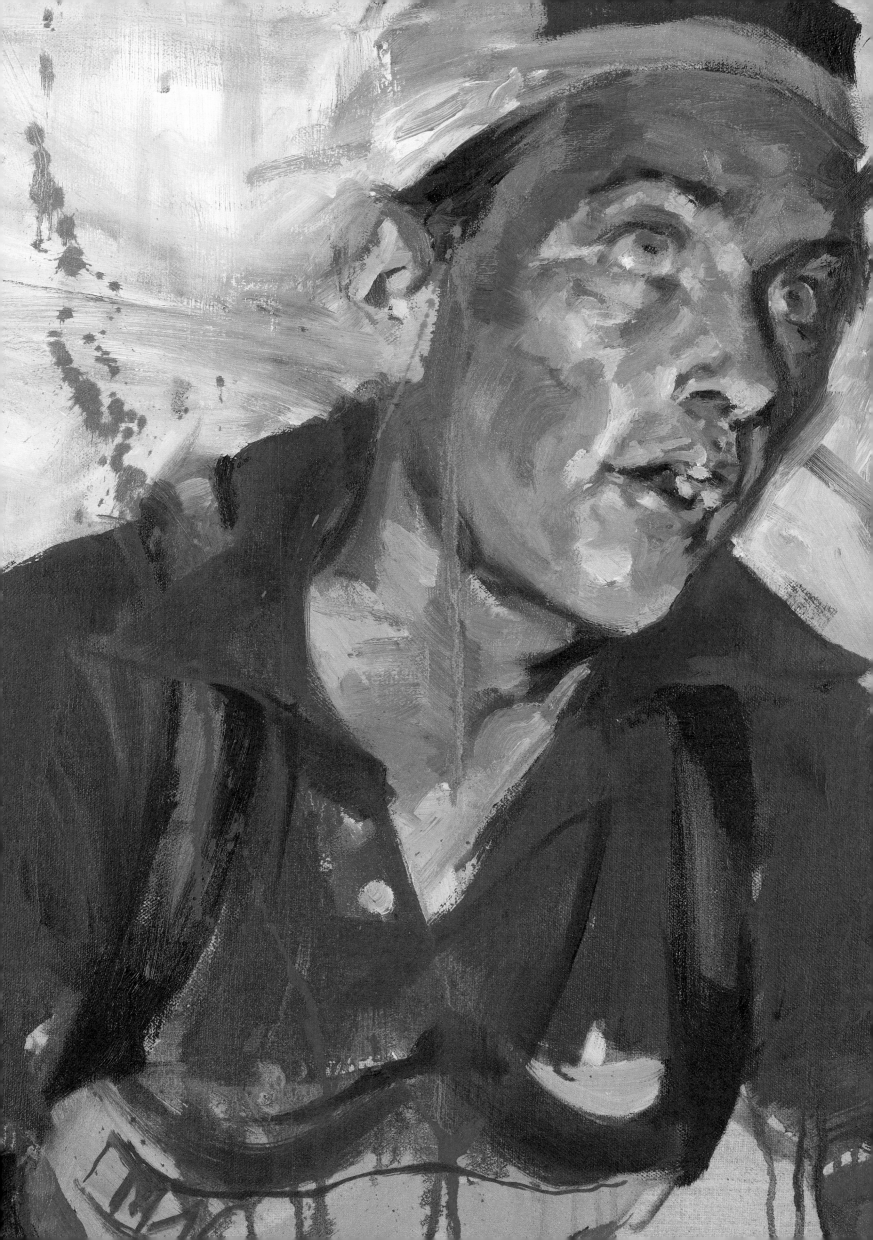

(Suite page 46)

Bruxelles, le vétéran de l'équipe de France René Vietto s'était emparé du maillot jaune au terme d'une longue échappée. C'était, sur le plan tactique, fort bien raisonné. Vietto était considéré comme un grimpeur, donc il attaquait d'entrée sur les pavés, où on le supposait vulnérable, et il s'imposait autant à ses équipiers tricolores, invités dès lors à se mettre à son service, qu'à ses adversaires. Hélas, le roi René n'avait plus ses jambes de 20 ans et il devait craquer définitivement, deux jours avant Paris, dans l'étape contre la montre de 139 kilomètres, Vannes-Saint-Brieuc.

Une « échappée-bidon » des plus pittoresques avait été celle du régional berrichon Albert Bourlon de Carcassonne à Luchon. Il déclara naïvement à un radio-reporter qu'il avait même eu le temps de s'arrêter pour satisfaire en toute quiétude un petit besoin naturel derrière un arbre.

LE PUISATIER DE CHEBLIS

Voyons, après ce Tour 1947, quelles furent les plus fameuses échappées au long cours qui, répétons-le, ne furent pas toutes « bidon », de beaucoup s'en faut.

Le Belge Maurice Blomme, un vainqueur du Grand Prix des Nations, roule seul presque de bout en bout dans l'étape Saint-Gaudens-Perpignan (233 km). Il est tellement épuisé qu'un représentant de l'organisation, Jean Garnault, doit le soutenir pour l'aider à parcourir, à pied, les derniers mètres. Ce qui provoquera des contestations aggravées encore du fait que Blomme, arrivé hors des délais d'étape la veille, avait été repêché. Mais Blomme, de toute façon, après cet exploit ne terminera pas le Tour.

Le lendemain de Perpignan à Nîmes (215 km), ce sont deux Nord-Africains qui tentent l'aventure : Abd-El-Kader Zaaf, le « puisatier de Chebli » et Marcel Molinès, formé à l'école parisienne du regretté Julien Prunier. Il fait très chaud. Zaaf assoiffé saisit au passage les bouteilles tendues à sa portée par les spectateurs. Elles ne contiennent pas toutes de l'eau, la région étant réputée pour son excellent vin rouge. A 20 kilomètres de Nîmes, Zaaf commence à zigzaguer sur son vélo, puis il s'effondre au pied d'un arbre. On le secoue, on le remet en selle... et il repart en sens inverse de la course. Il finit l'étape

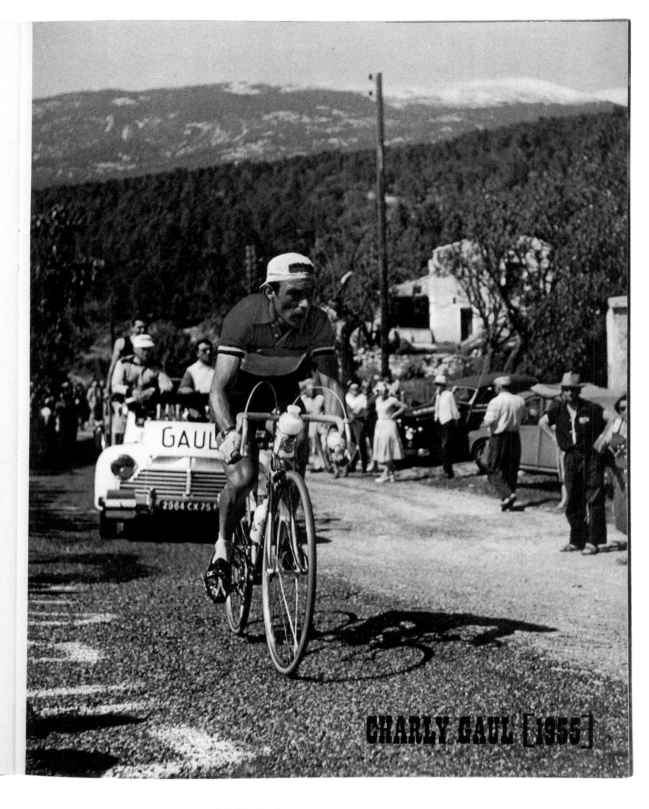

CHARLY GAUL [1955]

CHARLY GAUL

The other reason is the unusual story of his later life. When he retired he disappeared to live as a hermit in a forest in his native Luxembourg; he didn't re-emerge until a handful of years before his death in 2005 at the age of seventy-two.

Gaul was always a loner. He was also from Luxembourg, which made life difficult for him at a time when the field for the Tour de France was made up of national teams. Luxembourg didn't have enough riders of sufficient quality, so he had to be part of a team made up of the representatives of several minor nations, including the British. It's said that his brusque manner and generally awkward personality – such a contrast to his handsome face and his smooth riding style – meant that he found it hard to form useful alliances with other riders. Sometimes, in fact, he had feuds with his rivals: he and Louison Bobet had a notoriously bad relationship.

He also competed in the era of Jacques Anquetil, which inevitably restricted the number of big races he was going to win. But none of this stopped him from acquiring many, many fans, who admired the panache with which he set off on lone attacks in the most challenging terrain.

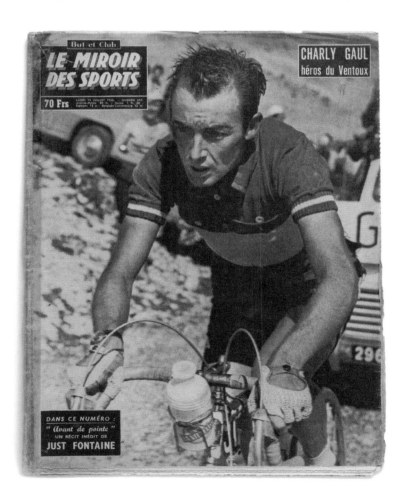

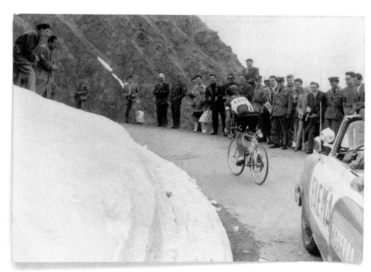

OPPOSITE: *On a mountain time trial in the 1955 Tour.*

ABOVE – Clockwise from top:
1. Gaul tells a French magazine how he intends to attack the 1962 Tour. 2. Climbing the Gran San Bernardo Pass during the Giro. 3. Gaul during the 1958 Tour, showing the effort of winning a stage on the Mont Ventoux.

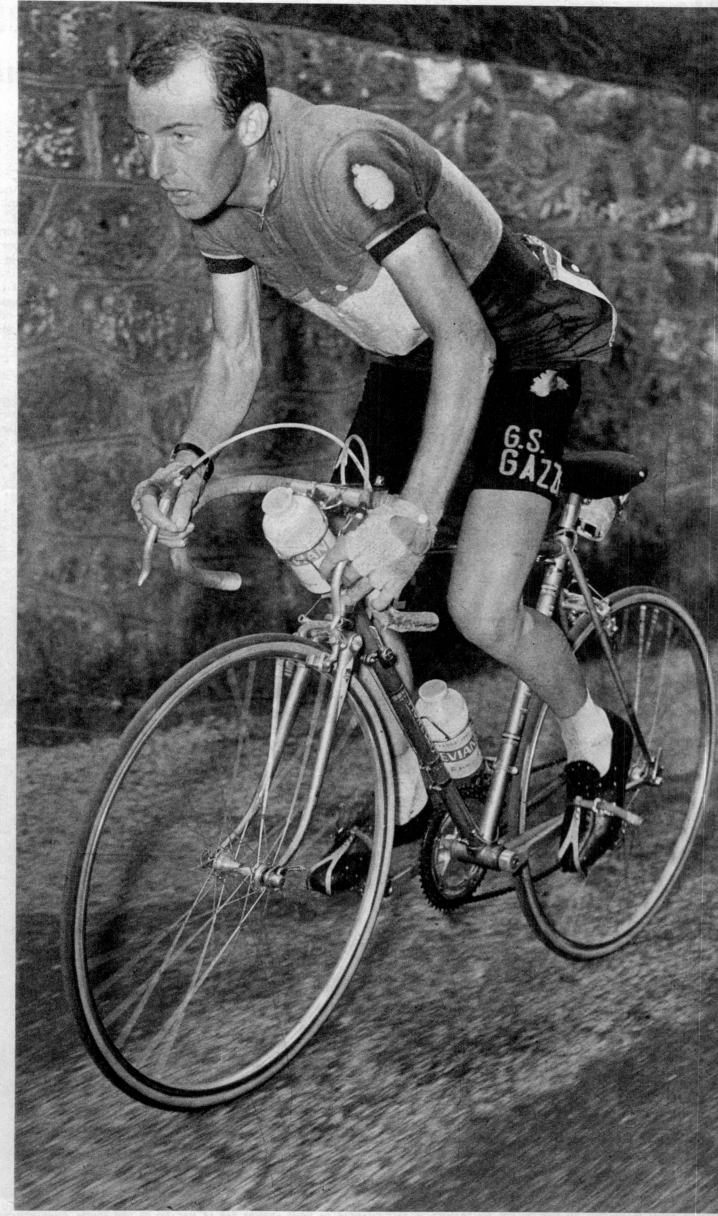

à coups de déclara-
es, au moral de l'ad-
on ne peut se raidir
dans une telle atti-
moments, dans la vie
i rapprochent malgré
les plus déterminés.
acques avait rendu un
ge à Charly :
plus dans les roues,
. Il participe aux
cela est nécessaire. Il
vrai coureur et non
r dans les étapes de

i déplaisait pas que
int d'honneur à lutter
la victoire n'en serait
« Dis-moi qui est le se-
ce que vaut ta vic-
des maximes du re-
élissier.
de chasse de Charly
ent délimités : il ne
que Toulouse-Super-
tape) et Luchon-Pau
st là, et là seulement,
er retourner la situa-
fit. Son attaque dans
renoble était prévue.
ent dissimulé son in-
un premier punch.
ge qui s'appesantissait
aissée du Granier ne
é. L'on avait retrouvé
seigneur de la mon-
dalât dressé sur ses
posé sur sa selle, en
oscillation du buste à

geait dans son sillage :
d Gaul ? Grimpait-il
? Tiendrait-il sur la
is cols ?
ait sa route attentif,
maintenant la même
re et l'écart avec ses
andissait.
eron, la pluie s'était
Le ciel prenait parti.
til tournait au temps
ança dans la descente
e maîtrise, le menton
, la fesse haute pour
re de gravité. Il effa-
inq, dix virages avec
isance, prenant tou-
tesse. Et il aborda de
ans aucune méfiance,
ortie de Saint-Pierre
lus aigu et plus traî-
ait fait ressortir des
esquels la roue avant
rly Gaul dérapa bru-
sa le danger avec une
nde de retard, mais
flexe de choisir son
en se jetant sur le
a route.

senti la douleur sur
l. Je n'avais qu'une
que la voiture Suisse-
onduite par Gold-
suivait au millimètre
corps. Quand j'ai re-
m'avait heureusement
tait arrêtée un virage
s reparti immédiate-
commencé à souffrir
trois ou quatre kilo-
. Mais le moment le
fut après l'arrivée,
ns qui me donnaient
es sur le dos et sur
me manifester leur

une fracture à la
Dumas, médecin du
une radio à Gaul le
ne décela, heureuse-
traumatisme. Mais le
ne repartirait pas le
déjà répandu : n'al-
tout, être tenté de
texte valable pour se
onneurs ? Charly ar-
de départ de Gre-
lite, sans une plainte,
sourire désabusé et
l'épaules à ceux qui
son courage.

re, avec ténacité, étu-
ude de ses moyens
es et, de toute façon,
ut, — à moins qu'on
avec la pen-
de ne pas diminuer

eau Charly Gaul...

APRÈS LA CHUTE DONT IL FUT VICTIME DANS LA DESCENTE DU CUCHERON, CHARLY GAUL JETTE SES DERNIERES FORCES DANS LA BATAILLE

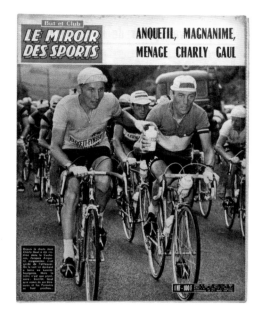

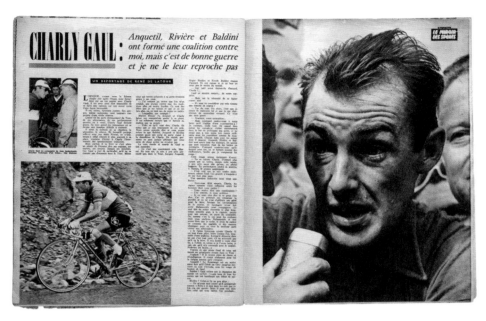

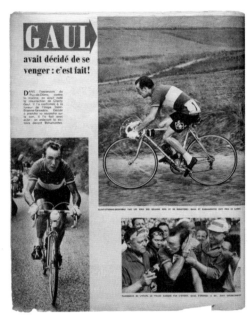

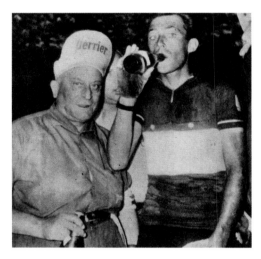

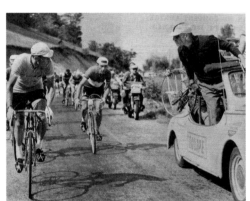

OPPOSITE: *Gaul fights on in the 1961 Tour, his jersey and shorts bearing the marks of a fall on the descent of the Cucheron.*

ABOVE – Clockwise from top left: *1. Anquetil hands Gaul a bottle during their battle in the 1961 Tour. 2. During the 1959 Tour, Gaul told journalists that Anquetil, Roger Rivière and Ercole Baldini had ganged up on him – 'But I don't blame them,' he added. 3. While the boss of the French national team, Marcel Bidot, issues instructions, Gaul lurks on Anquetil's wheel. 4. A drink of Perrier water at the stage finish in Grenoble in 1961. 5. Winning the stage from Saint-Étienne to Grenoble in 1959.*

That lovely nickname tells you what he was best at. He may have been the first of the great specialist climbers, and when you look at old photographs you can see the power and determination in his face. He was small and light – 1.73 m and 64 kg – and he turned the pedals at a high cadence with a wonderful suppleness, rarely needing to get out of the saddle.

Born in 1932, Gaul worked in an abattoir, slaughtering cattle, and took up cyclo-cross before turning professional at the age of twenty. In 1955 and 1956 he won the King of the Mountains jersey in the Tour de France, but a win in an individual time trial showed that he had plenty of strings to his bow. In 1958 he became the third rider from Luxembourg – after François Faber and Nicolas Frantz – to win the general classification, his stage victories including a time trial up the Mont Ventoux and a day on which he dropped Federico Bahamontes in a cloudburst on the Col de Luitel, having announced in advance the identity of the particular hairpin bend on which he planned to make his attack.

That sort of thing didn't make rivals like him any better, and they knew that the harsher the conditions, the more dangerous Gaul would be. He won the Giro d'Italia twice, in 1956 and 1959, the first of those including his most celebrated single exploit, when he won a stage to the 1,300-m summit of Monte Bondone by more than twelve minutes on a day when forty-nine of the eighty-six starters failed to make it through a blizzard to reach the finish. He had to be lifted from his bike and carried to his hotel wrapped in a blanket.

Anno XXXI - N. 28 - 16 luglio 1961
Spedizione in abbonamento postale - Gruppo II

50 lire

IL CALCIO E IL CICLISMO ILLUSTRATO

Direzione e Redazione: Roma
Viale Castrense, 9 - Telefono 778.906

Redazione di Milano: Via Civita-
vecchia, 102 - Telefono 25.63.141

E' in pieno svolgimento al Tour la seconda settimana dedicata agli scalatori. A Gaul spetta di diritto il ruolo di protagonista, specie dopo la stupenda vittoria colta sulle Alpi malgrado il suo volo fosse stato troncato da una rovinosa caduta. Accanto al campione lussemburghese il nostro Massignan tenterà di consolidare la sua posizione di leader della classifica del G. P. della Montagna, mentre Anquetil osserva e aspetta la tappa a cronometro.

In questo numero:

LA 5ª COLONNA di Alfredo Binda

★

L'epurazione del Comandante

★

Perchè Lindskog non è andato alla Juve

Gaul's career went downhill fast, and he retired in 1965. Separated from his second wife, he went with his dog to live in a hut in the forest. Nothing was seen of him for almost twenty years; he didn't answer the phone and he refused to talk to journalists. When he reappeared in 1983, twenty-five years after his Tour victory, he was unrecognizable: a barrel-shaped old man with a thick beard. He looked like the folk singer Burl Ives.

After so many years of rumours concerning his whereabouts, his old fans, and those who knew him only from stories, were delighted to welcome him back. He met the woman who became his third wife, moved back into the city, and was given a job in his country's sports ministry. He was present when the Tour started in Luxembourg in 1989, and was among the former winners of the race who gathered for the centenary banquet in Paris in 2002. His last public appearance was at the funeral of Marco Pantani, a rider he much admired, in 2004. He died the following year, after a fall at his home, aged seventy-three.

No Grand Tour winner had led a more unusual life. In the end, however, the one-time loner seemed pleased to find himself in the warm embrace of the cycling family, his place in history secure.

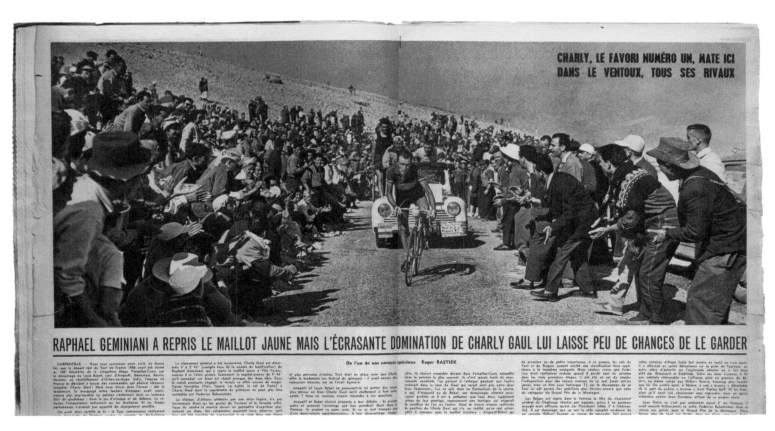

RAPHAEL GEMINIANI A REPRIS LE MAILLOT JAUNE MAIS L'ÉCRASANTE DOMINATION DE CHARLY GAUL LUI LAISSE PEU DE CHANCES DE LE GARDER

OPPOSITE: *Uncatchable in the Alps as the 1961 Tour enters its second week.*

ABOVE – Clockwise from top:
1. On the upper slopes of the Ventoux, Gaul announces his superiority in the 1958 Tour. 2. Gaul takes the yellow jersey with a win in the 71-km time trial from Besançon to Dijon. 3. Celebrating victory in the 1958 Tour, ahead of Vito Favero. 4. Scenes from the final stage in 1958, won in a sprint by Pierino Baffi.

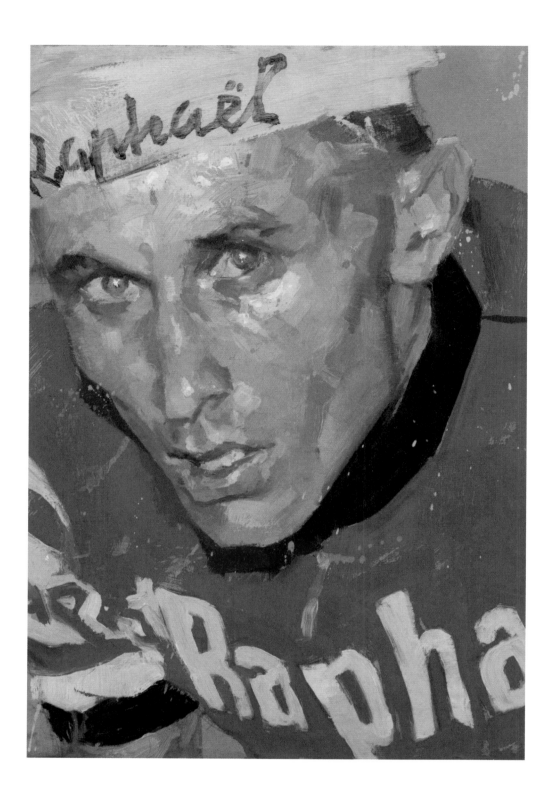

JACQUES ANQUETIL

When I was fourteen, I looked at Jacques Anquetil and decided that here was a man who defined cycling cool, thanks to his good looks and that red-and-white St Raphaël jersey. The first man to win the Tour de France five times, he had the confidence to start one year by announcing that he intended to wear the yellow jersey from the start to the finish of the race – and he did.

I was just beginning to race with my local cycling club when I heard about Anquetil. He'd already won his first Tour. There were two names that were always bandied about. One was Fausto Coppi and the other was Jacques Anquetil. I was too young to have been conscious of Coppi while he was racing, in

the late 1940s and early 1950s, but Anquetil was in his prime when I was starting to take an interest.

He was a great all-rounder. He was a good time triallist, and he took the hour record, which was a big deal then. His nickname was Monsieur Chrono: Mr Stopwatch. I loved his style on the bike. A lot of it was probably nonsense, but as a geeky schoolboy I used to get deeply into things like the length of the handlebar stem, the seat position, and the position of the brake levers. We were all looking for what we considered to be the perfect position on the bike. For instance, the bottom of the bars had to be absolutely flat, parallel to the ground.

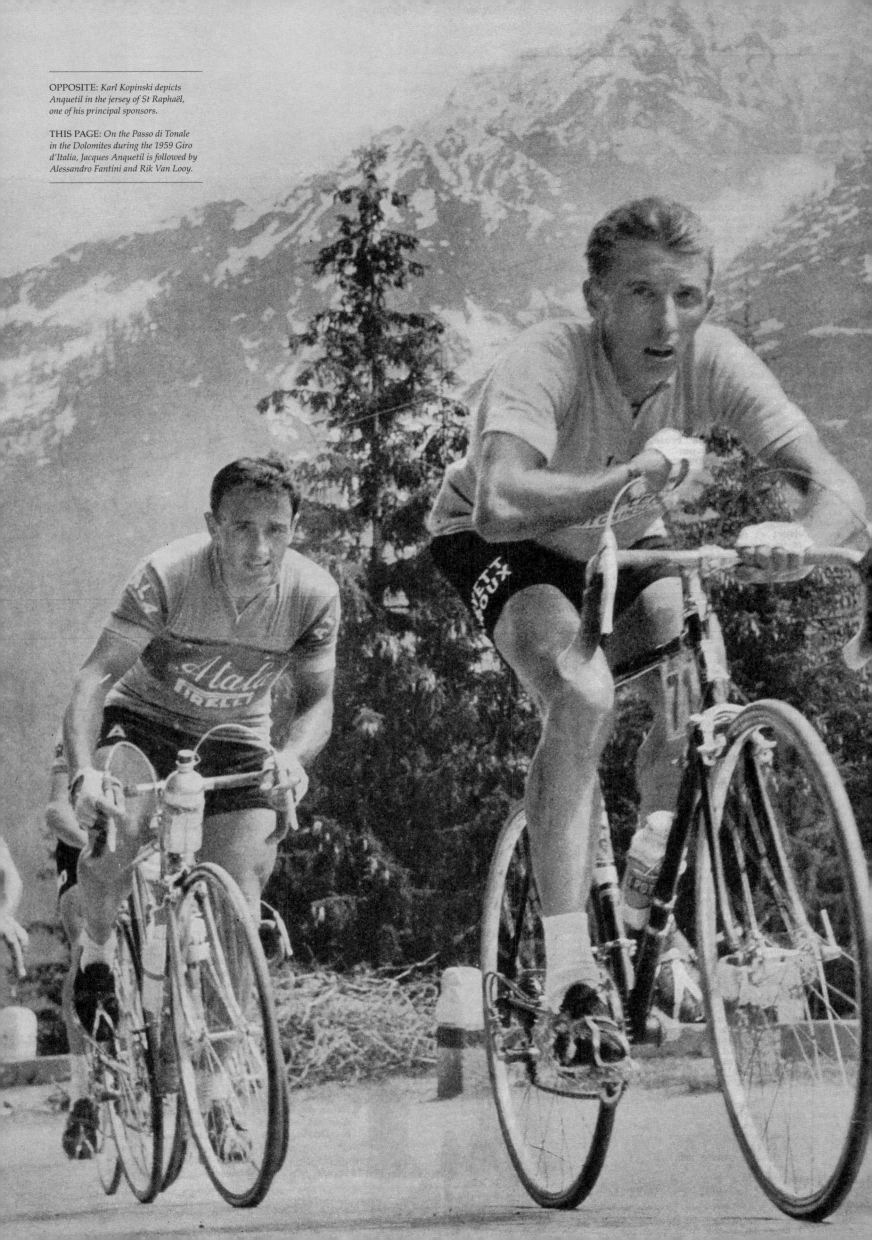

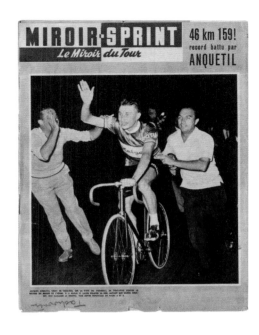

MIROIR-SPRINT
Le Miroir du Tour

46 km 159!
record battu par
ANQUETIL

LE MIROIR
DES SPORTS
présente

L'HISTOIRE DU TOUR 61

64
PAGES

1.50
N. F.

POUR ANQUETIL, LA PLUS DOUCE DES RÉCOMPENSES : LE BAISER DE SA FEMME JANINE

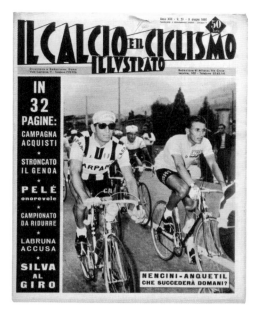

IL CALCIO E IL CICLISMO
ILLUSTRATO

IN
32
PAGINE:

CAMPAGNA
ACQUISTI

STRONCATO
IL GENOA

PELÉ
onorevole

CAMPIONATO
DA RIDURRE

LABRUNA
ACCUSA

SILVA
AL
GIRO

NENCINI-ANQUETIL
CHE SUCCEDERÀ DOMANI?

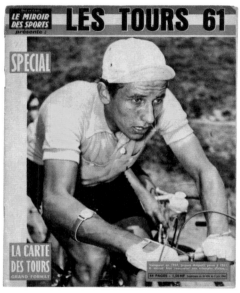

LE MIROIR
DES SPORTS
présente

LES TOURS 61

SPÉCIAL

LA CARTE
DES TOURS
GRAND-FORMAT

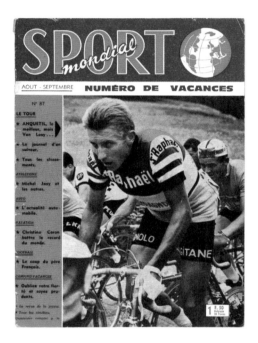

SPORT
mondial

AOUT - SEPTEMBRE

NUMÉRO DE VACANCES

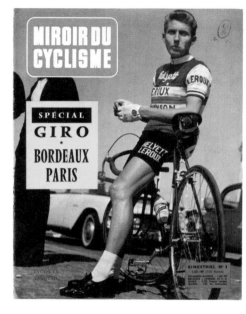

MIROIR DU
CYCLISME

SPÉCIAL
GIRO
★
BORDEAUX
PARIS

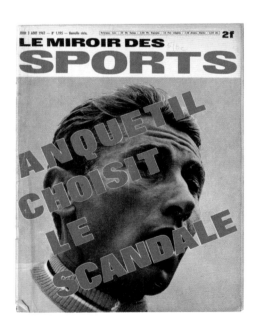

LE MIROIR DES
SPORTS

2f

ANQUETIL
CHOISIT
LE
SCANDALE

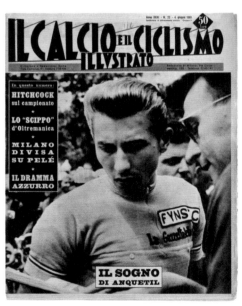

IL CALCIO E IL CICLISMO
ILLUSTRATO

In questo numero:

HITCHCOCK
sul campionato

LO "SCIPPO"
d'Oltremanica

MILANO
DIVISA
SU PELÉ

IL DRAMMA
AZZURRO

IL SOGNO
DI ANQUETIL

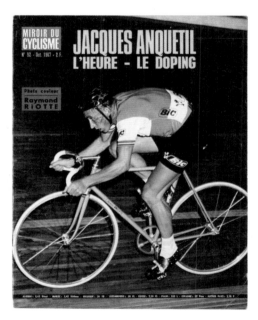

MIROIR DU
CYCLISME

JACQUES ANQUETIL
L'HEURE - LE DOPING

Photo couleur
Raymond
RIOTTE

ABOVE: *Probably only Brigitte Bardot scored more French magazine covers than Anquetil.*

OPPOSITE: *This special magazine was published in 1961 to celebrate Anquetil's exploits.*

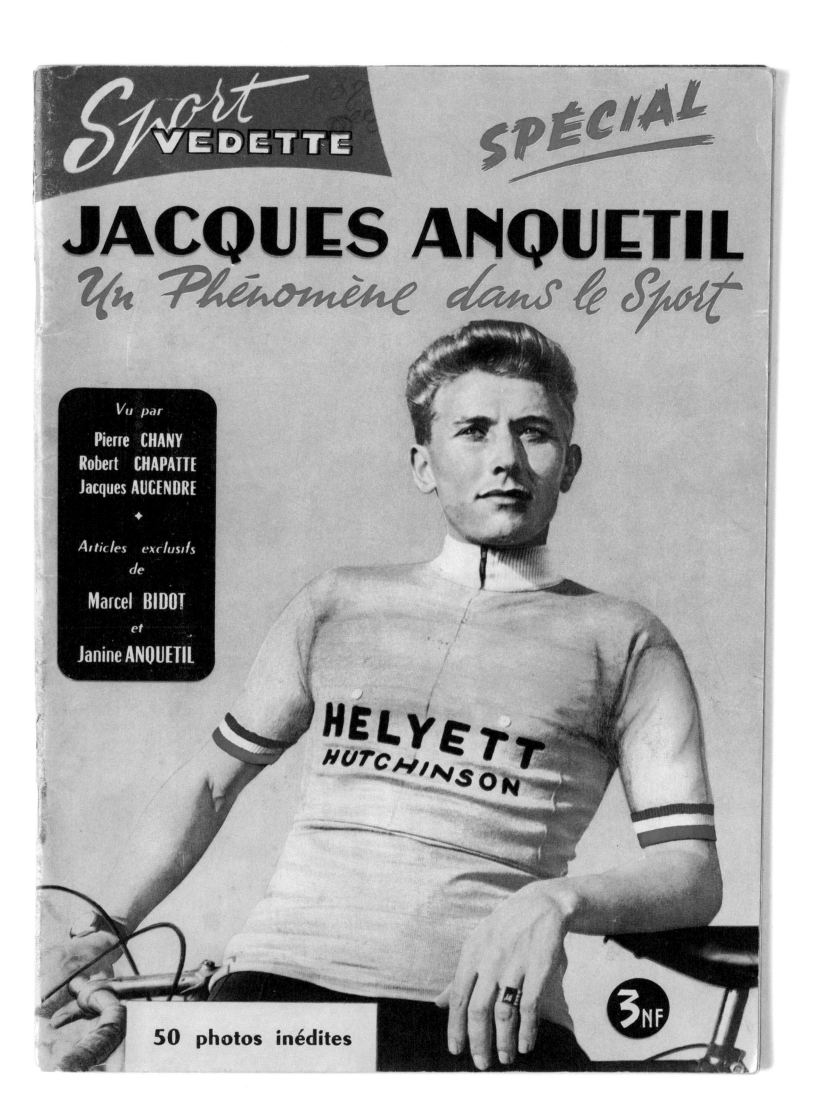

Sport VEDETTE SPÉCIAL

JACQUES ANQUETIL
Un Phénomène dans le Sport

Vu par

Pierre **CHANY**
Robert **CHAPATTE**
Jacques **AUGENDRE**

♦

Articles exclusifs de

Marcel **BIDOT**
et
Janine **ANQUETIL**

HELYETT
HUTCHINSON

50 photos inédites

3NF

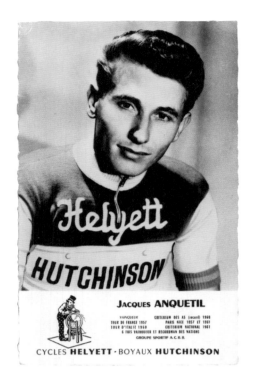

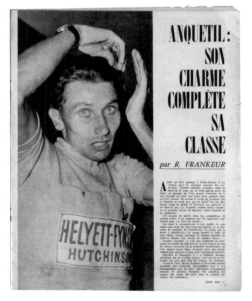

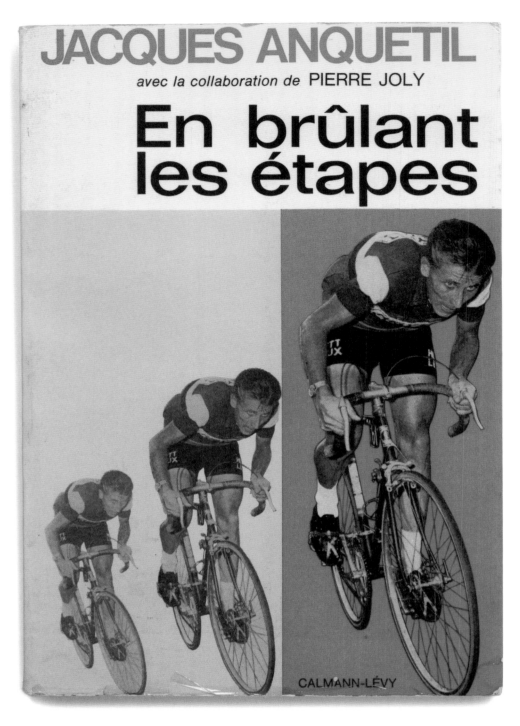

We'd look at photographs of Anquetil and try to copy how he did it and what equipment he used. 'He's got Mafac brakes!' 'He's got Campagnolo gears!' Eventually I had some Jacques Anquetil cycling shoes, black leather laced to the toe, with holes drilled in the soles as well as the uppers. So cool!

St Raphaël was one of Anquetil's sponsors. It made a herbal apéritif that was popular in those days. I don't think the firm makes it any more, but not long ago I bought an old St Raphaël clock from a café, just because of him, and the memory of seeing the name on his jersey. It was one of those names – like Anquetil, in fact – that you had to learn to say if you were a boy in the English Midlands who didn't speak a foreign language.

What I also didn't know at the age of fourteen – and what even the senior members of the club didn't know – was that Anquetil had a colourful private life, involving a ménage-à-trois with his wife and his stepdaughter, who was later replaced by the wife

of his stepson. He was also unrepentant about the widespread use of amphetamines. 'You can't win the Tour de France on mineral water,' he said.

Greatly admired by General Charles de Gaulle, the French president, Anquetil was a man of strong character and opinions – taking after his father, a builder who refused to do work on military installations for the occupying German forces during the Second World War.

Anquetil retired in 1969. He barely touched his bike again, becoming a commentator for radio and L'Équipe before dying of stomach cancer in 1987, aged fifty-three. On the tenth anniversary of his death the Tour visited Rouen, his home town. Eight of his old teammates were present, along with the team car from the year of his first success, 1957. That's the kind of gesture of respect for a hero of the past that helps to make cycling such a great sport.

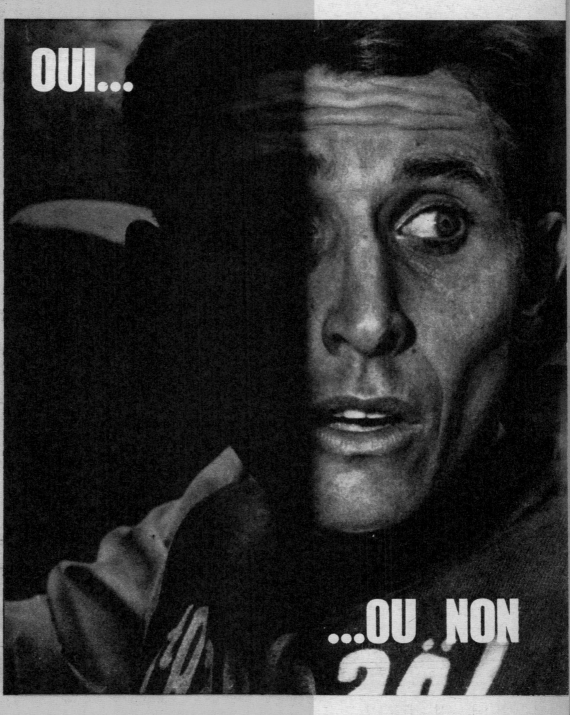

4/6

MIROIR SPRINT

JACQUES ANQUETIL DEVANT LE TOUR

40 PAGES

- Poulidor n'y voyait plus
- Van Looy sera terrible dans le Tour

N° 888
10 JUIN 1963
1,50 F

OUI...

...OU NON

OPPOSITE – Clockwise from top left:
1. Anquetil's charisma made him adored by sponsors as well as fans. 2. 'Burning Up the Stages': a ghosted autobiography. 3. It was said that he never set off without a comb in his pocket.

ABOVE: *In 1963 the shadow would be dispelled by Anquetil's fourth Tour win.*

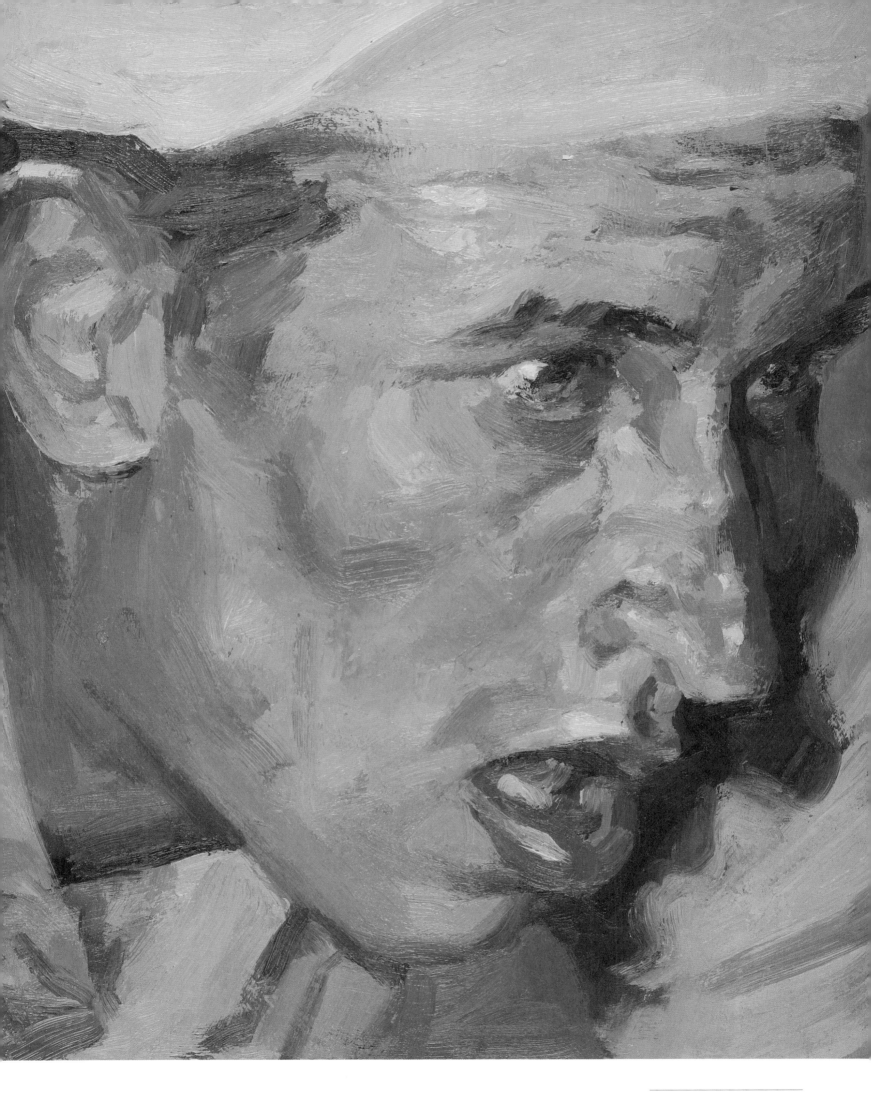

Karl Kopinski's painting captures the effort involved in hanging on to the yellow jersey, even for a five-times Tour winner.

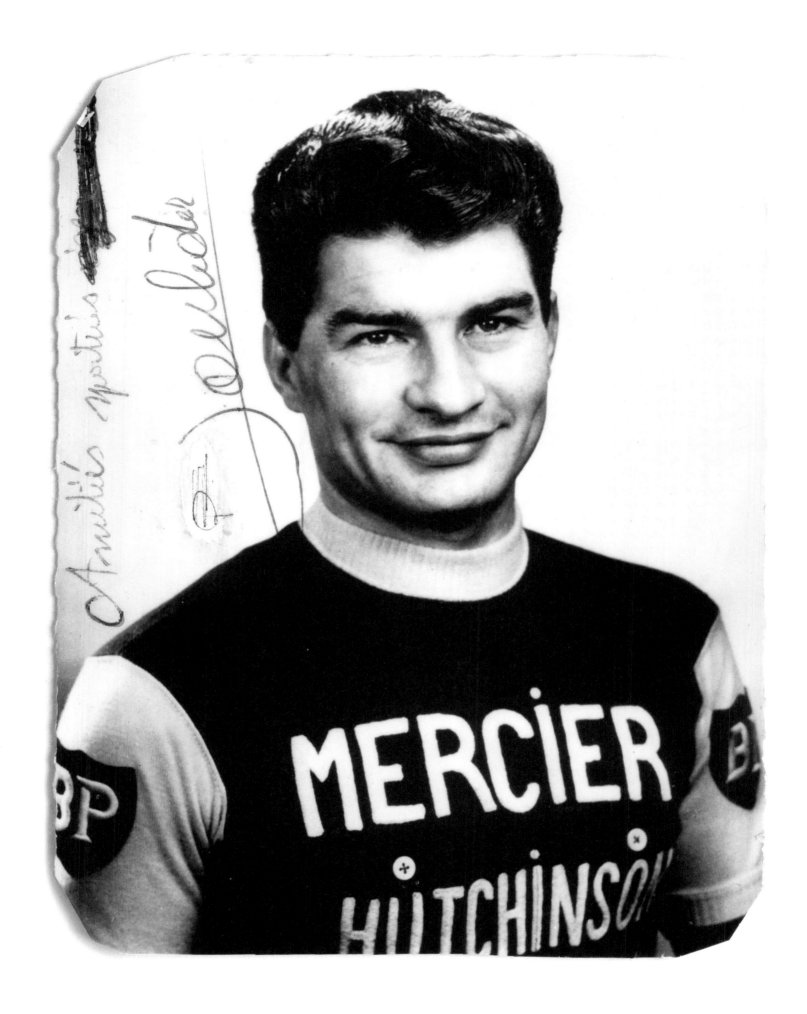

RAYMOND POULIDOR

THE ETERNAL SECOND! THAT MIGHT NOT SEEM MUCH OF A NICKNAME TO BE PROUD OF, ALTHOUGH FINISHING SECOND THREE TIMES (AND THIRD ON FIVE OCCASIONS) IN THE TOUR DE FRANCE AND TWICE IN THE GIRO D'ITALIA IS HARDLY A SHABBY RECORD.

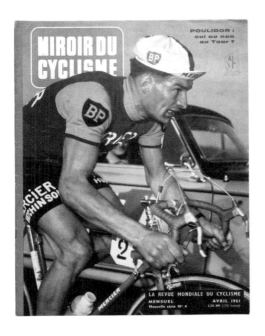

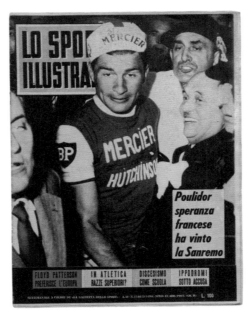

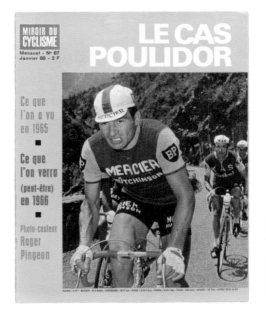

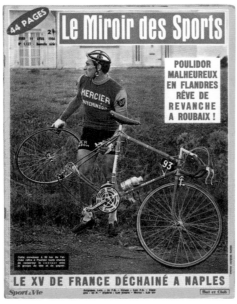

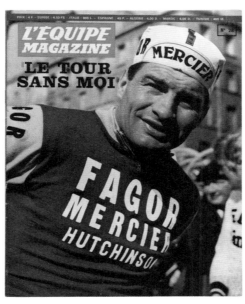

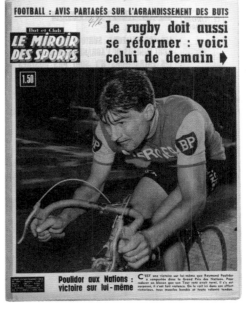

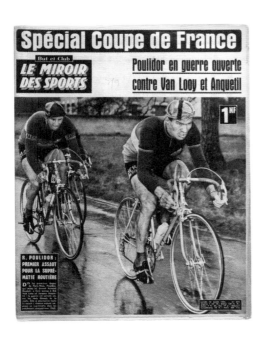

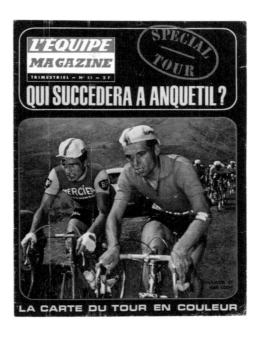

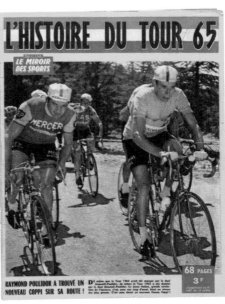

The very fact that he was destined to always come second – usually to Jacques Anquetil – was the basis of the French public's love affair with Raymond Poulidor.

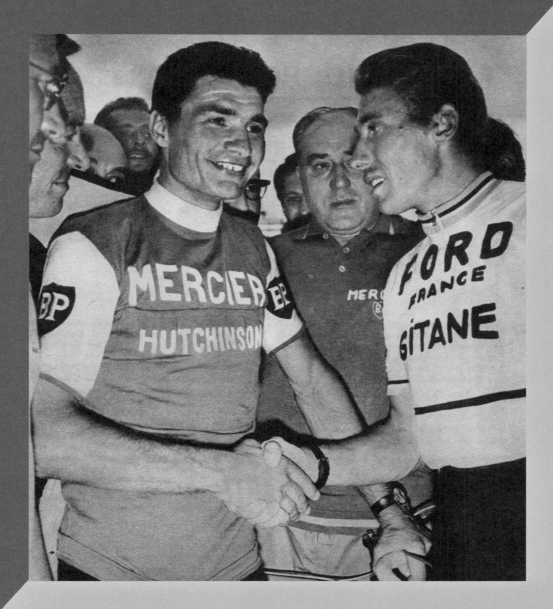

And Raymond Poulidor was everybody's favourite at our cycle club – the old British thing of supporting the underdog, I suppose.

It was just Poulidor's bad luck to compete in the era dominated by Jacques Anquetil, his fellow Frenchman. And when Anquetil bowed out of a rivalry that had divided friends and families across the nation, along came Eddy Merckx, the great Belgian, to spoil what had looked like Poulidor's chance to take advantage.

Poulidor's poor timing, however, endeared him to the French public, who treated their 'Poupou' like a son and covered him with the affection they withheld from the more successful but emotionally reserved Anquetil. Compared to the big-city ways of his rival, Poulidor's manner seemed like a throwback to an old, more rustic France.

Born in 1936 into a family of small farmers east of Limoges in central France, Poulidor spent his entire career racing for the Cycles Mercier team. Between 1960 and 1967 he made the purple and yellow colours of Mercier-BP a familiar sight on the covers of cycling magazines, not least in the famous photograph from the 1964 Tour, when he and Anquetil were captured banging elbows as they raced side by side to the summit of the Puy de Dôme, where Poulidor failed to capitalize on his best chance to wrest the leader's jersey from his rival's shoulders.

MAGNE-POULIDOR-LEONI
Un ménage à trois où il y a eu de l'eau dans le gaz !

par Francis HUGER

I l faudra sans doute se résoudre à abandonner cette couleur violine des maillots, à la maison Mercier. Elle est symbole d'humilité, de pénitence, d'effacement. C'est elle, sans nul doute, qui pèse comme un maléfice sur l'équipe d'Antonin Magne, encore une fois battu à travers Poulidor.

Le béret basque demeure solidement vissé sur la tête, mais c'est une tête déçue, dont bien des rêves se sont envolés.

— Raymond m'a bien contrarié, murmure cet homme qui avait misé en secret, comme les épouses se cachent de leur mari pour faire le tiercé.

Ici, bien sûr, il ne s'agissait que d'un seul cheval, un pur-sang, le doute n'est pas permis, mais à qui il a manqué la volonté d'obstination, peut-être seulement le bon vouloir.

C'est d'ailleurs cela qui heurte chez Poulidor, cette sorte de résignation constante, soitement paysanne, un fatalisme d'Asiatique au ventre et aux joues pleins.

— Mais, enfin, je n'étais pas seul dans le peloton. Ce Gimondi, c'est tout de même quelqu'un, vous ne pensez pas ?

— On y pense. Mais Poulidor n'a rien, non plus, de la Pasionaria. « Mourir debout plutôt que vivre assis » — est un argument qui lui échappe aussi complètement que le rite baluba.

Il n'a jamais eu de grandes joies explosives — et cette année singulièrement — ni non plus, de ces « fières douleurs » qu'un Van Looy, par exemple, promenait à l'arrière avec une distinction d'hobereau appauvri.

— Je n'ai jamais pensé que Gimondi tiendrait le coup.

Petites, pauvres excuses banales qui n'ont rien à faire dans la bouche du champion, sous une tête de champion.

Depuis Cologne pourtant, Antonin Magne avait inscrit Gimondi sur la liste de douze apôtres à ne pas quitter de la pupille. Poulidor songe peut-être que la poésie pour certain juteux — est une mauvaise habitude. Il ne l'a pas suivie.

Un chasseur de papillon...

Et cela est encore un paradoxe de ce garçon, complètement hypnotisé, du moins au début, dominé, écrasé par la personnalité d'Antonin Magne, jusqu'au point... du la désobéir.

Quand Poulidor dit encore :

— J'ai donné le meilleur de moi dans le Tour de France », c'est ce que lui-même considère comme son meilleur. Mais dans une circonstance pareille, c'est le « tout » qui seul qu'il faut donner.

Tonin donc, ancien champion de légende, légion d'honneur, présidents des laitiers-nourrisseurs de la région parisienne quand il n'allaite pas un cycliste, se met à la besogne. Il y employa avec le mysticisme d'un chasseur de papillon et la patience d'un moine qui veut transcrire l'Iliade sur un grain de riz. Il entreprit de révéler Poulidor et, d'abord, de le révéler à lui-même.

10

5 SAINT-BRIEUC-CHATEAULIN
(147 km)

LES 26,700 KM DE CHATEAULIN : UNE PÉRIPÉTIE

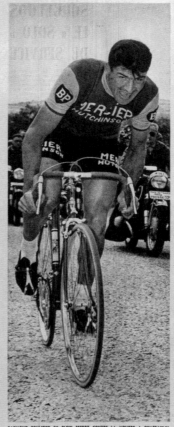

O n attendait avec grande impatience l'épreuve contre la montre qui, le samedi 20 juin dans l'après-midi, devait être disputée sur le circuit de Châteaulin. Il suffit, en effet, de parler de course contre le chrono pour que tout le monde entre en transes dans la caravane, comme si ses effets devaient être décisifs. En réalité, pour ce qui est de l'épreuve de Châteaulin, cette heure de vérité ne se prolongea guère plus... d'une demi-heure ! La distance était très courte (26,700 km) : elle ne pouvait provoquer de gros écarts. Comme prévu, Raymond Poulidor se montra le meilleur rouleur du lot, mais sans, pour autant, affirmer une suprématie éclatante, puisqu'il ne prit que 7" à Felice Gimondi et 19" à Gianni Motta. Et l'on ne pouvait pas penser, décemment, que cette poignée de secondes pèserait lourd finalement dans la balance. En somme, Châteaulin n'avait été qu'une péripétie. Une péripétie, cependant, qui confirmait que Poulidor aurait à compter avec les deux Italiens. Une péripétie qui, également, semblait écarter Bahamontés de la course au maillot jaune, puisqu'il avait tout de même perdu 2' 16" sur Raymond Poulidor.

RAYMOND POULIDOR EN PLEIN EFFORT CONTRE LA MONTRE A CHATEAULIN FELICE GIMONDI S'EST AFFIRME EXCELLENT ROULEUR, NE CEDANT QUE 7"

18 4

9 DAX-BAGNERES-DE-BIGORRE
(226,500 km)

R. POULIDOR MENACÉ PAR GIMONDI ET MOTTA

A BAGNERES-DE-BIGORRE, on se posait la question : André Foucher n'aurait-il pas rejoint Jimenez s'il n'avait pas été victime d'une chute dans la descente du Tourmalet ? Mais l'on s'interrogeait aussi et surtout au sujet de Raymond Poulidor : que lui était-il arrivé ? Dans le Tourmalet, en particulier, il n'avait pas été à son affaire et il avait dû laisser filer deux adversaires aussi dangereux que les Italiens Felice Gimondi et Gianni Motta. Encore eut-il la chance que Gimondi fût retardé par une crevaison dans la descente, ce qui permit au Limousin de limiter les dégâts. Quoi qu'il en soit, après cette première étape pyrénéenne, qui donna lieu à une véritable hécatombe (onze abandons et non des moindres), la situation devenait claire : ils n'étaient plus que cinq qui pouvaient prétendre à la victoire finale, Gimondi de nouveau maillot jaune (Van de Kerkhove ayant abandonné), Poulidor, 2e à 3' 12", Lebaube et Foucher à 4' 28", Motta à 4' 32". Et l'on considérait les deux Italiens comme les plus menaçants.

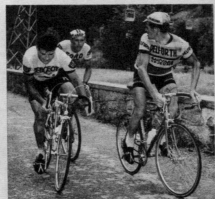

DANS LE TOURMALET, FOUCHER EST ACCOMPAGNE PAR DELISLE ET LEBAUBE

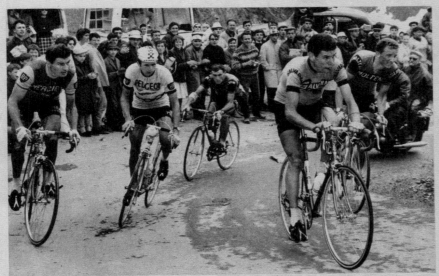

DE G. A D., DANS LE TOURMALET : POULIDOR, ZIMMERMANN, DE ROSSO, GIMONDI ET MOTTA. BIENTOT, POULIDOR, EN DIFFICULTE, VA FLECHIR DANGEREUSEMENT...

23

THIS PAGE – Clockwise from top left: 1. *'There was water in the gasoline,'* Poulidor says of his failure to win the 1965 Tour de France after a great duel with Felice Gimondi. 2. But he did win the 26-km time trial on the circuit of Châteaulin, in which he finished seven seconds up on Gimondi. 3. On the mountain stage to Bagnères-de-Bigorre in the Pyrenees, he fought off a challenge from Gimondi and Gianni Motta.

OPPOSITE, TOP: *The time trial during the 1965 Tour.*

OPPOSITE, BOTTOM: *'I intend to end the way I started out,' Poulidor claims, preparing to draw the curtain on his career.*

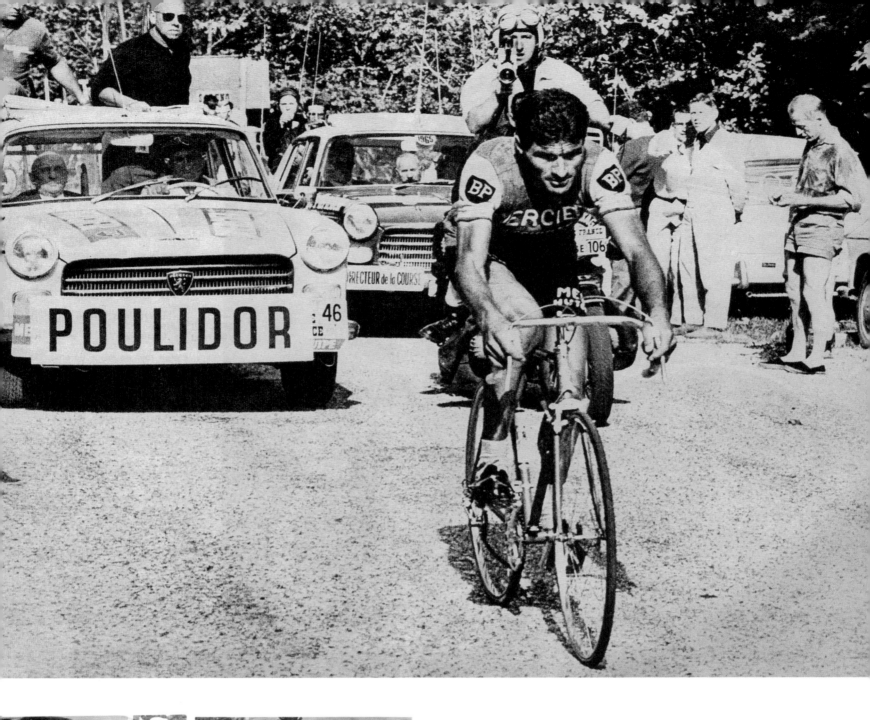

Although Poupou did manage to win the Vuelta a España in 1964, seven stage wins in his fourteen appearances in the Tour de France never brought him a single day in the yellow jersey. But he did win several stage races and classics during his seventeen-year career, including the Critérium International five times, the Critérium du Dauphiné Libéré twice, Paris–Nice twice, Milan–San Remo, the Flèche Wallonne and the Grand Prix des Nations. In 1966 he had the honour of becoming the first rider to be drug-tested at the Tour.

On his frequent visits to the modern Tour, where he represents a sponsor, Poulidor invariably draws an admiring crowd of those still attracted to the legend of an underdog. But when he visited Anquetil on his deathbed in 1987, he heard his old rival say, 'My friend, you will come second to me once again.'

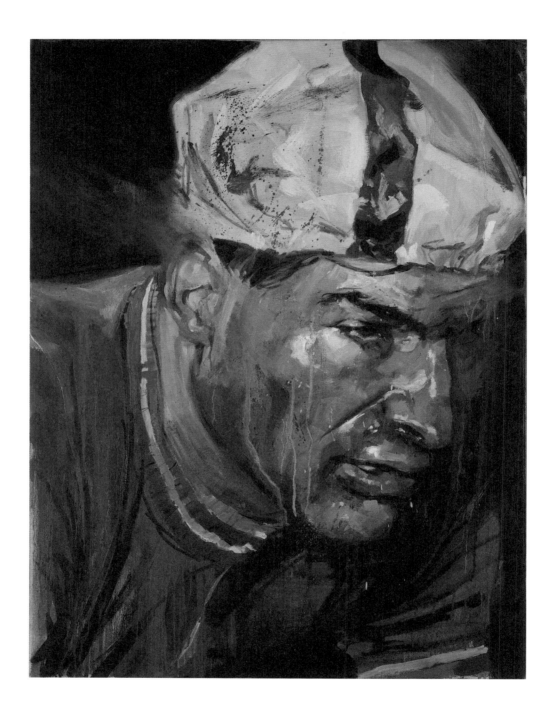

ABOVE: *Poulidor's endless suffering,*
captured in Karl Kopinski's portrait,
won French hearts.

OPPOSITE: *Half a wheel behind the*
yellow jersey, as usual – in this case,
that of Felice Gimondi in the 1965 Tour.

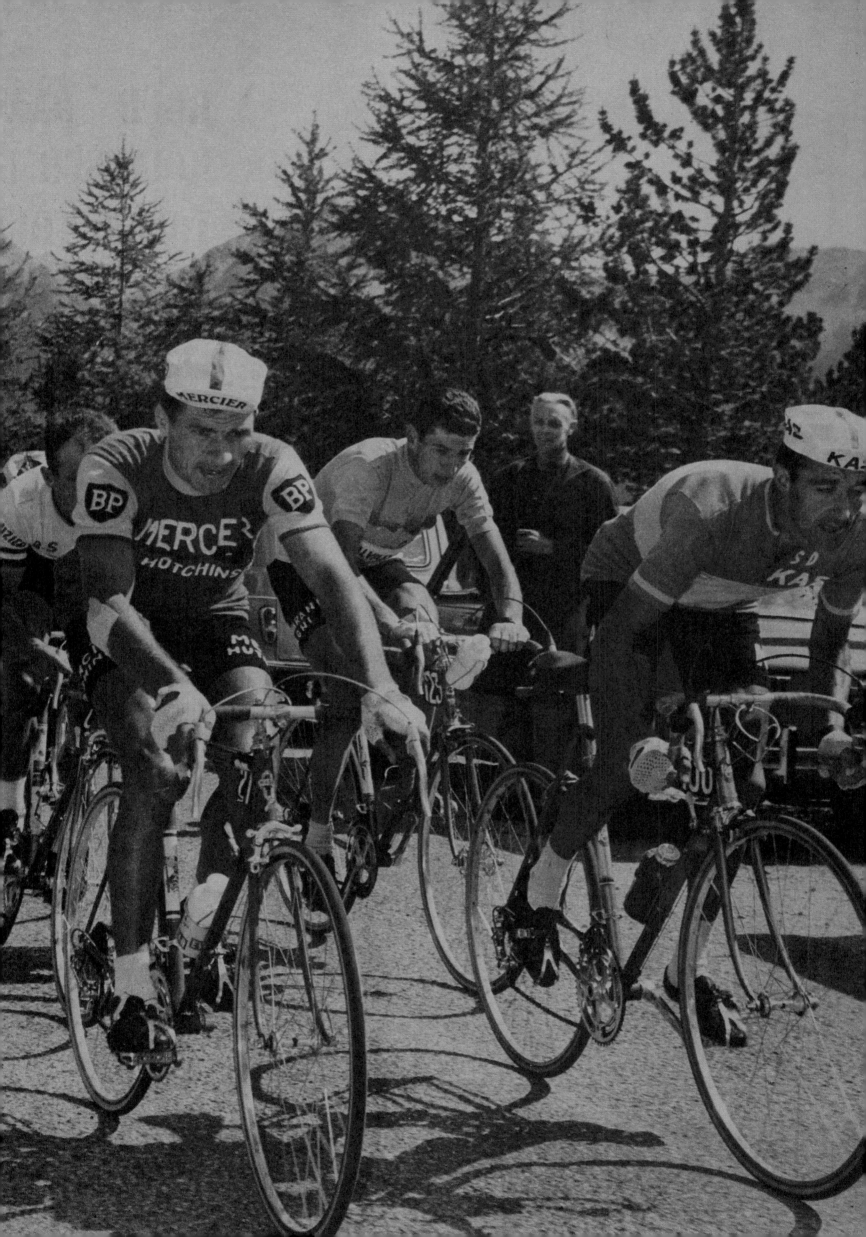

ROGER RIVIÈRE HAD THE LOOK OF A LITTLE ANGEL, AND THE PHOTOGRAPHS OF HIM LYING CRUMPLED ON A HILLSIDE IN THE MIDDLE OF FRANCE ON 10 JUNE 1960, FACE DOWN ON A BED OF FALLEN LEAVES AFTER CRASHING WHILE CHALLENGING FOR THE OVERALL LEAD OF THE TOUR DE FRANCE, ARE REMINISCENT OF RELIGIOUS ICONOGRAPHY.

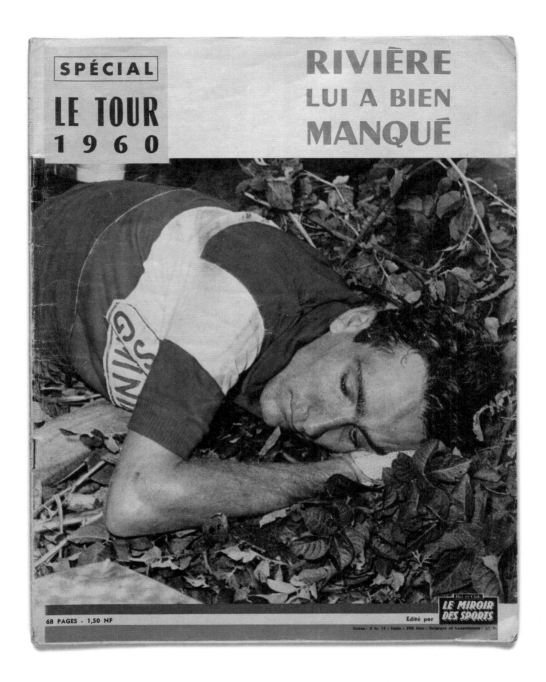

SPÉCIAL

LE TOUR 1960

RIVIÈRE LUI A BIEN MANQUÉ

68 PAGES - 1,50 NF

Edité par

LE MIROIR DES SPORTS

ROGER RIVIÈRE

He was twenty-four years old, the golden boy of French cycling. But this was the end of what had promised to be a glittering career. On the fast descent of Mont Aigual during stage fourteen, from Millau to Avignon, the first day of the final week of the Tour, Rivière was following Gastone Nencini, the eventual winner of the general classification. The Italian was celebrated for his speed going downhill, and Rivière was trying to keep up with him when he overcooked it on one of the zigzag bends, hitting a low wall and shooting over the edge before tumbling down the steep slope.

They carried him back up to the road as gently as they could, but when they got him to hospital it was discovered that he had broken his back in two places. Paralysed by the fractured vertebrae, Rivière never regained full movement of his limbs and lived the rest of his days in a wheelchair.

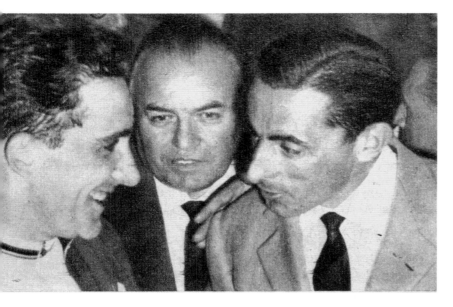

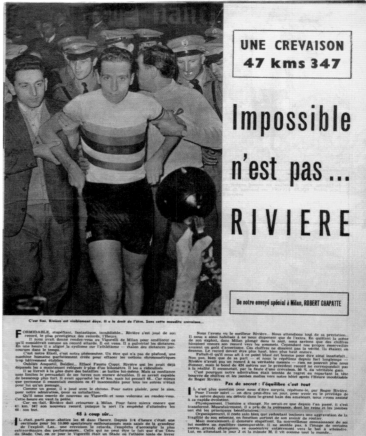

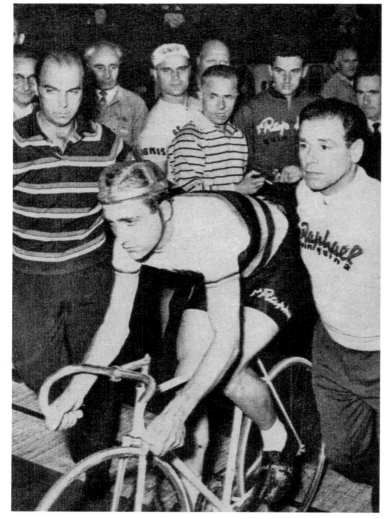

ABOVE – Clockwise from top left: *1. Fausto Coppi, a former holder of the world hour record, congratulates Rivière on setting a new mark in Milan's historic Vigorelli velodrome. 2. Rivière has just ridden 47 km 347 m in sixty minutes. 3. The young Frenchman sets off on his attempt in the world champion's rainbow jersey.*

OPPOSITE: *Rivière celebrates his success with a bottle of the sponsor's product.*

He had been an amazing-looking man – the way he wore his jersey, everything about him. He was born in Saint-Étienne in 1936 and started as a track rider in the local velodrome. At nineteen years of age he caused a sensation when he went to Paris and beat Jacques Anquetil in a pursuit race in the Parc des Princes. He turned professional in 1957 and won the world pursuit championship, when he was still doing his military service.

That same year he went to the Vigorelli velodrome in Milan and took the hour record, riding 46.923 km to beat Ercole Baldini's mark. The hour was a big deal in those days – as it is once again now – and Rivière's success proved that he was no flash in the pan. The following year he won the world pursuit title again and then had another go at the hour, once more at the Vigorelli, this time becoming the first man to exceed 47 km.

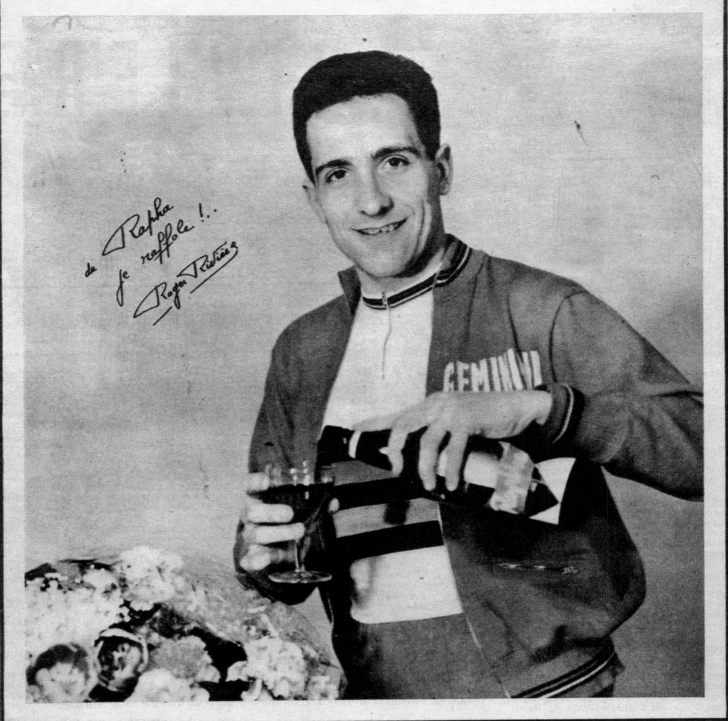

ROGER RIVIERE, du Groupe Sportif **GEMINIANI**-St **RAPHAEL**, déjà détenteur du Record du Monde de l'Heure, vient de réaliser un nouvel exploit en portant celui-ci à 47 km. 347. Après son magnifique effort, **ROGER RIVIERE** est heureux de fêter sa victoire en buvant un bon verre de vin doux naturel **RAPHA**.

de Rapha je reffôle !..
Roger Rivière

The 1960 Tour was Rivière's fourth participation in the race. He won the opening time trial and then took a road stage at the end of the first week. The accident came when he knew that if he could keep pace with Nencini throughout the final week, he would be capable of taking back the 1 min 38 sec needed to tear the yellow jersey from his Italian rival's back in the final time trial.

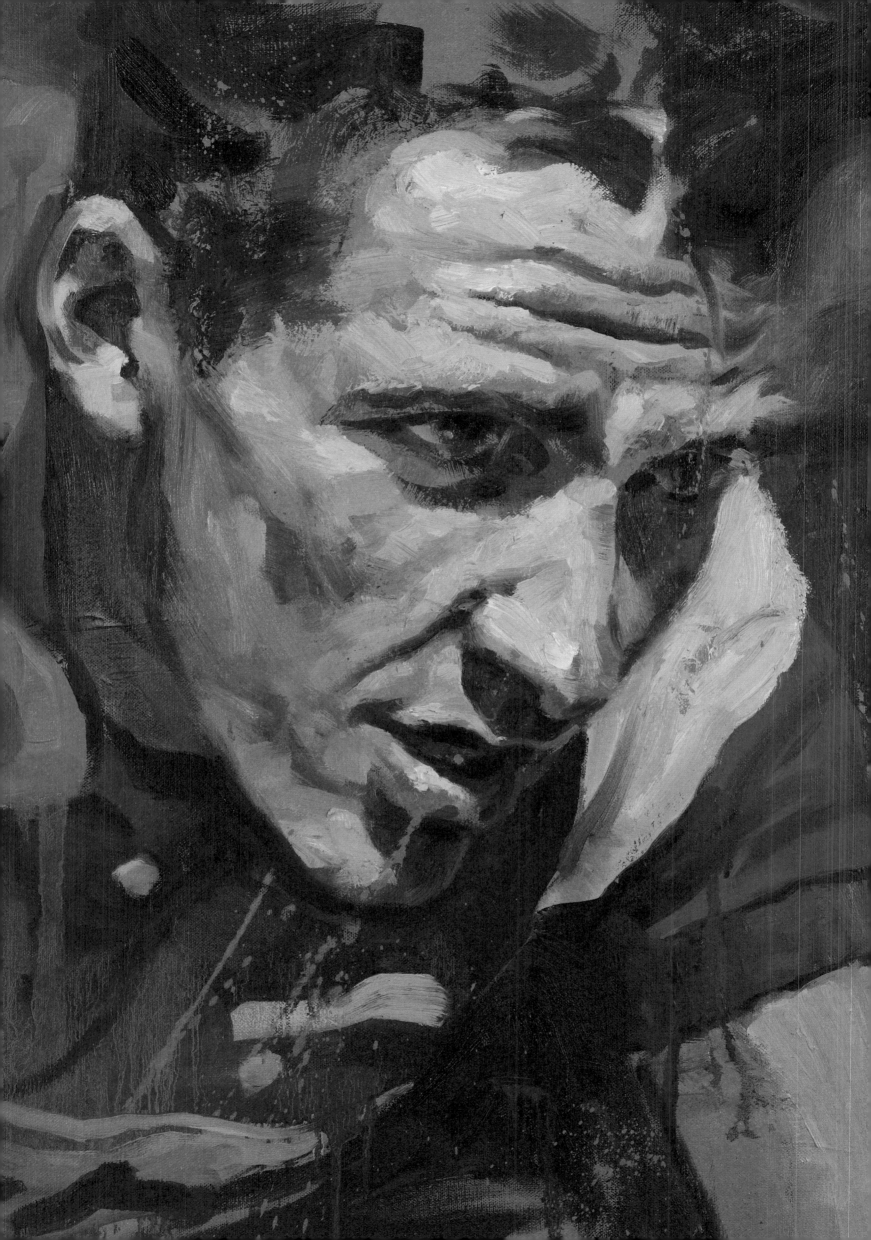

BELOW: *Rivière has just won the second of his three stage victories in the 1960 Tour de France. His grave expression is probably the result of accusations that he had colluded with Gastone Nencini against the interests of his fellow Frenchmen. Nine days and one more stage win later, his career at the top would be over.*

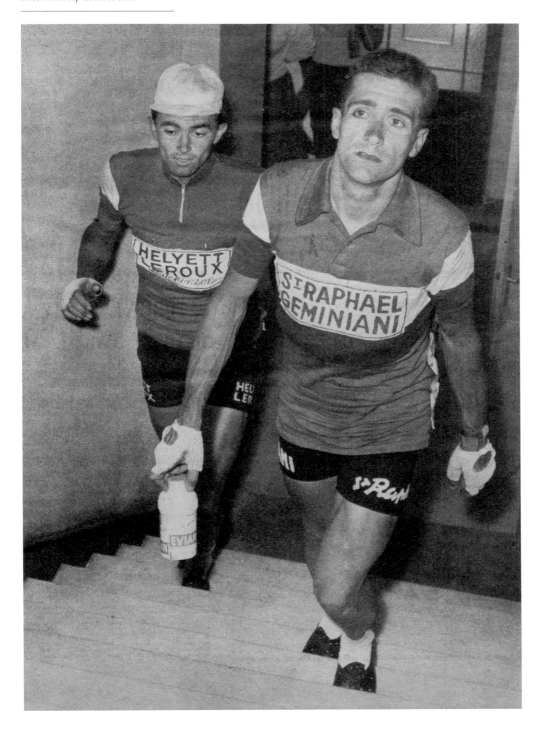

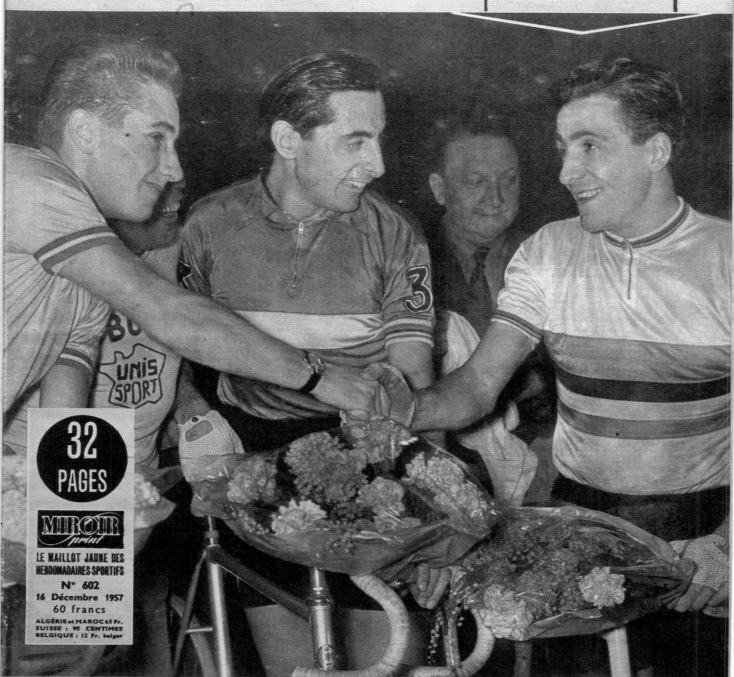

MIROIR-SPRINT
Le Reflet du Sport

**ANQUETIL
COPPI
RIVIÈRE**

32 PAGES

MIROIR
sprint

LE MAILLOT JAUNE DES
HEBDOMADAIRES SPORTIFS

N° 602
16 Décembre 1957
60 francs

ALGÉRIE et MAROC 65 Fr.
SUISSE : 95 CENTIMES
BELGIQUE : 12 Fr. belges

LE PLUS FORMIDABLE TRIO DE ROULEURS JAMAIS RÉUNI SUR UNE PHOTO !

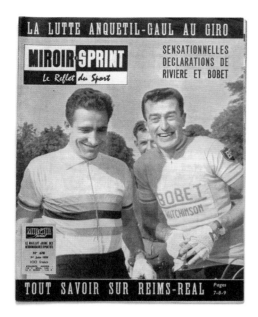

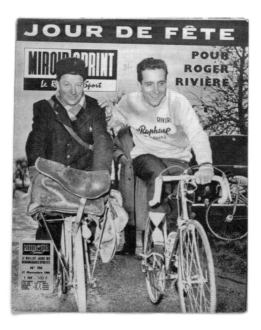

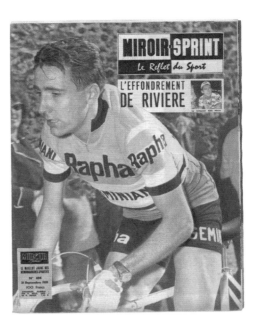

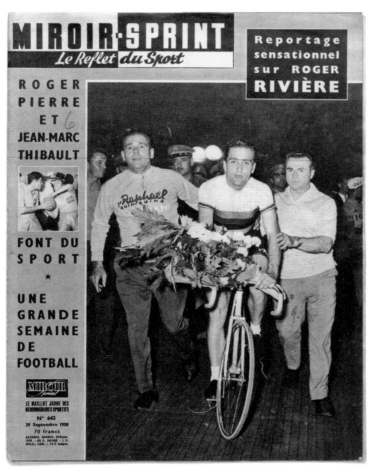

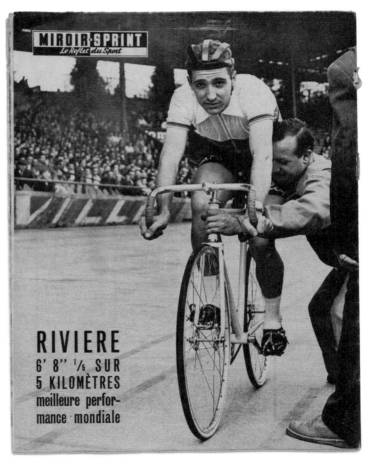

Back in Saint-Étienne after the accident, his riding career over, Rivière opened a restaurant called Le Vigorelli. It was not a success; neither were the business ventures that followed it, a garage and a holiday camp. He died of throat cancer in 1976, aged forty.

Perhaps it's a surprise that I knew anything about him. I was just a teenager from a place called Beeston, outside Nottingham, in the middle of England, a member of a local cycle club. I had parents who hadn't travelled abroad, who didn't speak any foreign languages, who always had their holidays in England, who didn't have a strong link with any sport. But the names of the great riders were like punctuation marks in this young man's life, and Roger Rivière's was certainly one of them.

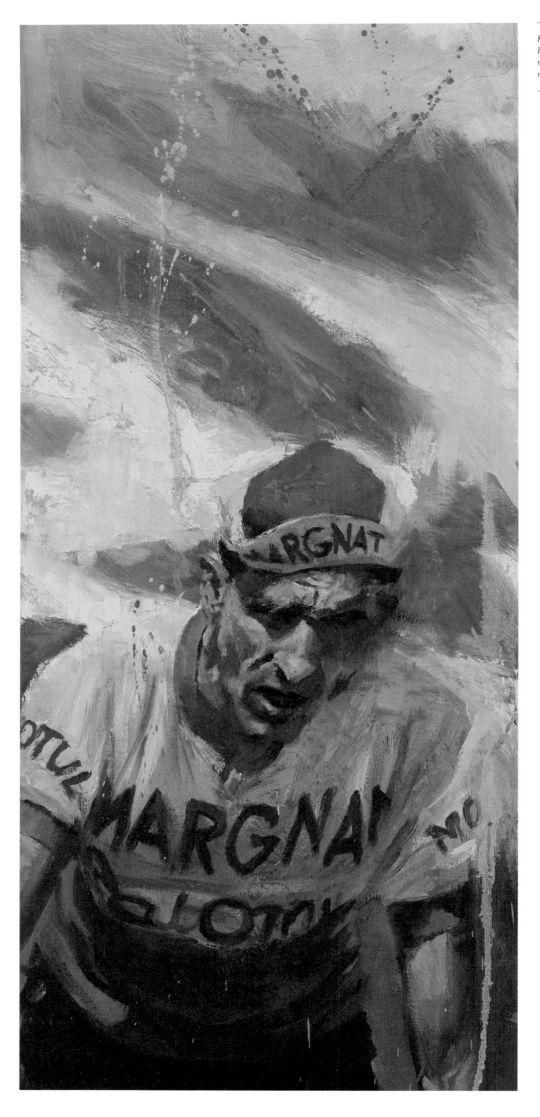

Karl Kopinski depicts Federico Bahamontes on the sort of mountain stage where he won his nickname, the Eagle of Toledo.

BAHAMONTES Federico

FEDERICO BAHAMONTES

Perhaps Bahamontes didn't win a lot by the standards of an Anquetil, a Merckx or a Hinault. His only Grand Tour victory came in the Tour de France in 1959. But he was also the first man to win the King of the Mountains jersey in all three: six times in all in the Tour between 1954 and 1964, once in the Giro d'Italia in 1956 and twice in the Vuelta a España in 1957 and 1958. That's a fair achievement.

Bahamontes is remembered as one of the great climbers, which inspired his wonderful nickname: the Eagle of Toledo. I looked at photographs of him – he was often on the covers of the magazines I used to buy – and I always noted how he pushed back in the saddle and climbed with his hands on the centre of the bars – something we used to refer to as 'digging in'. His back was straight and he was always looking ahead.

He was born in Toledo in 1928, but his family moved to Madrid during the Spanish Civil War. He began riding a bike as a delivery boy and made the acquaintance of Julián Berrendero, the winner of two wartime Vueltas (1941 and 1942). Bahamontes won the first race he entered, in 1947, two weeks after his nineteenth birthday.

He was with a team called Splendid when he entered the Tour for the first time in 1954, winning the King of the Mountains award at his first attempt, but then he seemed to wear a different team jersey each year: Terrot-Hutchinson in 1955, Girardengo-ICEP in 1956, Mobylette in 1957, Faema-Guerra in 1958, Tricofilina-Coppi/Kas in 1959, Faema in 1960, VOV in 1961 and – settling down – Margnat-Paloma-Inuri from 1962 until his retirement in 1965.

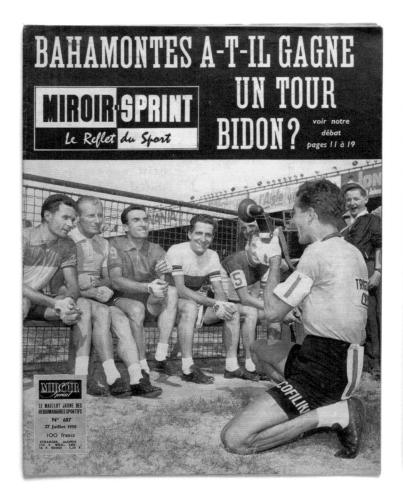

BAHAMONTES A-T-IL GAGNE UN TOUR BIDON?

MIROIR·SPRINT
Le Reflet du Sport

voir notre débat pages 11 à 19

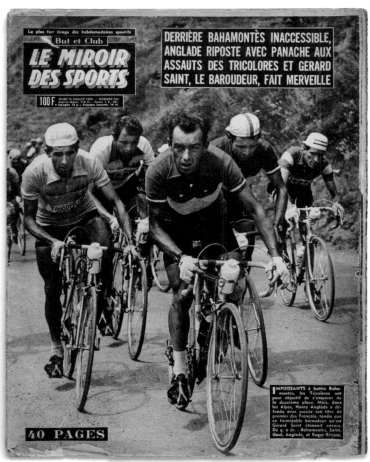

LE MIROIR DES SPORTS
But et Club

DERRIÈRE BAHAMONTÈS INACCESSIBLE, ANGLADE RIPOSTE AVEC PANACHE AUX ASSAUTS DES TRICOLORES ET GÉRARD SAINT, LE BAROUDEUR, FAIT MERVEILLE

40 PAGES

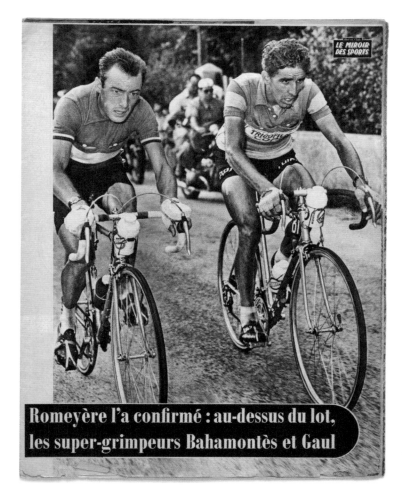

LE MIROIR DES SPORTS

Romeyère l'a confirmé : au-dessus du lot, les super-grimpeurs Bahamontès et Gaul

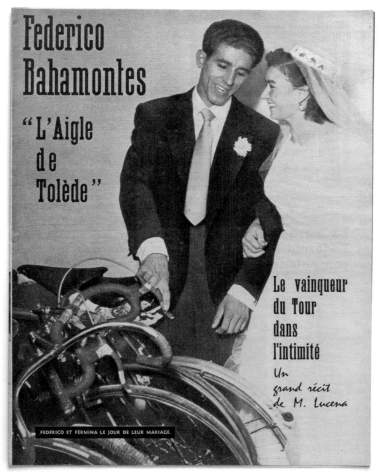

Federico Bahamontes

"L'Aigle de Tolède"

Le vainqueur du Tour dans l'intimité

Un grand récit de M. Lucena

FEDERICO ET FERMINA LE JOUR DE LEUR MARIAGE.

Clockwise from top left: 1. The French were puzzled by Federico Bahamontes's victory in the 1959 Tour, and by the failure of France's four pre-race favourites, who refused to help their compatriot Henri Anglade in his fight against the Spaniard. 2. Bahamontes, on the left, is in the yellow jersey as Charly Gaul leads the general classification contenders up an Alpine climb. 3. Federico and Fermina Bahamontes on their wedding day. 4. Wingtip to wingtip, the Angel of the Mountains and the Eagle of Toledo fight it out.

BAHA

voulait le maillot jaune : il l'a pris !

BAHAMONTES commençait à s'impatienter. Depuis le Puy-de-Dôme, il voulait le maillot jaune : à Grenoble, il l'obtenait, après avoir franchi Romeyère devant Gaul qui le rejoignit dans la descente. Son premier maillot jaune, l'Espagnol l'avait solidement accroché, semblait-il.

ILS FONCENT VERS L'ARRIVÉE. BAHA, SUR UN PAPIER QU'ON VIENT DE LUI PASSER, APPREND SON AVANCE : PRÈS DE 4'

BAHAMONTES, RADIEUX, ENFILE SON PREMIER MAILLOT JAUNE. A SA DR., L'EX-VAINQUEUR DU TOUR KUBLER

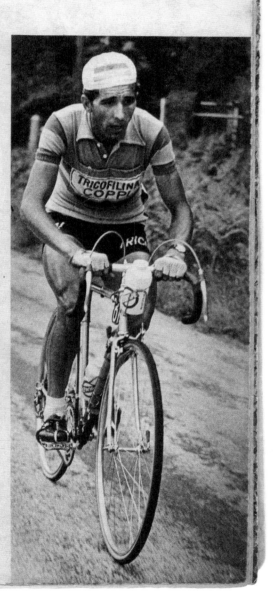

Bahamontes took the yellow jersey in Grenoble, at the end of the seventeenth stage, and wore it all the way to the Parc des Princes.

— 65 —

The 1959 Tour de France was supposed to have been a showdown between four Frenchmen: Louison Bobet, the winner of a hat-trick of Tours in 1953, 1954 and 1955; Jacques Anquetil, who had registered his first success in 1957; Roger Rivière, the new star; and Raphaël Géminiani, Rivière's mentor. But Bobet abandoned the race early on, Géminiani was in nothing like the form that had taken him to third place in Paris a year earlier, and Anquetil and Rivière were watching each other so closely that they failed to prevent Bahamontes and Henri Anglade, another Frenchman, from establishing leads of ten and five minutes respectively.

Bahamontes took the yellow jersey in the Alps, after finishing second behind Charly Gaul on stage seventeen, from Saint-Étienne to Grenoble. On the following day, which started in Le Lautaret and ended in Saint-Vincent, his poor descending caused him to lose time on the backside of the Col de l'Iseran. Instead of helping Anglade take advantage of the opportunity, Anquetil and Rivière simply sat at the back of the group, refusing to help maintain the pace and allowing the Spaniard to ride back up to rejoin them. They seemed concerned only to prevent a compatriot stealing the glory that should have been theirs. Trailing by almost six minutes as the riders went into a 69-km time trial into Dijon on the penultimate day, Anglade could make up only a quarter of his deficit. When Bahamontes entered the Parc des Princes in triumph, the crowd booed the stars who had failed to throw their support behind their fellow Frenchman.

One of the saddest photographs in all cycling history features Bahamontes's exit from the following year's Tour. It shows him sitting on his suitcase on a railway platform somewhere in France. The defending champion has just abandoned the Tour and he's waiting, all alone, for a train to take him home to Spain.

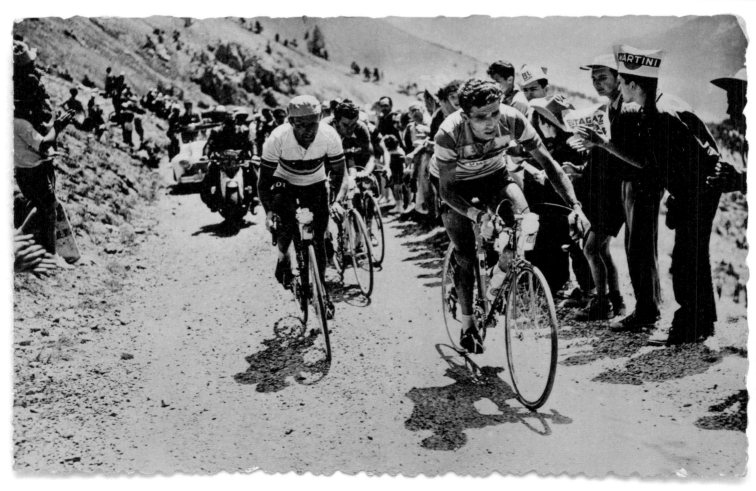

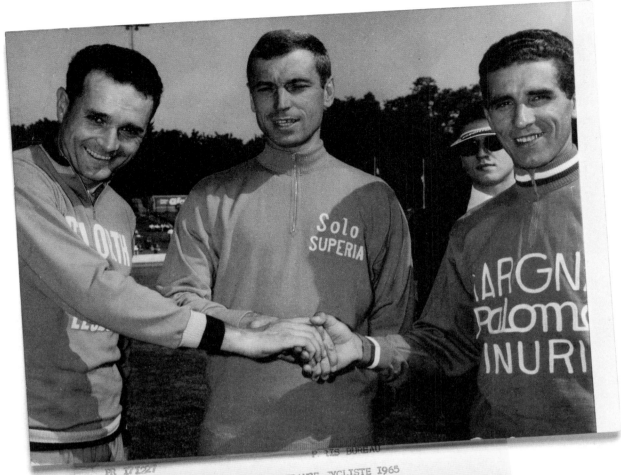

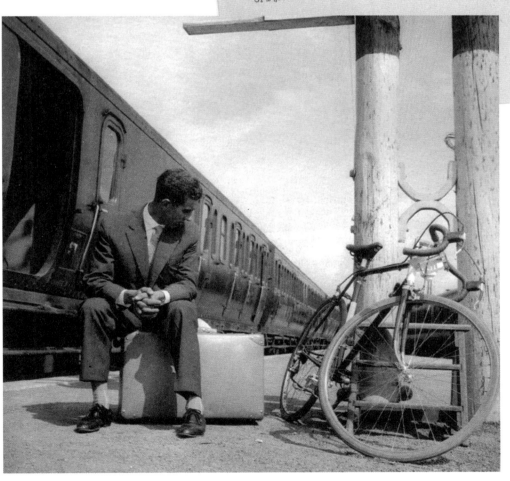

OPPOSITE: *Bahamontes leads Stan Ockers and Roger Walkowiak on the road from Gap to Turin.*

ABOVE: *Henri Anglade and Rik Van Looy shake hands with Bahamontes before the start of the 1965 Tour.*

LEFT: *Having quit the 1960 Tour, the defending champion sits alone in a French railway station, waiting for the train home.*

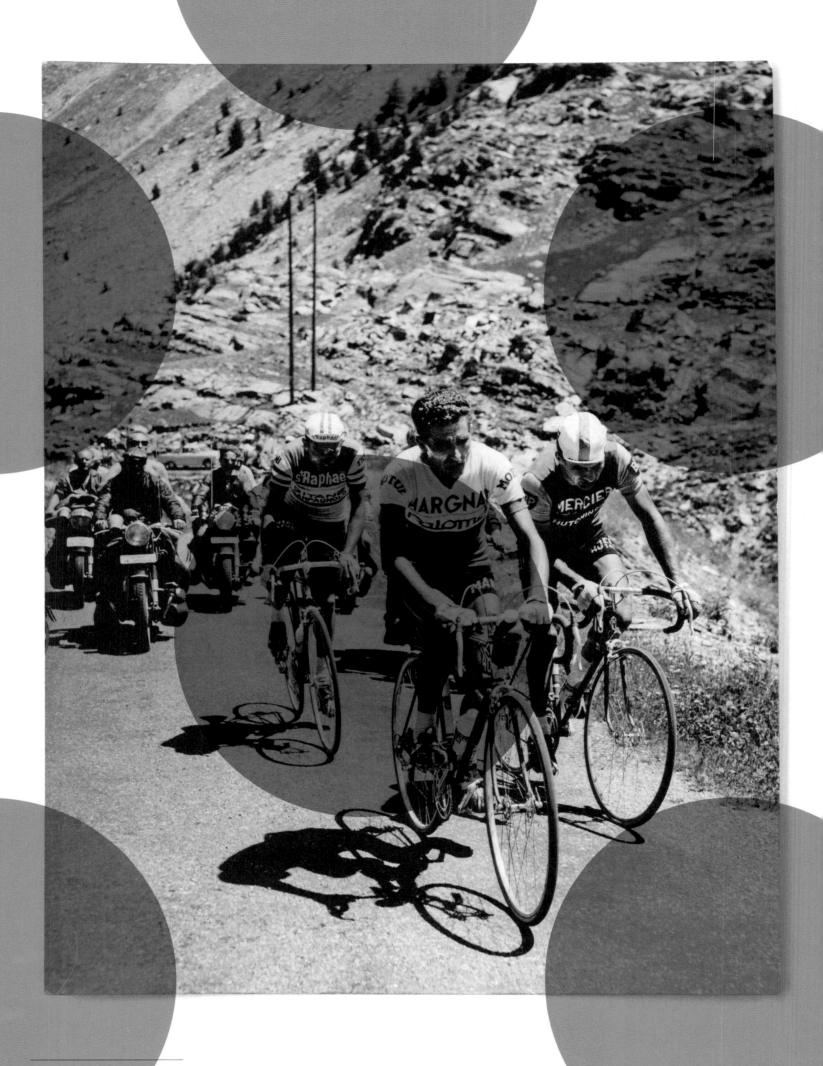

The summer sun is near its zenith as Bahamontes leads Poulidor and Anquetil through a landscape of scree and wild flowers in the Hautes-Alpes.

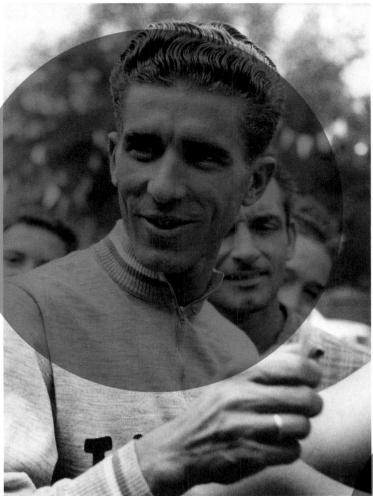

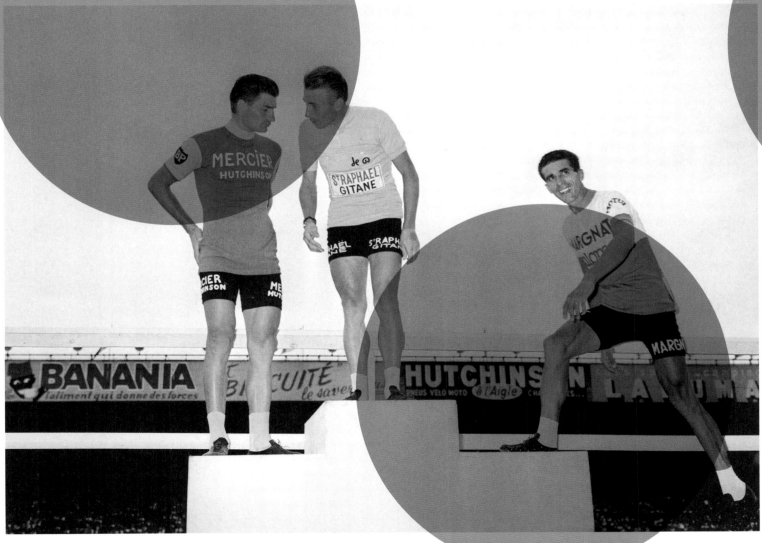

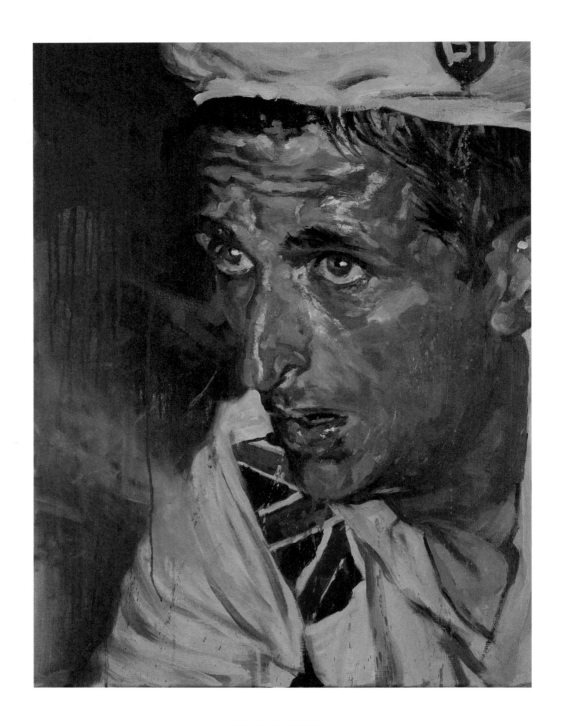

TOM SIMPSON

When I think of Tom Simpson, the first image that springs to mind is not of a man on a bicycle. Instead, he's wearing a Prince of Wales check suit with a bowler hat and carrying an umbrella, posing for the photographers of foreign newspapers and magazines during the years when he lived in Belgium and rode for a Continental team. Over there they enjoyed the caricature of the English gentleman, and called him 'Mister Tom'. It was pretty unusual behaviour at the time, and, for somebody in my world, his willingness to get dressed up was very interesting. Today there are many very nicely dressed cyclists, like Bradley Wiggins or David Millar: people who care a lot about what they wear when they're off the bike. I could never work out whether Simpson wore that outfit as an attention-seeking device or whether it was something he did naturally, a product of his sense of humour. If he was doing it to get publicity, it's interesting that he had that sort of approach back then.

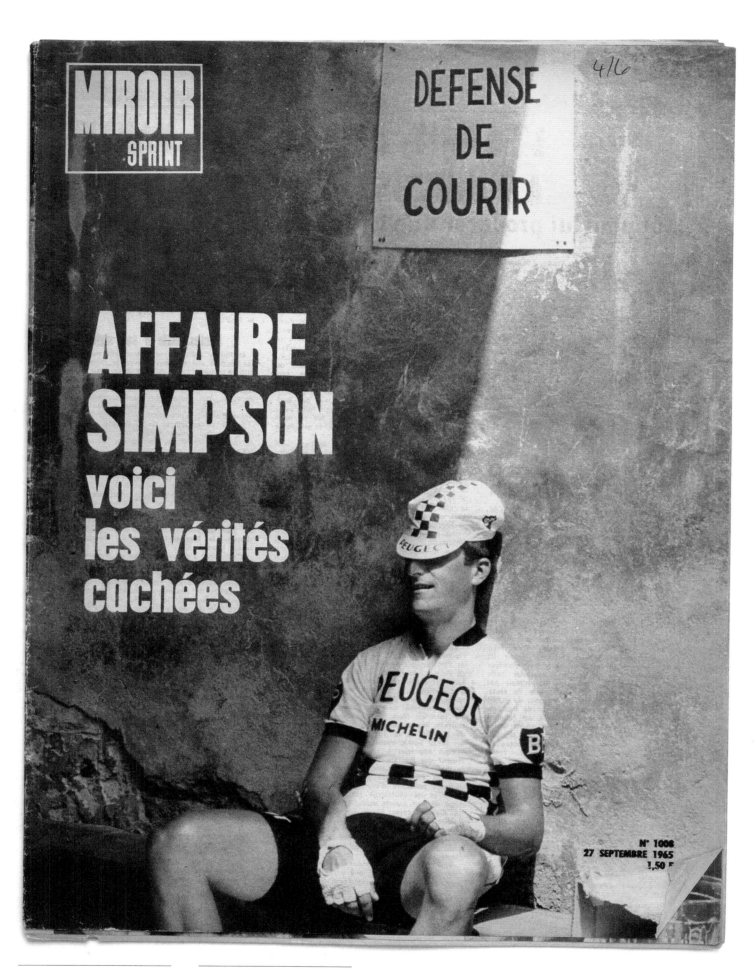

MIROIR SPRINT

DÉFENSE DE COURIR

4/6

AFFAIRE SIMPSON
voici
les vérités
cachées

N° 1008
27 SEPTEMBRE 1965
1,50 F

PREVIOUS PAGES, LEFT: *Painted by Karl Kopinski, Simpson displays the Union Jack on the shoulder of his Peugeot jersey.*

PREVIOUS PAGES, RIGHT: *Living up to the Continental media's image of him as an English gentleman, Tom Simpson was happy to sport a bowler hat and umbrella for the camera.*

ABOVE: *'No racing,' the sign says, as* Miroir-Sprint *promises to reveal the 'hidden truths' about the new world champion's revelation (in an article written for the British readers of* The People) *that the results of races on the Continent are sometimes prearranged by the participants.*

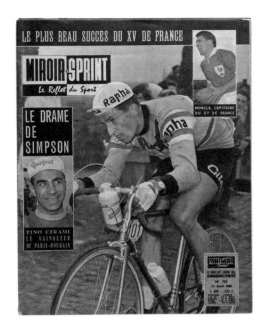

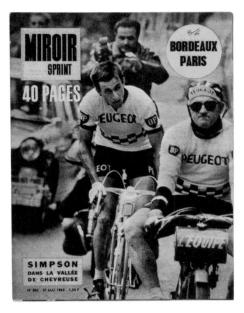

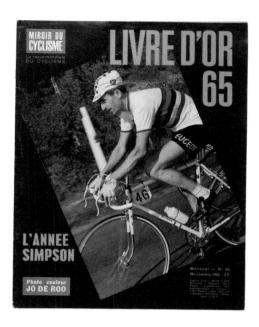

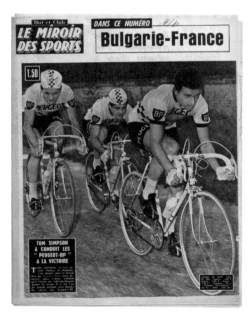

ABOVE: *The first British rider to make a significant impact at the highest level of road racing, Simpson was the object of admiration at home and curiosity abroad.*

NEXT PAGE: *In 1963 Simpson became the third British rider to win Bordeaux–Paris, after G.P. Mills took the inaugural edition in 1891 and Arthur Linton followed up in 1896.*

For me, Simpson had the special appeal of being one of my countrymen, a cyclist representing Britain going off to the Continent to do battle with aces like Anquetil and Bahamontes – a bit like Stirling Moss and Mike Hawthorn going off to compete against Fangio and Ascari in motor racing in the 1950s. Simpson had to be brave to do that, taking on a different language and culture. He wasn't the absolute pioneer: others had tried moving to Europe before him and Brian Robinson, from Yorkshire, was the first British rider to win a stage of the Tour, in 1956. But there was something special about Simpson, particularly when he became the first Brit to win a one-day

classic, the Tour of Flanders, in 1961, followed by Bordeaux–Paris in 1963, Milan–San Remo in 1964, and the world road championship in San Sebastian – outsprinting Rudi Altig in the finale – and the Giro di Lombardia in 1965.

At the end of that year Simpson was voted the BBC's Sports Personality of the Year, ahead of Jim Clark, who had just won his second Formula One world title: quite an achievement, since there was virtually no cycling on the television back then. Two years later came his last major victory, which was also his only success in a big stage race: Paris–Nice, the week-long 'race to the sun', in 1967.

SPÉCIAL
BORDEAUX
PARIS

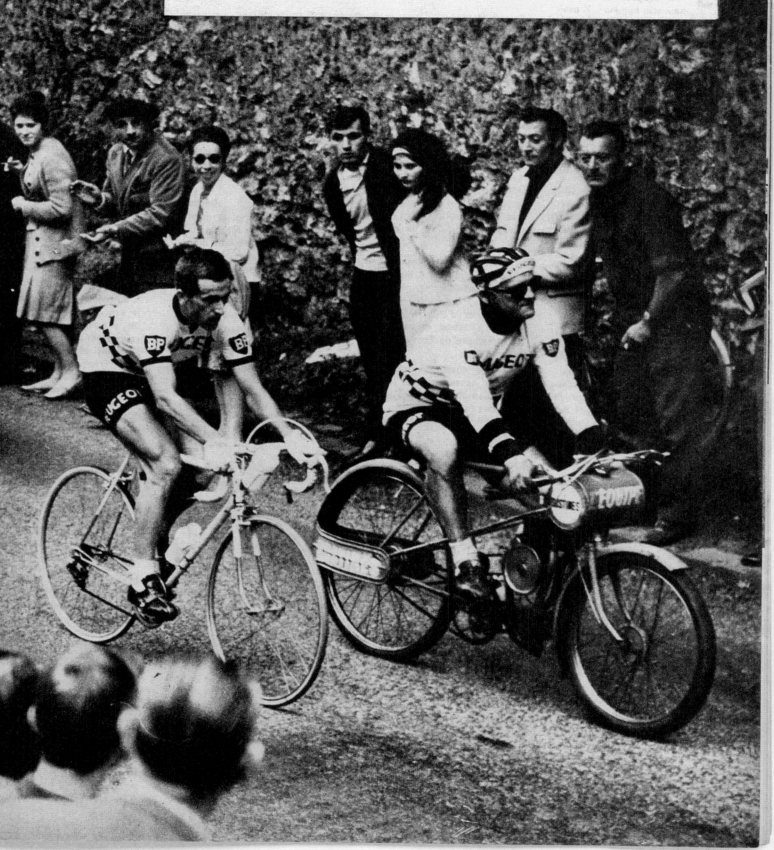

TOM SIMPSON (1963)

Deux noms anglais figuraient déjà au palmarès de Bordeaux-Paris : ceux de G.-P. Mills qui avait gagné la première édition de l'épreuve en 1891 et d'Arthur Linton qui avait triomphé en 1896. Il a donc fallu attendre 67 ans pour voir un Britannique caracoler dans la Vallée de Chevreuse.

EVIDENCE
in the case of
SIMPSON

who crossed the frontier of endurance while too doped to know when he had 'had enough'

THIS IS a detailed report on the death of Tommy Simpson, aged 29, Britain's most successful and experienced professional cyclist, during the Tour de France. I spent a week interviewing senior police officers and eye-witnesses in Marseille and Avignon and assessing technical evidence.

The questions posed are:

1 Could his death have been prevented?

2 Will Olympic athletes face similar dangers during next year's Games in Mexico City?

3 Will French authorities try to hush up aspects of the death to safeguard the reputation of the most spectacular sporting event in Europe — the Tour de France?

Investigation by J L MANNING

Simpson died at 4.35 p.m. on July 13 during the 13th stage of the 2,974-mile Tour. He had cycled 1,684 miles at an average speed of 22 m.p.h. and had only one day's rest in the 15 since the race began.

Between 3.45 p.m. and 4 p.m. 98 cyclists, including Simpson, forming part of the Tour's £400,000 caravanserai, reached the lower slopes of the 6,217ft.-high Mont Ventoux. They had then covered 88 miles from Marseilles since 10 a.m.

Before them was a 45-mile loop around the town of Carpentras and over the Ventoux pass. This has one-in-ten gradients. At the summit there are no sheltering trees or bushes; nothing but limestone chips stretching as far as the eye can see across the bleached and barren peak.

Thirty thousand spectators gathered on the Ventoux that day to see what their heroes could do.

My first evidence is about Simpson's ability to tackle the Tour. It was his seventh since 1960. He did not finish in 1961, 1965 and 1966. His best performance had also won several of Europe's big tours. No British cyclist was so experienced or successful.

He had complained of a bronchial cold earlier in the race, but when he reached Marseilles on the evening of July 12 he was fit and cheerful. Between the seventh and eighth stages he had improved his overall position from 30th to seventh and was holding that position. So he had every prospect of doing better than ever.

The first witness is the journalist and Simpson's close friend, Jean Leulliot. On the morning of this last ride, according to Leulliot in an article, Simpson said:

"It is very hot and I could not sleep last night. This Ventoux run is suicidal. Have they planted any trees there to give us shade?"

If Simpson had any obsession about the Ventoux he said no more to show it.

PUSHED

BEFORE the Tour left Marseilles four police officers, accompanied by two police doctors, carried out dope tests on six French and Italian riders. There were none on the British team; nor was the police car was the British team's baggage searched.

These tests were authorised under the Republic's Law 65412. This forbids the consumption, prescription and offer of listed drugs to enhance performances artificially during sporting contests. Penalties range from fines of £39 to £390 and from one month to one year's imprisonment.

Statements that these were the first witness is Jean Glidet, who went from the small town of Apt to watch the race climb the Ventoux. He told me that between 3.45 and 4 p.m. he saw some Tour cyclists raid a cafe-bar on route N 574, near the village of Bedoin. They took mineral waters, cognac and pastis without paying for them.

He did not see British riders in this raid, but he did see spectators push Simpson several times "because he was very tired."

Bernard Babiere and Roger Viau are proprietors of the restaurant Chalet Reynard, which stands in a wide sweep of the Ventoux road 34 miles from the summit. They told me their brass thermometer outside the restaurant that afternoon registered 55 degrees centigrade (131 deg. F).

They explained that it would be at least five degrees hotter lower down the mountain and stifling because there was no wind. It was not the hottest day of the summer, but the tarred road was "melting badly."

On the road above the Chalet, about 1½ miles from the top of the pass, and below 6,000 feet, I found two piles of stones 420 yards apart.

At the first it was scrawled on a piece of paper: "Here Tom Simpson fell." On the second was written on cardboard: "Here Tom Simpson died tragically on the 13th stage of the Tour de France."

I was told Simpson fell twice between these two piles of stone, but only once was he helped to remount. He did not seem to hear spectators shout: "Give up! You have had enough."

on the pass, and he, Dr. Macorigh and Nurse Daumas continued resuscitation.

The police say that Simpson, apparently dead, was put aboard the helicopter at 4.40 p.m. and arrived at Avignon's central hospital at 5.15. At 5.40 his death was announced and a burial certificate refused until after an autopsy.

"It is not normal for a fit and experienced cyclist to die like this," said Dr. Dumas.

A small amount of liquid taken from Simpson's body, which was said to be in an advanced state of dehydration, was sent to the forensic laboratory in Marseille. It was analysed by Mme. Jacqueline Quicke and the pathological examination was by Professor Vuillet.

PROBE

I WAS not permitted to see these reports, but at the Hotel de Police in Marseilles the officer, Robert Picq, with the knowledge of his chief, Commissioner Matthieu, told me: "Traces of amphetamine have been found in the urine."

Picq then summarised the result of police investigations at Avignon and Sete, where the next stage of the Tour finished on July 13.

At Avignon—and this was confirmed by a statement made to me there at the central police commission headquarters—police found three glass tubes in a satchel on Simpson's racing jersey. Two were empty. A third contained a few tablets.

As a result Commissioner Guy Denis, in Marseilles, ordered a thorough investigation. The British team's baggage car was seized in Sete. Among Simpson's gear in a carton, 12in. by 8in. and 3in. deep, were found more tubes of tablets and...

Dumas, chief of ...vice, arrived ...for the last ...e trying the ...umas radioed ...e helicopters

ANOTHER CYCLE ACE DIES

VALENTIN URIONA

EIGHTEEN days after the death of Tommy Simpson in the Tour de France, another leading racing cyclist died yesterday.

Police are investigating how Valentin Uriona, a 26-year-old Spaniard, fell from his cycle and died two and a half miles from the finish of the Spanish national race. He had been climbing the 3,000ft.-high mountain roads between Cantina and Sabadell, near Barcelona and collapsed at the summit in a temperature of 110F. He appeared to be suffering from the heat.

An inquiry was begun and an autopsy ordered to see if Uriona, an experienced professional rider, had taken stimulants. Eye-witnesses said...

Simpson was killed by drugs

By J L M...

TOMMY S... ...ode to l... France so ...e did no... had rea... limit of...

He died ...lowly asph... effort in a ...ing methyl... and alcohol ...bidden by...

This inform... authorised ...police offi... investigation... Simpson, B... ...pion cyclist, ...6,217ft. Mon... Police repo... ...tubes were...

Special protecti...

TRANSPORT has ...lightly. There is no ...better than Mrs Ca... squeezing blood from th... ...ury's stone heart. Her ...on spending programm... she succeeded in ...before the economy dri... was able to promise a ...tial reduction in the ...deficit during the coming ...years; consequently, ...spending remains at about ...National Plan level, which was...

37,63

...alance of payments ob... ...o cut back on hospitals, ...and roads. He is seekin... ...between now and 1970—... ...ternative figure—£400 ...—is under consideration ...Cabinet. With abo... ...millions of military s... ...already earmarked—pe... ...perhaps a windfall fr... ...opportune collapse of ...expensive aircraft—civil ...and Ministers are being ...by the Treasury to mak... ...mies of between £...millions.

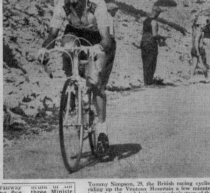

Tommy Simpson, 29, the British racing cyclist, riding up the Ventoux Mountain a few minutes before he collapsed during yesterday's stage of the Tour de France. He died in hospital at Avignon.

Briton d... in Tou... de Fran...

FROM OUR CORRESPO...
CARPENTRAS,
Southern France, Th...
TOMMY SIMPSON...
British profession... ...list, collapsed while ra... ...the Ventoux Mounta... ...day's stage of the T... ...France. He died in h... ...at Avignon where ...taken by a police heli... Simpson, aged 29, ...with members of the ...group of riders, includi... ...leader, Roger Pingeon, ...three miles from th... ...of the 7,750ft. mount... ...the "Giant of Prove... ...The Englishman then ...back and was seen to ...ing with extreme diffi... ...tually he fell by the roa...

Second fall
The British team car, ...Ken Ryall, a cycleTwickenham, was imme... ...hind and Harry Hall, ...went to help Simpson. ...Simpson said he w... ...complete, remounted an... ...further half-mile an... ...scorching sun—tempera... ...in the 90s. He fell ...when the Tour doctor ...within a minute or so ...was unconscious.
At the start of today ...successful placings. Mr... ...British team manager, ...night that the British r... ...race tomorrow.
Tommy Simpson was ...successful road racing ...Britain had produced ...the world professional r... ...possibly in 1965. His ...tories included the "...Paris, the Tour "of...— Milan-San Remo ...Tour of Lombardy ...
J. B. Wadley and Ob...

Dying Simpson's last words: Put me on my bike

From SIDNEY SALTMARSH
CARPENTRAS, Thursday

BRITISH racing cyclist Tommy Simpson died today a few minutes after this picture was taken as he rode in the Tour de France.

Twenty-nine-year-old Simpson collapsed as he raced up a steep road to the summit of 6,273ft. Mount Ventoux, near here, with the sun blazing down and the temperature in the nineties.

Simpson was so anxious to keep up with the race leaders that he told British officials who went to his aid: "Put me back on the bike." He was helped back on the machine, but collapsed again.

Simpson was taken unconscious to a shaded spot where a doctor tried the kiss of life before ordering the cyclist's transfer to hospital.

HELICOPTER

Simpson was taken to hospital at Avignon by a police helicopter.

A few minutes later M. Felix Levitan, co-director of the Tour de France, told reporters: "It is my duty to announce officially that Tommy Simpson is dead."

A hospital official said: "Simpson died shortly after he was brought to the hospital despite all our efforts to save him."

Simpson, world champion professional cyclist in 1965, is believed to have died from heat exhaustion, but doctors refused to sign a burial certificate so there will probably be a post mortem examination.

It is the first death in the history of the Tour de France — the world's most gruelling cycle race.

Before today's stage of the race—from Marseilles to Carpentras — Simpson was seventh in the overall placings, eight minutes behind the leader, Roger...

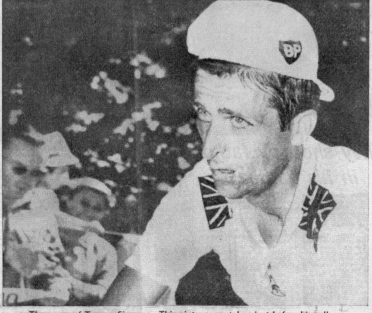

The agony of Tommy Simpson. This picture was taken just before his collapse

STAT

Tommy Simpson collapses and dies in Tour de France

From GEOFFREY NICHOLSON
Carpentras, July 13

Tommy Simpson, the British cyclist, died early this evening after collapsing during a mountain stage of the Tour de France in intense heat this afternoon on the ascent of Mont Ventoux, a barren mountain rising over 6,000ft. near Carpentras.

A doctor tried to give him artificial respiration and he was flown at once by ambulance helicopter to Avignon hospital. But, soon after 6.30 p.m. the press at Carpentras were told that Simpson, who was 29, had died.

The collapse came two miles before the summit of Mont Ventoux on the thirteenth stage of the race from Marseilles to Carpentras. Simpson had been riding well through the day; all that struck one of his teammates was that he was taking drinks more often than usual.

At the bottom of the Col he had been dropped by one of the leading groups but, towards the top of the climb he was still well up in the broken field and trying to regain contact with Aimar's small pursuing group 200 yards ahead.

Fell by road

Then, as the few eyewitnesses described it, he faltered in his riding and fell over to the side of the road. The British team car was right behind him. Harry Hall, the team's chief mechanic, helped Simpson remount his cycle, but Simpson fell once more.

Dr. Pierre Dumas, the doctor who travelled with the tour, examined him and immediately ordered his transfer by police helicopter to the nearest hospital. Simpson's was the first known death in the tour's history.

He was lying 7th in the overall race after the 12th lap and the only Briton ever to have worn the yellow jersey of overall leader in the race—in 1962. Tour officials announced that a ceremony to mark his death would be held tomorrow morning at the start of the 14th lap. "It is just like autoracing. The race goes on," said one.

The doctor who attended...

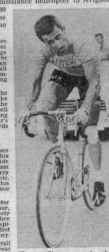

Tommy Simpson wearing the race leader's yellow jersey in 1962, when he became the first British rider to lead the Tour

Simpson —the last ride home

THE body of Britain's greatest cyclist, Tommy Simpson, began the slow journey by road from Avignon in France yesterday to the tiny graveyard in the mining village where he lived as a young man.

And there to see Simpson begin his last ride home to Harworth, Notts, will be his widow Helen, who travelled to Avignon soon after her husband died on his bicycle while competing in the gruelling Tour de France cycle race.

She left soon afterwards to board an aeroplane for London from where she will travel to Harworth for the funeral on Tuesday.

Waiting

In their home at Festival avenue, Harworth, his parents were waiting.

The body was being taken by road to Calais, where it was expected to arrive tomorrow.

Meanwhile police investigating the possibility that Simpson, aged 29, had been taking pep pills before his collapse, stopped cars following the British and Belgium teams in yesterday's 14th leg of the tour and searched them.

They seized some...

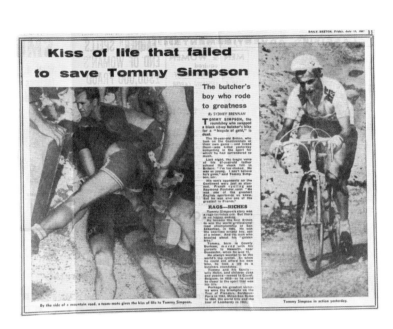

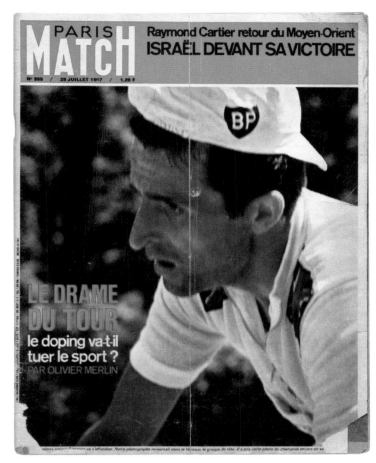

Simpson's death on Mont Ventoux in 1967 brought the question of doping into the spotlight for the first time, triggering decades of debate.

And then, of course, there was the absolute tragedy of his death during the Tour de France in 1967, at the age of twenty-nine. It might sound strange today, but in a way that made him fit in with the likes of Che Guevara and Jimi Hendrix in the roll call of fantastic 1960s icons brought down in their prime.

Simpson was born in County Durham but brought up in Harworth, a village in the coal-mining region of north Nottinghamshire. I lived in a suburb of Nottingham, only about 50 km from Harworth, but oddly enough I had no real idea at the time that he was a local man. His first road race as a junior had been on the Forest Recreation Ground in Nottingham. He'd gone to Brittany in 1959, aged twenty-one, with £100 in his pocket and a dream of doing better than any British rider before him.

There were very few British riders competing at the top level in those days, and it was hard to get information about their exploits. Nowadays you can go online and find out everything straight away, but in those days it was a matter of exchanging stories on Thursday nights at the local cycle club, a very basic environment with a tea urn and not much else. You'd just sit there and listen to the older riders talking. 'Oh, yes, he trains in Flanders, you know.' You'd ask yourself, 'What's Flanders? It sounds like a pudding or something.' I think young people today are missing out on that kind of experience: getting drawn into a fascination with something so exotic and exciting that just

hearing the names gave you goosebumps.

If you want to know more about the miner's son who conquered the world, you can visit the little museum in Harworth, where the display includes Simpson's jerseys and one of his bikes. And you could read William Fotheringham's excellent biography, which takes its title from the last thing Simpson is supposed to have said to his mechanic when he fell for the first time on the fatal climb to the summit of Mont Ventoux: 'Put me back on my bike.' Cyclists are as familiar with those words as most people are with the last words of Julius Caesar or Lord Nelson.

The post-mortem examination discovered amphetamines in his system, and he'd apparently taken a drink of brandy at the bottom of the climb, but that was hardly unusual in those days. It wasn't a good thing, of course, but it doesn't affect the way most people view Simpson's achievements. It was part of the culture at the time: something that would get much worse, through the era of steroids and EPO, before it began to get better.

Mister Tom died wearing his Peugeot team colours, the white jersey with the black-and-white chequered band and a small Union Jack on each shoulder. It really made him stand out in the peloton. Now I think about it, I don't have one of those in my collection. Must sort that out.

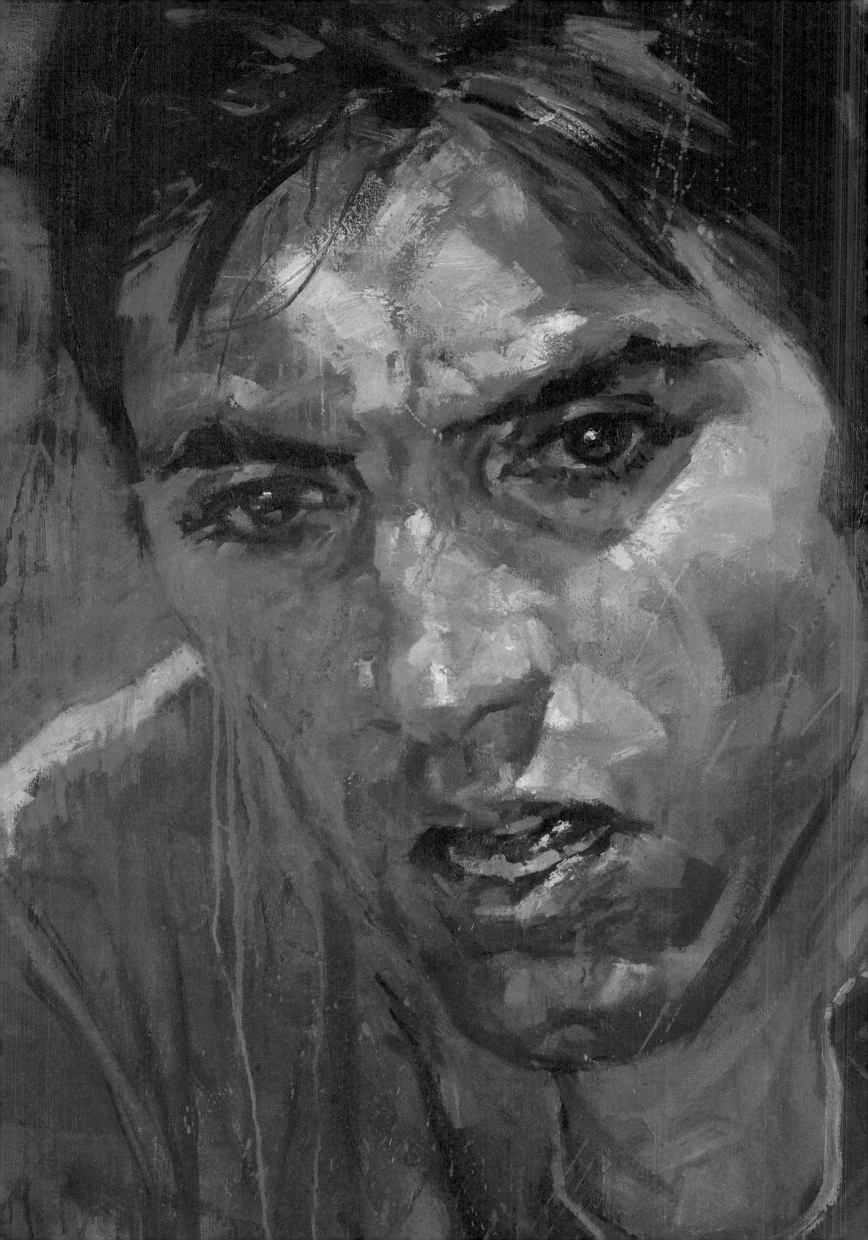

EDDY MERCKX

Oddly enough, I don't know all that much about Eddy Merckx, who they say was the greatest all-rounder of all time – and might very well be the world's most famous Belgian. I know they called him the Cannibal, because he gobbled up all his rivals. And his record of wins is unbelievable.

Merckx's great period, when he dominated the entire scene, came after I'd had the crash that ended my hopes of becoming a professional rider. When I recovered, I met a group of new friends through whom I found a new career in the world of fashion. I got so involved in it – first as the manager of the menswear floor of a boutique in Nottingham, and eventually with my own shops and other projects – that I couldn't concentrate on anything else for quite a long time. I never completely lost touch with cycling, but it wasn't until about twenty years later that I started to take a serious interest in it again. And by that time Merckx's great career was over.

I met him at the finish of the Olympic road race on the Mall in London in 2012, and then he came to the opening of my shop in Antwerp. His people sent me a beautiful book about his achievements. After that I was asked if I'd like to collaborate on the design of bikes for his very successful company, which has its headquarters in Brussels, but I'd already committed to another project so it wasn't possible, unfortunately.

It's a sign of his importance that he's entitled to be addressed as Baron Merckx, because that's the honour bestowed on him in 1996 by King Albert II of Belgium. You could say that set a precedent for the award of knighthoods to Chris Hoy and Bradley Wiggins by the Queen of England.

KX

retenaient
complices,
enouvelées.
ère et celui
à l'unisson
r a dit en
ez pas, ce
us. »

ort à une
r chapitre
dernier à
sait sur la
u Tour de
ller rendre
. Il ne lui
rche avait
dy s'enhar-
t la main

embre. Les
périphérie
oigner du
aint-Pierre

dire, une
n coureur,
urd'hui, il
obert Ou-
eur techni-

allemande
à tous les
champion,
le.

avoir vêtu
e premier
trois ans,
ndosser les

en train
'est méta-
nter la vie
k ce qu'il
a conquis
défendre
il entend

doit être
sa pleine
dversaires,

emblable-
plus pres-
n de per-
trée toni-
cité spor-
oupe, qui
non seu-
issimo de
blanche.
équipiers
ment tout
omme je
serai pas
ement en
ez excep-
ne peut
dirigeants
rs moi. »
en 1968
a fortune

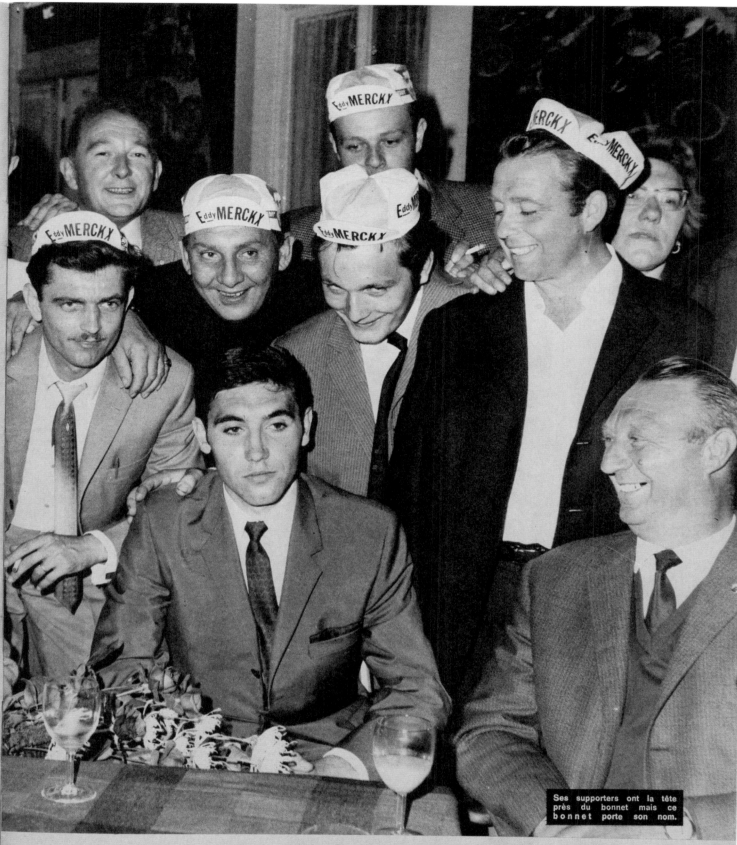

Ses supporters ont la tête près du bonnet mais ce bonnet porte son nom.

LE RETOUR TRIOMPHAL DE MERCKX

5

Surrounded by his fans, Merckx
celebrates his first world championship.
It is 1967, and he is twenty-two years old.

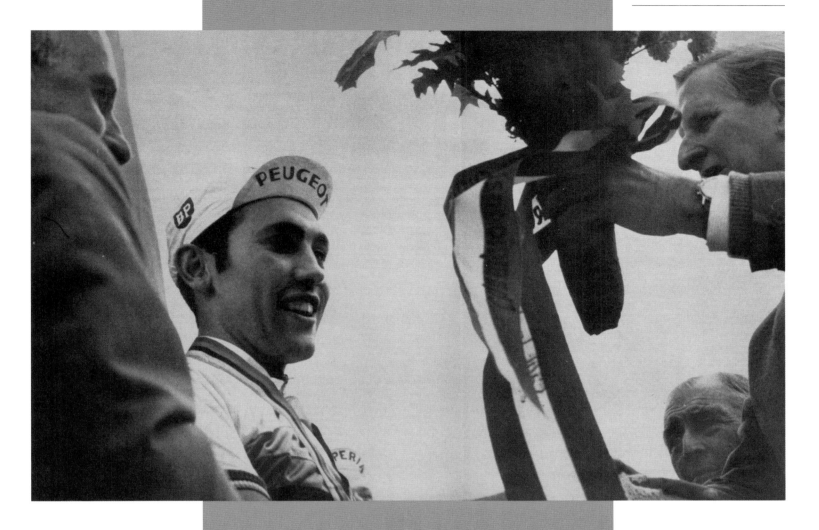

The son of a grocer, Merckx was born in a small town near Brussels in 1945 and got his first racing bike when he was eight. He comes from a part of the world where bike racing is embedded in the culture, and he idolized Stan Ockers, the great Belgian sprinter who was killed in a crash on the track in 1956, a year after winning the Ardennes double of the Flèche Wallonne and Liège–Bastogne–Liège as well as the world road-race title.

Merckx started racing at sixteen, competed at the Olympic Games in Tokyo in 1964 and became the world amateur champion that year. He turned professional in 1965 and won his first classic, Milan–San Remo, the following year – the first of his seven victories in La Primavera. He rode his first Grand Tour, the Giro d'Italia, in 1967, winning two stages. He was on his way, and the following year, having moved to Faema, an Italian team sponsored by a coffee-machine company, he won the Giro.

In 1969, aged twenty-four, Merckx achieved an astonishing clean sweep of jerseys in the Tour de France: the general classification, the points jersey, the King of the Mountains award, the combativity prize and the combined award. On stage seventeen, from Luchon to Mourenx in the Pyrenees, in probably his greatest single day on a bike, he rode the first of the day's four big climbs, the Col du Tourmalet, in the company of a small group including two of his principal rivals, Raymond Poulidor and Roger Pingeon, before attacking with 140 km to go and completing the rest of the stage alone, finishing eight minutes ahead of his nearest rival. That year he also won Paris–Nice, Milan–San Remo (for the third time), the Tour of Flanders and Liège–Bastogne–Liège. It was his annus mirabilis.

Merckx would go on to wear the Tour's yellow jersey five times in all, matching that feat with five pink jerseys from the Giro. When he won the Vuelta a España in 1973, it gave him the complete set of Grand Tour winners' jerseys. Over the course of his career he won thirty-four stages in the Tour, twenty-four in the Giro and six in the Vuelta. It would take practically the rest of this book to give a full list of his wins in all races. His record lacks only a world championship, although he was awarded the Super Prestige Pernod International, a prize awarded for performance throughout the season, on seven occasions in a row, from 1969 to 1975.

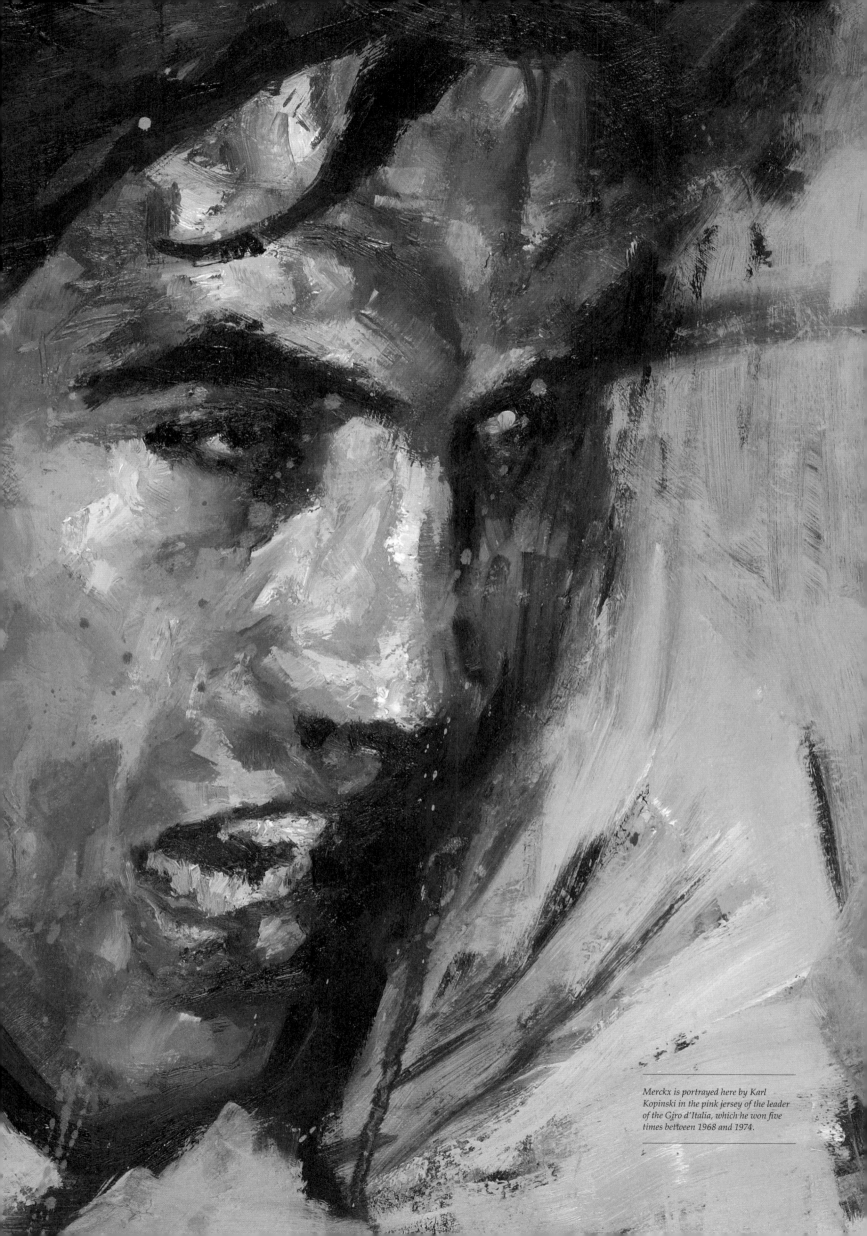

Merckx is portrayed here by Karl
Kopinski in the pink jersey of the leader
of the Giro d'Italia, which he won five
times between 1968 and 1974.

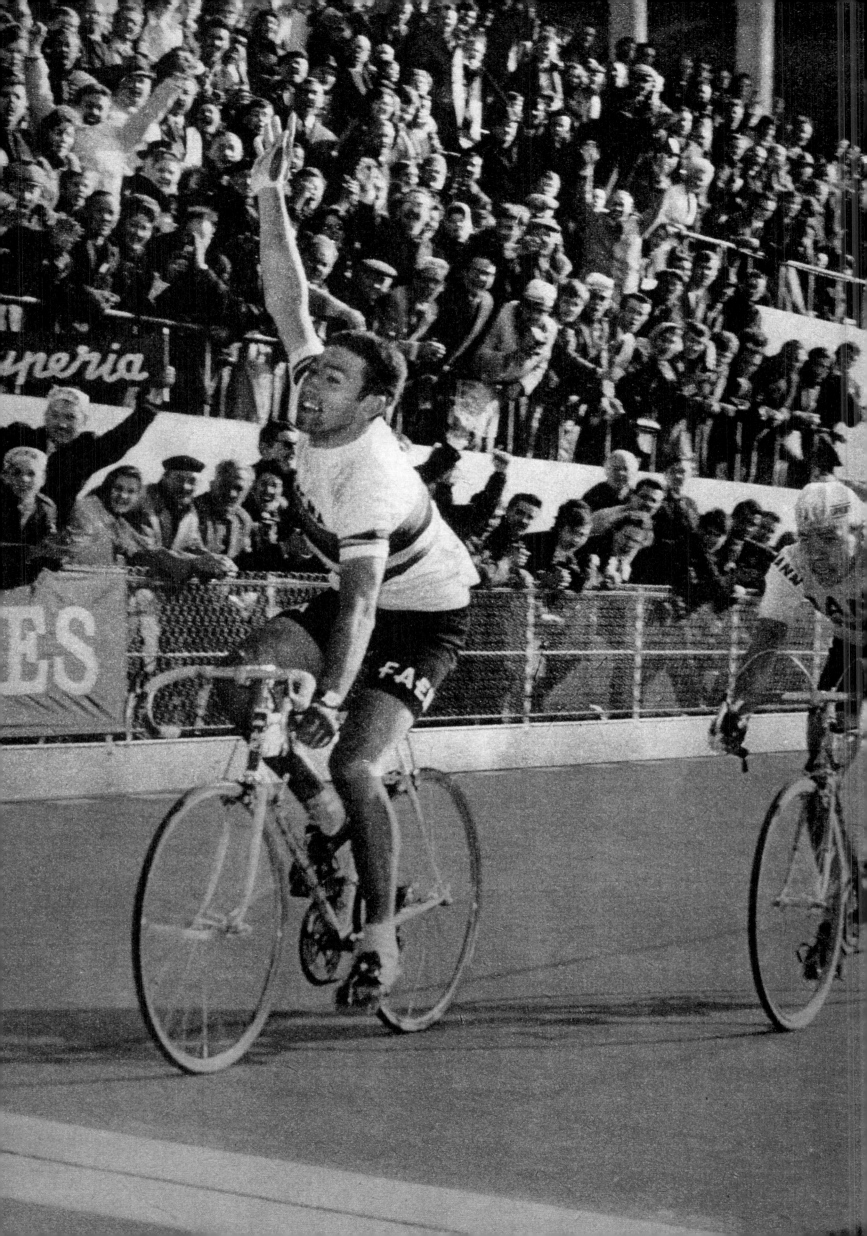

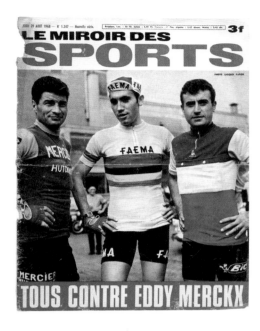

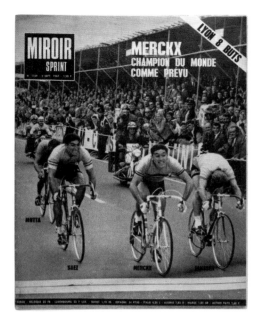

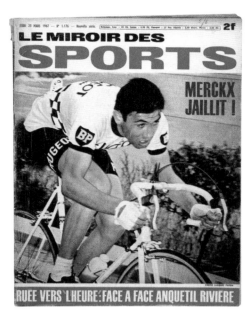

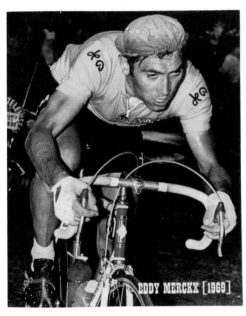

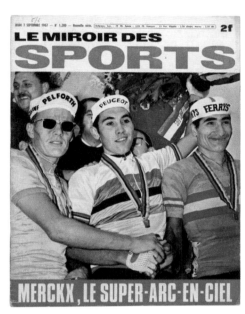

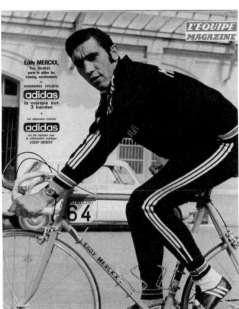

OPPOSITE: *Merckx is seen at another world championship, this time in the Roubaix velodrome, ahead of his compatriot Herman Van Springel.*

ABOVE: *During his long domination of the sport, Merckx became known as the Cannibal, for the way he gobbled up his rivals.*

In 1972, at the end of a long season, Merckx travelled to Mexico, where he took advantage of the altitude to challenge the hour record, then held by the Danish rider Ole Ritter. Using a special lightweight Colnago-built bike, Merckx set a new mark of 49.431 km. It stood until 1984, when Francesco Moser became the first man to ride 50 km in sixty minutes.

Merckx's dominance was not to everyone's taste. Some accused him of killing cycling, and were always happy to see him lose. But his form had declined and he was no longer a threat to a new generation of riders when he retired in 1978 to spend the next two years in planning the opening of the bike firm that bears his name. Like a lot of ex-riders, he didn't keep up his fitness and became rather a rotund figure. After stomach surgery in 2004 he started riding his bike again in order to get fit, and he soon lost 30 kg, often going out with old teammates who were now employed at his factory. Whenever he's at a race, a crowd gathers to stare at the once all-devouring Cannibal.

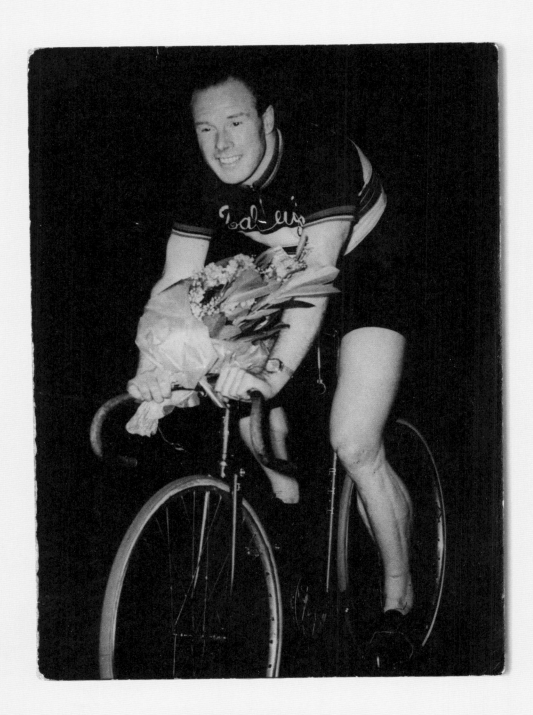

REG HARRIS AND RALEIGH

Reg Harris was only a name to me when I was a small boy. He was one of the big names – like Stanley Matthews in football, Roger Bannister in athletics, Stirling Moss in motor racing and Denis Compton in cricket – that everybody knew. Now everyone is familiar with so many more names, thanks to all the sport on television. What I remember of Reg Harris was a photograph of him on a bike without brakes – a track bike, of course. I was amazed: 'He's got no brakes!' And you could see his enormous thighs. He was a big guy.

Born in 1920 near Bury in Lancashire, Harris was preparing for the 1939 world amateur track championships in Milan when the Second World War broke out and the members of the British team were forced to return home. He served as a tank driver and was wounded in North Africa, and after returning to the sport he won the world amateur sprint championship in 1947. The following year, despite suffering injuries that hampered his training in the run-up to the Olympic Games in London, he won two silver medals at Herne Hill, and went on to capture the world professional sprint title four times between 1949 and 1954. In 1974, at the age of fifty-four, he made a comeback and won the British sprint title again.

OPPOSITE: *Reg Harris and his Raleigh with the victor's bouquet, inspiring a generation of schoolboys.*

ABOVE: *Harris spearheaded Britain's first post-war cycling boom, drawing crowds from towns and cities as far apart as Halesowen and Glasgow.*

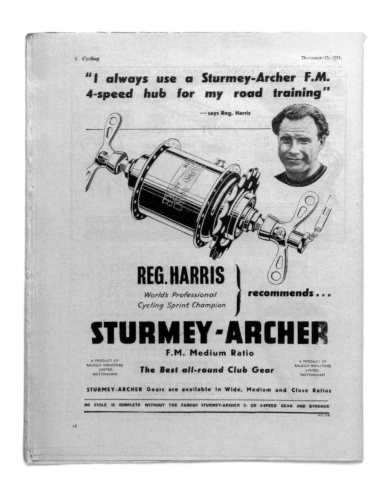

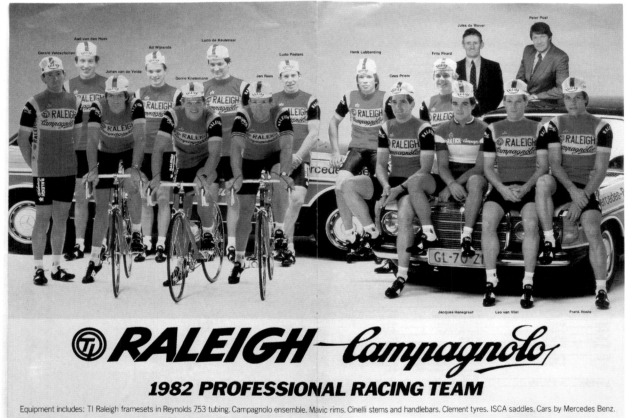

ABOVE: *Raleigh was still the world's biggest bicycle manufacturer when Harris raced for it, and equipment manufacturers such as Sturmey-Archer and Dunlop also benefited from his success. By 1982 the team was being run from Holland – although the bikes were still made in the East Midlands.*

OPPOSITE: *Harris's track frames were made by Mercian in Derby, and badged as Raleighs.*

NEXT PAGE: *Like Stirling Moss in motor racing and Stanley Matthews in football, Harris symbolized his sport for a generation of schoolboys in the 1950s.*

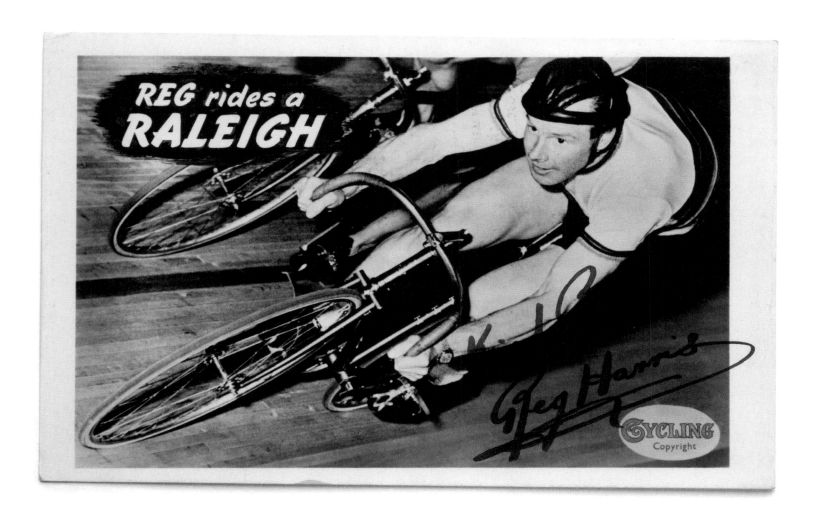

REG rides a RALEIGH

Reg Harris

For much of his career Harris's bike was a Raleigh – or at least that's what it said on the down tube. Specialist frame-builders have always made equipment for top riders, knowing that they would have paint and transfers applied to match the riders' commercial contracts. Just as Faliero Masi in Milan had made frames for Fausto Coppi, which were painted in the Bianchi company's trademark pale blue, so Harris's track bikes were made by Mercian of Derby.

Raleigh was a big part of Nottingham life in those days. The company had lots of factories on the city's ring road, and one of them was used by the author Alan Sillitoe as a setting for *Saturday Night and Sunday Morning*, his famous novel of working-class life – which he wrote in 1958, the year I got my first racing bike. Sillitoe describes Arthur Seaton, his twenty-one-year-old anti-hero, sitting at a lathe churning out bottom-bracket axles, earning £14 a week – a handy wage back then – but frustrated by the repetitive work.

The company started up in 1888, and was named after the location of the first workshop, in Raleigh Street, in an area where there were many lace factories – the industry for which Nottingham was then famous. It became enormously successful very quickly indeed, and by the time the First World War broke out it could claim to be the biggest bicycle manufacturer in the world. After the Second World War, when an increasing number of people could afford cars, bikes began to lose popularity as everyday transport. Raleigh's sales started to fall, although it enjoyed a boost when it launched the Chopper

in 1969, selling millions to the younger segment of the worldwide market over the next few years. The Special Products Division designed and built advanced racing bikes for the Dutch-based TI-Raleigh team of the 1970s and '80s, which was run very successfully by Peter Post with riders like Gerrie Knetemann, Jan Raas and Joop Zoetemelk. But gradually the mass production moved to the Far East, and in 1999 the company's last Nottingham factory closed. There's still a Raleigh headquarters in the city, however (and another in Seattle), and it was very good to see Team Raleigh being relaunched in 2010.

I know the architect Michael Hopkins, who designed the new halls of residence for students at Nottingham University – and they're all where the old Raleigh factories used to stand. I don't suppose many of today's students will ever know that they're living on the site of what was once the world's most dynamic and productive bicycle factory, a vital part of Britain's old industrial base.

Reg Harris died after suffering a stroke in 1992, aged seventy-two. There's a fine statue of him at the Manchester velodrome, the headquarters of British Cycling, where he has kept an eye on recent generations of Britain's Olympic hopefuls going through their training laps, some of them destined to win the gold medals that narrowly escaped his clutches.

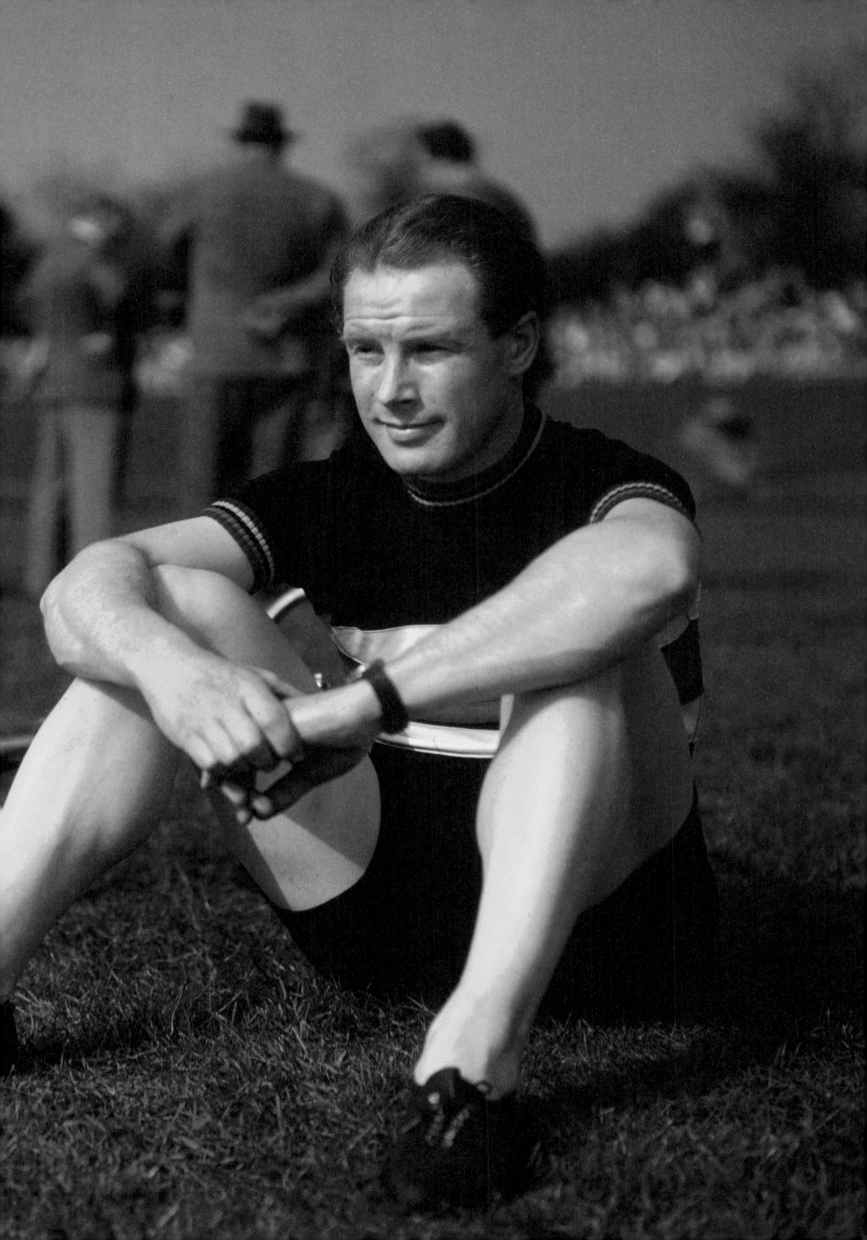

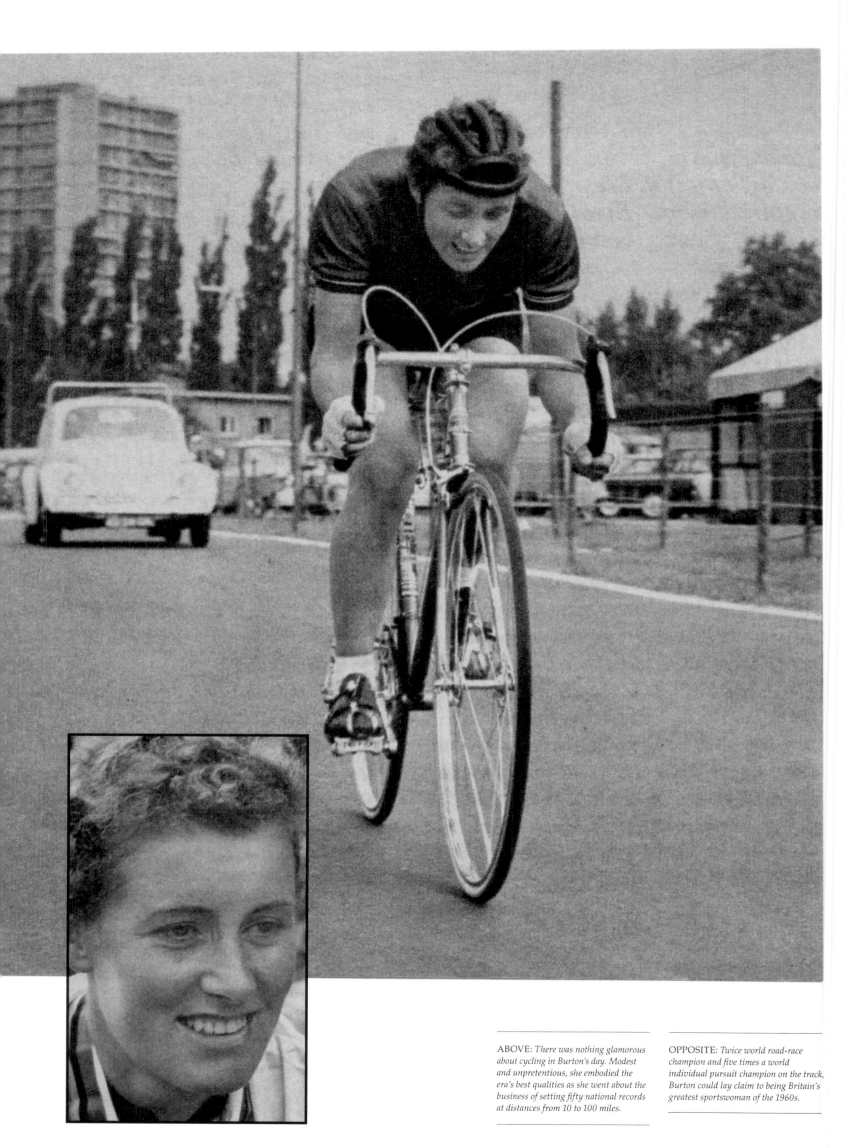

ABOVE: *There was nothing glamorous about cycling in Burton's day. Modest and unpretentious, she embodied the era's best qualities as she went about the business of setting fifty national records at distances from 10 to 100 miles.*

OPPOSITE: *Twice world road-race champion and five times a world individual pursuit champion on the track, Burton could lay claim to being Britain's greatest sportswoman of the 1960s.*

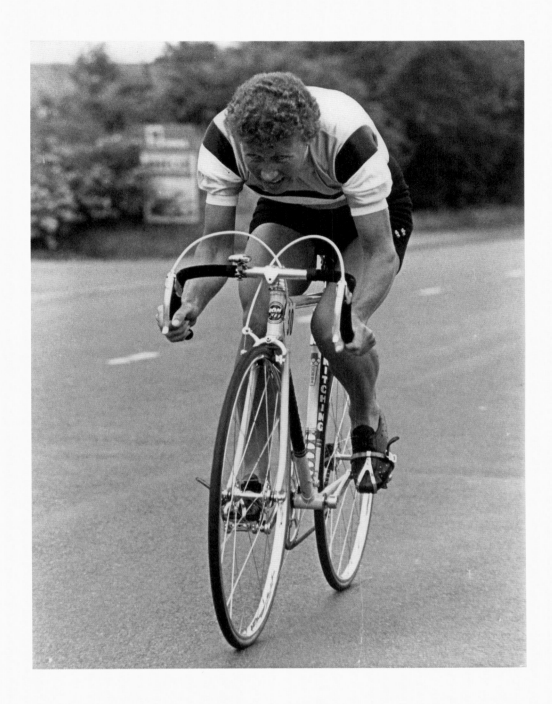

BERYL BURTON

There was just the one girl in our cycling club. All the rest of the members were blokes. I think her name was Irene, and I remember that I always thought of her as our very own Beryl Burton. She was a strong rider who went out with us whatever the weather.

We were very familiar with Beryl Burton's exploits. She was a bit of a pioneer of cycling for women. I don't suppose she would have influenced someone like Nicole Cooke directly, but maybe Cooke's parents, who are cycling fans, knew about her.

Burton was born just outside Leeds in 1937, and took up cycling after suffering from rheumatic fever as a child. She was equally strong on the road, in time trials and on the track. She won the women's world road-race championship twice, in 1960 and 1967. On the track she was world champion in the individual pursuit five times between 1959 and 1966, and won the silver

medal three times and the bronze medal four times. In Britain she won seventy-two national individual time-trial titles, twelve road-race titles and twelve pursuit titles. She set fifty national records over distances from 10 to 100 miles, and in 1967 she broke the twelve-hour record with a distance better than any British man had then achieved. As a result she was named Britain's best all-rounder for twenty-five years in a row: that's a quarter of a century with nobody else getting a look-in!

In 1968 Burton was awarded an OBE and in 1972 she and her daughter Denise were both selected to represent Britain at the track world championships. Sadly, Burton died of a heart attack while out riding her bike in 1996, a week before her fifty-ninth birthday. It's a pity she wasn't around to see the success that British women have enjoyed in recent years, and the huge rise in the number of women who take cycling seriously.

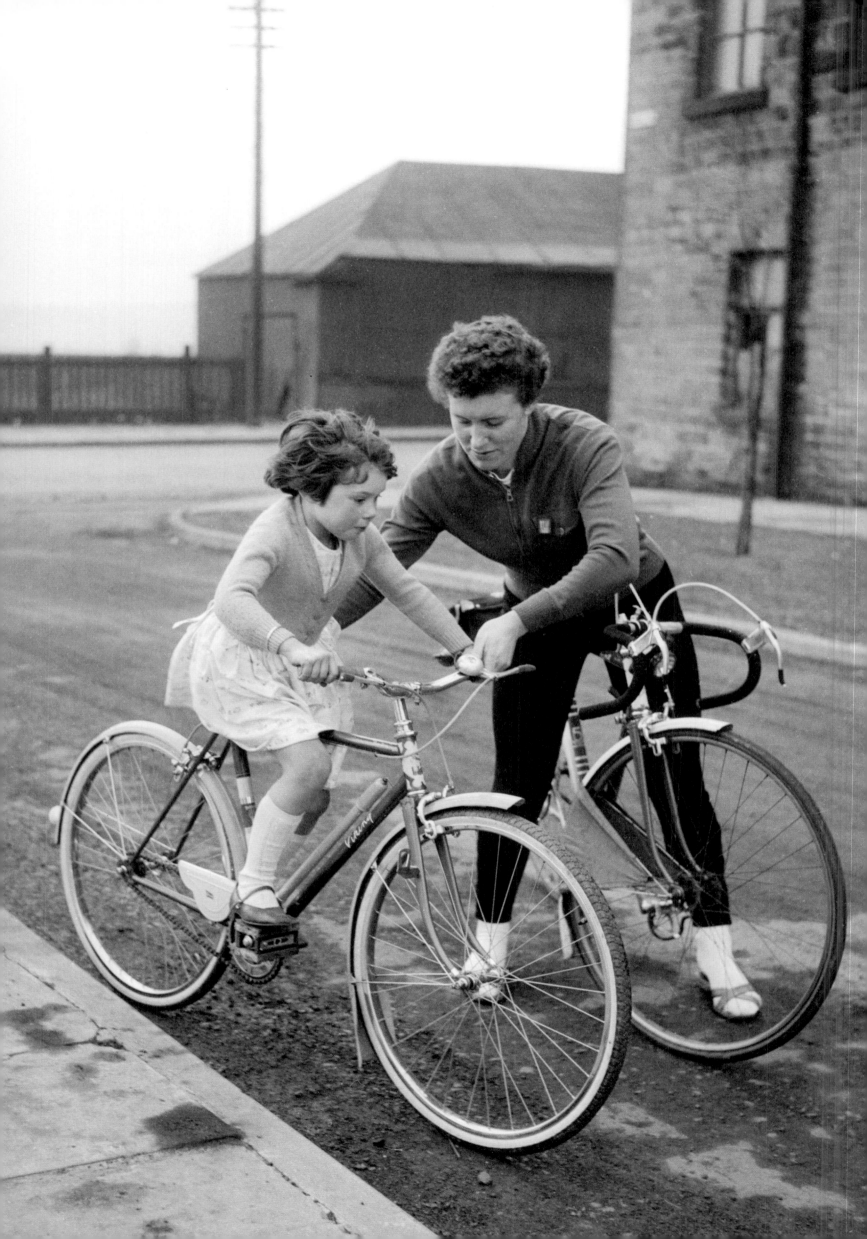

THE LOOK

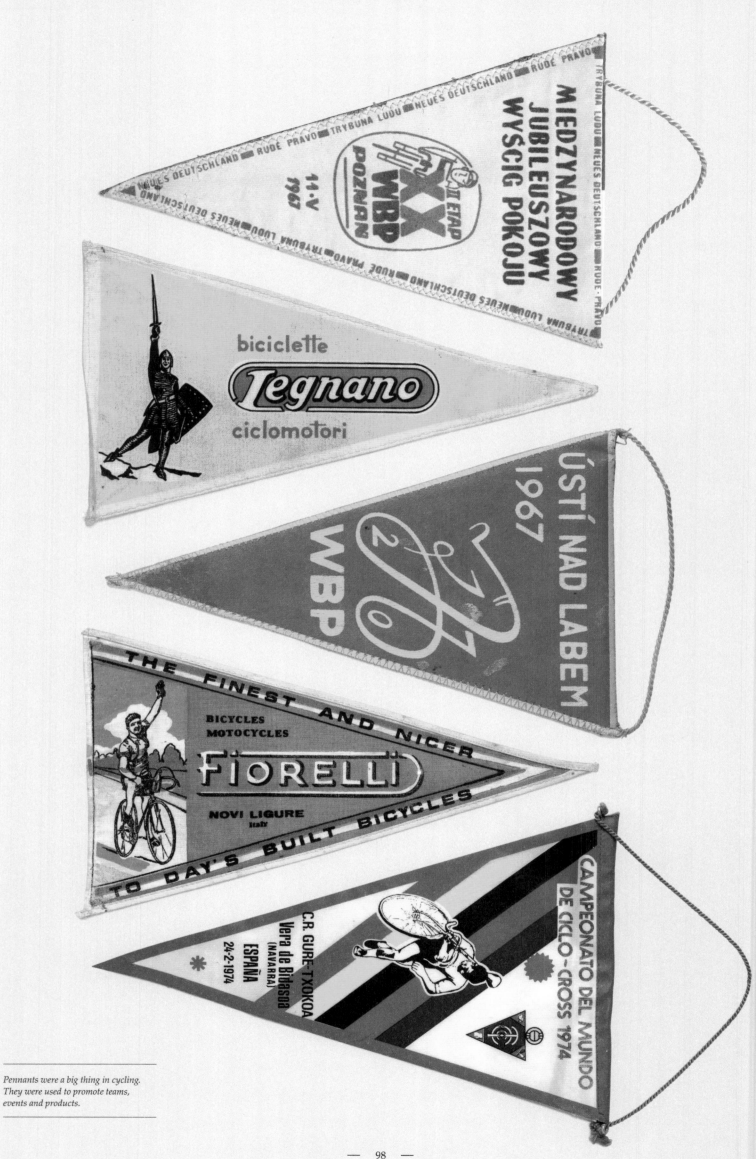

Pennants were a big thing in cycling. They were used to promote teams, events and products.

THE LOOK

I'd never seen writing on clothing before I saw cycling jerseys. That was something very different. The names seemed very mysterious and exotic. And it wasn't just the writing on the jerseys. In the days when I was riding I bought a tin of Evian water because I connected it with cycling, and I kept it on a shelf in my bedroom as if it were a trophy. It was a link to a world that, as a teenager, I wanted to know more about and be part of.

So much of that mystery has disappeared because in today's world everybody is bombarded with stuff. Back then there were threads that you'd pick up and follow: the name of Jacques Anquetil's sponsor, the design of his jersey, the things he advertised in the French and Italian magazines, where the adverts were often designed with real style, whether they were for coffee-making machines or razor blades.

In that era cyclists were the only sportsmen who wore sponsors' names on their kit. Cricketers and tennis players wore all white, footballers didn't even have a club badge on their shirts, golfers wore cardigans and plus-fours, and racing drivers wore plain cotton overalls (or, in the case of Mike Hawthorn, who in 1958 became the first British world champion, a sports jacket and a bow tie). So perhaps cyclists were the pioneers, and I suppose for me this was a first encounter with the effect of graphic design on clothes – and on the world in general.

Cycling has always been a place to look for fine design. Engraved handlebars and stems, the fine ridges on a Campagnolo aluminium seat-post (and the box it came in, with the world championship stripes), the holes drilled in the brake levers to save weight, gear levers mounted on the down tubes or the handlebar ends, the beautiful decorative lugs where the tubes meet on a steel frame, lined with paint in a contrasting colour – it's all geeky stuff, I suppose, but not in a bad way.

When I was young I had a pair of Fausto Coppi cycling shoes. I mentioned them to Mark Cavendish once, and he was really interested. He's got a terrific knowledge of things like that, which is probably surprising for someone of his generation. We've had nice conversations about the design of team jerseys, too. Almost all of them have to carry too many logos, which makes life very hard for a designer who is trying to come up with something that looks good.

Mark and I also agreed that all riders should be made to wear black shorts, rather than having shorts in the same colour as their jerseys. They often look terrible – and particularly when it comes to the women, who are sometimes given kit that is actually embarrassing for the riders.

Why don't people think a bit harder about that, and design something more flattering? It's a question of style. And style, as I hope you can see in this book, is almost as important a part of cycling as the suffering.

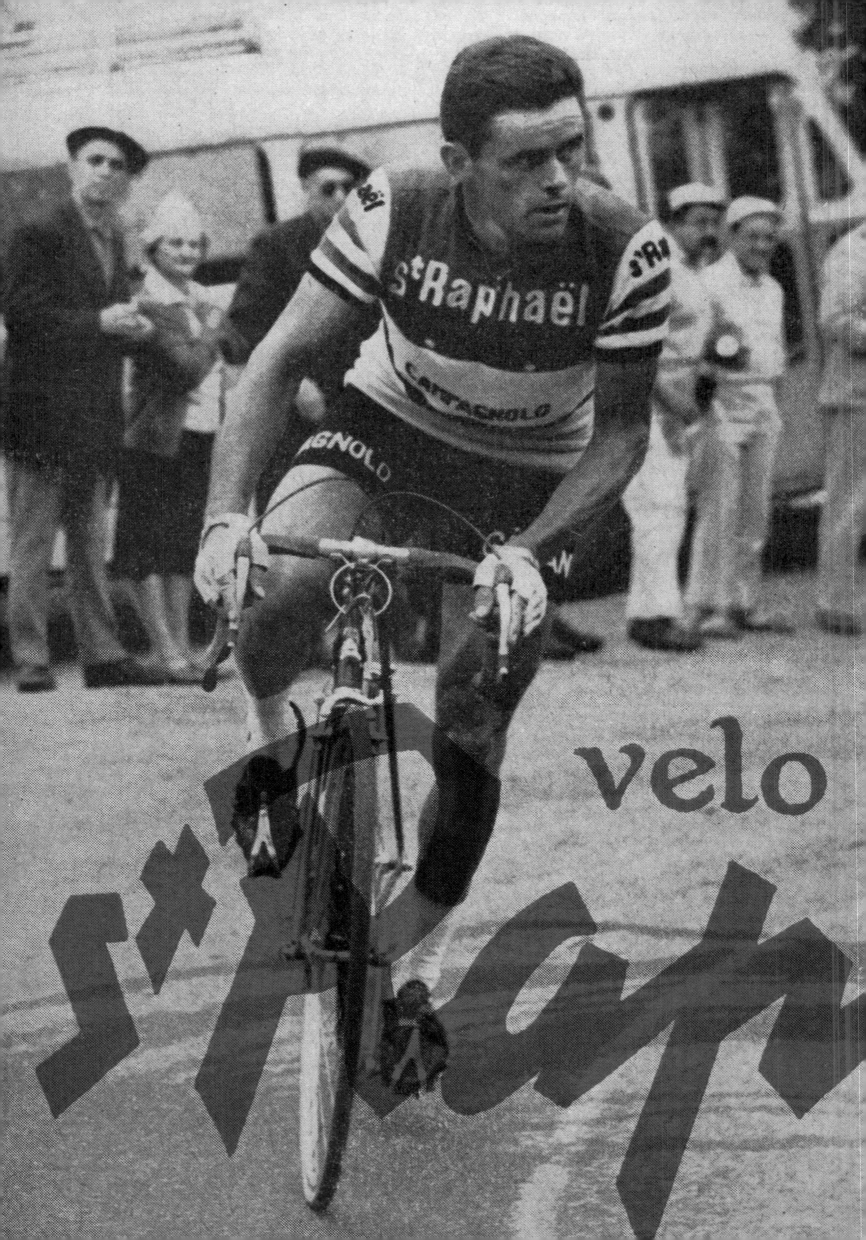

OPPOSITE: *The French rider Guy Ignolin, a teammate of Jacques Anquetil, is seen on his way to winning a stage of the 1963 Tour de France, from Bagnères-de-Bigorre to Luchon in the Pyrenees.*

BELOW: *Few sponsors made more creative use of graphic design than St Raphaël, manufacturer of an aperitif that became a popular cocktail ingredient.*

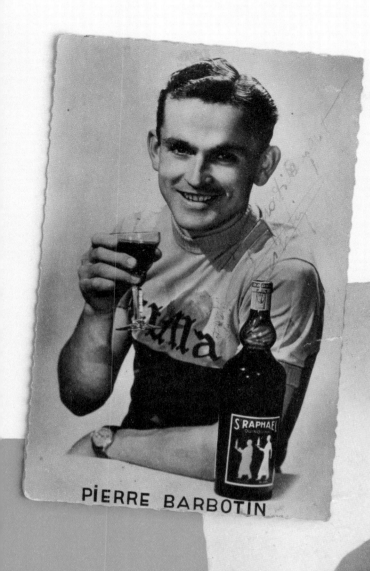

PIERRE BARBOTIN

DUBONNET

ANISADE
BERGER

20

ROBINSON BRIAN

Studio 'G'

The French rider Pierre Barbotin raced
as a domestique for the St Raphaël-
Geminiani team from 1955 to 1957.
Brian Robinson wore the same colours
from 1957 to 1959, becoming the first
British rider to win a Tour de France
stage in 1958, and repeating the feat
the following year.

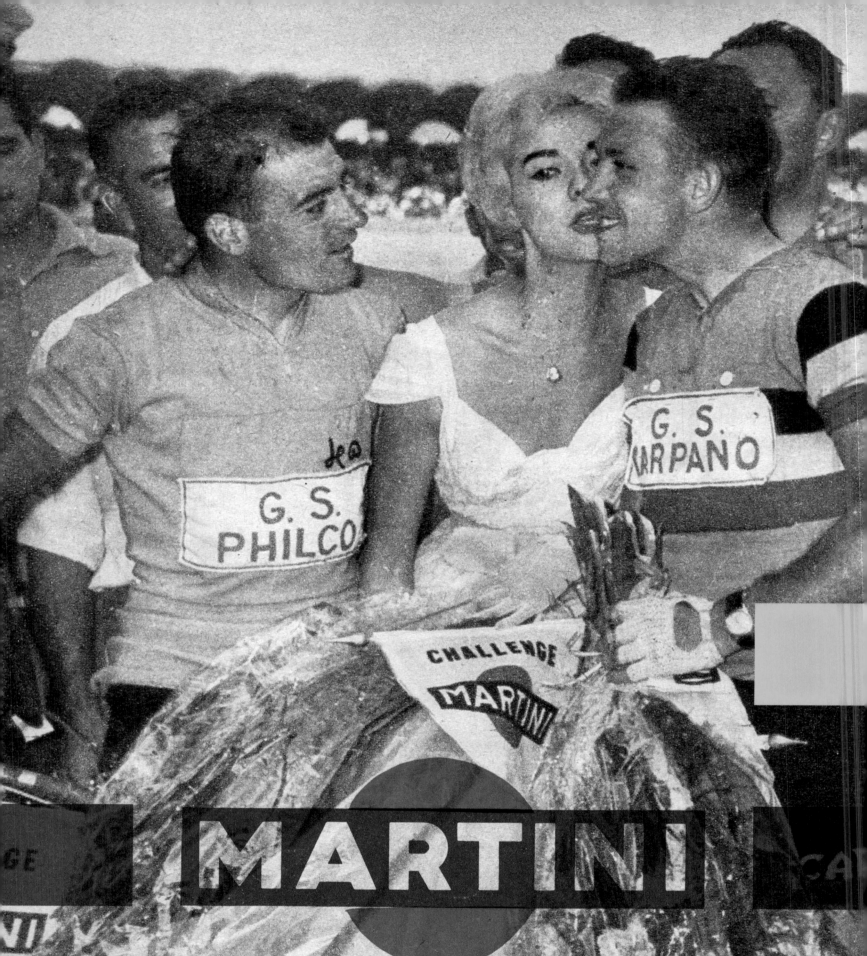

Remington...

...Remington

L'HOMME...

...ET LE CHAMPION

par Pierre Chany

LA BONNE POSITION

Le corps s'adapte parfaitement au cadre. Il n'est ni trop allongé, ni « ramassé ». Le coureur conserve sa liberté de mouvements, tout en respectant un aérodynamisme indispensable. Remarquer l'inclinaison des bras. Les mains sont bien posées sur le cintre.

Fig. 13

LA MAUVAISE POSITION

Un exemple de mauvaise position. La selle est trop avancée, le corps trop droit. Un coureur ne peut pas obtenir un bon rendement dans ces conditions.

Fig. 14

die Welt

Časovka družstev byla etapou deště. Nechybělo ani krupobití. A jak to vypadalo na stadiónu, to nejlépe ukazuje náš snímek: tehdy ještě reprezentanti NDR jeli v modrých trikotech ...

Dva bojovníci po dobojované bitvě. Vlevo sovětský reprezentant Sajdchužin, vítěz soutěže o nejaktivnějšího jezdce, vpravo náš Schejbal.

ČASOPIS ČESKOSLOVENSKÉHO SVAZU TĚLESNÉ VÝCHOVY

Cyklistika
ČASOPIS ČESKOSLOVENSKÉHO SVAZU TĚLESN...
ROČN.

ÚSPĚCH DOLEŽELA

XVIII. ZÁVOD MÍRU

1. SSSR	1. Lebeděv (SSSR)
2. Polsko	2. DOLEŽEL (ČSSR)
3. NDR	3. Kudra (Polsko)
4. ČSSR	4. Sajdchužin (SSSR)

VOL. III APRIL — 1951 No. 4

THE LEAGUER

Official Journal of
THE BRITISH LEAGUE OF RACING CYCLISTS

CONTENT

PERSONALITY PARADE

•

L. T. P.'s WINNING LINE

•

LETTERS TO THE EDITOR

•

SCOTTISH PAGE

•

CLUB & SECTION NOTES

IT'S ALWAYS
"VIKING" SHOW WEEK
AT
HERBY RAY'S !

TYNESIDE'S ONLY VIKING AGENT ★ SPECIAL DISPLAY OF RACING PHOTOGRAPHS DURING APRIL

★ **" SEVERN VALLEY "** ★

SERIES "SS" PEMBROKE to LONDON R.R.A. Record-Holder Ted Jones June 1950 The NEW **" MILEATER "**

Proved "MASTERS" on Track and Road Setting a NEW STANDARD in LIGHTWEIGHT Value and Finish

★

VIKING
RACING CYCLES

HERBY RAY, PERCY STREET, NEWCASTLE-ON-TYNE
— TELEPHONE 27920 —

PRICE - SIXPENCE

A. P. Phillips

RULES & REGULATIONS

BRITISH LEAGUE OF RACING CYCLISTS

1/- 1956

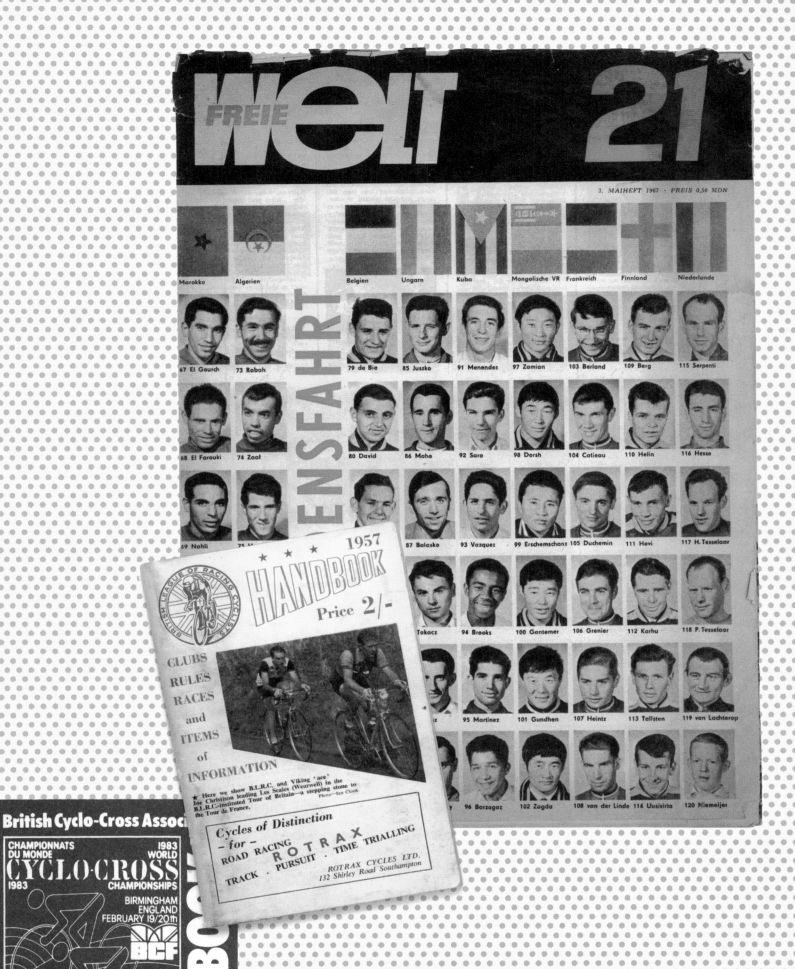

France, Italy, Spain and the Benelux countries may have been the heartland, but bike racing gathered adherents in Britain and Germany, as well as behind the Iron Curtain.

Vol. X.—No. 6. DECEMBER, 1954 PRICE 6d.

Official Journal of
THE BRITISH LEAGUE OF RACING CYCLISTS

EARL'S
COURT
EXHIBITION
REPORT
By
Lon Pullen

THE LEAGUER

CONTENTS

HASSENFORDER
STORY
By Bari Hooper

•

TRAINING TALK

•

REPORTS—REVIEWS
—OPINION

TO ALL CYCLISTS WHEREVER YOU ARE
A Merry Christmas and a
Happy New Year

from

Viking

VIKING CYCLES LIMITED - WOLVERHAMPTON

A SPECIALIST JOURNAL FOR SPEEDMEN

MEMORIA

SOCIEDAD CICLISTA MUNGUIA

TEMPORADA

1962
1963

quina
quin

SPORT mondial télévision

Le magazine mensuel du sport et de l'automobile

Nº 65 — JUILLET

TOUT SUR LE TOUR

* Anquetil est prêt, mais...
* La dernière cote
* Le Tour à la Télé
* Une passerelle lancée à temps
* La complainte du suiveur
* Il y a 40 ans...
* Le vrai Tour de l'Avenir
* Quand ils vident leur sac
* Pellos vous questionne

ATHLETISME

* Trois records qui donnent le ton
* Jazy et la Télévision

AUTOMOBILE

* Au Mans, 22 h. de fiesta mexicaine

FOOTBALL

* Pour Monaco la passe de trois ?

TOUS LES SPORTS

* Campeurs, équipex-vous
* 60 ans de sport
* Voulez-vous jouer avec moi ?
* Aroues ou écrasez-vous (nouvelle)
* Tous les résultats

(Sommaire complet page 7)
Le Nº France 1 NF (100 tr.)
Belgique 15 frs

LE TOUR SPÉCIAL DERNIÈRE

1 N.F.
(100 FRS)

OPPOSITE: *Compared to the geniuses who designed St Raphaël's adverts, Viking's art department was modest in its achievements.*

BELOW: *For the 1967 Peace Race from Warsaw to Prague via Berlin, Polish designers produced a striking image.*

WYŚCIG POKOJU

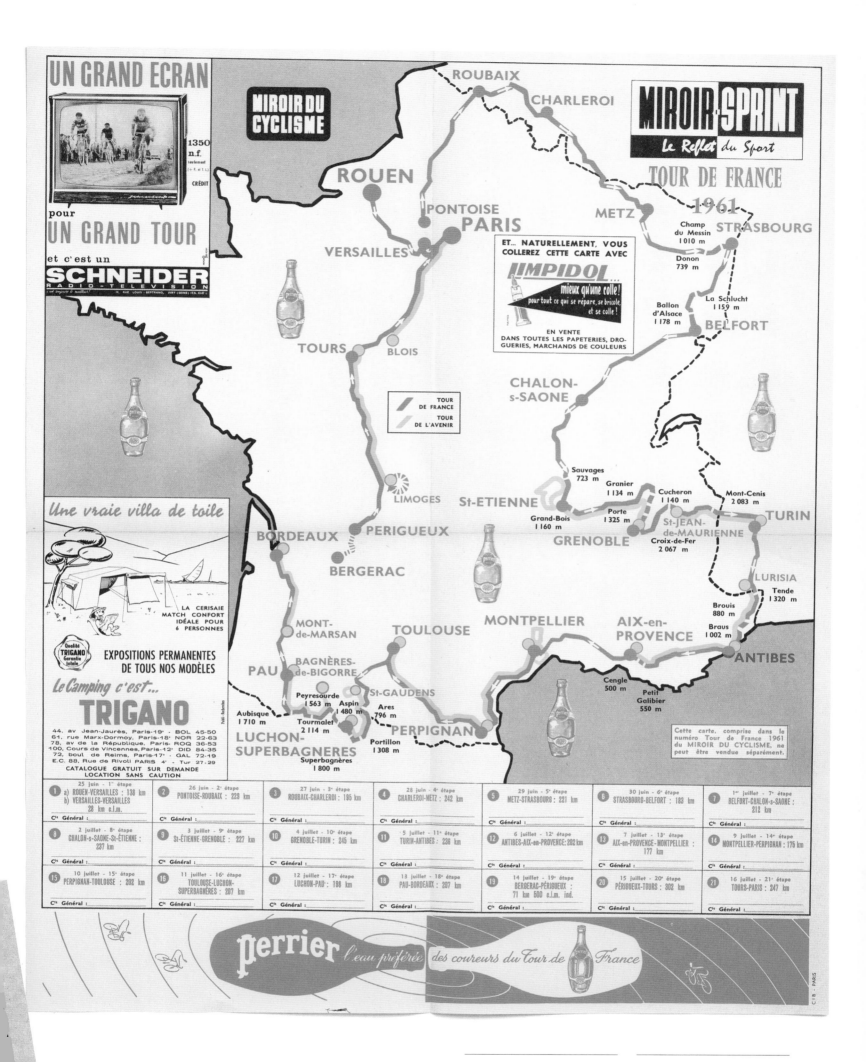

TOUR
DE FRANCE
TOUR
DE L'AVENIR

ROUBAIX
CHARLEROI
ROUEN
PONTOISE
PARIS
METZ
Champ
du Messin
1 010 m
STRASBOURG
VERSAILLES
Donon
739 m
La Schlucht
1 159 m
Ballon
d'Alsace
1 178 m
BELFORT
TOURS
BLOIS
CHALON-
s-SAONE
Sauvages
723 m
Granier
1 134 m
Cucheron
1 140 m
Mont-Cenis
2 083 m
LIMOGES
St-ETIENNE
Grand-Bois
1 160 m
Porte
1 325 m
St-JEAN-
de-MAURIENNE
TURIN
BORDEAUX
PERIGUEUX
GRENOBLE
Croix-de-Fer
2 067 m
BERGERAC
LURISIA
Tende
1 320 m
Brouis
880 m
MONT-
de-MARSAN
TOULOUSE
MONTPELLIER
AIX-en-
PROVENCE
Braus
1 002 m
BAGNÈRES-
de-BIGORRE
St-GAUDENS
ANTIBES
PAU
Peyresourde
1 563 m
Aspin
1 480 m
Ares
796 m
Cengle
500 m
Petit
Galibier
550 m
Aubisque
1 710 m
Tourmalet
2 114 m
PERPIGNAN
LUCHON-
SUPERBAGNERES
Portillon
1 308 m
Superbagnères
1 800 m

1	25 juin - 1re étape a) ROUEN-VERSAILLES : 138 km b) VERSAILLES-VERSAILLES 28 km c.l.m.	2	26 juin - 2e étape PONTOISE-ROUBAIX : 229 km	3	27 juin - 3e étape ROUBAIX-CHARLEROI : 195 km	4	28 juin - 4e étape CHARLEROI-METZ : 242 km	5	29 juin - 5e étape METZ-STRASBOURG : 221 km	6	30 juin - 6e étape STRASBOURG-BELFORT : 183 km	7	1er juillet - 7e étape BELFORT-CHALON-s-SAONE : 212 km
	Clt Général :		Clt Général :		Clt Général :		Clt Général :		Clt Général :		Clt Général :		Clt Général :
8	2 juillet - 8e étape CHALON-s-SAONE-St-ETIENNE : 237 km	9	3 juillet - 9e étape St-ÉTIENNE-GRENOBLE : 227 km	10	4 juillet - 10e étape GRENOBLE-TURIN : 245 km	11	5 juillet - 11e étape TURIN-ANTIBES : 238 km	12	6 juillet - 12e étape ANTIBES-AIX-en-PROVENCE: 202 km	13	7 juillet - 13e étape AIX-en-PROVENCE-MONTPELLIER : 177 km	14	9 juillet - 14e étape MONTPELLIER-PERPIGNAN : 176 km
	Clt Général :		Clt Général :		Clt Général :		Clt Général :		Clt Général :		Clt Général :		Clt Général :
15	10 juillet - 15e étape PERPIGNAN-TOULOUSE : 202 km	16	11 juillet - 16e étape TOULOUSE-LUCHON-SUPERBAGNÈRES : 207 km	17	12 juillet - 17e étape LUCHON-PAU : 188 km	18	13 juillet - 18e étape PAU-BORDEAUX : 207 km	19	14 juillet - 19e étape BERGERAC-PÉRIGUEUX : 71 km 500 c.l.m. ind.	20	15 juillet - 20e étape PÉRIGUEUX-TOURS : 302 km	21	16 juillet - 21e étape TOURS-PARIS : 247 km
	Clt Général :		Clt Général :		Clt Général :		Clt Général :		Clt Général :		Clt Général :		Clt Général :

OPPOSITE: *After winning a stage of
the 1961 Tour in Versailles, the great
sprinter André Darrigade takes a bottle
from the representatives of a well-known
mineral-water company.*

ABOVE: Miroir-Sprint's map of the
1961 Tour de France, including such
classic climbs as the Ballon d'Alsace,
the Croix-de-Fer, the Tourmalet and
the Aubisque.

LO SPORT ILLUSTRATO

FÉLIX POTIN
Toute l'Alimentation

MI

BERTIN "PORTER 39"

Legnano

But CLU

LE MIRO
DES SPORTS

sur bicyclette ELVÉ FABRI

Peugeot

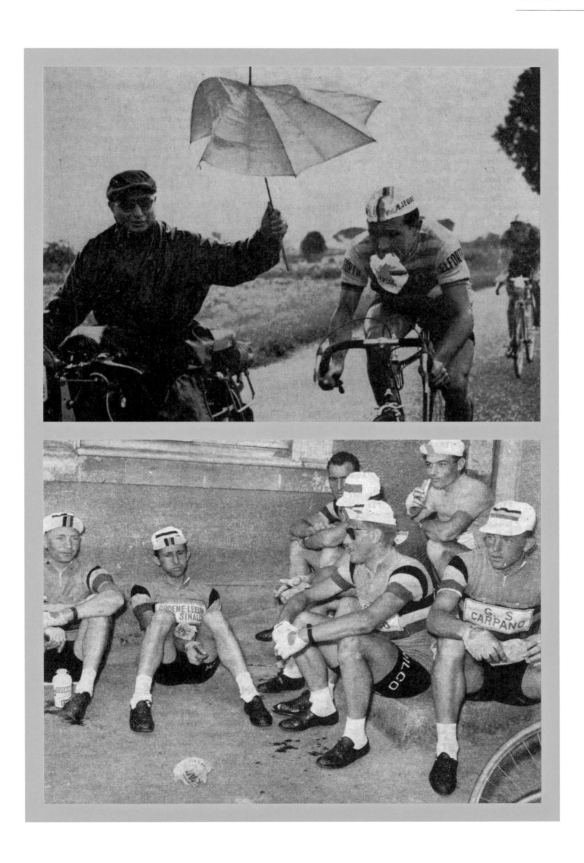

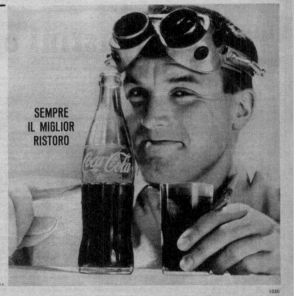
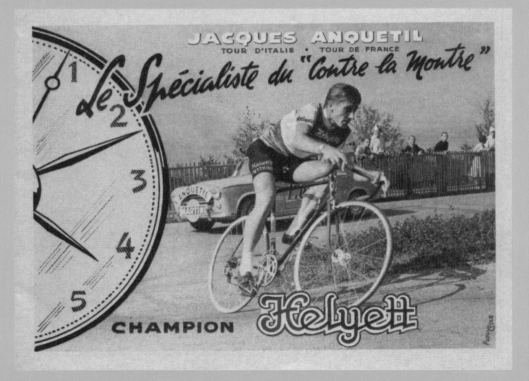

Une passionnante bataille : celle des grimpeurs pour le trophée St-Raphaël-Quinquina.

CHOISISSEZ
la bicyclette
des champions...

...comme Anquetil une

Helyett

SULLY-SUR-LOIRE (LOIRET) - Tél. : 16

LE TOUR COMME SI VOUS Y ÉTIEZ

But et Club
LE MIROIR DES SPORTS

PARAITRA LUNDI
EN BISTRE

avec des articles de
FÉLIX LÉVITAN
directeur-adjoint du Tour

ROGER BASTIDE, ANDRÉ CHASSAIGNON, RENÉ
DE LATOUR, FRANCIS HUGER, ROGER FLAMBART

L'opinion d'André Leducq
deux fois vainqueur de l'épreuve

et le "GRAIN DE SEL"
DE JACQUES GRELLO

*

LES MEILLEURES PHOTOS SUR
LES ULTIMES BATAILLES DANS

ANNECY-CHALON
CHALON-DIJON
(contre la montre)

et sur le parcours-apothéose

DIJON-PARIS

avec le couronnement du vainqueur
et le tour d'honneur des rescapés au

PARC DES PRINCES

But et Club
LE MIROIR DES SPORTS

Le plus fort tirage des hebdomadaires sportifs
RETENEZ-LE DÈS MAINTENANT
CHEZ VOTRE MARCHAND HABITUEL

But et Club
LE MIROIR DES SPORTS

offre
chaque semaine
à ses lecteurs

LE PLUS ATTRAYANT
PANORAMA DES GRANDS
ÉVÉNEMENTS DU SPORT
TRAITÉS PAR LE TEXTE ET
PAR L'IMAGE

Reportages, enquêtes, révélations,
confidences des champions, commen-
taires techniques par les spécialistes
les plus autorisés font de

But et Club
LE MIROIR DES SPORTS

LE NUMÉRO UN
DES HEBDOS OMNISPORT

COMME LES CHAMPIONS

Massez-vous
vous-même

avec

HOLO-ÉLECTRON

Appareil diffuseur de RAYONS VIO-
LETS, particulièrement efficaces dans
les cas de : RHUMATISMES, SCIA-
TIQUE, COURBATURE, FATIGUE

DONNE...
SOUPLESSE
RÉSISTANCE
ENDURANCE

ACTIVE... LA
CIRCULATION
DU SANG

Documentation sur demande
ÉMILE MICHEL & Cie Constructeur
55, r. de Bretagne, Paris-3e. TUR 96-66

HOLO-ÉLECTRON

Spécialités T.A.
NOUVEAUTÉ

MANIVELLES
EN DURALUMIN
FORGE

BIDONS - CALE-CHAUSSURES
GUIDOGAINES - PLATEAUX
COUPLES - PORTE-BIDONS

T.A. 2, rue de Salféino
VANVES (Seine).

PATIN ZÉBRÉ
VÉLO

CYCLOMOTEUR
GUTTACOLL
FREINE PAR TOUS LES TEMPS

28

GRAND PRIX DES NATIONS
R. POULIDOR
Gr. Sp. MERCIER-BP
SUR CYCLES MERCIER
avec

1er SEDIS
La chaîne française de Qualité

GRAND PRIX DES NATIONS
1er POULIDOR (MERCIER-BP)

AVEC
LES
FREINS
MAFAC
« RACER »
ou
« TOP 63 »

C'est tellement plus sûr !

LA PLUS HAUTE PERFECTION TECHNIQUE
POUR LA PLUS TOTALE SATISFACTION DE TOUS

suite pages 16-17 13

OPPOSITE: *Jacques Anquetil was
one of several top riders who used bikes
carrying the distinctive logo of the
Helyett company, which was founded
in France in 1926.*

THIS PAGE: *Success in competition
was used to promote components such
as Mafac centre-pull brakes, used by
Raymond Poulidor to win the Grand
Prix des Nations.*

LE TOUR DE FRANCE 56
comme si vous l'aviez suivi

GRACE A NOTRE ALBUM QUI RÉUNIT
LES 25 PLUS BELLES PHOTOS
de la plus grande course cycliste du monde
LE TOUR **MIROIR·SPRINT**
Le Reflet du Sport
vu par
TIRAGE LIMITÉ. — N'attendez pas pour passer votre
commande à notre Service photo - MIROIR-SPRINT
6, rue de la Chaussée-d'Antin — PARIS (9e)
Prix de vente : 500 frs, envoi compris

UN
PRIMATO
DI
QUALITÀ

AMADIS

17

Toujours prêt
à faire *flamme!*

Le vent de la
vitesse n'interdit
pas la détente
d'une cigarette
à qui possède...

LE BRIQUET
Olympic-gaz

A PARTIR
DE 1.750 Fr.

LE 1er BRIQUET TEMPÊTE A GAZ DU MONDE

DISTRIBUTEUR: Éts. LAFOREST 11, Rue des Petites-Ecuries, PARIS-10e

7

THIS PAGE: *A limited-edition booklet
of Tour photos, a lighter that works in the
wind, a cigarette smoked by top riders…*

OPPOSITE: *In the United States,
advertisements for highly desirable
European equipment carried the names
of Raleigh, Holdsworth, Colnago,
Bob Jackson, Peugeot and Atala.*

PKO · PKO · PKO · PKO · P

II ETAP
11 MA

SWARZĘDZ
WRZEŚNIA

POZNAŃ

PKO · PKO · PKO · PKO · PKO · PKO · PKO · PKO · PK

PKO · PKO · PKO · PKO · PKO · PKO · PKO

OZNAŃ
1967

KŁODAWA·
KUTNO
ONIN
KOŁO

A scarf made in Poland to commemorate
a stage of the 1967 Peace Race, from
Poznan to Kutno. The sixteen-day
race began in Warsaw and ended in
Prague. The winner was Marcel Maes
of Belgium.

ANQUETIL
conseille la chaussure
Anquetil de chez

PATRICK

451 - Anquetil
Super compétition.
Tige box noir perforé
1er choix. Ultra-légère
Semelle armée. Crou-
pon anglais.

CONTRASTE - PA 40

Guaranteed for Years

- Milano -

POUR VÉLOS ET CYCLOMOTEURS

VÉLOMOTEURS ET MOTOS

PNEUS
DUNLOP

64, RUE DE LISBONNE - PARIS (8ᵉ)

44° Giro d'Italia

*La sfortuna ha decimato la squadra
ma non ha spento lo spirito e l'orgoglio*

L'esordiente **Vito TACCONE**
dopo una spettacolosa corsa d'attacco
VINCE la tappa BARI-POTENZA
e porta al trionfo la sua bicicletta

GOMME **PIRELLI**
Catena e ruota libera EVEREST
CAMBIO
DERAGLIATORE
MOZZI
BLOCCAGGI
STERZO
MOVIMENTO
PEDALI
REGGISELLA
GUARNITURE
Campagnolo

Atala

CESARE RIZZATO & C. - PADOVA

OPPOSITE: *As a teenager, I would have lusted after those Jacques Anquetil shoes, made by the Patrick company, or that lightweight Milano frame.*

BELOW: *Team mechanics work long hours, not always getting the sort of willing help from their riders that this one appears to be receiving in 1961.*

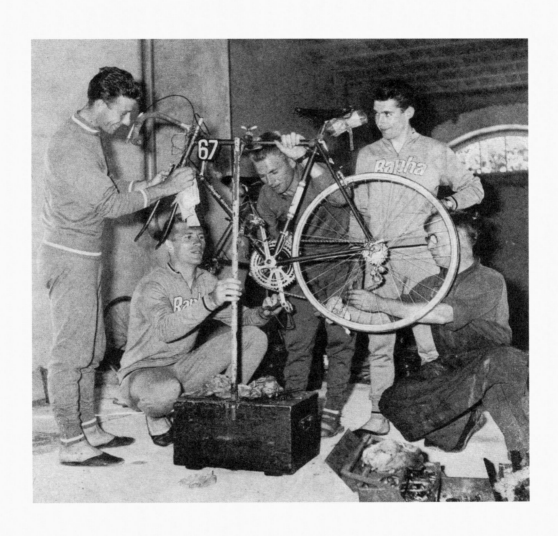

Vol.1 No.1

Tour De France Special!

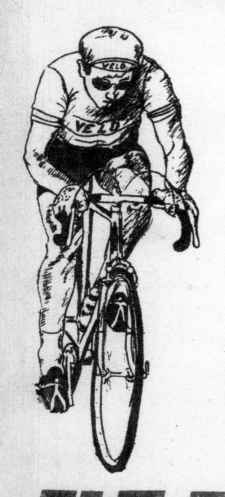

JULY 1959

CONTENTS

VELO

Price
Sixpence

ABOVE: *Duplicated on cheap paper and stapled together like an early punk fanzine, this special launch issue of the London-based* Velo *magazine previews the 1959 Tour de France.*

OPPOSITE: *British cycling magazines in the pre-Rouleur age were more modest affairs than their Continental equivalents, but* The Leaguer *– the organ of the British League of Racing Cyclists – was not entirely devoid of good photographs and stylish graphics.*

BREASTING THE SUMMIT
JIMMY GREENHOLT

I.T.P.'s WINNING LINE
by G. R. W.

(continued on page 5)

6 7

JACQUES GODDET — Maintenon, du Tour de l'Avenir.

FÉLIX LÉVITAN — Nous sommes d'accord ...

COLONEL CRESPIN, anticlub.

(French dialogue text, illegible)

18 19

MY CLUB
by J. C. HOLMES

RACING JERSEYS IN ANY CLUB COLOUR

Makers of

MAILLOT JAUNE

for

" DAILY EXPRESS " TOUR of BRITAIN

&

NATIONAL INDEPENDENT CHAMPION

MADE IN FINEST WOOL THROUGHOUT

Pockets back and front.

Delivery two weeks

CASH WITH ORDER

50/-

F. BARNES,

181 CHARMINSTER ROAD BOURNEMOUTH, HANTS.

THE LEAGUER'S CREED

NEWS briefs

BOUQUETS OF THE MONTH

To—THOMAS C.R.C.
(Yet again ! Three increases in Three Months !!!)
LOWESTOFT City.
TYNE City.
BRADFORD R.C.C.
STREATHAM C.R.C.
WESTERN SECTION.
ORION R.C. (Soton.)
BRENT JEWISH R.C.
for increasing their Orders

Has YOUR CLUB made that EXTRA EFFORT YET ? ? ?

Use order form on other page

Don't forget to mention the name of club or section to all correspondence.

DON'T DELAY

DO IT TODAY

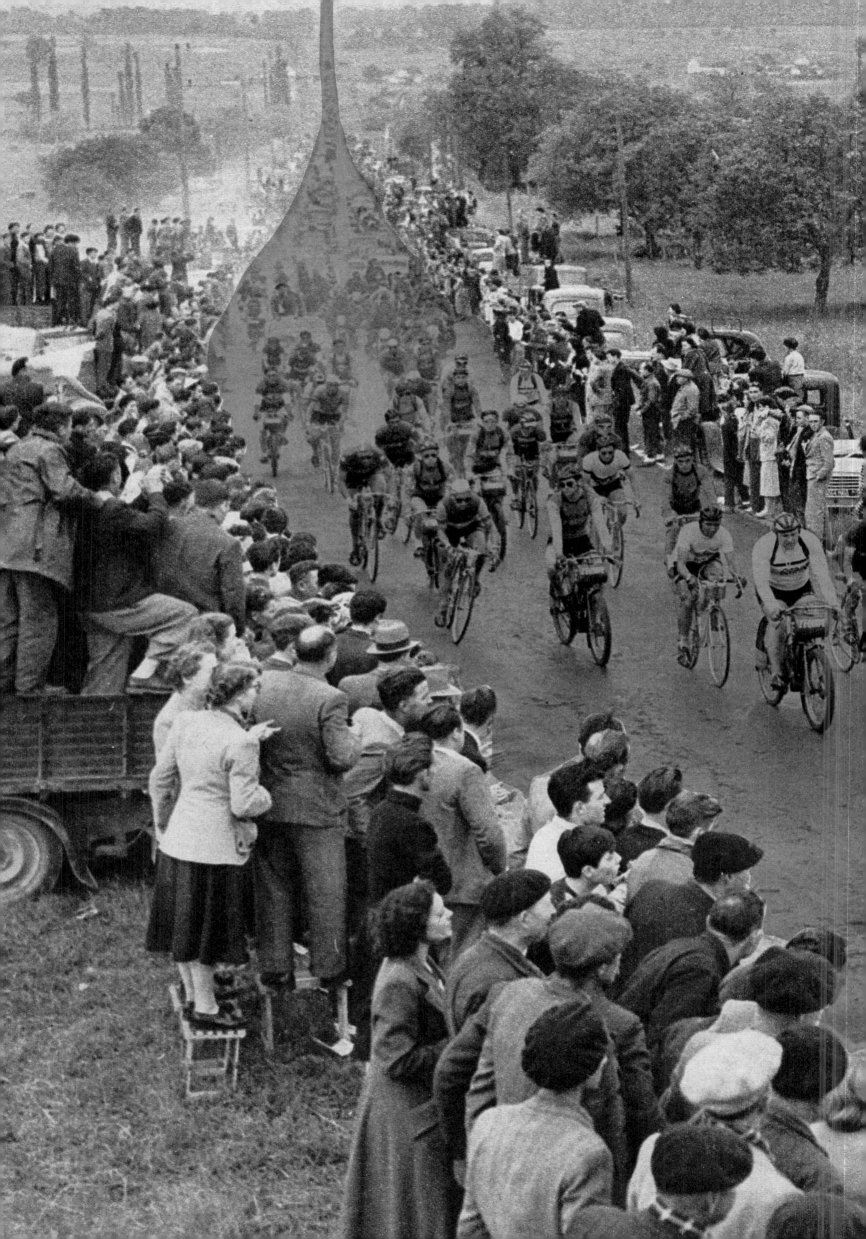

THE GREAT RACES

MILAN — SAN REMO

The one-day spring classics get the season under way, and Milan–San Remo is known as La Primavera: the race of spring. For the professionals, it's the year's first big target.

I remember when Mark Cavendish won it in 2009, by the width of a tyre in a photo finish after a fantastic sprint with the Australian rider Heinrich Haussler. I talked to him about it, and what I remember vividly is how thrilled he was with that victory. And this is a man who's won such a lot. You could see how much it still means. Look at all the people who've won it: it's a race of great prestige.

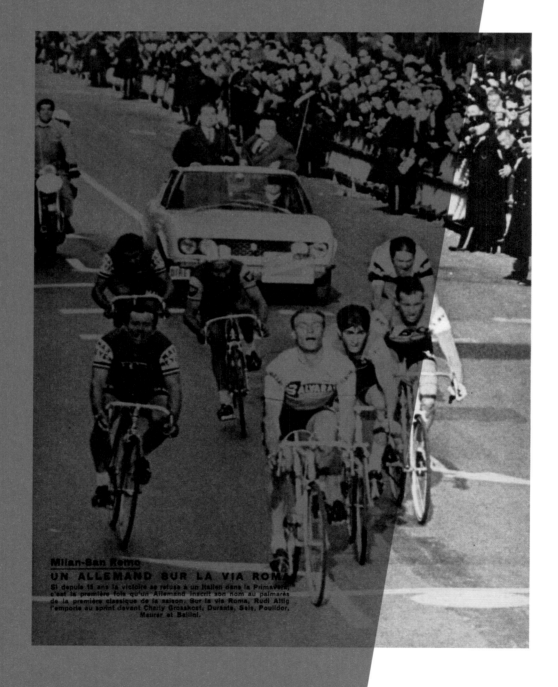

Milan-San Remo
UN ALLEMAND SUR LA VIA ROMA
Si depuis 15 ans la victoire se refuse à un Italien dans la Primavera, c'est la première fois qu'un Allemand inscrit son nom au palmarès de la première classique de la saison. Sur la via Roma, Rudi Altig l'emporte au sprint devant Charly Grosskost, Durante, Sels, Poulidor, Meurer et Bellini.

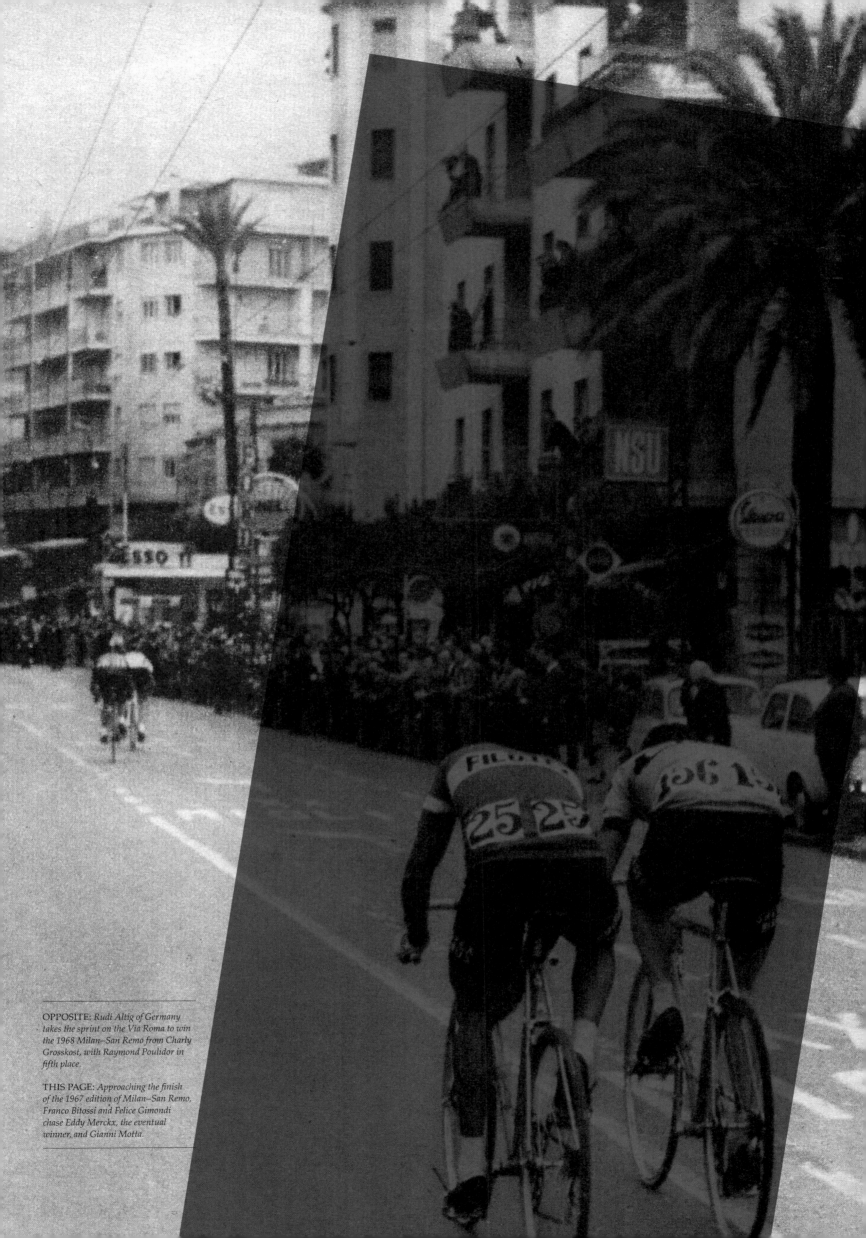

OPPOSITE: *Rudi Altig of Germany takes the sprint on the Via Roma to win the 1968 Milan–San Remo from Charly Grosskost, with Raymond Poulidor in fifth place.*

THIS PAGE: *Approaching the finish of the 1967 edition of Milan–San Remo, Franco Bitossi and Felice Gimondi chase Eddy Merckx, the eventual winner, and Gianni Motta.*

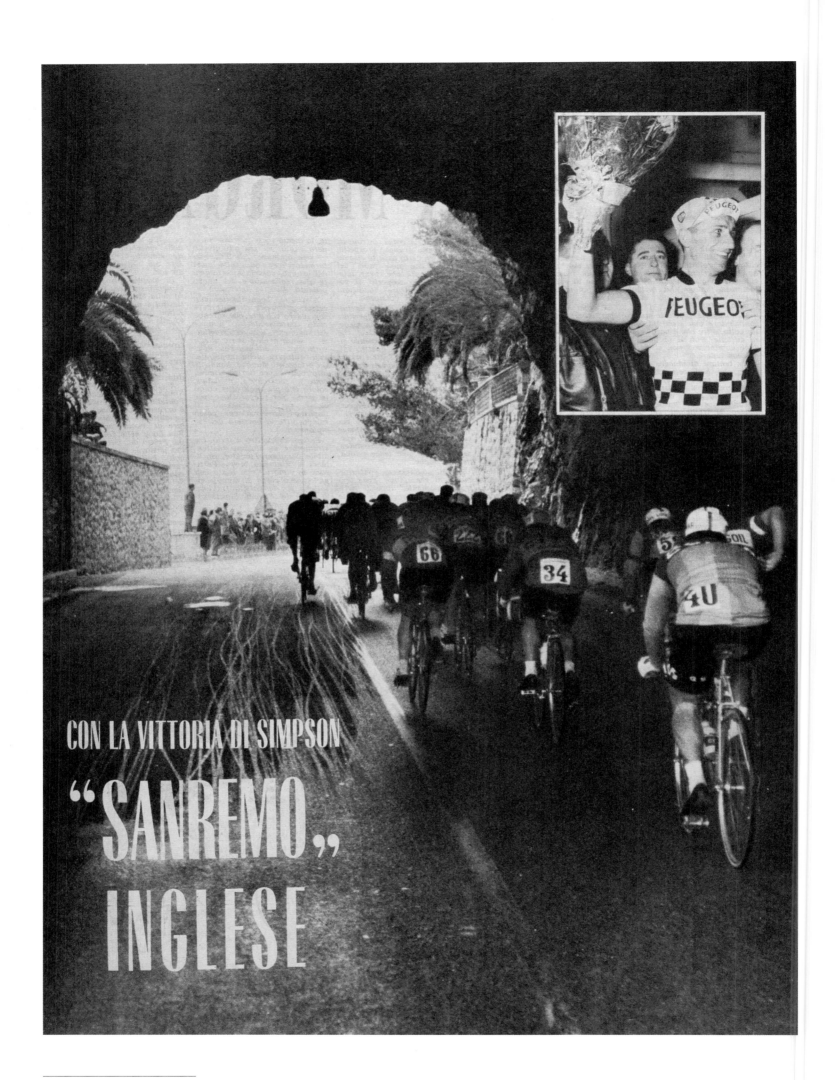

CON LA VITTORIA DI SIMPSON

"SANREMO" INGLESE

Tom Simpson's victory made him the first British rider to win one of cycling's one-day classics.

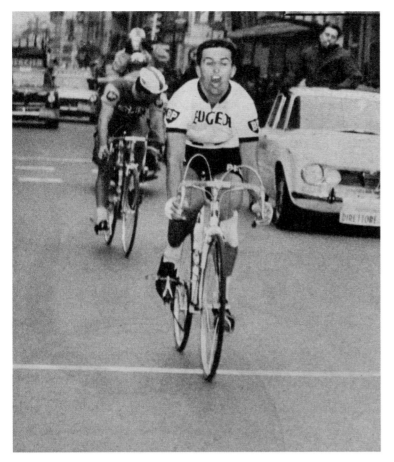

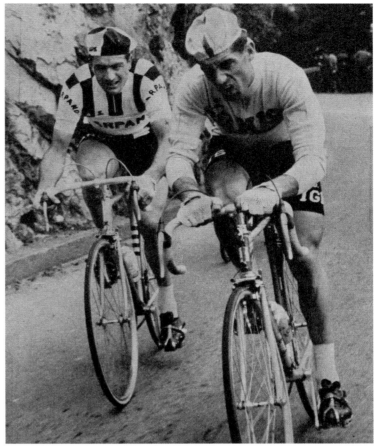

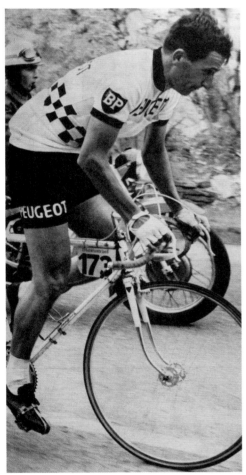

Simpson's win in the 1964 Milan–San Remo was one of the greatest of his career. He attacked on the climb of Capo Berti and finished two seconds ahead of Raymond Poulidor. TOP LEFT: Simpson and Poulidor. TOP RIGHT: Giuseppe Fezzardi and Antonio Bailetti on the Passo del Turchino. ABOVE: Simpson in the famous black-and-white jersey of the Peugeot team.

It began in 1907, and at 298 km it is the longest one-day race in the current professional calendar. Although it often turns into a battle between the sprinters, the inclusion of several interesting climbs – such as the Passo del Turchino, the Poggio and the Cipressa – means that it can favour a breakaway or a late escape, as it did in 2014, when the Norwegian rider Alexander Kristoff of Team Katusha managed to get away in the closing stages.

The French rider Lucien Petit-Breton won the first edition, in the same year that he also took the first of his two consecutive Tour de France victories. But from 1917 to 1950 a run of Italian successes was interrupted only once, in 1934, by the Belgian rider Jef Demuysere. Otherwise, there was a succession of wins for the great names of Italy, such as Alfredo Binda, Gino Bartali and Fausto Coppi, before the French and the Belgians muscled back in to share the spoils with the locals. In 1964 a victory for Tom Simpson made him the first British rider to win one of the 'monuments', as the five greatest one-day classics are known. Great Britain had to wait forty-five years for Cavendish to provide a second.

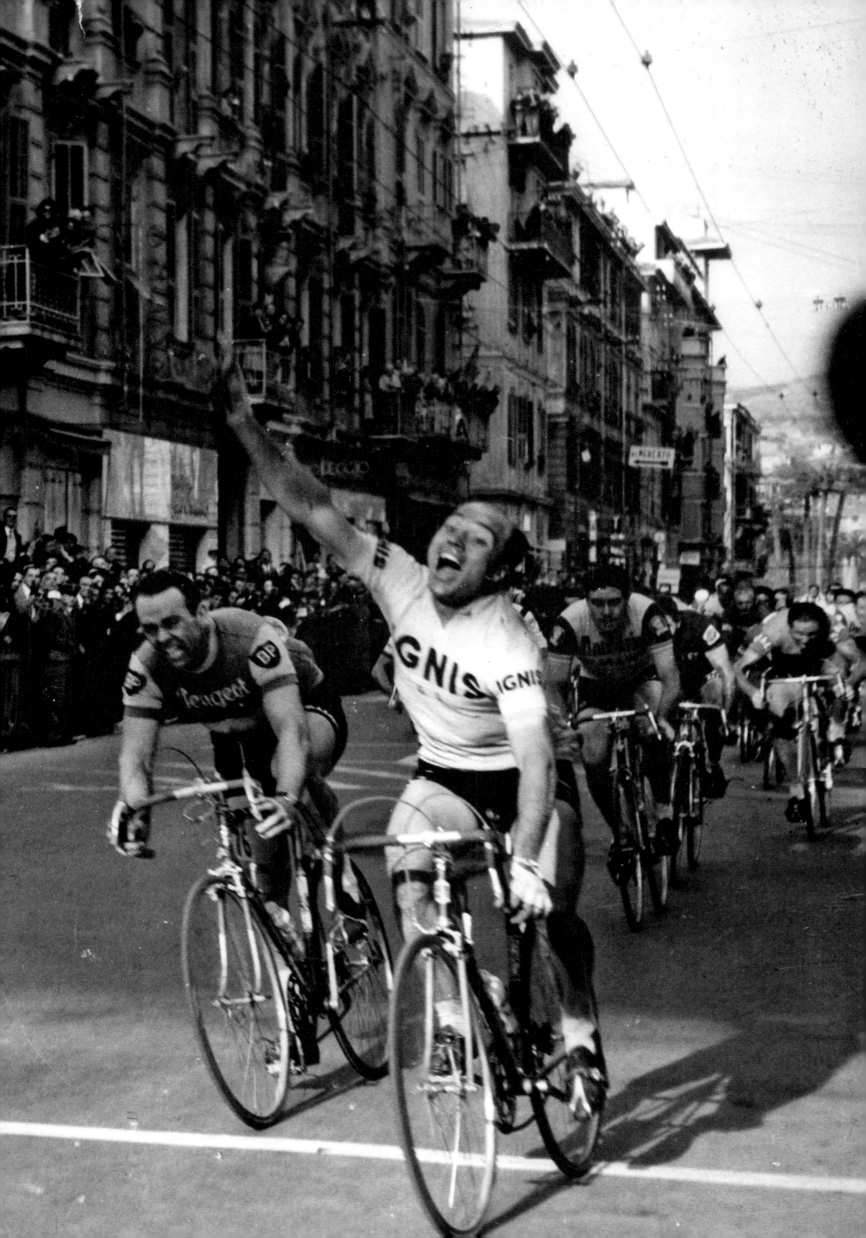

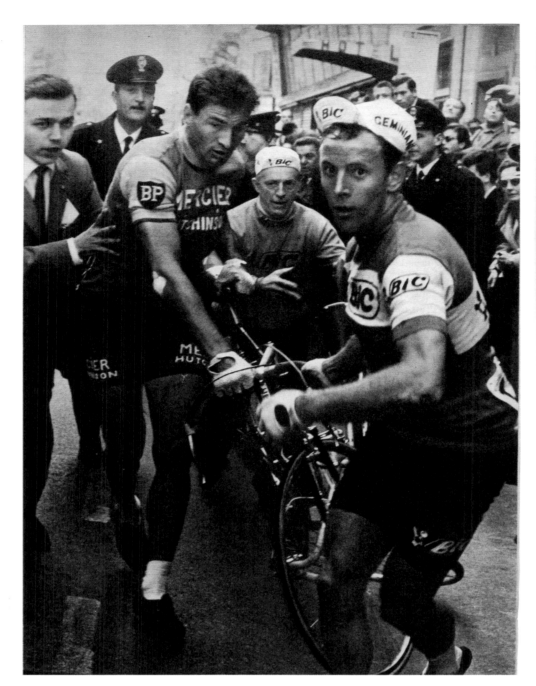

PREVIOUS PAGES: *Miguel Poblet of Spain crosses the line to win the 1959 Milan–San Remo, a length ahead of Rik Van Steenbergen of Belgium.*

ABOVE LEFT: *Raymond Poulidor and Jan Janssen try to salvage something from a crash during the sprint for the line in the 1961 Milan–San Remo.*

ABOVE RIGHT: *Fausto Coppi signs a poster in 1948, after the second of his three Milan–San Remo wins.*

OPPOSITE: *Le Miroir des Sports announces the birth of 'Merckxisme' following the Belgian's Milan–San Remo win in 1967. The phenomenon would come to dominate road racing totally.*

Eddy Merckx holds the record with seven victories. Erik Zabel, the German sprinter who was Cavendish's mentor during his time with the High Road team, would have had five if he hadn't lifted his hands from the bars in celebration too early in 2004, allowing Spain's Oscar Freire to snatch the win.

Although its timing in late March means that the route sometimes has to be altered at the last minute to take account of snowfalls, the sight of the riders getting close to the finish on the seafront at San Remo, the elegant old resort on the Ligurian coast, brings a reminder that winter is almost past.

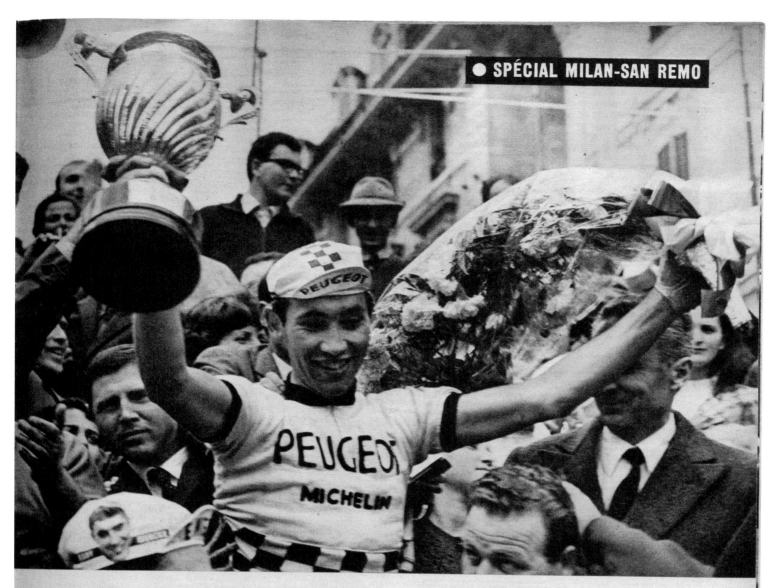

LE "MERCKXISME" EST NÉ A SAN REMO

UN REPORTAGE DE ROBERT SILVA

Il est entré dans la carrière quand ses aînés y sont encore. Presque sans transition, il est passé du vedettariat des rangs amateurs au rôle de super-vedette à l'échelon professionnel. Voici guère plus d'un an, cinq ou six groupes belges, italiens et français, se disputaient aux enchères son concours. Peugeot-BP a su trouver les arguments sonnants et trébuchants auxquels nul garçon de 20 ans ne peut demeurer insensible. En parallèle avec ses intérêts pécuniaires, Merckx aligne son ambition. Il s'est évertué à trouver le moyen de mieux s'exprimer. Il ne pouvait pas rester plus de quelques mois aux côtés de Rik Van Looy dans l'ombre duquel il fit ses premières armes.

Et le voilà qui bouscule aujourd'hui toutes les hiérarchies ! Pour la seconde fois, au seuil d'un printemps tout neuf, pour la seconde fois en l'espace d'un an, Merckx a fait pleurer l'Italie. La Saint-Joseph est en passe de devenir la Saint-Eddy sur la via Roma de San Remo où le grand garçon du Nord a jeté sans vergogne la consternation et imposé du même coup le respect.

A l'âge où Louison Bobet devenait champion de France des amateurs et où Rik Van Looy effectuait sans tapage de discrets débuts de professionnels, Eddy Merckx est, aujourd'hui, le nouveau « tortionnaire des pelotons » et la Belgique tout entière s'est convertie au « merckxisme » !

Ce grand garçon brun est le type même du coureur attachant. ➤

33

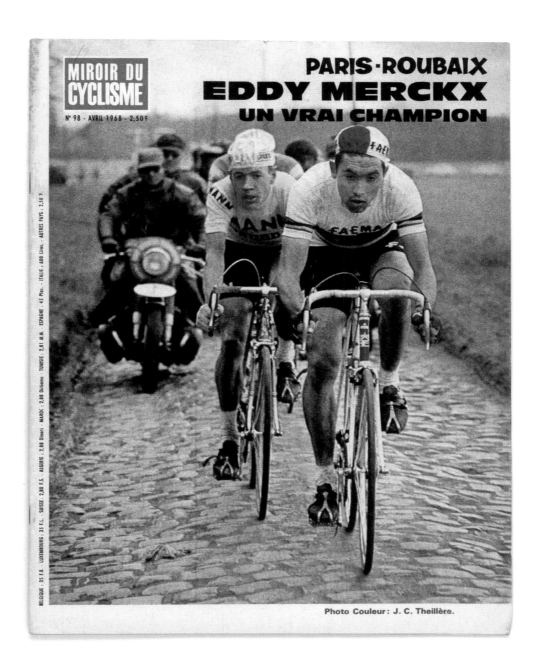

MIROIR DU CYCLISME

N° 98 - AVRIL 1968 - 2,50 F

PARIS-ROUBAIX
EDDY MERCKX
UN VRAI CHAMPION

Photo Couleur : J. C. Theillère.

PARIS — ROUBAIX

Near my office in Covent Garden there are some old cobbled streets, carefully preserved. But those cobbles are nothing like the ones you find on the Paris–Roubaix course. The London cobbles are small and smooth and the spaces between them are filled with cement. They're not particularly comfortable to ride on, but they're nothing like the giant stones that were laid down for armies to travel over, with their horse-drawn gun carriages, in the Napoleonic era. When I look at those stretches of pavé, and contemplate what it would mean to spend most of a day riding a lightweight modern bike over them, I just think, 'Help!'

But that, of course, is what makes Paris–Roubaix a race that all the hard men want to win. They're the riders who've managed to accept the need to suffer as part of the job – and even an enjoyable part, once it's over and you can look back on your achievement. To win Paris–Roubaix is to be granted a very special kind of immortality.

The Hell of the North: that's its nickname, and one that sums up its appeal. It takes place in early April, and whether the conditions are wet and treacherously muddy or dry and chokingly dusty, the riders often finish the race looking as though they've been to hell and back.

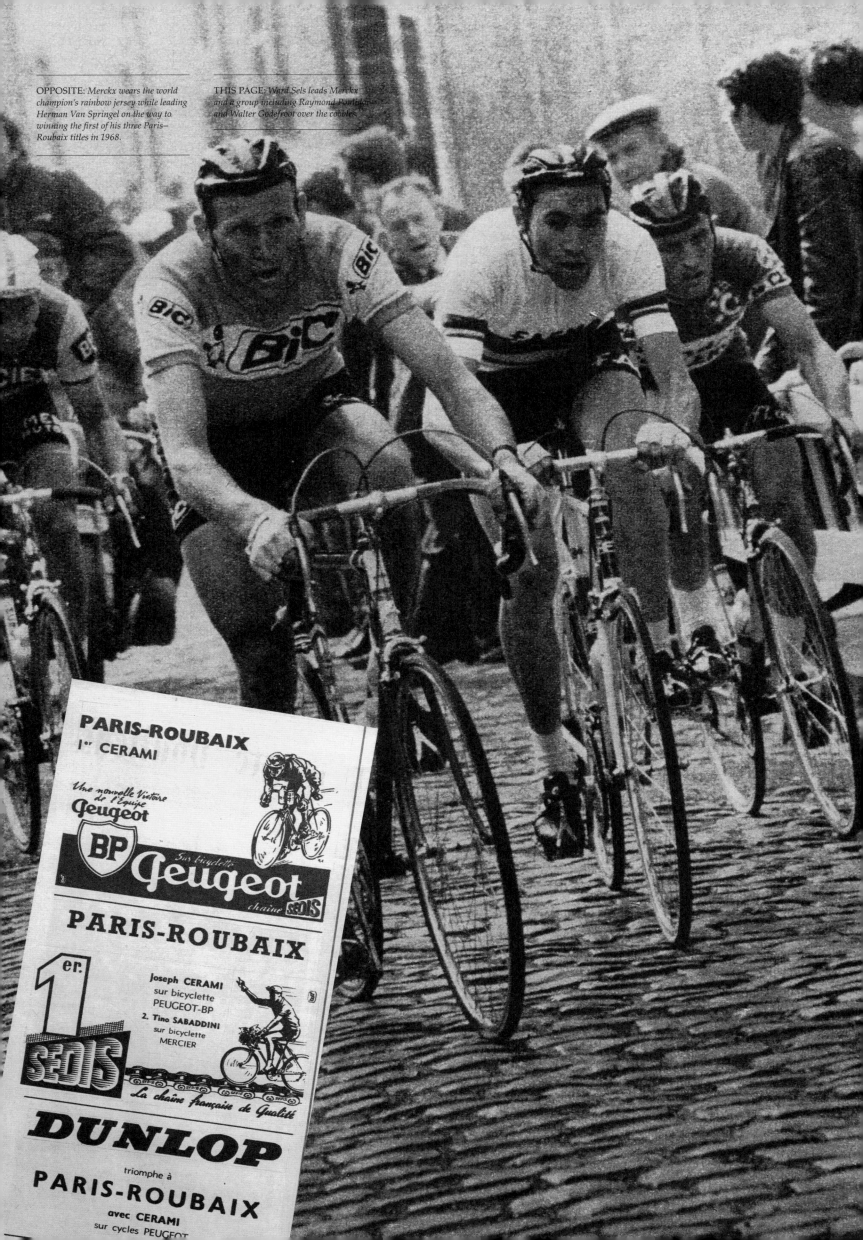

OPPOSITE: *Merckx wears the world champion's rainbow jersey while leading Herman Van Springel on the way to winning the first of his three Paris–Roubaix titles in 1968.*

THIS PAGE: *Ward Sels leads Merckx and a group including Raymond Poulidor and Walter Godefroot over the cobbles.*

Created by two Roubaix businessmen who had built a velodrome and were looking for ways to draw attention to their facility, the race was first run in 1896, right back at the dawn of cycling history. The inaugural race, over 280 km, started from a brasserie in Paris, and the field included Maurice Garin, who ran a cycle shop in Roubaix with his brother and who would become the first winner of the Tour de France seven years later. The champion of the first Hell of the North, however, was a tough German rider with a handlebar moustache, named Josef Fischer. Garin's turn came in the second year, when he fended off a Dutchman, Mathieu Cordang, who had fallen soon after they began the final laps of the velodrome but climbed back on to give chase and failed to catch the winner by only a couple of metres. Garin repeated his victory in 1898.

In the early days the riders were allowed to be paced by friends – initially on bikes or tandems but later on motorcycles and in cars. After the First World War the race travelled through a landscape of towns and villages ruined by four years of artillery bombardment, a legacy that helped to create its unique atmosphere.

UN CHAMPION DE 38 ANS PINO CERAMI

L'ENFE

nquetil qui peine. Kerkhove à ses côtés. La crevaison de Graczyk qui lui enlèvera toute chance. Sur les pavés noirs, la chute qui éliminera Colette. Cerami et Sabaddini sortant l'Enfer.

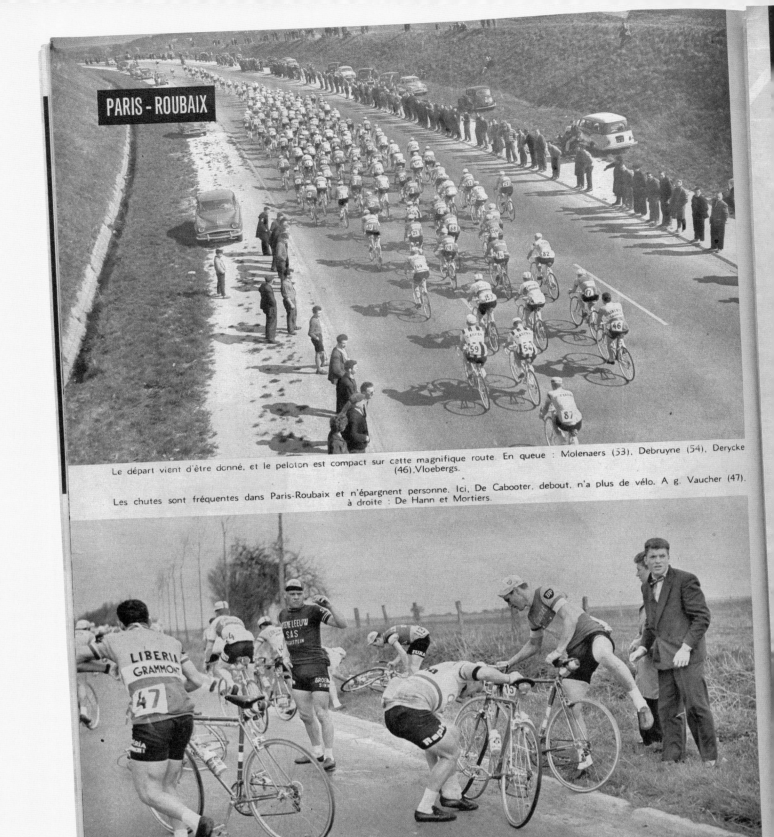

PARIS - ROUBAIX

Le départ vient d'être donné, et le peloton est compact sur cette magnifique route. En queue : Molenaers (53), Debruyne (54), Derycke (46),Vloebergs.

Les chutes sont fréquentes dans Paris-Roubaix et n'épargnent personne. Ici, De Cabooter, debout, n'a plus de vélo. A g. Vaucher (47), à droite : De Hann et Mortiers.

OPPOSITE – Top: *At thirty-eight years of age, Peugeot's Italian rider Pino Cerami was the surprise winner of the race in 1960. Bottom: Jacques Anquetil leads the Belgian rider Norbert Kerckhove in 1960.*

ABOVE: *Soon after the start of the 1960 Paris–Roubaix, the peloton is still looking serene in the sunlight, but even before they reach the cobbles, trouble strikes.*

Since the Second World War the race has been started outside Paris – in Saint-Denis, then Chantilly, and, since 1968, in Compiègne. The distance is now 240 km to the finish, which is still in the velodrome, but the course is no easier on the riders than in the days of Fischer and Garin, even though today's competitors ride specially built bikes with a longer wheelbase, wider tyres than usual and handlebars wrapped in thicker tape to absorb some of the constant vibration. Occasionally someone tries out a bike with suspension – the Pinarellos of Team Sky used it on the rear seat stays in 2015 – but it never seems to reduce the suffering much.

THERE ARE MORE THAN TWO DOZEN STRETCHES OF COBBLES ON THE ROUTE, GRADED FROM ONE TO FIVE STARS IN DEGREE OF SHEER UNPLEASANTNESS. IN THE EARLY DAYS THE COURSE WAS ALL ON MAIN ROADS, BUT AS THEY WERE RESURFACED AND THE COBBLES DISAPPEARED, NEW STRETCHES HAD TO BE DISCOVERED IN ORDER TO MAINTAIN THE CHALLENGE.

*A crash on the cobbles ends the 1960
race for the Peugeot rider Claude Colette.*

Champions en difficultés ...

Jacques Anquetil n'apprécie guère ce genre d'exercice cyclotouristique.

Jan Janssen, vainqueur l'an passé, fut victime lui aussi, d'incidents mécaniques.

Une roue voilée pour Felice Gimondi qui portait tous les espoirs italiens.

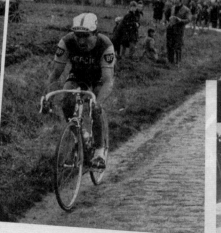

Raymond Poulidor commit l'erreur de au suicide des routiers-sprinters bel

LA FOLLE EQUIPEE DE DEUX GRANDS

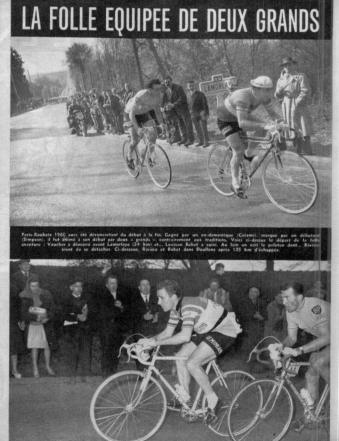

Paris-Roubaix 1960 aura été déconcertant du début à la fin. Gagné par un ex-domestique (Cerami), marqué par un débutant (Simpson), il fut animé à son début par deux « grands », contrairement aux traditions. Voici ci-dessus le départ de la folle aventure : Vaucher a démarré avant Lamorlaye (24 km) et... Louison Bobet a suivi. Au loin on voit le peloton dont... Rivière vient de se détacher. Ci-dessous, Rivière et Bobet dans Doullens après 125 km d'échappée.

Among the most famous stretches is a long-abandoned road called the Carrefour de l'Arbre, which was rediscovered by one of the organizers and added to the route in 1980, coming just before the finish. Two kilometres long, it is worth every one of its five stars. Like the rest of the course, it is looked after by the volunteers of the Amis de Paris–Roubaix; repairs are made, whenever necessary, by horticulture students from nearby colleges, who are brought there as part of their training.

The race has always suited the characteristics of Belgian riders, hardened by their training on the roads of Flanders. Roger De Vlaeminck and Tom Boonen won it four times, and Gaston Rebry, Rik Van Looy and Eddy Merckx were all three-time winners. The other riders with three victories to their credit were Octave Lapize of France, Francesco Moser of Italy and Fabian Cancellara of Switzerland. Ireland's Sean Kelly (1984 and 1986) and Australia's Stuart O'Grady (2007) are the only English-speaking riders to have their names inscribed on plaques mounted in the old shower cubicles at the finish – an honour that, like the mounted cobble presented to the winner, indicates the uniqueness of an event that no one would dare to invent today.

Passage à niveau fermé sous un ciel apocalyptique.

Images de l'enfer

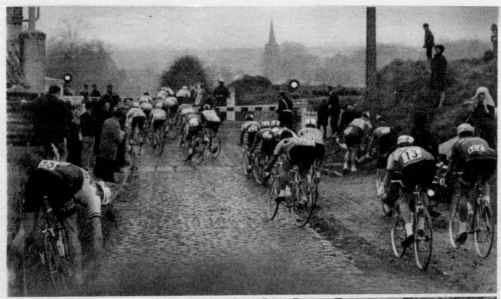

Chute sur des pavés d'un autre âge.

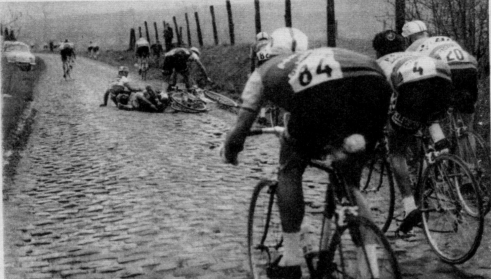

Felice Gimondi mène la chasse sur les bas-côtés de la « route ».

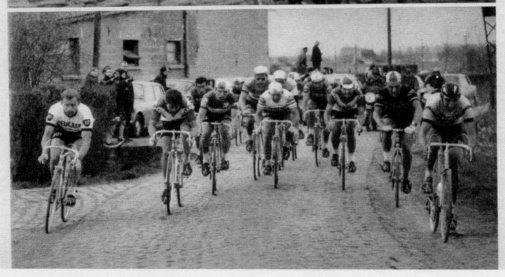

OPPOSITE – Top: *Anquetil, Janssen, Gimondi and Poulidor were among those who hit trouble in 1960.* Bottom: Miroir-Sprint *records the vain attempts of other big names, including Roger Rivière and Louison Bobet, to gain ground on the eventual winner.*

ABOVE: *Chaos everywhere in the 1960 Paris–Roubaix. In the bottom picture, Gimondi finds a smoother ride in the gutter at the side of the cobbles.*

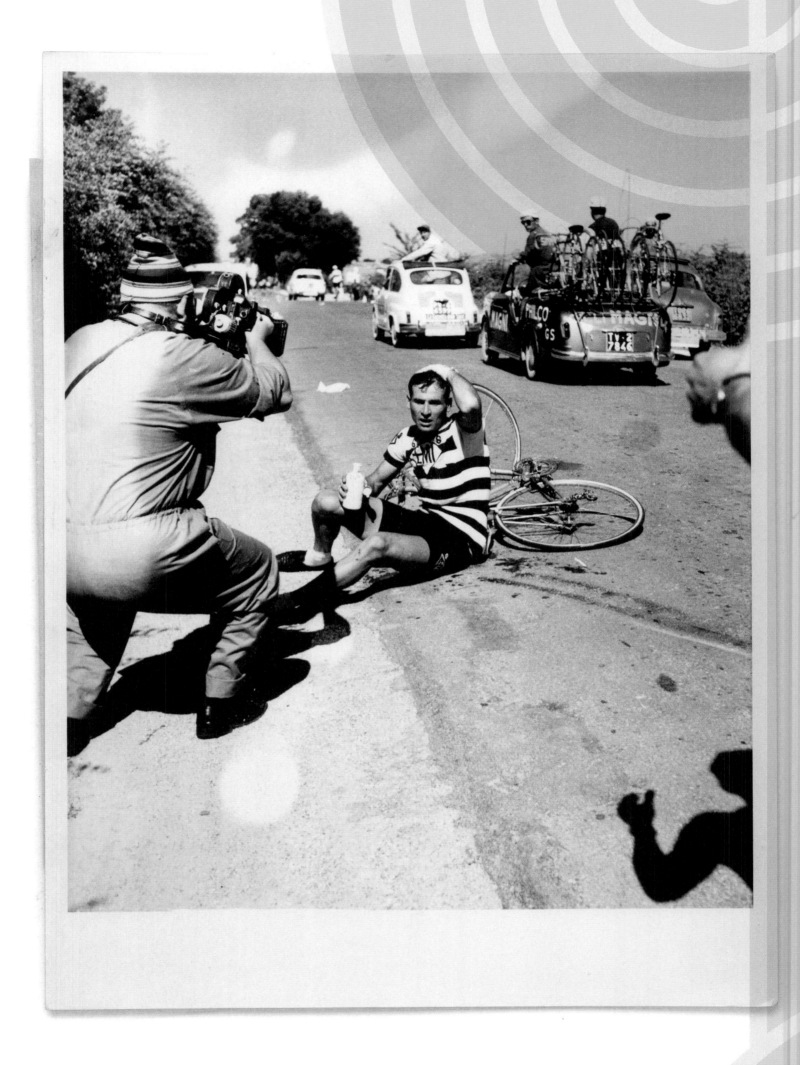

GIRO D'ITALIA

The Giro d'Italia is the first Grand Tour of the year, and the start of all those
days from spring to autumn when cycling fans would rather be spending their
afternoons watching the riders on television than getting on with their work.

It has been going almost as long as the
Tour, but it has a very different feeling.
Because of the time of year, the weather is
more challenging and can become pretty
dangerous. And, of course, it's very Italian.
I don't know how to explain what I mean
by that. Perhaps you could say that it's a
little bit more stylish than the Tour, and
maybe more commercial. And some of
the places it goes to are magical.

It was founded in 1909, six years after
the Tour, to promote sales of Italy's
leading daily sports paper, La Gazzetta
dello Sport, which had already been
associated with the Giro di Lombardia and
Milan–San Remo, founded in 1905 and
1907 respectively. The Giro was to be
the crowning glory of Italian cycling – and
since the Gazzetta is always printed on
pink paper, that became the colour
associated with the race. Milan, where the
newspaper has its head office, became
the Giro's headquarters.

The pink jersey, awarded to the leader in
the general classification, was adopted
in 1931, and was first worn by Learco
Guerra, a great figure of Italian cycling
who won four stages that year but missed
out on the eventual victory. Three years
later he captured ten stages and took the
overall win for the first and only time.
After the war he served as directeur
sportif for two other Giro winners, Hugo
Koblet and Charly Gaul.

The race had been dominated in the 1920s
by Alfredo Binda, another legendary
figure, who won the Giro a record five

times between 1925 and 1933. In that
last year he also won the King of the
Mountains jersey, awarded for the first
time. Gino Bartali won three Giros between
1936 and 1946, but his younger rival
Fausto Coppi came along to take five
wins between 1940 and 1953. There
were a lot of classy winners in the 1950s
and '60s – Gaul, Fiorenzo Magni, Jacques
Anquetil and Franco Balmamion, who
each won twice – before Eddy Merckx
came along in 1968, winning the first of
his five Giros (including three in a row
between 1972 and 1974 – a feat never
matched).

Bernard Hinault won three in the 1980s,
Stephen Roche became the first English-
speaking rider to win, in 1987 (the year
he also won the Tour and the world
championship), Miguel Indurain won
two in the 1990s, and in 1998 Marco
Pantani became the last man to complete
the double of Giro d'Italia and Tour de
France in the same year.

Because it's held in late May and early
June, and because the route normally
takes in the mountain passes of the Alps
and the Dolomites, the riders can usually
count on a day or two in which they'll
need every item of weather protection
they can lay their hands on. Some years
they find themselves riding between high
banks of snow, or descending in freezing
rain. The conditions can be brutal enough
to force some to abandon the race, and to
reduce others to tears of pain and
frustration, while those who struggle
through attain the status of instant heroes.

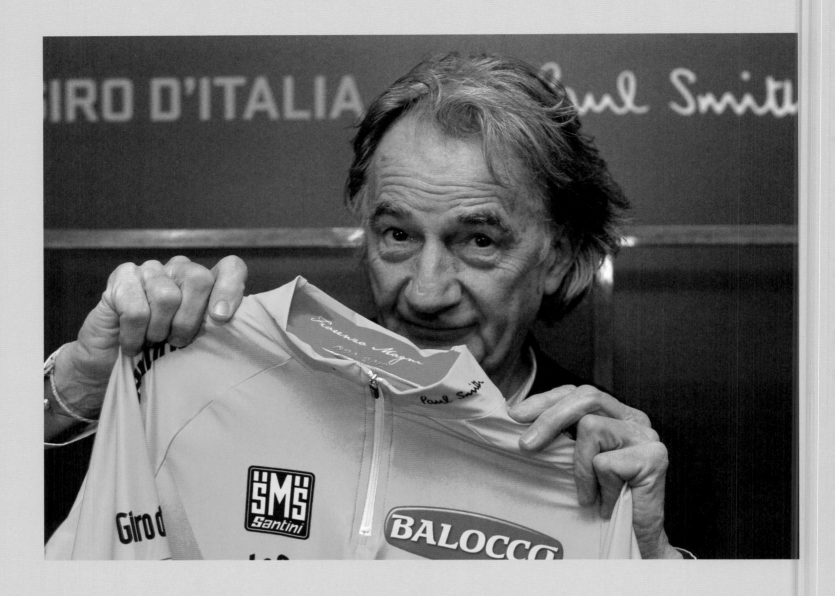

In 2013 I was invited to design all the jerseys for that year's race. It felt like a great honour and I was delighted to do it, although it's not as simple a job as it might seem. I inherited certain elements that had to be incorporated, such as the colour and the sponsors' logos. I tried to keep it as simple and elegant as possible. If you looked at the left sleeve, you'd see a band of multicoloured stripes – they are one of the design features people associate with my clothes, and we put them on scarves, on linings, on wallets, on cufflinks and all kinds of stuff. In 2013 they were on the Giro d'Italia's *maglia rosa*, and when Mark Cavendish won the first stage, I was invited to present it to

him on the podium in the centre of Naples. Five days later in Vicenza I was back to present him with the red jersey for the leader in the points classification. As he pulled it on, this time I made sure to do the zip all the way up, so that the world could see the Paul Smith name on the collar…

We got a bigger response to it than for anything we've ever done. The sales of the pink jersey went up by a thousand per cent, or something like that. They sold really well in places like Japan, South Korea and China. And even though they sold out long ago, people are still asking for them.

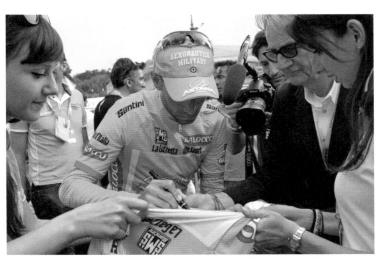

Not only did I get to design the jerseys for the 2013 Giro, but also I was invited to present the leader's maglia rosa *to the winner of the first stage in Naples. It was an additional thrill to give it to my friend Mark Cavendish, who shared his joy with his little daughter, Delilah Grace.*

N. 24 del 14-6-1962

SPORT ILLUSTRATO

A BALMAMION IL 45° GIRO D'ITALIA

I "MONDIALI" DI CALCIO

RIENTRATI IN ITALIA GLI AZZURRI CI HANNO DETTO

LE CLASSIFICHE DI ATLETICA PUGILATO - BASKET

Settimanale a colori de « La Gazzetta dello Sport » - Anno 51 - Spedizione in abbonamento postale (Gr. II) - L. 100

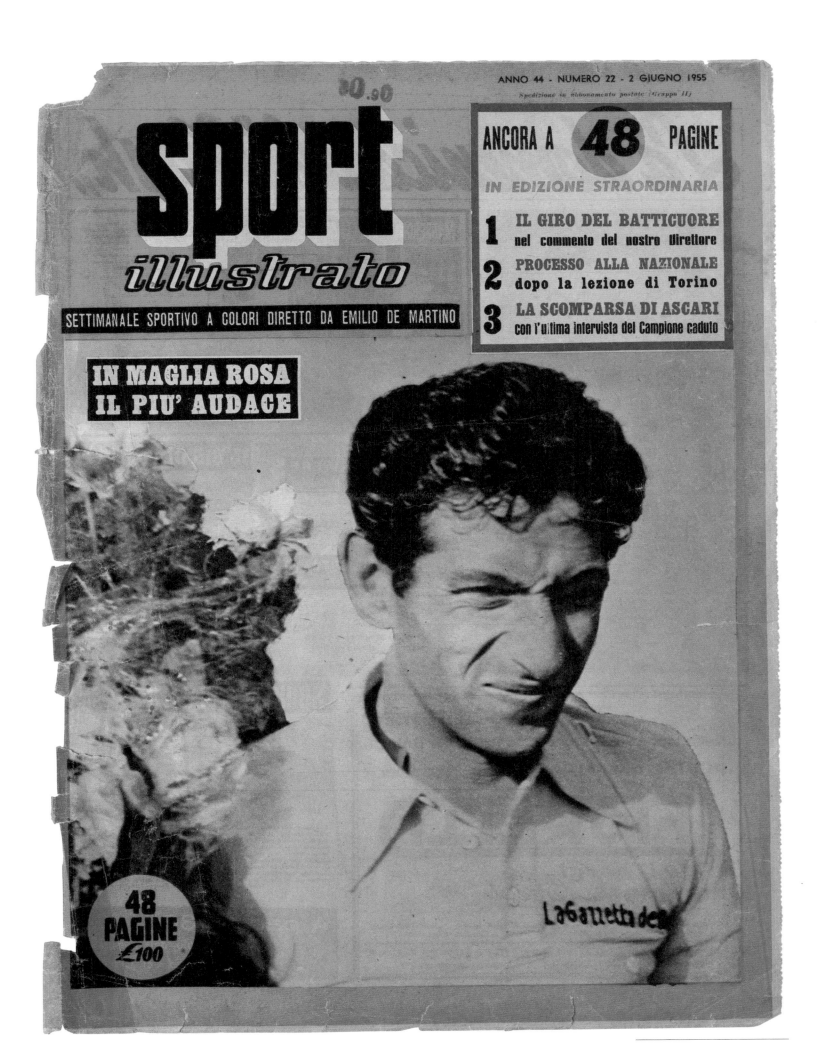

OPPOSITE: *Another home victory, this time for Franco Balmamion in the 1962 Giro.*

ABOVE: *Fiorenzo Magni, in a pink jersey with a very handsome collar, celebrates victory in the 1955 race.*

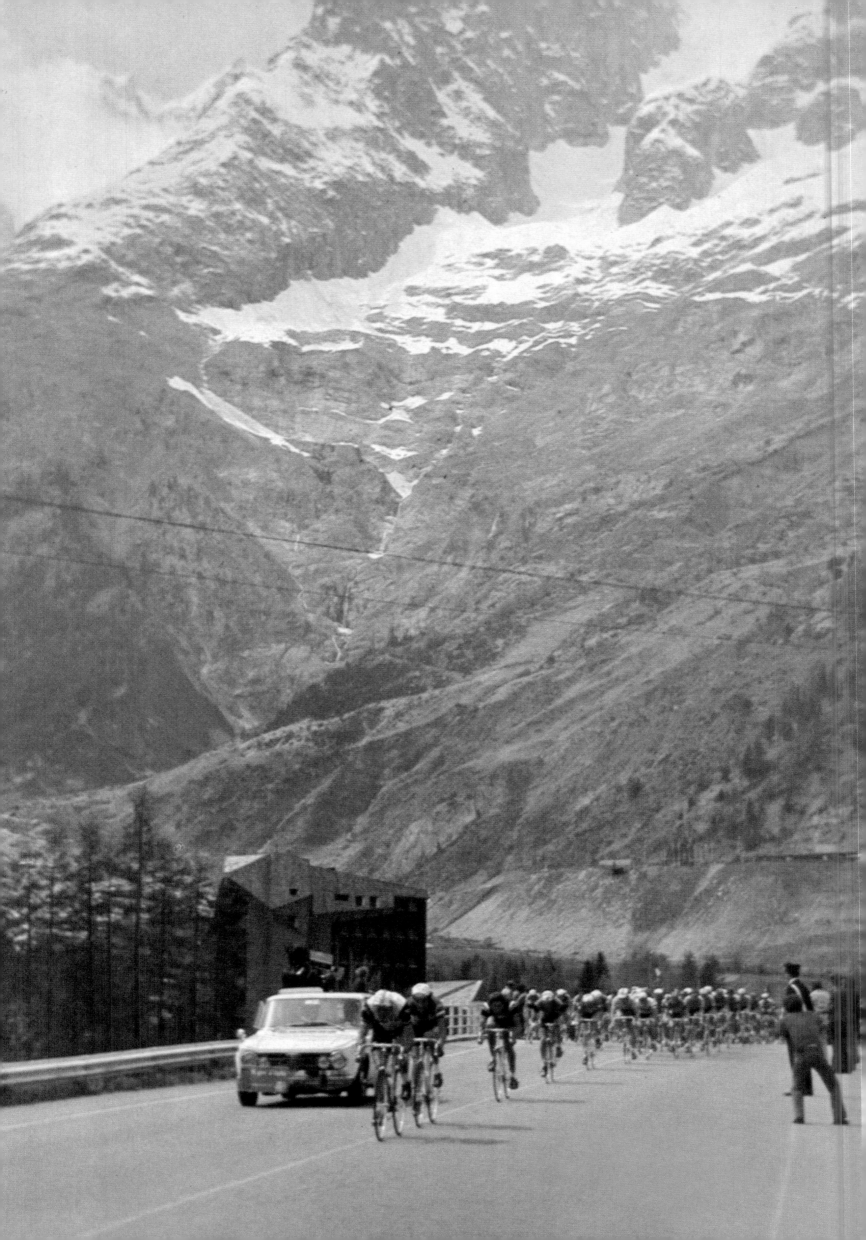

OPPOSITE: *Mont Blanc provides a spectacular backdrop for the peloton in 1973.*

THIS PAGE – Clockwise from right: *1. On a stage from Rome to Rocca di Cambio in the 1966 Giro, Felice Gimondi gets caught up in a crash caused by another rider. 2. Fausto Coppi in Palermo, before the start of stage two of the 1954 Giro. 3. World champion Mario Basso expresses his feelings about the tactics of his fellow sprinters during the 1973 Giro. 4. Under the spires of Milan's Duomo in 1956, a hatless Coppi and his Bianchi teammates roll towards the start.*

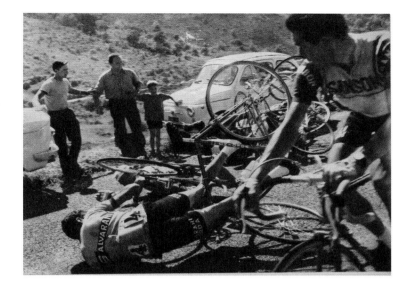

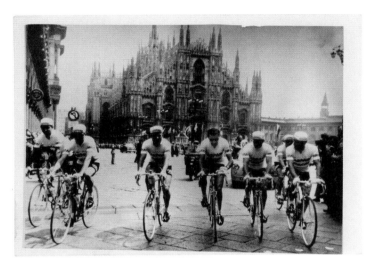

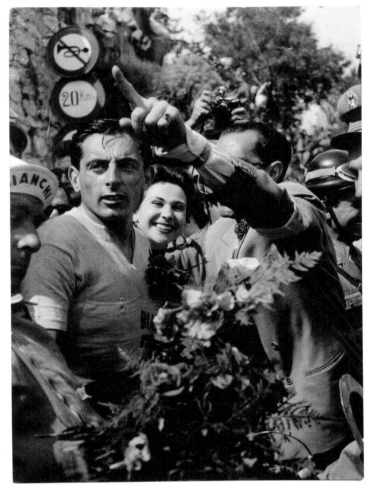

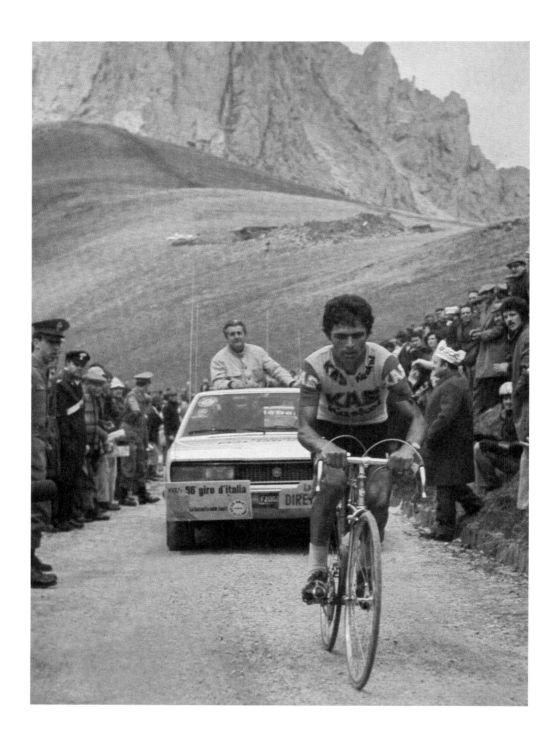

N. 20 del 18 maggio 1961

LO SPORT ILLUSTRATO

IL GIRO D'ITALIA DEL CENTENARIO

56 pagine

Settimanale a colori de **L. 100**
"La Gazzetta dello Sport,,
Anno 50 Sped. in abb. post. (Gr. II)

NEXT PAGE: *Jacques Anquetil, Graziano Battistini, Charly Gaul and Imerio Massignan were this publication's favourites for the 1961 Giro, but overall victory went to the Italian rider Arnaldo Pambianco.*

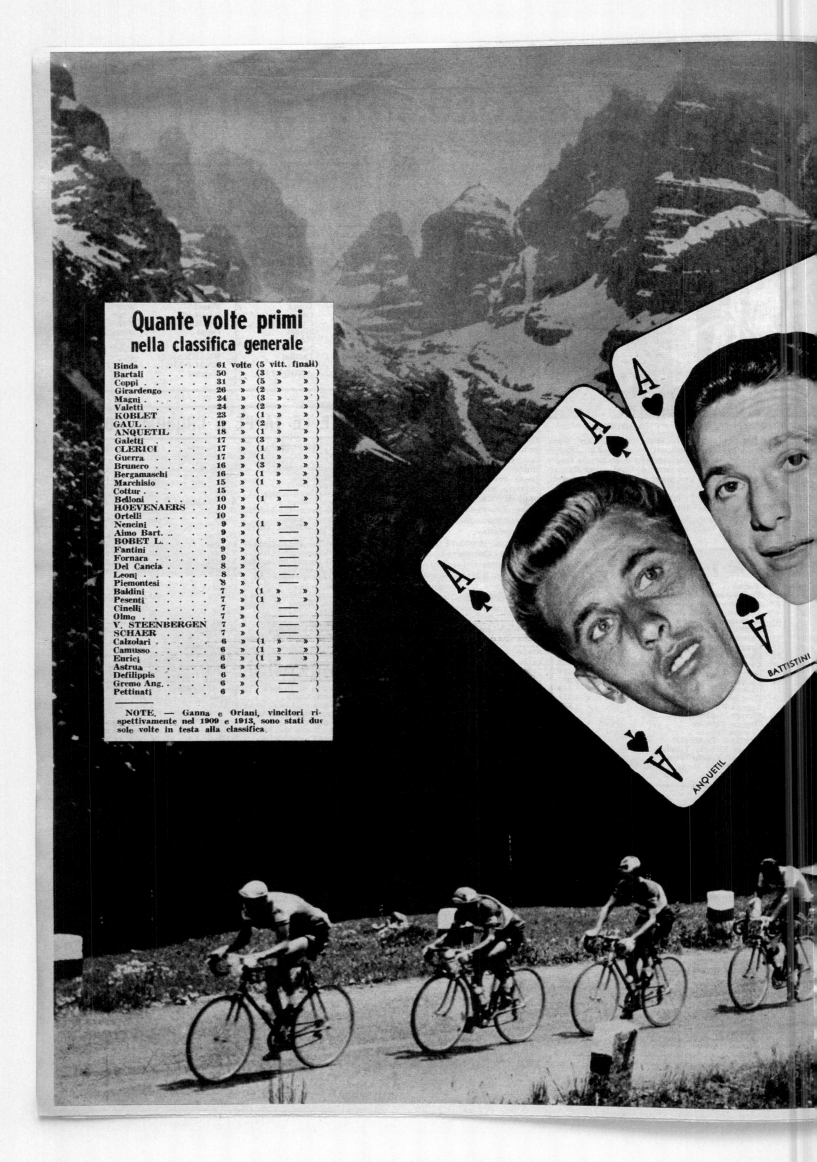

Quante volte primi
nella classifica generale

Binda	61	volte	(5	vitt. finali)		
Bartali	50	»	(3	»	»)
Coppi	31	»	(5	»	»)
Girardengo	26	»	(2	»	»)
Magni	24	»	(3	»	»)
Valetti	24	»	(2	»	»)
KOBLET	23	»	(1	»	»)
GAUL	19	»	(2	»	»)
ANQUETIL	18	»	(1	»	»)
Galetti	17	»	(3	»	»)
CLERICI	17	»	(1	»	»)
Guerra	17	»	(1	»	»)
Brunero	16	»	(3	»	»)
Bergamaschi	16	—	(1	»	»)
Marchisio	15	»	(1	»	»)
Cottur	15	»	(——)
Belloni	10	»	(1	»	»)
HOEVENAERS	10	»	(——)
Ortelli	10	»	(——)
Nencini	9	»	(1	»	»)
Aimo Bart.	9	»	(——)
BOBET L.	9	»	(——)
Fantini	9	»	(——)
Fornara	9	»	(——)
Del Cancia	8	»	(——)
Leoni	8	»	(——)
Piemontesi	8	»	(——)
Baldini	7	»	(1	»	»)
Pesenti	7	»	(1	»	»)
Cinelli	7	»	(——)
Olmo	7	»	(——)
V. STEENBERGEN	7	»	(——)
SCHAER	7	»	(——)
Calzolari	6	»	(1	»	»)
Camusso	6	»	(1	»	»)
Enrici	6	»	(1	»	»)
Astrua	6	»	(——)
Defilippis	6	»	(——)
Gremo Ang.	6	»	(——)
Pettinati	6	»	(——)

NOTE. — Ganna e Oriani, vincitori rispettivamente nel 1909 e 1913, sono stati due sole volte in testa alla classifica.

BATTISTINI

ANQUETIL

TRA QUESTI
L'ASSO DEL CENTENARIO

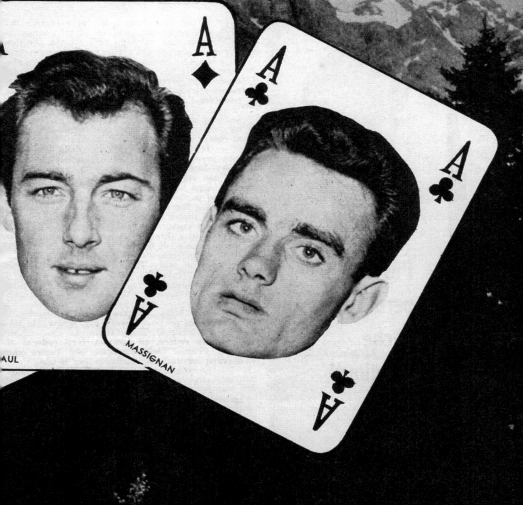

GAUL

MASSIGNAN

Anquetil, Battistini, Gaul, Massignan sono quattro assi che sulle strade del Giro correranno verso il traguardo della maglia rosa. Anquetil ha vinto l'anno scorso ed ha annunciato il proposito di fare il bis; Gaul si è affermato nel 1956 e nel 1959: tenta, quindi, per la terza volta, il successo nella nostra grande corsa a tappe e si è preparato con particolare scrupolo. Battistini e Massignan sono le nostre promesse: il primo per quanto ha saputo fare nel Giro di Francia dello scorso anno, il secondo per le sue eccezionali qualità di scalatore. Quale sarà l'asso degli assi che vestirà la maglia rosa del 1961, che vincerà il Giro del Centenario?

TOUR DE FRANCE

I grew up listening to older cyclists talking about the Tour de France, and learning about its legends. Names like the Galibier and the Tourmalet became very familiar, even though I knew them only from black-and-white photographs.

The first time I actually saw the Tour was when I went to Paris one Sunday in the late 1970s, to watch the final stage. I was with Pauline Denyer, who was then my girlfriend and business partner and is now my wife, and we found a spot on the Place de la Concorde, so that we could enjoy the spectacular sight of the riders turning into the Champs-Élysées. Even though we're both quite tall, the crowd was so big that we needed a couple of those cardboard periscope things to see over their heads.

In 2014, when the Tour started with three days in England, it was all a bit different. It's not often that you get to follow the race by helicopter, in the company of a couple of men who, between them, have won the yellow jersey seven times. But that's what happened on stage three, when I travelled from Cambridge to London in the company of the two Bernards, Hinault and Thévenet. It was an enormous thrill.

The excitement surrounding the Grand Départ in England was extraordinary. People spent months making plans for the biggest single event that would ever come their way. I was invited to design three official posters, one for each day of the race in England. I've got a shop in Leeds, where the first stage began, so we mounted an exhibition of race jerseys from my collection. In one of my London shops we had an exhibition of beautiful portraits of Tour heroes – Coppi, Bartali, Anquetil, Gaul, Simpson and so on – by the painter Karl Kopinski, the son of an old friend of mine and a fellow cycling enthusiast. You'll find some of them in this book.

Thanks to Britain's cycling explosion over the last ten years, the roadsides were as crowded as they have ever been in the race's birthplace. French viewers could see from the television pictures that Yorkshire is not just a very picturesque region but also real cycling territory. It's the birthplace of several important riders, including Barry Hoban, who won eight Tour stages between 1967 and 1975. Hoban's record was eventually beaten by my friend Mark Cavendish, whose mother comes from Harrogate, which was where the first stage finished and where Mark, who was super-motivated by the local connection, sadly ended his race with a crash.

Mark's bad luck was followed by that of Chris Froome, whose injuries forced him to retire soon after the race had reached France. But no one will ever forget the time the 2014 Tour spent in England. When a Eurosport reporter asked Bernie Eisel, the Austrian rider with Team Sky, what memory of the race he'd be carrying away with him, he replied, 'Yorkshire. Yorkshire beats everything.'

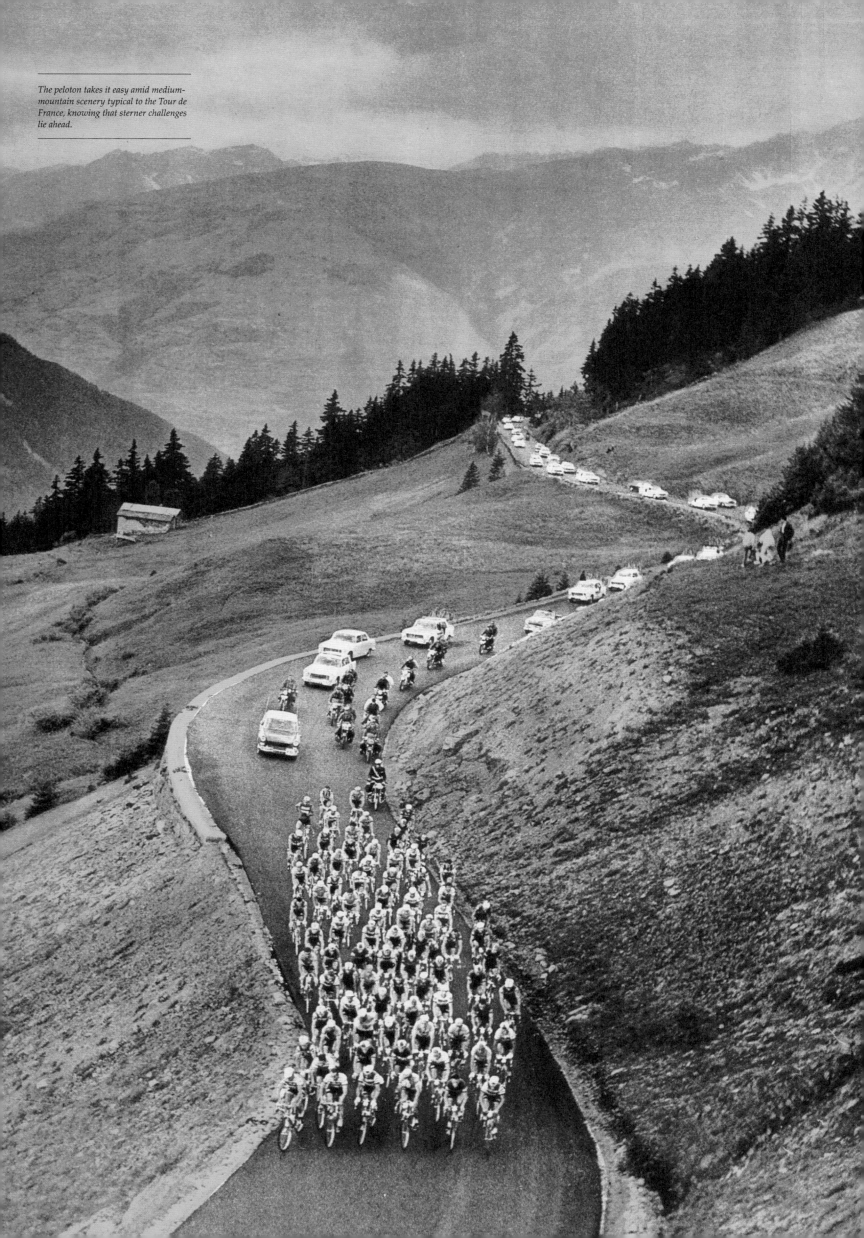

The peloton takes it easy amid medium-mountain scenery typical to the Tour de France, knowing that sterner challenges lie ahead.

The Tour was founded in 1903 as a publicity device for *L'Auto*, a daily sports newspaper that wanted to increase its circulation. Maurice Garin, a thirty-two-year-old who had started his working life as a chimney sweep before opening a bike shop in Roubaix with his two brothers, was the first winner. In its early years the race was incredibly gruelling, not least because it was quite a long time before Henri Desgrange, the founder, could be persuaded to drop his insistence that the competitors use single-speed bikes and wheels with wooden rims. The stages were often more than twice as long as they are today. Riders got lost, and occasionally resorted to shortening the route by taking a train – something for which Garin was disqualified in 1914, having arrived in Paris to be acclaimed as winner of the second edition.

Countless legends surround the race. Every time I see a rider suffering in the mountains I think of Octave Lapize, who rode in four Tours. Lapize won in 1910, the first year the Tour went into

the Pyrenees. As he reached the summit of the Col du Tourmalet, exhausted and enraged, he screamed at the officials, 'You are all assassins! Assassins!' It's a cry that still echoes through the mountains whenever the Tour heads uphill.

Another of my favourite stories concerns Eugène Christophe, who failed to win any of the eleven Tours in which he competed. In 1913 he was descending the Tourmalet when his front forks broke. Having walked 10 km, he encountered a young girl who led him to the local blacksmith, where he spent three hours making a repair. Under Desgrange's rules competitors were not allowed outside assistance, and the officials penalized him three minutes for allowing a seven-year-old boy to pump the bellows for the forge's fire, but he still managed to finish the Tour in seventh place. Christophe must have been an unlucky man: nine years later, while he was lying second, another fork broke. But in 1919 he became the first man to wear the newly created yellow jersey, guaranteeing him a place in history.

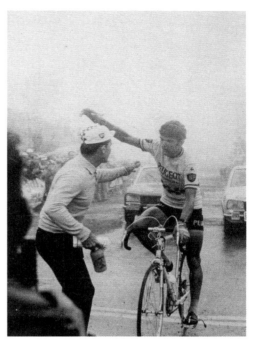

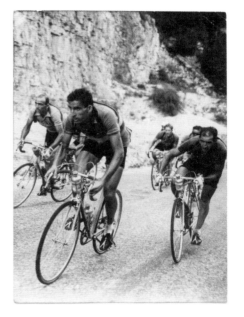

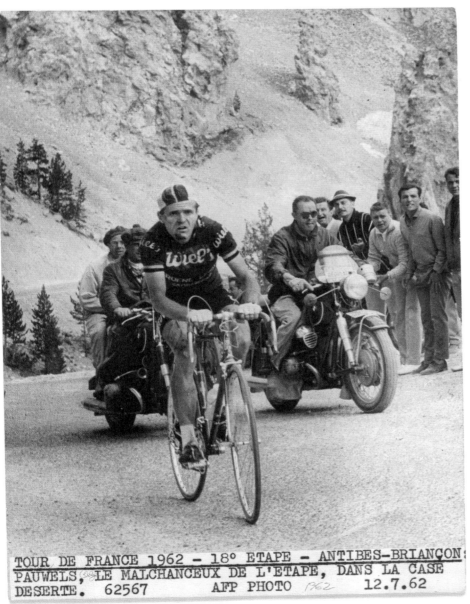

TOUR DE FRANCE 1962 - 18º ETAPE - ANTIBES-BRIANÇON
PAUWELS, LE MALCHANCEUX DE L'ETAPE, DANS LA CASE
DESERTE. 62567 AFP PHOTO 1962 12.7.62

OPPOSITE: *An anonymous artist has hand-coloured the yellow jersey in this photograph of Felice Gimondi, taken during the twenty-three-year-old's winning ride in the 1965 Tour.*

THIS PAGE – Clockwise from top left: 1. *The British rider Alan Ramsbottom, a member of the Pelforth-Sauvage team, is interviewed by the American Forces Network during the 1962 Tour, in which he finished forty-fifth.* 2. *Bernard Thévenet wins the stage to La Mongie in 1970.* 3. *Raphaël Géminiani in the mountains, flanked by Fiorenzo Magni (left) and Gino Bartali.* 4. *Amid the strange beauty of the Col d'Izoard, Eddy Pauwels of Belgium puts in a ride that will help him to win the Tour's combativity award.*

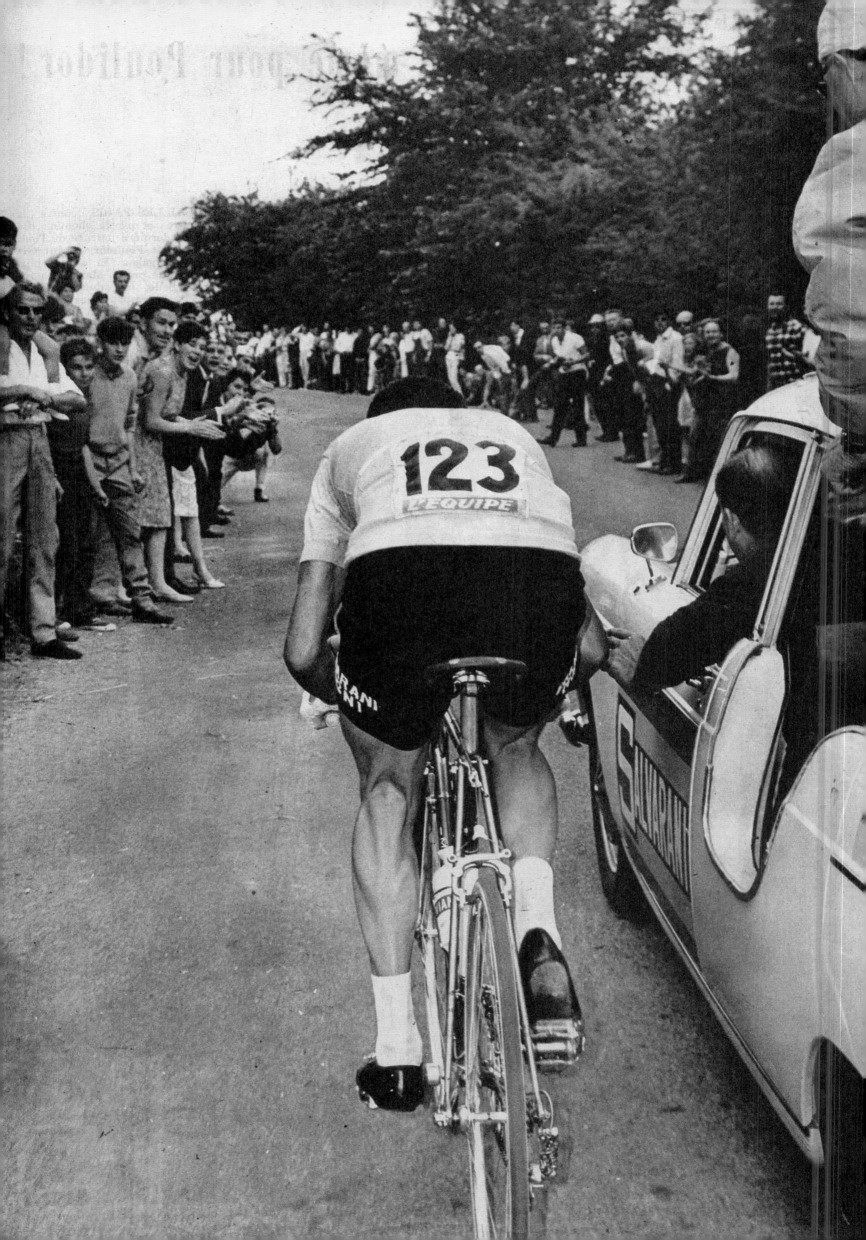

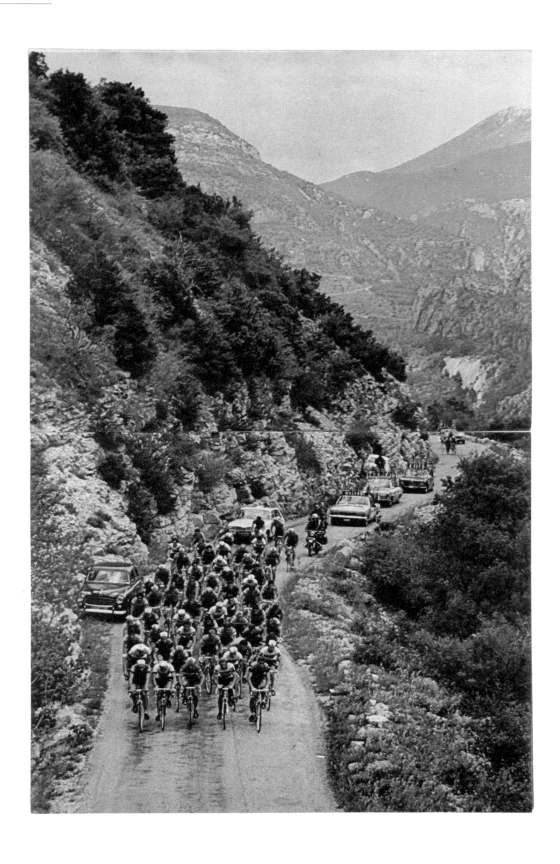

THIS PAGE – Clockwise from above: 1. *Bouquets on the podium in Paris in 1965, with Felice Gimondi flanked by Raymond Poulidor (left) and Gianni Motta. 2 and 3. Previewing the 1977 Tour, which was won by Bernard Thévenet of France. 4. Thévenet deals with the fans' over-enthusiasm.*

OPPOSITE: *As they grind around the hairpins, do the riders notice the signs of encouragement?*

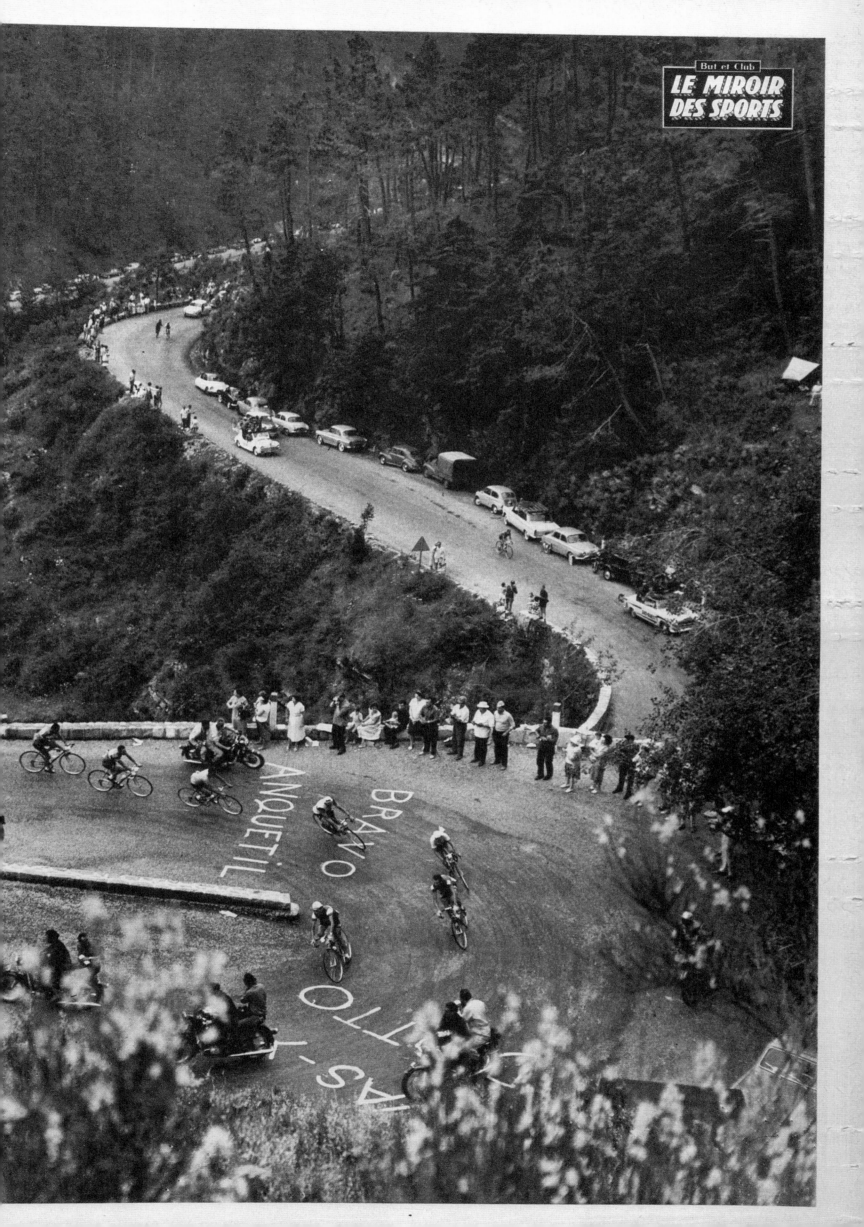

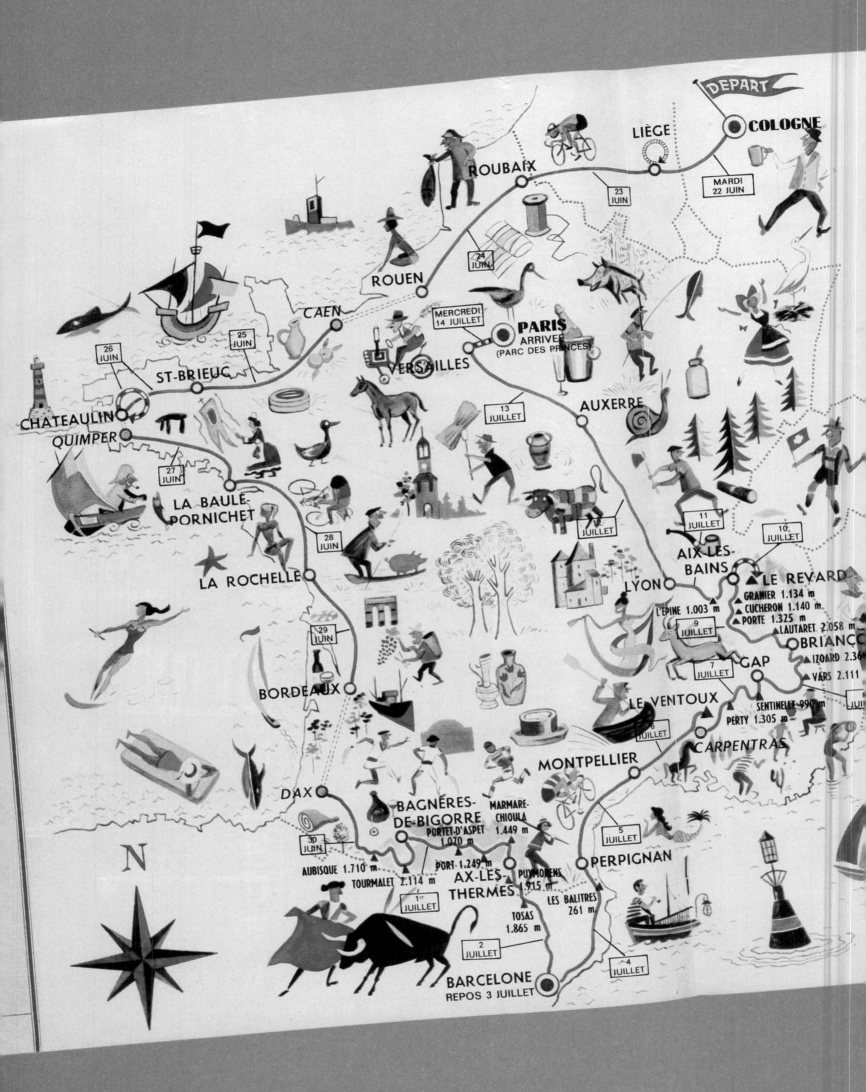

OPPOSITE: L'Équipe's colour magazine presents the route of the 1965 Tour, from Cologne to Paris.

ABOVE: The announcement of the parcours is swiftly relayed to the readership of the specialist magazines.

So many heroes (and the occasional villain), so many stories: Gino Bartali and Fausto Coppi crossing the border to win the race for Italy twice each before and after the Second World War; the success in 1951 of Hugo Koblet, the Swiss rider known as 'le pédaleur de charme'; the climbers with great nicknames, like Charly Gaul, the Angel of the Mountains, and Federico Bahamontes, the Eagle of Toledo; Jacques Anquetil, the first man to win the race five times; Raymond Poulidor, fated always to finish second, usually to Anquetil; Greg LeMond edging out Laurent Fignon to win in 1989 by eight seconds in a time trial on the final day, the closest finish in the history of the Tour, after three weeks and 3,285 km of racing…

And, of course, the British heroes, starting with Brian Robinson, the first to finish the race in 1955 and the first to win a stage three years later. Then Tom Simpson, from a mining village in my native Nottinghamshire, who died near the top of the Mont Ventoux in 1967, and his friend Barry Hoban, whose British record of eight stage wins would stand for many years. Robert Millar, the brilliant climber, Chris Boardman and David Millar (no relation), the prologue specialists, and then Mark Cavendish, who gobbled up Hoban's record and won the final sprint on the Champs-Élysées four years in a row. And, of course, Bradley Wiggins, in 2012 the first ever British winner of the yellow jersey, followed by Chris Froome. Both of them were wearing the colours of Sky Procycling, the team created by the astute manager Dave Brailsford, who declared that he aimed to win the Tour with a clean British rider within five years, and heard the scorn turn to cheers when he did it in three.

Sometimes it seems as though the Tour de France is the only bike race that matters, which isn't true. But it's certainly the one that acts as an attention-grabber for the sport, and I can't see that changing.

WHAT OTHER MAJOR SPORTING EVENT COULD HAVE WITHSTOOD THE SCANDAL OF HAVING TO DELETE THE NAME OF THE WINNER IN SEVEN CONSECUTIVE YEARS? AS I LEARNED MANY YEARS AGO, THE TOUR REMAINS THE GREATEST SYMBOL OF OUR LOVE OF CYCLING.

Hennie Kuiper wears the King of the Mountains jersey as he leads the field up the Alpe d'Huez in 1977.

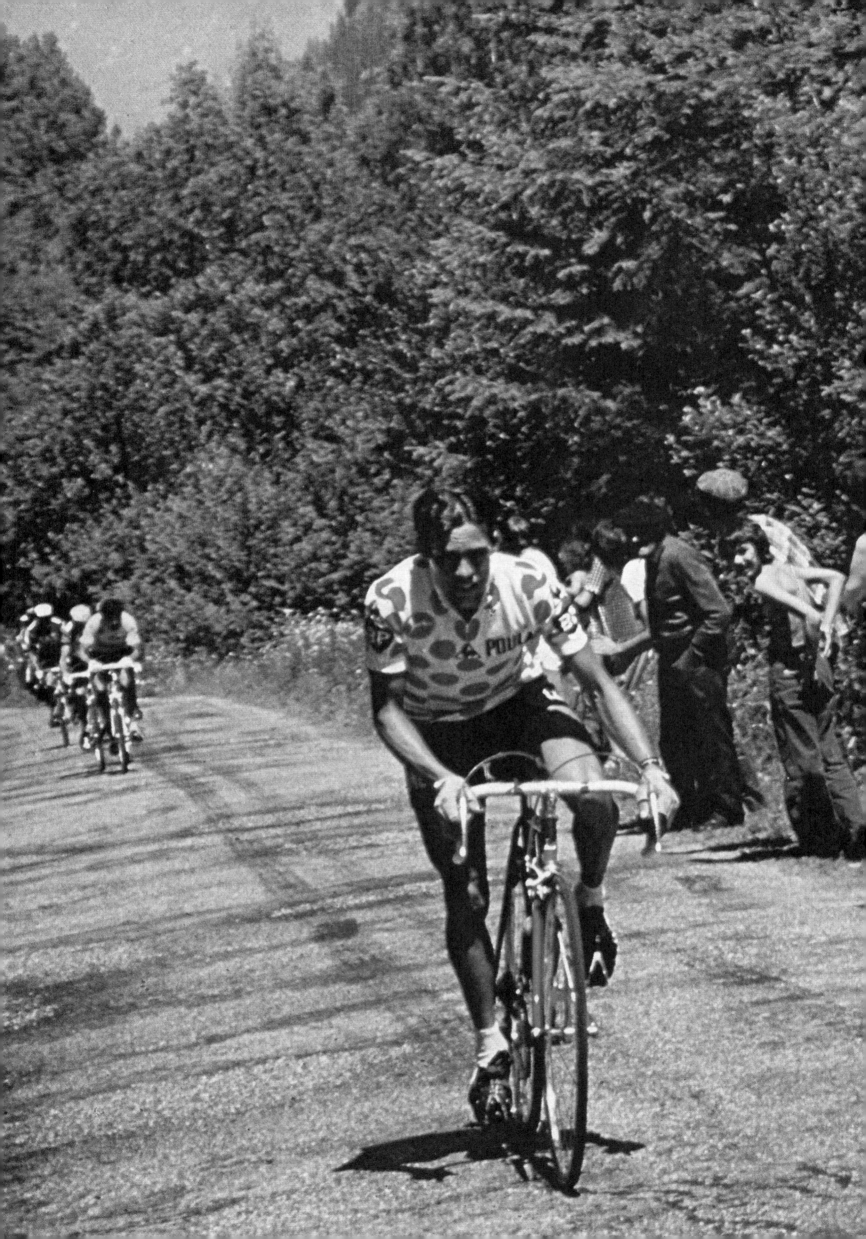

VUELTA A ESPAÑA

I've never been to the Vuelta, which is a shame, because friends tell me that it's a more informal and intimate experience than visiting the Tour or the Giro. It travels with nothing like the vast infrastructure that accompanies the others, and they say that in some ways it's more enjoyable.

It depends on the year, but in 2014 the Vuelta was almost more important than either of the other Grand Tours, because of the riders who were there. Alberto Contador and Chris Froome were able to confront each other in the sort of battles that injuries and crashes had denied them in the Tour. In this way the Vuelta can be the saving grace of the year for riders who've had problems earlier in the season but get themselves fit in time to race for three weeks in Spain.

It's the youngest of the trio of Grand Tours. Like the others, it was started by a paper, the Madrid daily *Informaciones*, which saw the race as a device for building circulation among people who would buy the paper every day to read the bulletins on the race's progress. The race was founded in 1935, but its development was quickly halted by the Spanish Civil War and then the Second World War. It didn't really get going again until 1955, when the organization was taken over by an ambitious Basque newspaper.

OPPOSITE: *Gilbert Bauvin of France wins the tenth stage of the 1956 Vuelta in Tarrega.*

BELOW: *Jacques Anquetil sets the pace in the 1962 Vuelta. He was chased all the way to Madrid by a Spanish rival, José Pérez Francés.*

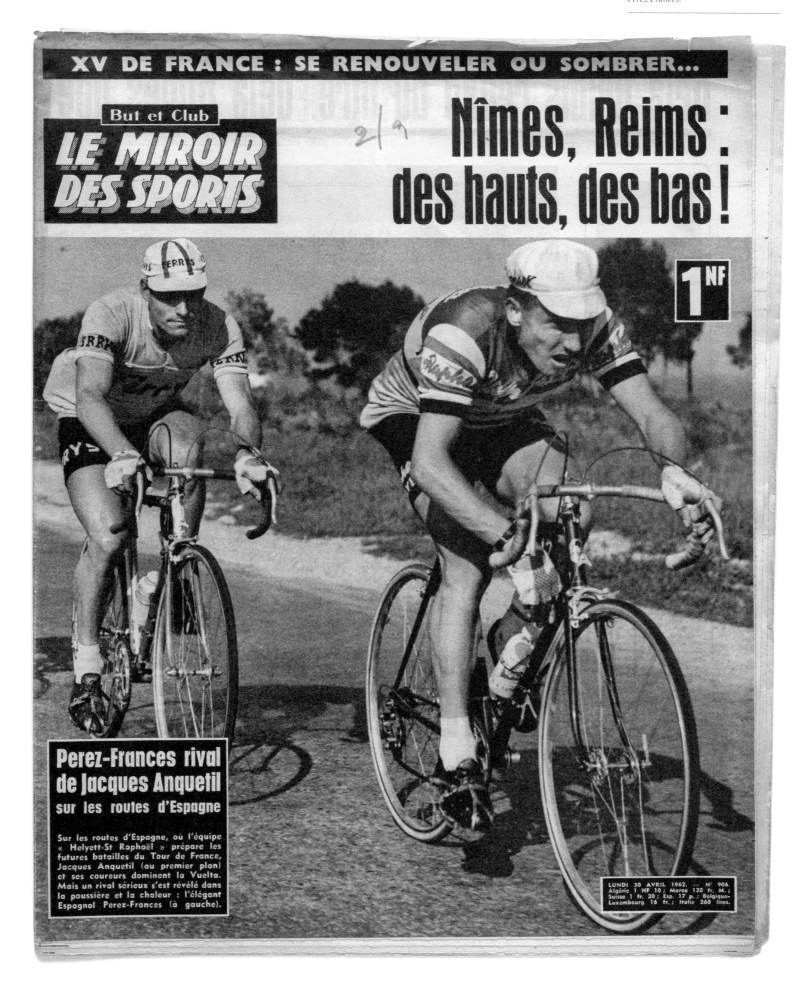

XV DE FRANCE : SE RENOUVELER OU SOMBRER...

But et Club

LE MIROIR DES SPORTS

Nîmes, Reims : des hauts, des bas !

1 NF

Perez-Frances rival de Jacques Anquetil sur les routes d'Espagne

Sur les routes d'Espagne, où l'équipe « Helyett-St Raphaël » prépare les futures batailles du Tour de France, Jacques Anquetil (au premier plan) et ses coureurs dominent la Vuelta. Mais un rival sérieux s'est révélé dans la poussière et la chaleur : l'élégant Espagnol Perez-Frances (à gauche).

LUNDI 30 AVRIL 1962. — N° 906.
Algérie 1 NF 10 ; Maroc 120 fr. M. ;
Suisse 1 fr. 20 ; Esp. 17 p. ; Belgique-
Luxembourg 16 fr. ; Italie 260 lires.

CELA SENT LE GOUDRON, LA POUSSIERE, LE THYM ET LA LAVANDE. PARMI LES ARBRES EN FLEURS, SUR LES ROUTES SINUEUSES DE LA CATALOGNE, LE PELO

DANS L'OMBRE DE JACQUES ANQUETIL, UN E

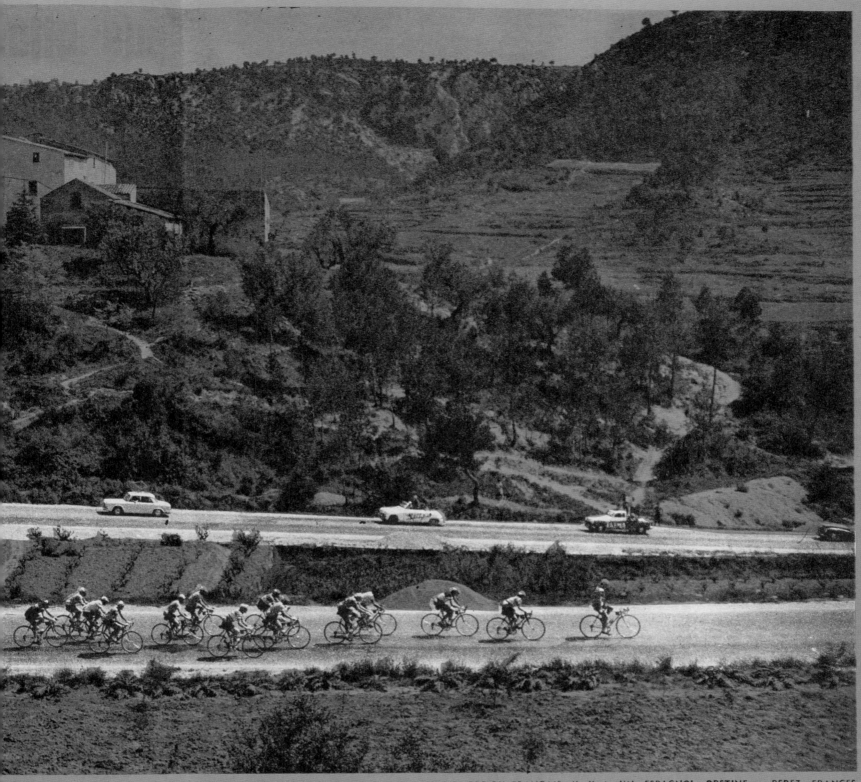

GNOL AMBITIEUX ET TENACE : PEREZ-FRANCES

ABOVE: *The peloton winds through the heat and the herb-scented air of the hills of Catalonia in 1962.*

OPPOSITE: *Leaders of the pack: José Pérez Francés (left), Jean Stablinski (centre) and Jacques Anquetil.*

Spain is known for producing great climbers, such as Federico Bahamontes, Luis Ocaña and Pedro Delgado, and the Vuelta often tends to suit the sort of men who thrive when the road starts tilting upwards. It's the race in which Lucho Herrera became the first Colombian – indeed the first South American – to win a Grand Tour, back in 1987. Spanish riders account for almost half the winners in the race's history, but others who have claimed victory include Jacques Anquetil, Raymond Poulidor, Felice Gimondi, Eddy Merckx, Bernard Hinault, Joop Zoetemelk and Sean Kelly. Three men – Tony Rominger, Roberto Heras and Contador – have won it three times.

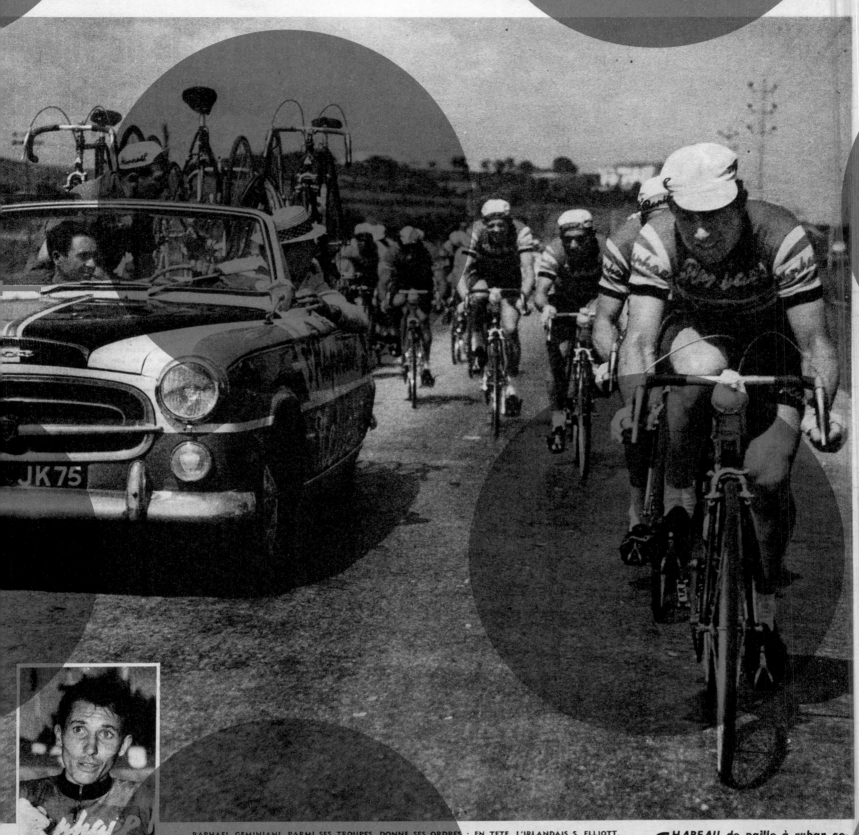

RAPHAEL GEMINIANI, PARMI SES TROUPES, DONNE SES ORDRES : EN TETE, L'IRLANDAIS S. ELLIOTT.

ANQUETIL : « QUELLE CHALEUR ».

ALTIG : VAINQUEUR ASSOIFFE.

RAPHAEL GEMINIANI

chapeau de paille sur l'œil, mène les "St. Raphaël" à l'assaut sur les routes du Tour d'Espagne

CHAPEAU de paille à ruban coquettement rejeté sur l'oreille, son grand nez fendant le vent, « Grand Fusil », dressé sur la banquette de sa voiture, dirige l'assaut de ses troupes sur les routes brûlantes du Tour d'Espagne. « Grand Fusil », c'est Raphaël Géminiani, l'inattendu directeur sportif des « Helyett-St Raphaël ». Préféré à Mickey Wiegant pour diriger l'équipe dans la « Vuelta », Géminiani n'avait pas le choix : il devait obtenir de ses coureurs qu'ils se distinguent pour prouver que sa présence apportait quelque chose. Le grand Gem a su convaincre : les St Raphaël dominent la course. Jacques Anquetil, Seamus Elliott, Rudi Altig sont de toutes les batailles et, chaque jour, à toutes les places d'honneur.

13

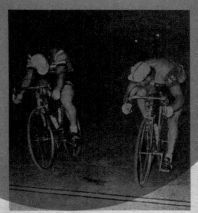

PREMIÈRE ÉTAPE DE LA VUELTA : S. ELLIOTT EST BATTU AU SPRINT PAR L'ESPAGNOL BARRUTIA.

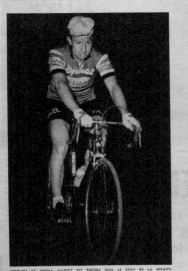

PERPLEXE ET DÉSOLÉ, ELLIOTT EST ENCORE SOUS LE COUP DE LA DÉFAITE.

Anquetil : "Je ne voulais pas attaquer mais Gem et Stablinski ont insisté"

De l'un de nos env. spéc.
Roger BASTIDE

VALENCE. — Cette arrivée de la Vuelta sur le petit vélodrome de Tortosa...

(texte d'article illisible)

UNE ARRIVÉE PITTORESQUE

(texte d'article illisible)

VAN LOOY ET ANNAERT TOUJOURS LEADERS DES PRESTIGES PERNOD

(texte d'article illisible)

TROP DE CHUTES

(texte d'article illisible)

Reportage photographique
Jacques PAPON

PREMIÈRE ÉTAPE
Barcelone-Barcelone (90 km.)

(classement illisible)

DEUXIÈME ÉTAPE
Barcelone-Tortosa (185 km.)

(classement illisible)

TROISIÈME ÉTAPE
Tortosa-Valence (188 km.)

(classement illisible)

LE CLASSEMENT GÉNÉRAL

(classement illisible)

PAR ÉQUIPES

(classement illisible)

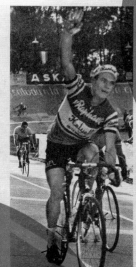

TORTOSA : L'ALLEMAND R. ALTIG REVÊT LE MAILLOT DU LEADER

RUDI ALTIG GAGNE À TORTOSA ET PREND LE MAILLOT JAUNE. STABLINSKI ET GELDERMANS (À DR.) PARLENT DE LA COURSE.

C'EST LA DEUXIÈME ÉTAPE, ENTRE BARCELONE ET TORTOSA, OÙ SE JOUERA L'ARRIVÉE. LE FRANÇAIS JEAN STABLINSKI, MAINS CRISPÉES SUR SON GUIDON, EMMÈNE RAPIDEMENT LE PELOTON.

OPPOSITE: *A straw-hatted Raphaël Géminiani, in the team car, keeps a watch on his boys, including Jacques Anquetil and Rudi Altig, in 1962.*

ABOVE: *After injury removes Anquetil, his teammate Altig, the German sprinter, wins the overall classification and the points jersey.*

The Vuelta started as a spring race, and was not switched to September until 1995. The late summer seems to suit it better: those parched hillsides and that afternoon heat create the impression of a very Spanish experience. It's delightful to watch, winding for day after day through the glorious scenery of a beautiful country – but certain areas can be very tough indeed, with fearsome mountain-top finishes on extreme gradients like the Bola del Mundo outside Madrid or the Alto de l'Angliru in Asturias.

At the end of one of those stages you see the riders falling into the arms of their soigneurs on the finishing line, completely exhausted and unable to manage another pedal-stroke. That's when you see how different these riders are from the likes of you and me.

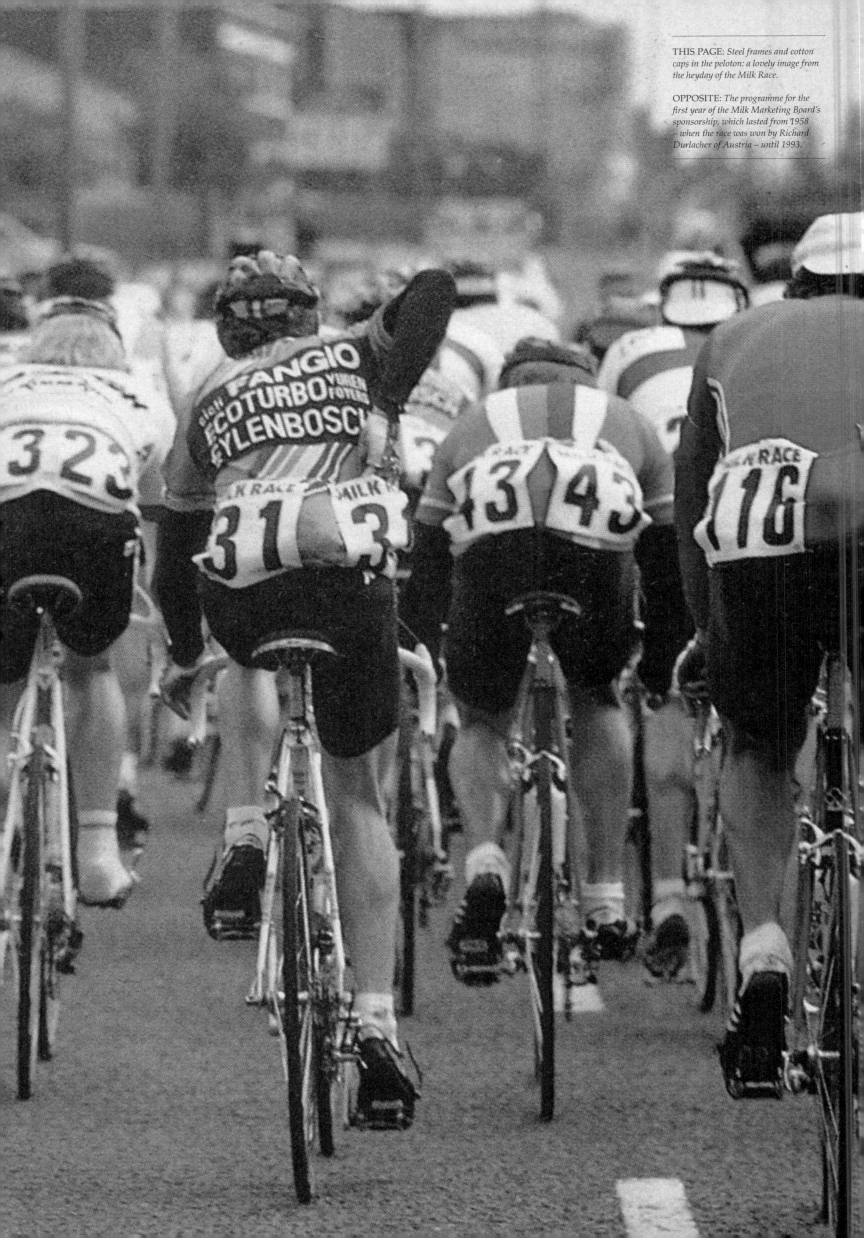

THIS PAGE: *Steel frames and cotton caps in the peloton: a lovely image from the heyday of the Milk Race.*

OPPOSITE: *The programme for the first year of the Milk Marketing Board's sponsorship, which lasted from 1958 – when the race was won by Richard Durlacher of Austria – until 1993.*

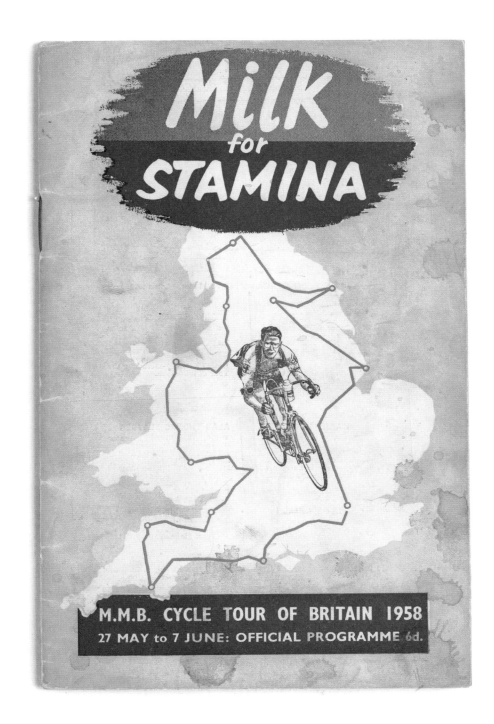

TOUR OF BRITAIN

I always wanted the Tour of Britain to mean more than it did, to be accepted at a higher level. I never expected it to rival the Tour de France – that would be unrealistic. I just wanted to see it gain greater acceptance among the British public, and more coverage in the media. And now, thanks to the international success of British riders and the increased enthusiasm for cycling in general, that seems to be happening at last.

I love going to watch races, whether it's the midsummer Nocturne around the Smithfield meat market in central London, where I sometimes present the winners with their prizes, or the finish of the 2012 Olympic road race on the Mall. Now the atmosphere seems to be spreading to embrace stages and one-day races around the country. No one has ever seen crowds for a bike race like those that turned out for the opening stages of the 2014 Tour de France in Yorkshire, and the Tour of Britain has clearly benefited from the arrival of new fans wanting more. Maybe it has finally turned the corner.

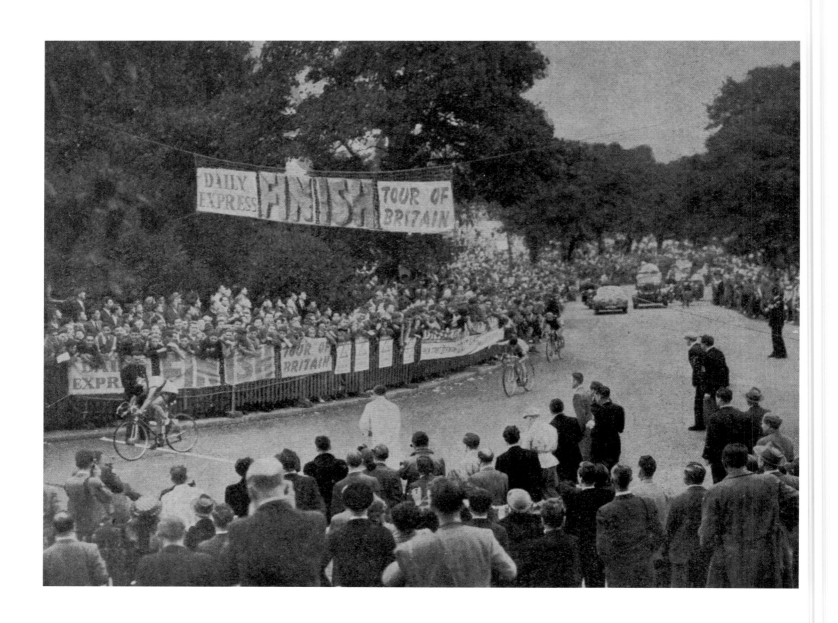

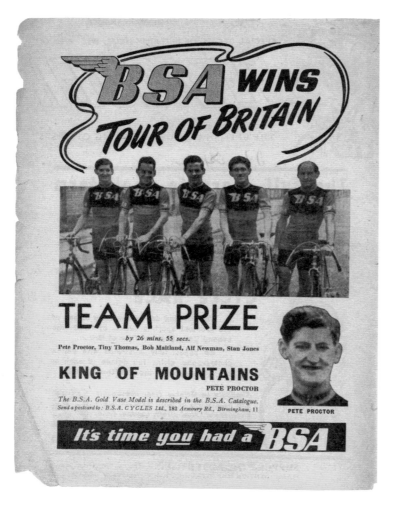

The first edition was held in 1945, and tens of thousands turned out to watch a race that started in Brighton, ended in Glasgow, and was won by a Frenchman, Robert Batot. But for the next few decades it struggled to remain afloat as a race for amateurs and then as a professional-amateur, sponsored from 1958 to 1993 by the Milk Marketing Board, which rechristened it the Milk Race. Hennie Kuiper of Holland was a big-name winner in 1972, the year he also won the gold medal in the Olympic road race. The Kellogg's Tour of Britain ran from 1987 to 1994 as a professional event in parallel with the Milk Race (and with Robert Millar, Phil Anderson and Maurizio Fondriest among the winners), before an insurance company took over to sponsor the PruTour, as it became known, in 1998 and 1999. The problem with stage racing is that people wait for hours to see the race go past, but if the riders are all bunched together they're gone in a flash. That's why, for a non-specialist audience, it can be better to have races in a town centre, like the final stage of the Tour of Britain, around a circuit in central London, taking in most of the great landmarks and with the finishing line in Whitehall. It's much easier for people to understand, and they get better value.

SPECIAL "TOUR OF BRITAIN" ISSUE, 1952 Price 6d

THE *LEAGUER*

Official Journal of
THE BRITISH LEAGUE OF RACING CYCLISTS

John Spence

The full story in book form
of the second
DAILY EXPRESS
TOUR of BRITAIN
CYCLE RACE

The exciting day-by-day story of one of the greatest sporting events of 1952—the second Daily Express Tour of Britain.

48 pages, fully illustrated with action photographs, giving full details of each of the 14 stages in the 1,470-mile race.

Available in October from newsagents and booksellers or Daily Express Books Department, Fleet-street, London, E.C.4. Price 2'3 including postage.

PRICE
2/-

ORDER YOUR COPY NOW!

SUPPORT THE ADVERTISERS—*They Support Your Journal*
PLEASE MENTION THE "LEAGUER" WHEN WRITING TO ADVERTISERS

OPPOSITE – Top: *Ken Russell takes the overall victory after finishing second to Les Scales in the final sprint at Alexandra Palace in north London, with a crowd of 50,000.* Bottom: *The team prize went to BSA, whose rider Pete Proctor won the King of the Mountains award.*

ABOVE: *In 1952 Lord Beaverbrook's Daily Express sponsored the Tour of Britain for a second year.*

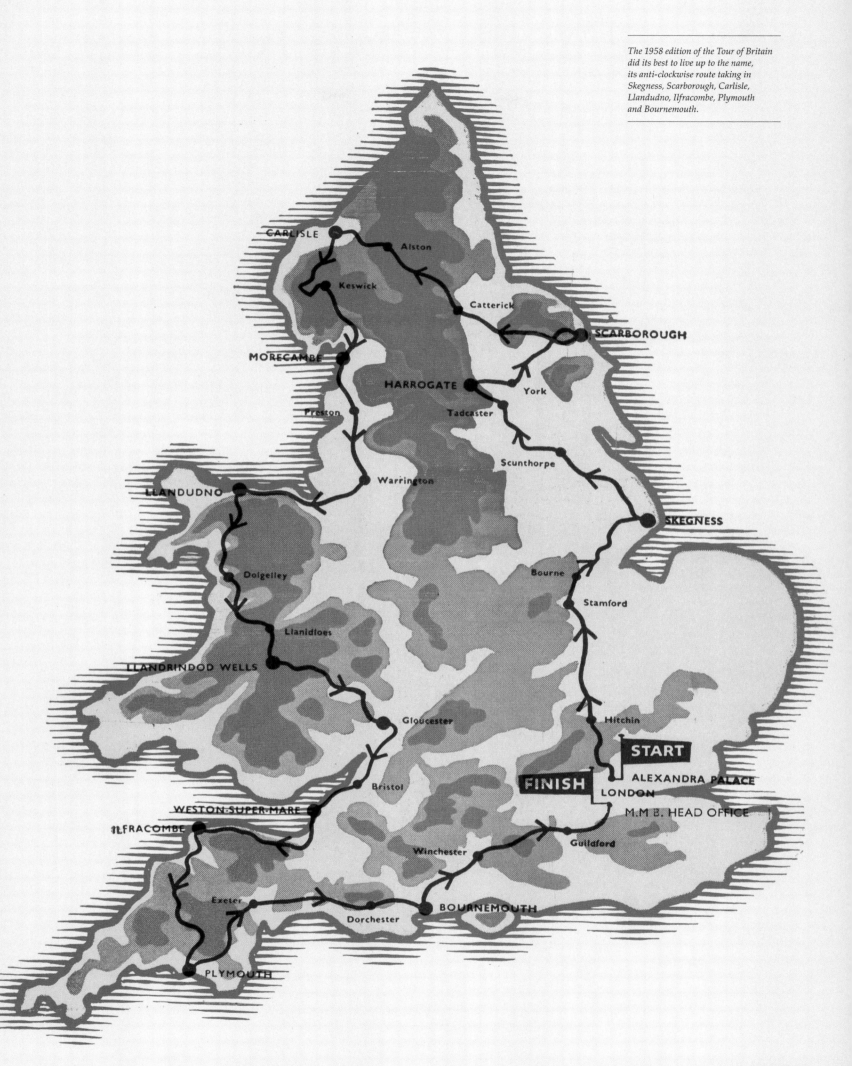

The 1958 edition of the Tour of Britain did its best to live up to the name, its anti-clockwise route taking in Skegness, Scarborough, Carlisle, Llandudno, Ilfracombe, Plymouth and Bournemouth.

CARLISLE
Alston
Keswick
Catterick
MORECAMBE
SCARBOROUGH
HARROGATE
York
Preston
Tadcaster
Warrington
Scunthorpe
LLANDUDNO
SKEGNESS
Dolgelley
Bourne
Stamford
Llanidloes
LLANDRINDOD WELLS
Gloucester
Hitchin
START
ALEXANDRA PALACE
Bristol
FINISH
LONDON
WESTON-SUPER-MARE
M.M.B. HEAD OFFICE
ILFRACOMBE
Winchester
Guildford
Exeter
BOURNEMOUTH
Dorchester
PLYMOUTH

TOUR OF BRITAIN: MAP OF THE ROUTE

THIS PAGE: *Images from the Kellogg's Tour of Britain in the 1980s and '90s, when the field included the likes of Sean Kelly and Robert Millar.*

OPPOSITE: *The versatile Malcolm Elliott on the start line, wearing the leader's jersey.*

Cycle Peugeot-Dan Air
(France)

Sponsors: Car and bicycle manufacturer; airline
Manager: Roger Legeay
Riders:
Jan Koba
P. Laouvel
Gilbert Duclos-Lassalle
Pascal Simon
Bruno Wojtinek

Ever Ready-Ammaco
(Great Britain)

Sponsors: Battery and portable lighting manufacturer; cycle manufacturer
Manager: Mick Bennett
Riders:
Phil Bayton
Danny Clark
Glen Clark
Dudley Hayton
+ one other

21

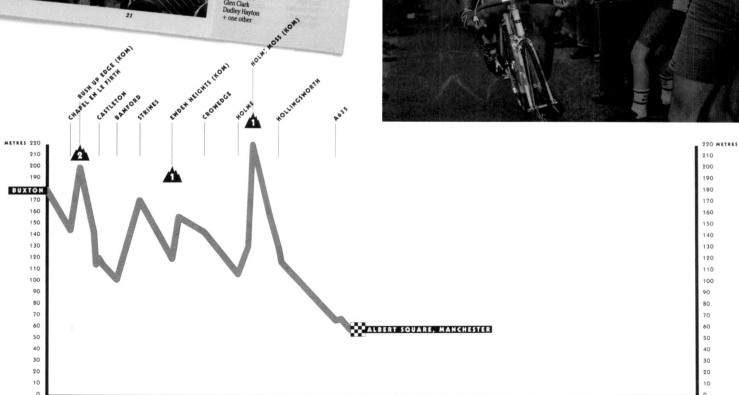

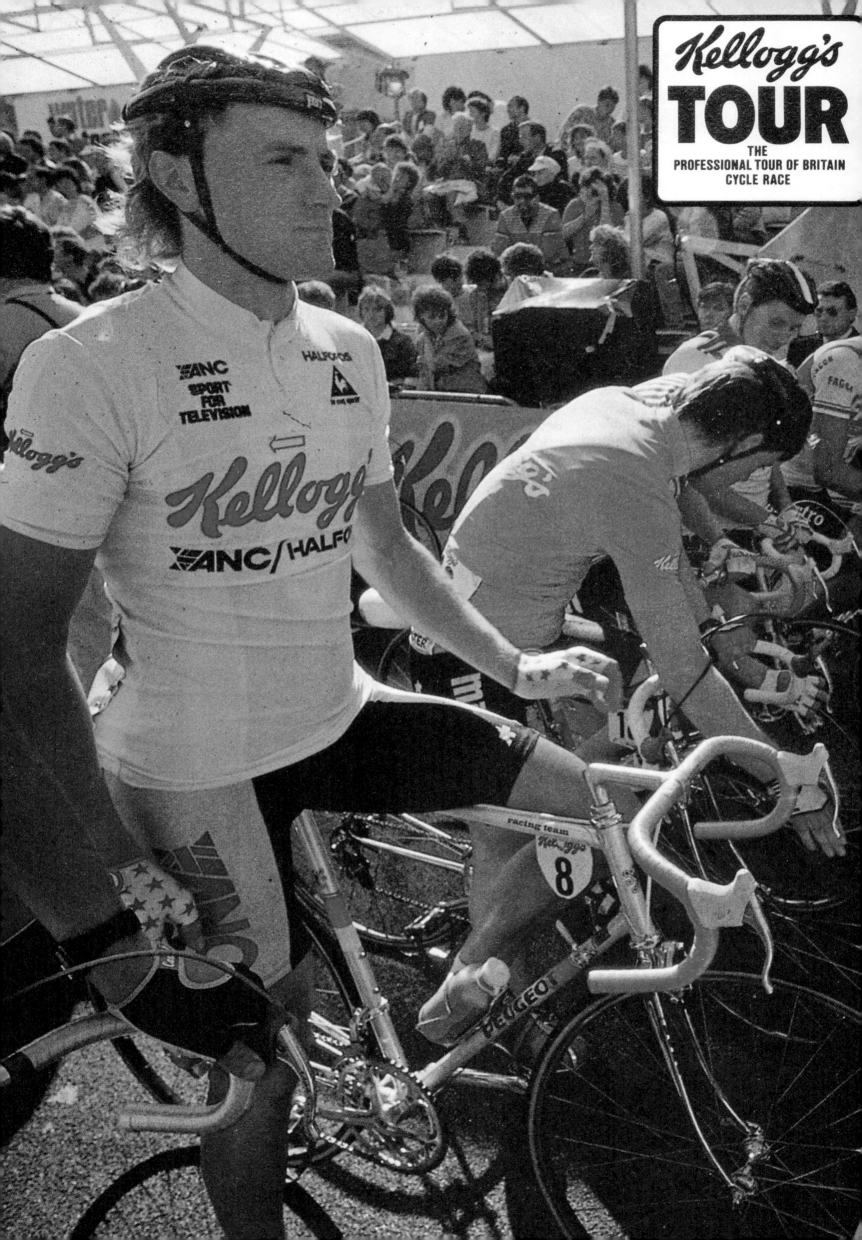

MILK
for STAMINA

CYCLE TOUR OF BRITAIN

27 MAY TO 7 JUNE

MILK IS A STRONG MAN'S DRINK

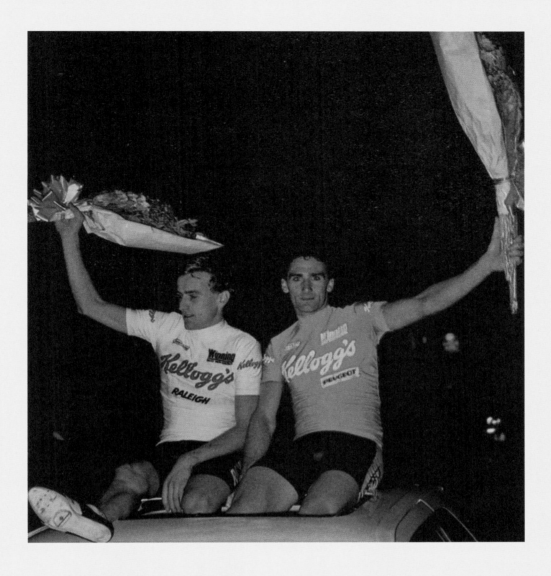

It was different when the Tour de France came to Yorkshire and all the towns and villages turned it into a festival. They really got into the spirit of it in a way that probably no one expected. The French organizers were flabbergasted – and delighted, of course. Maybe that will help the Tour of Britain to prosper.

It's important that the Women's Tour gets established, too. You see a lot of women riding on the road and at the velodromes, and the promotion of their races should reflect that level of involvement. When Laura Trott, Dani King and Joanna Rowsell raced at the Smithfield Nocturne the year after the Olympics, they got louder applause from the crowd than the male riders. What women's road racing needs is more exposure on television. Then the sponsors will follow.

Of course, there are more television channels now, and better technology for the broadcasters, and there's also Twitter and the other social media, so the race probably stands a better chance of establishing itself as a fixture in the public mind and in the calendar of major British sports events. I really hope so, because it would help to prove that the current cycling boom in Britain isn't just a passing fad.

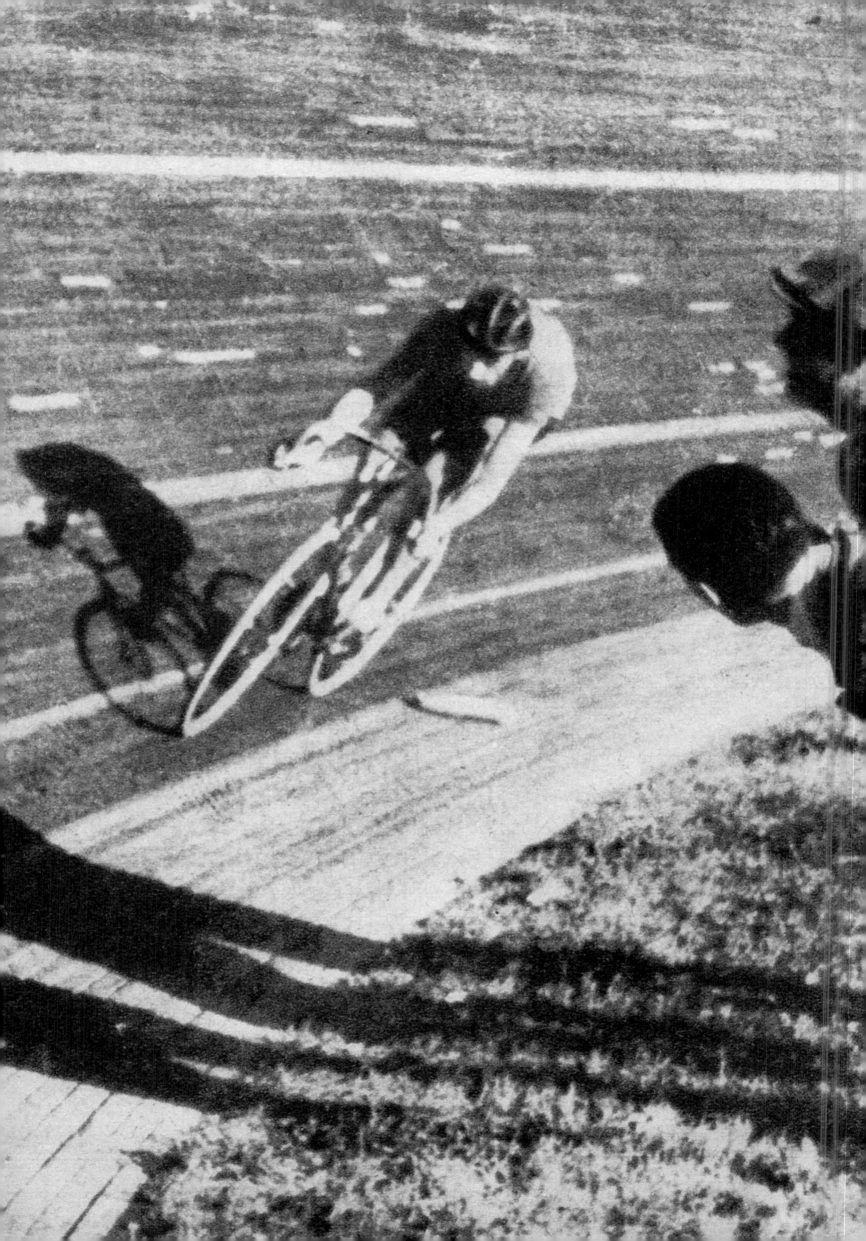

OPPOSITE: *The twenty-three-year-old Fausto Coppi covers 45 km 871 m on the boards of Milan's Vigorelli velodrome to take the hour record in 1942.*

NEXT PAGE: *The Rocket: Another great win for Coppi in the Vigorelli velodrome, this time over 5 km against Syd Patterson, Australia's world champion, in 1953.*

VELODROMES

When I stepped inside the Vigorelli, the velodrome in Milan where Fausto Coppi and others broke the world hour record, I could hear the crowds in my head. It was like a Fellini movie. I could feel the Italian passion, even though it's many years since bikes raced there, and the wooden track has mostly rotted away. But I could imagine Coppi after setting his record, with a big bouquet of gladioli, which is a flower the Italians love, then getting changed into one of his stylish double-breasted suits.

There are plans to restore the Vigorelli, and to have bike racing there again instead of American football, for which it has provided the venue in recent years. Meanwhile, under one of the grandstands, there's a workshop occupied by Alberto Masi, whose father used to make Coppi's frames. Signor Masi inherited the skill and still makes the occasional steel frame in the traditional way, but his business now is mostly restoring classic bikes, many of them made by his dad.

When I was a teenager I raced at Herne Hill in south London, where the track events were held during the 1948 Olympics, and at velodromes in Leicester and Nottingham. Herne Hill is the only one of those three that's still going. They were all open-air tracks, with a concrete surface. I rode my yellow Paramount fixed-wheel bike and I tried some sprints to start with, but I just wasn't the right build. Then I did some pursuiting, which suited me better, although I never did well.

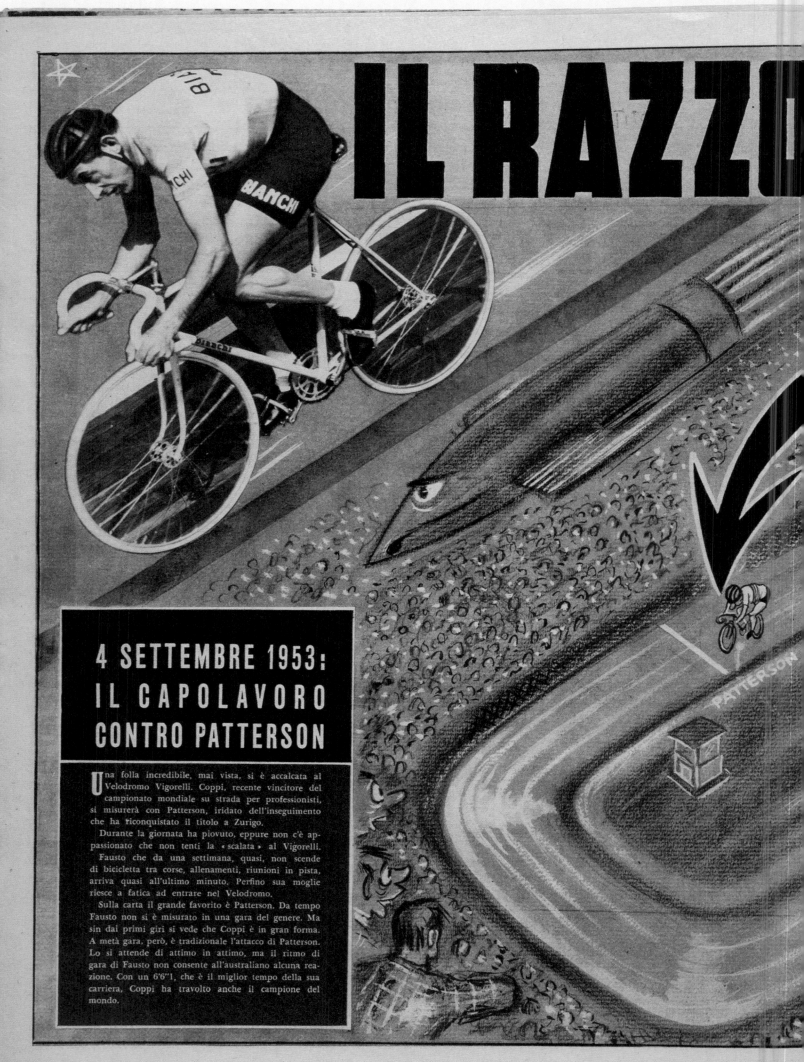

IL RAZZO

4 SETTEMBRE 1953: IL CAPOLAVORO CONTRO PATTERSON

Una folla incredibile, mai vista, si è accalcata al Velodromo Vigorelli. Coppi, recente vincitore del campionato mondiale su strada per professionisti, si misurerà con Patterson, iridato dell'inseguimento che ha riconquistato il titolo a Zurigo.

Durante la giornata ha piovuto, eppure non c'è appassionato che non tenti la «scalata» al Vigorelli.

Fausto che da una settimana, quasi, non scende di bicicletta tra corse, allenamenti, riunioni in pista, arriva quasi all'ultimo minuto. Perfino sua moglie riesce a fatica ad entrare nel Velodromo.

Sulla carta il grande favorito è Patterson. Da tempo Fausto non si è misurato in una gara del genere. Ma sin dai primi giri si vede che Coppi è in gran forma. A metà gara, però, è tradizionale l'attacco di Patterson. Lo si attende di attimo in attimo, ma il ritmo di gara di Fausto non consente all'australiano alcuna reazione. Con un 6'6"1, che è il miglior tempo della sua carriera, Coppi ha travolto anche il campione del mondo.

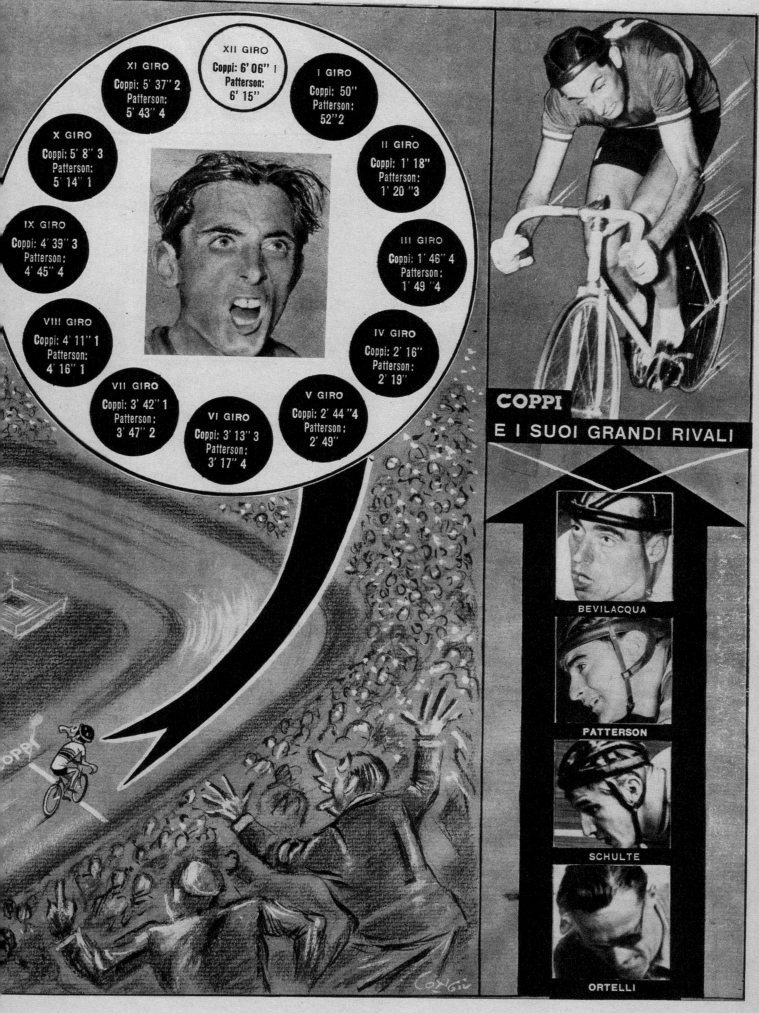

XII GIRO
Coppi: 6' 06" 1
Patterson: 6' 15"

XI GIRO
Coppi: 5' 37" 2
Patterson: 5' 43" 4

I GIRO
Coppi: 50"
Patterson: 52" 2

X GIRO
Coppi: 5' 8" 3
Patterson: 5' 14" 1

II GIRO
Coppi: 1' 18"
Patterson: 1' 20 "3

IX GIRO
Coppi: 4' 39" 3
Patterson: 4' 45" 4

III GIRO
Coppi: 1' 46" 4
Patterson: 1' 49 "4

VIII GIRO
Coppi: 4' 11" 1
Patterson: 4' 16" 1

IV GIRO
Coppi: 2' 16"
Patterson: 2' 19"

VII GIRO
Coppi: 3' 42" 1
Patterson: 3' 47" 2

VI GIRO
Coppi: 3' 13" 3
Patterson: 3' 17" 4

V GIRO
Coppi: 2' 44 "4
Patterson: 2' 49"

COPPI
E I SUOI GRANDI RIVALI

BEVILACQUA

PATTERSON

SCHULTE

ORTELLI

33

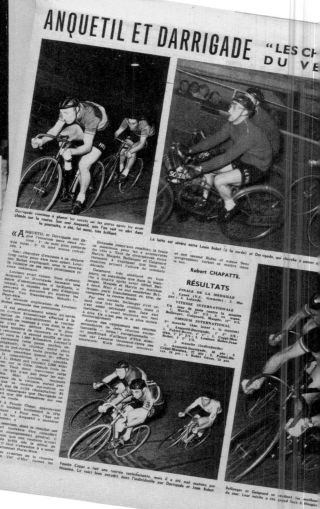

The thing that's always struck me, although it's not necessarily true, is that the top riders all seem so laid back. I used to get very apprehensive before a race. I'd never have done really well as a cyclist because I wasn't brave enough. I was always too conscious of falling off and hurting myself. So many of these guys are so relaxed. Obviously if you're like that you're going to do a better job. I can draw parallels with when I have a fashion show four times a year: everybody says, 'You're so relaxed – the mood is really lovely, there's no shouting or screaming, everything is organized, everybody says please and thank you.' They're surprised by that. In my job I seem to have achieved that relaxed atmosphere. But in cycling I didn't. I was too scared.

I went a few times to the old Skol six-day races at Wembley Empire Pool, where they used to build a banked wooden track specially for the event. I was interested in the absolute madness of it. It's a bit like the keirin racing in Japan, where there's so much going on. People were whizzing round all the time under floodlights, and there were little cabins in the middle of the track where the riders would sleep when they weren't on the track. The atmosphere was very intense and really wonderful.

I've visited the modern tracks in Manchester and London. I've even ridden on the Manchester track, while making a little tongue-in-cheek promotional film with what was then the Rapha-Condor team. They wore suits and I wore their team kit – and I won, of course! I was actually very scared, not least because Chris Hoy was watching in the stand. It was my first time on an Olympic-style 250-m wooden track with a 40-degree banking. I wasn't really that fit. I went there thinking, 'I'll do three minutes of filming and that'll be it.' I ended up riding for about an hour, with a guy giving me instruction and keeping an eye on me, before the filming started. I discovered that whatever I'd once known about riding on a track, I'd forgotten it.

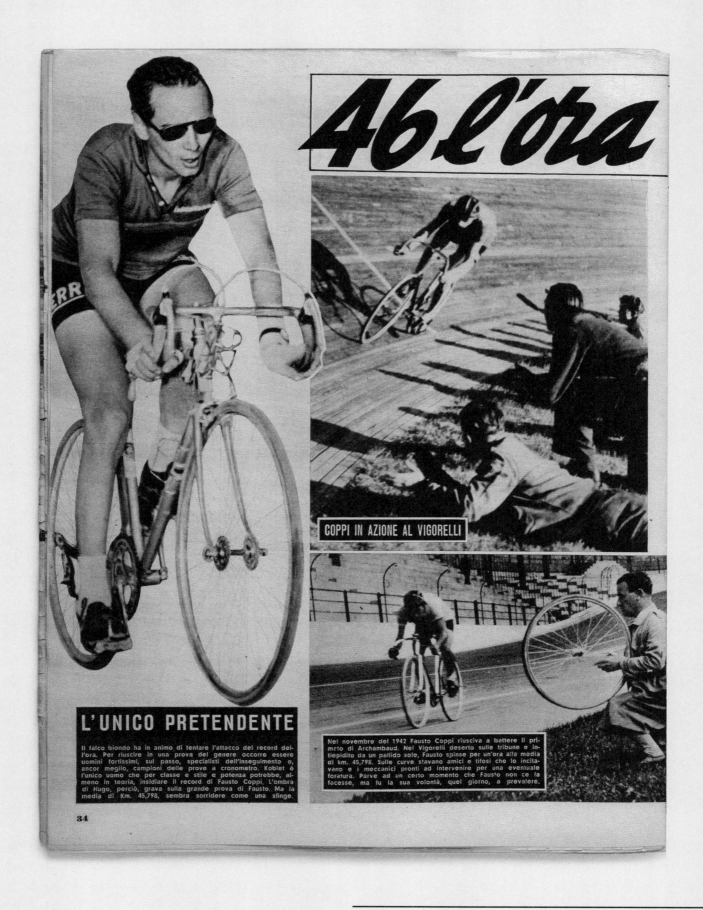

46 l'ora

COPPI IN AZIONE AL VIGORELLI

L'UNICO PRETENDENTE

Il falco biondo ha in animo di tentare l'attacco del record dell'ora. Per riuscire in una prova del genere occorre essere uomini fortissimi, sul passo, specialisti dell'inseguimento o, ancor meglio, campioni delle prove a cronometro. Koblet è l'unico uomo che per classe e stile e potenza potrebbe, almeno in teoria, insidiare il record di Fausto Coppi. L'ombra di Hugo, perciò, grava sulla grande prova di Fausto. Ma la media di Km. 45,798, sembra sorridere come una sfinge.

Nel novembre del 1942 Fausto Coppi riusciva a battere il primato di Archambaud. Nel Vigorelli deserto sulle tribune e intiepidito da un pallido sole, Fausto spinse per un'ora alla media di km. 45,798. Sulle curve stavano amici e tifosi che lo incitavano e i meccanici pronti ad intervenire per una eventuale foratura. Parve ad un certo momento che Fausto non ce la facesse, ma fu la sua volontà, quel giorno, a prevalere.

34

Coppi's great record stood until 1956 (above), when it was beaten by Jacques Anquetil (opposite), also in the Vigorelli.

The London Olympic velodrome (now the Lee Valley VeloPark) is fabulous. It's very beautiful to look at from the outside and the inside. The man who designed it, Mike Taylor of Hopkins Architects, is a cyclist, so there was real knowledge and passion involved, as well as professional skill. Chris Hoy told me that in terms of the conditions, such as the quality of the air inside and the temperature control, it was perfect for the riders. It certainly produced results, and now it's open to anyone who wants to go and find out if they have what it takes to become a Hoy or a Pendleton. Too late for me, I'm sorry to say.

THE JERSEYS

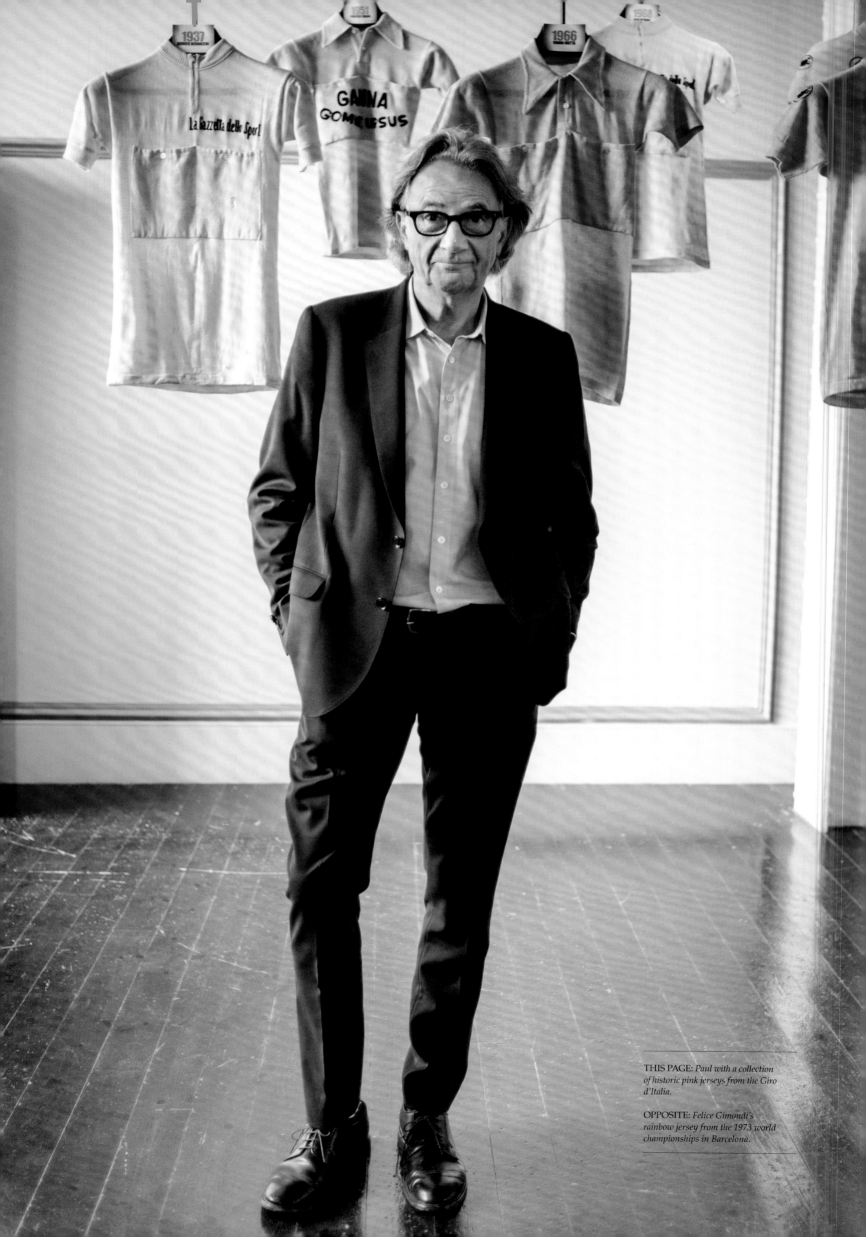

THIS PAGE: *Paul with a collection of historic pink jerseys from the Giro d'Italia.*

OPPOSITE: *Felice Gimondi's rainbow jersey from the 1973 world championships in Barcelona.*

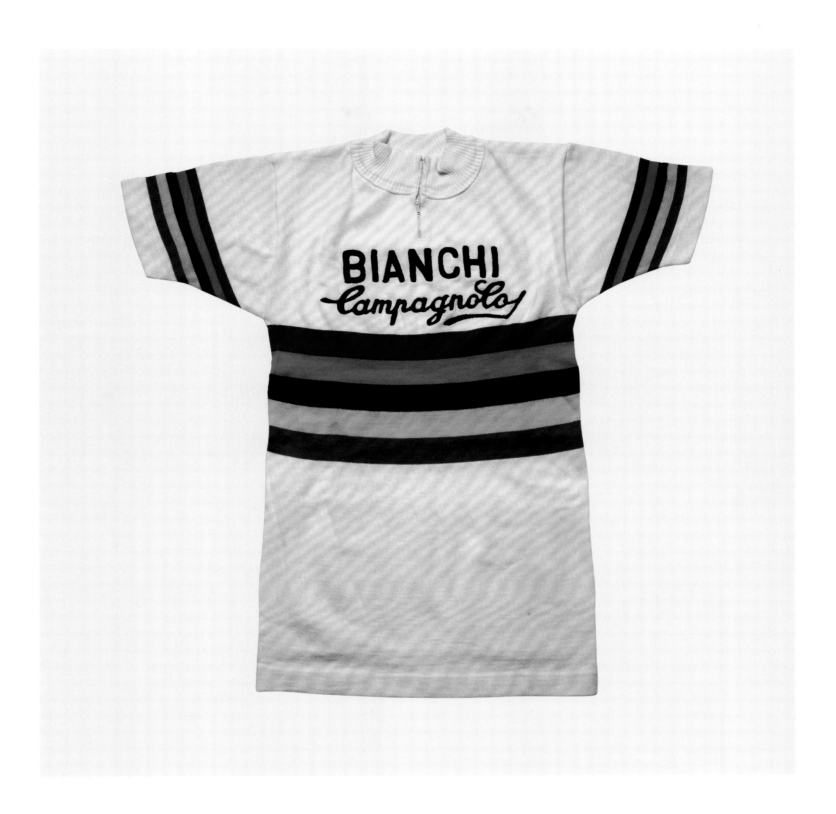

As a designer, one of the ways I find inspiration is by going to street markets. Wherever I go on my business travels, whether it's Florence or New York, I tend to know where the weekly markets are and what day they're on. I might find an old sweater or something with a special type of knitting or interesting colours. And slowly, especially in Italy, I began coming across old cycling jerseys. So I started buying them.

Recently they've become a lot more expensive. In Forte di Marmi, a resort in Tuscany, there is a big market twice a year, and there's a man who sells old jerseys. He sold me the one that's probably my favourite in my collection: it's Felice

Gimondi's world championship jersey, in wool, with the rainbow stripes. It came with a letter of authentication, and obviously I had to pay quite a lot for that. But last time I went, the prices had gone right up and I just couldn't buy any. It's got to the point where the sellers think they're more valuable than they are.

But I've got a good collection of old wool jerseys, and people love to look at them. They made a great display for my first exhibition at the Design Museum in London several years ago. I spread them all out on the large table in my office the other day, and I was astounded by how many I've got.

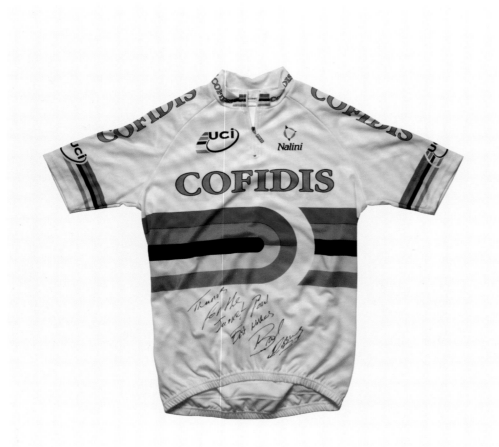

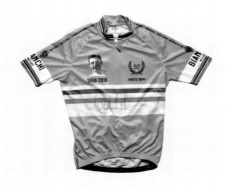

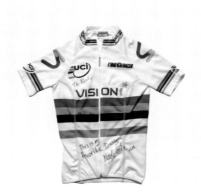

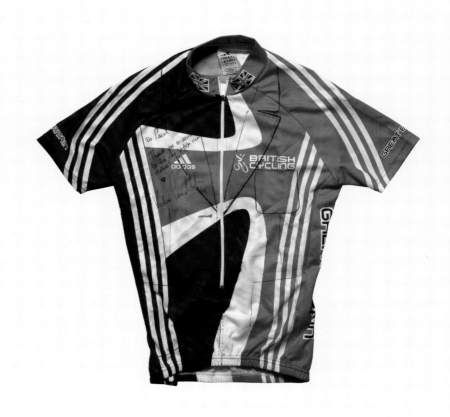

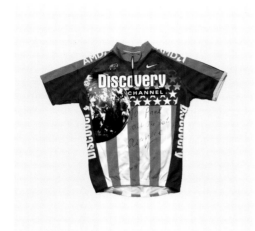
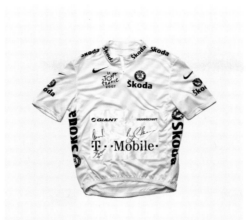
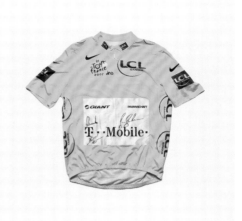
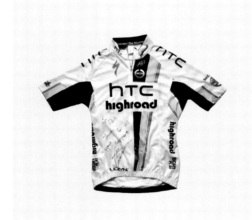
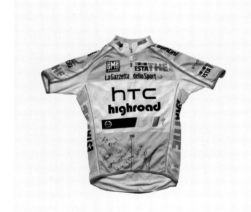

Then I started meeting people in cycling and, because they knew I had this collection, they began giving me new jerseys. There are jerseys from Bradley Wiggins and Mark Cavendish with the racing numbers still pinned on. I've got one from Fabian Cancellara, which he gave to David Millar on the Champs-Élysées, at the end of the Tour de France, to give to me. And there are others from Philippe Gilbert, Thor Hushovd, Nairo Quintana, Chris Froome, Tony Martin, Cadel Evans, Bernard Hinault…it's quite an interesting selection. I feel really privileged.

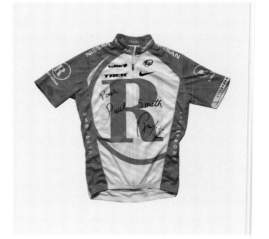

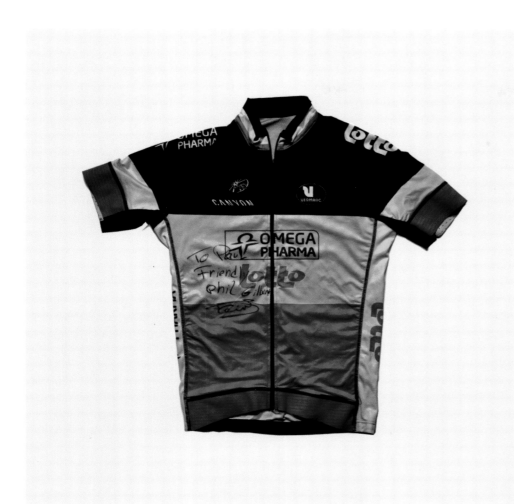
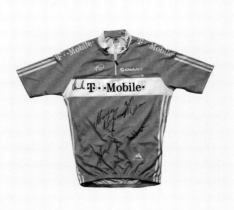
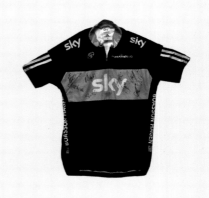
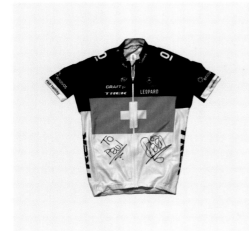
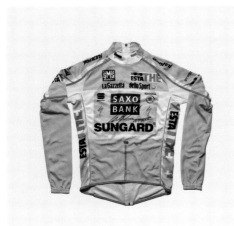
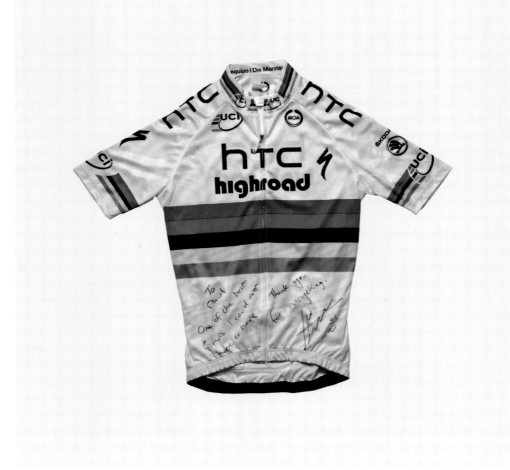

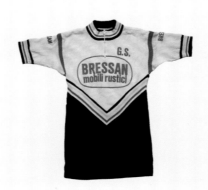

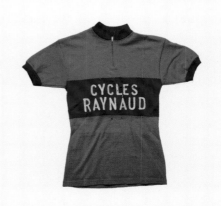

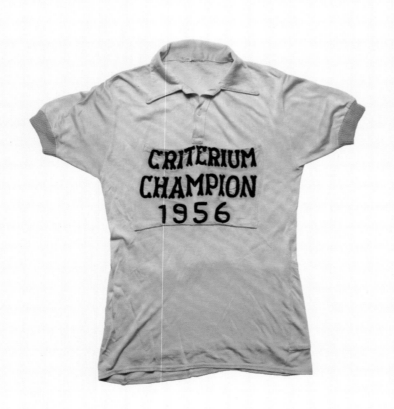

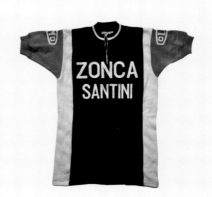

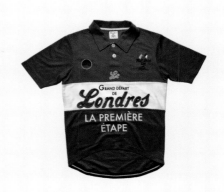

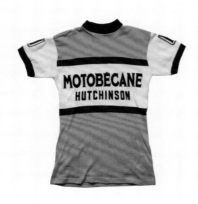

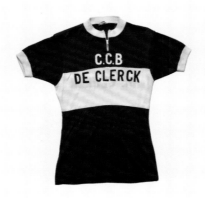

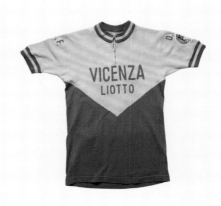

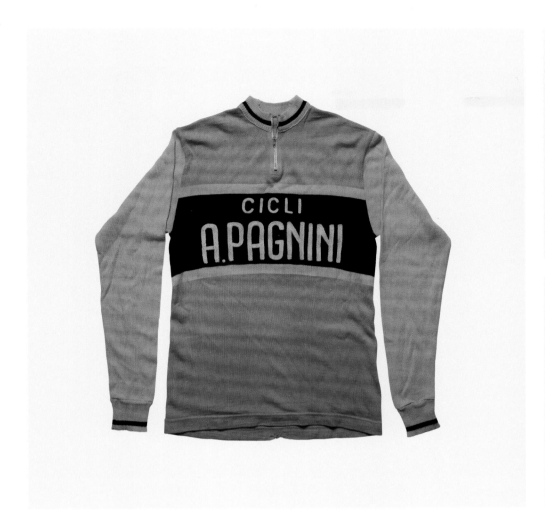

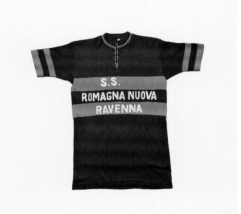

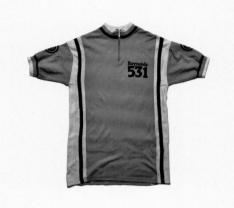

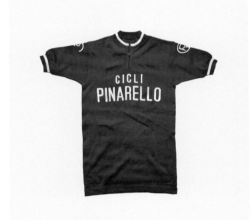

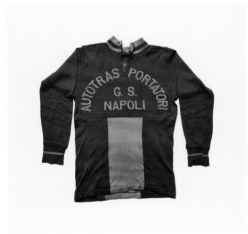

The old jerseys are so beautiful. I can't work out whether it's something to do with nostalgia or whether, as a designer, I just appreciate their simplicity. In the 1950s there was a really nice Rayon that was probably awful to wear but visually was really good. I've got a pink one from that era that I've often gone back to and used as inspiration for men's and women's clothes. Of course, there's a lot less advertising on the old ones than there is on the modern shirts. That's true of all sports today: even in darts and snooker, they find a space for promotion.

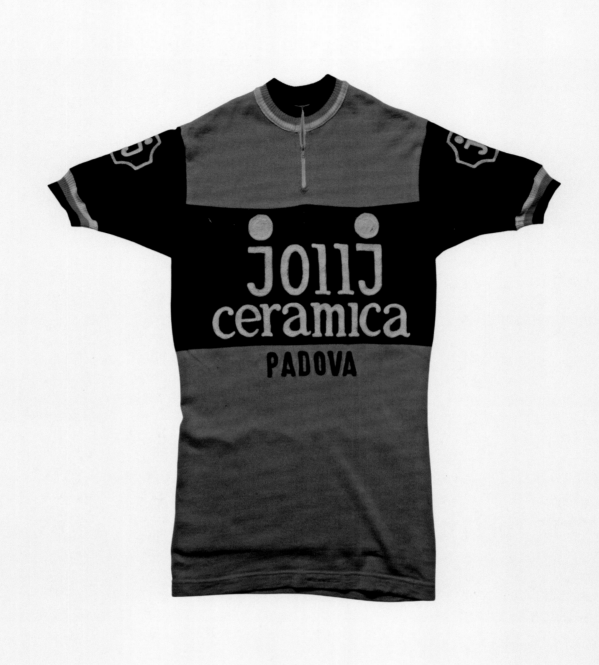

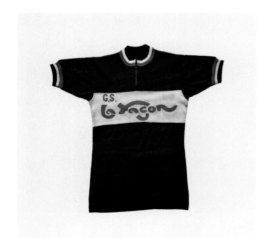

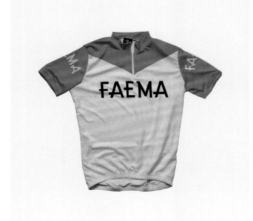

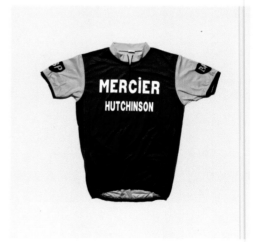

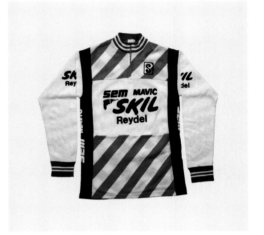

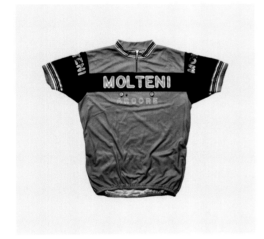

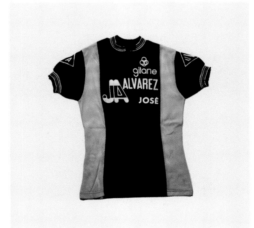

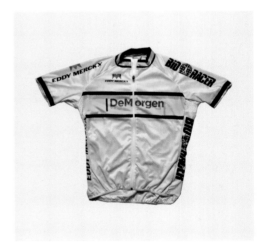

You can see from the success of Rapha and other companies that people today would like to get back to that simplicity. It's a look that a lot of today's cyclists appreciate. I've had very interesting conversations with Mark Cavendish about whether you could ever do something like that again, something really simple, where the simplicity of it became the advert, if you see what I mean. For the time being, I'll carry on collecting.

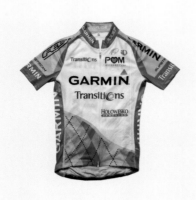

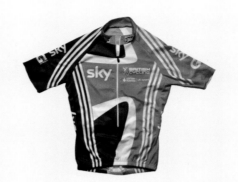

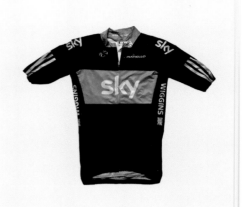

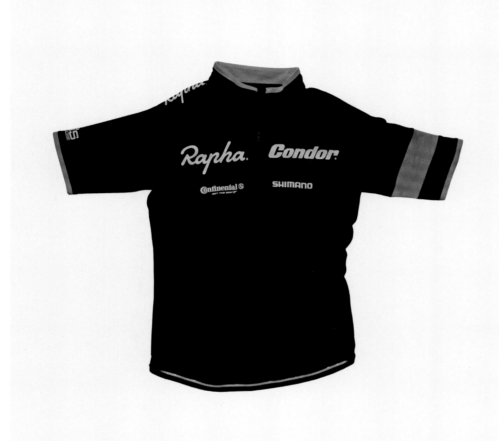

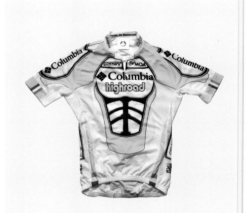

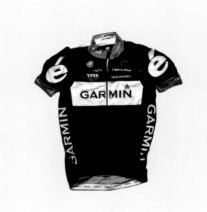

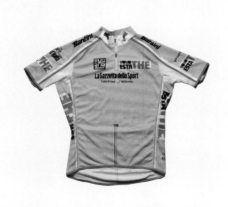

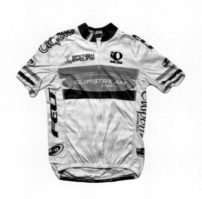

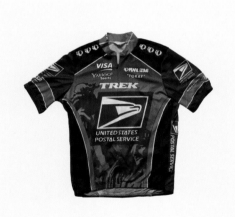

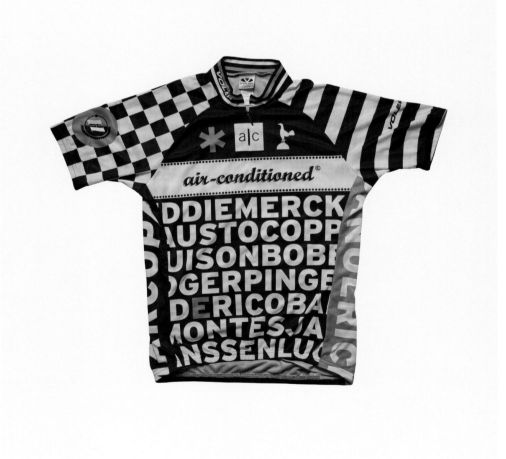

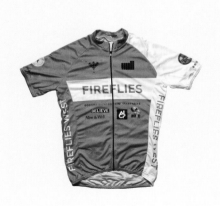

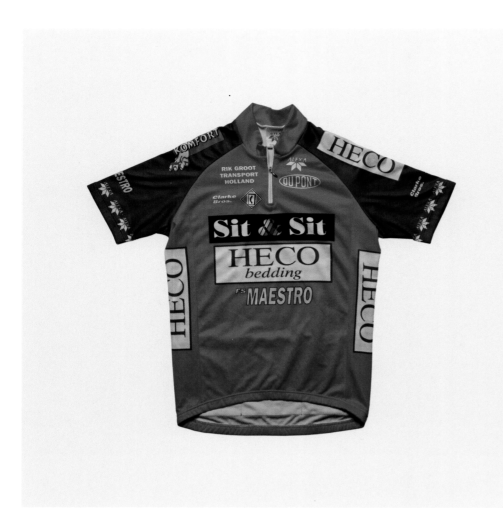

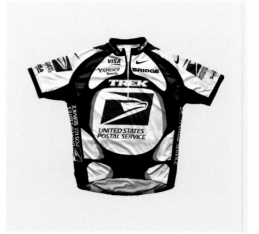

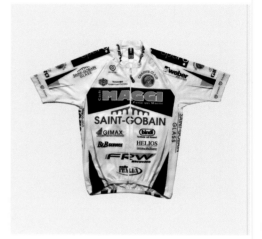

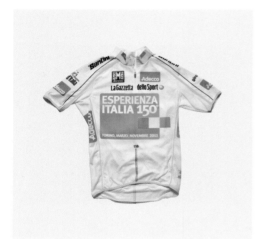

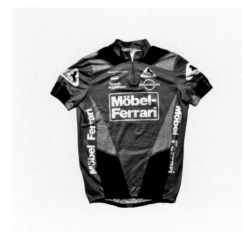

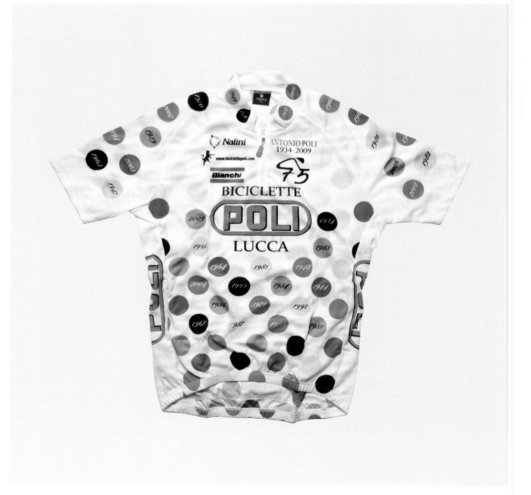

CONTEMPORARY HEROES

DAVID MILLAR

As well as having been an accomplished rider, David Millar is a very charismatic and eloquent man. I'd imagine he was a very good teammate, and now that he's retired I'm sure he will have absolutely no problem in continuing to do well in his career, in television commentary, writing for newspapers or team management, or whatever else he chooses.

He's a good all-rounder, and quite an entrepreneur as well. I know he's already designed some cycling shoes with Fizik, an Italian company, and he also has a clothing line of his own. I'll have to keep an eye on him: he might turn out to be a dangerous competitor in my world, too!

David's two-year doping ban in 2004 was a tragic episode in his life, but in fact that's how I got to know him. We gave him a suit for the trial so that he'd look smart in court. The people who are attracted to any sport want to do well. That's the main reason they're in it. And human nature suffers from greed and jealousy, so if you think you're as fit as your friend but your friend keeps winning and you find out that he's on some sort of substance, you might decide that you need to put yourself on an equal footing by doing the same thing. That's how David got caught up in cycling's culture of doping.

You can draw parallels with drug-taking in society generally, and the peer pressure that comes with it: 'You wimp, why won't you join in?' I actually flip that on its head. I think anybody who doesn't go along with it is probably quite strong and interesting.

What was good is that David said, 'Yes, I was wrong. I was put under pressure and that's why I did it.' He's found a way to live with the knowledge that what must have felt at the time like great achievements have quite rightly been taken away from him. And by being very vocal in the anti-doping movement, he's turned himself into a good guy as far as the future of cycling is concerned.

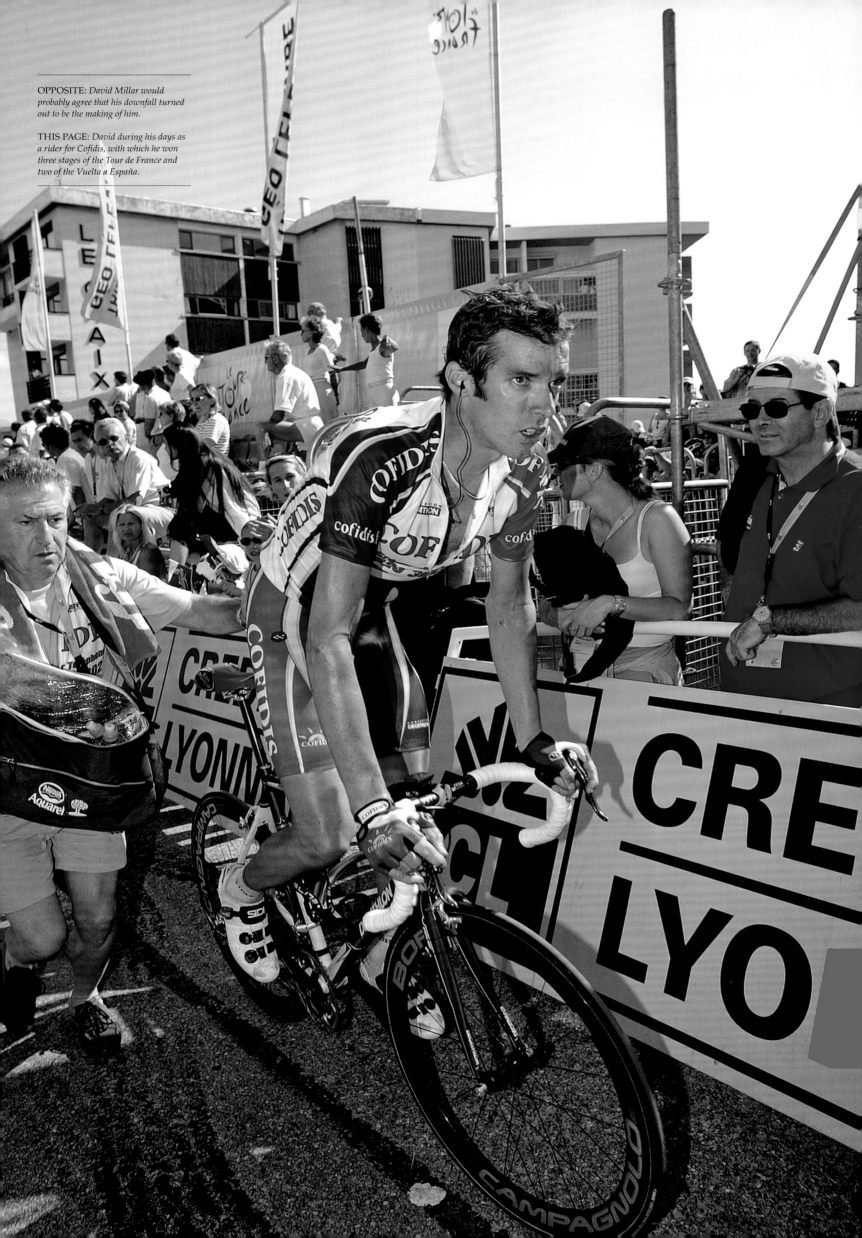

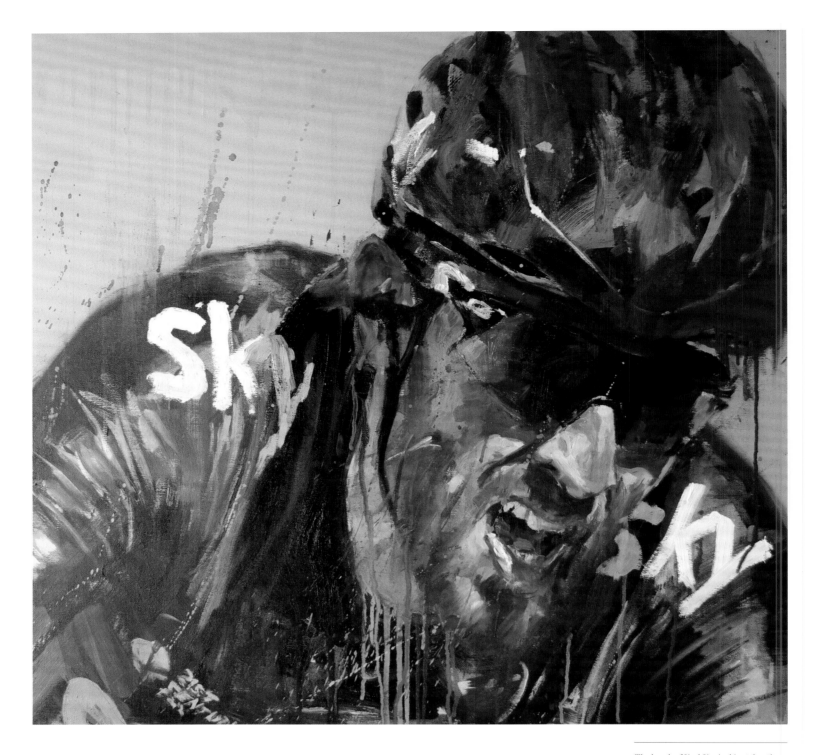

BRADLEY WIGGINS

Like many British cycling fans, I never thought I'd live to see a rider from our country win the Tour de France. That it happened in 2012, when Bradley Wiggins rode into Paris in the yellow jersey, was the result of a coming together of Dave Brailsford, Shane Sutton and Tim Kerrison as the team behind Bradley.

I can draw parallels with my industry. Over the years certain people in charge of fashion studies at colleges and universities have realized that it's okay to do extreme clothes but one day the students will have to pay the rent somehow. So those

people have got the balance right between creating attention-seeking clothes and bearing in mind how the world actually works. I think that's also happened in many sports – for so long it was about strength, but now it's about mixing strength with technology, with finesse, with discipline. It took people like Brailsford, Sutton and Kerrison to do all that.

Bradley has always been very hungry for success. I think it comes from his difficult relationship with his father, who was a bike rider but went off to Australia and was never really around much.

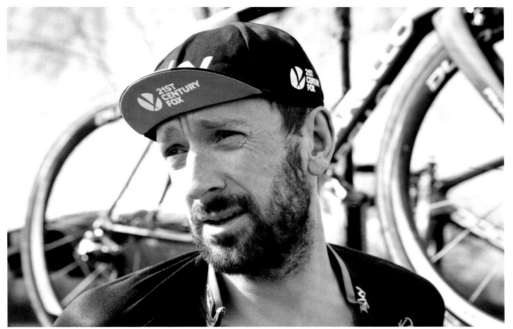

Bradley Wiggins is a man of considerable style, with a sense of humour to which his public responds. In becoming the first British rider to win the Tour de France, he made what had appeared to be an impossible dream come true.

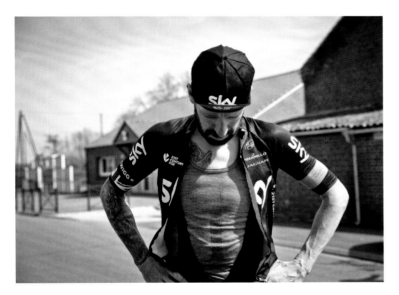

For many years Bradley was very insecure – wanting to do well, and then doing well, but still not sure of himself. Not surprisingly, after winning the Tour de France and Olympic gold medals and world championships, he's gained confidence. For someone like Bradley, it's about keeping calm and not making a fool of yourself by being too egotistical. We've all seen it with musicians and politicians and other people. It can easily happen.

He's a very witty man. And, as with any comedian, it's all about timing. If you get the timing right, you'll continue to be funny. When he won the Tour and made that joke about drawing the raffle in his speech, or when he won the BBC's Sports Personality of the Year award and was a bit cheeky with the presenter, his timing was good and he was very amusing, at least to us Brits. I'm not sure what the French crowd on the Champs-Élysées made of it, but there were so many Brits there to cheer him that it probably didn't matter.

Bradley's personal style is fantastic. He adores Mod culture, and he met Paul Weller through me, in London. He finished the Giro on the Sunday, and I said to him, 'If you want to meet Paul, get yourself on a plane because he's doing an event at my shop tomorrow night.' So he came specially for that.

Since then I think he's developed more of his own style, so it's not just Mod-related now. He did some clothes with Fred Perry, and they were quite good. He's just got to make sure he keeps his feet on the ground.

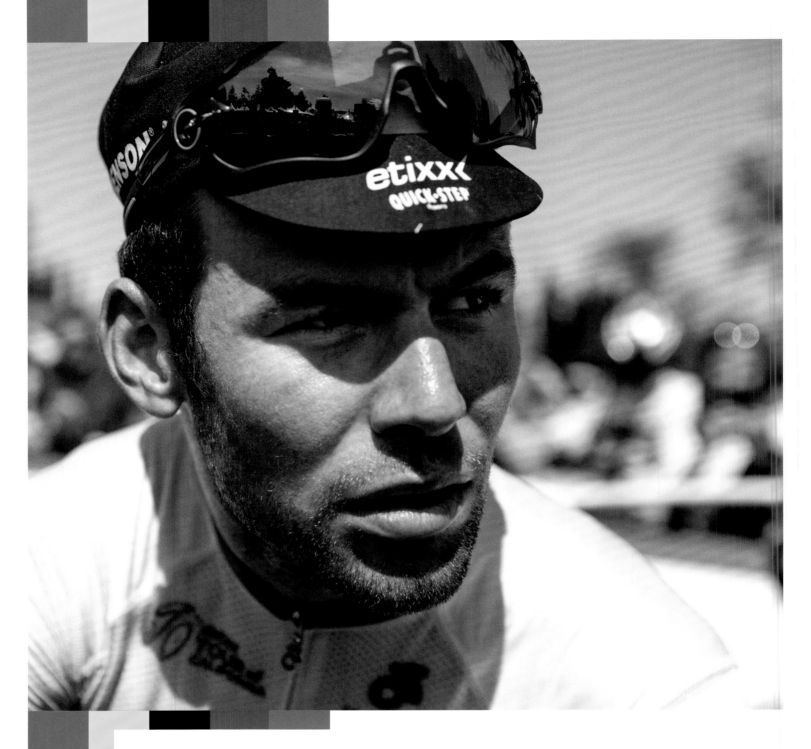

MARK CAVENDISH

In my experience Cav has always been very polite, very gentlemanly and very humble. He's got a bit of a reputation for being quite aggressive and forthright, but I think that's the nature of a sprinter, really. You can't be seen to be weak when you're going along at 70 kph with your rivals' elbows in your chest.

We've built a very nice friendship that happened very casually through Brian Holm, Cav's *directeur sportif* at HTC and then at Quick-Step. One day Brian asked if he could come and meet me, and he brought Cav and Bradley Wiggins along. Cav and I got on straight away. He's a nice guy. He's got a nice wife and a nice

daughter, he's been to quite a few of my events, and we keep in pretty close touch.

I've talked to him and to Bradley about life after cycling, and I've said to them that you've got to start sorting it out now so that you don't get a shock. When you're in their position you get used to being the centre of attention and it's hard to do without it. It's like rock bands: some of them keep touring into their sixties and seventies because they can't just sit at home: they need the attention. It's a problem as you get older, but I think both Cav and Brad can sort it out. They're both bright guys with the support of nice women, which is important.

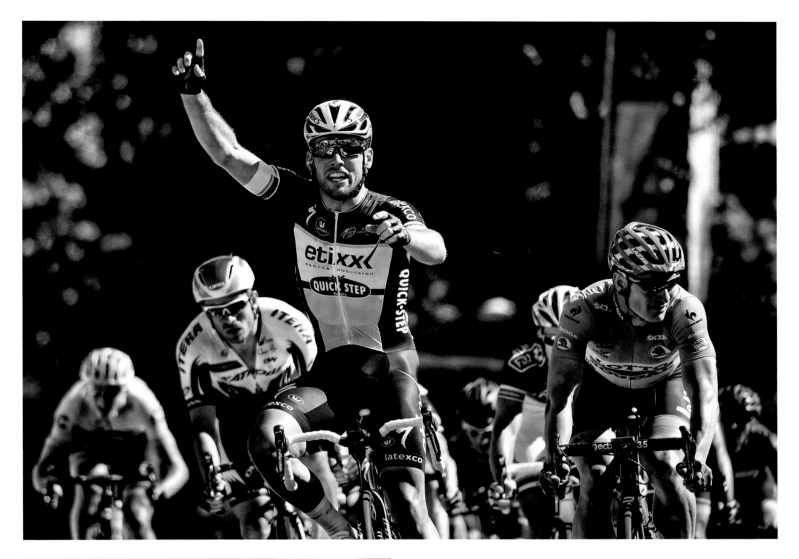

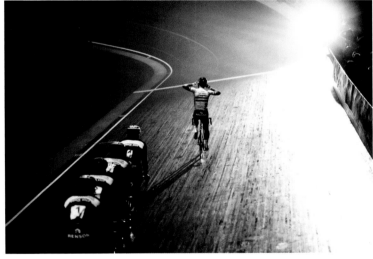

Cav is a bit like Chris Hoy: you don't know how he gets through those gaps when he's driving for the finishing line. Unlike the track, the road has manhole covers, kerbs, metal barriers with legs that stick out, it can be uphill, it can be raining – there are all sorts of variable factors that he has to take into account. He's unbelievably quick in his reactions and his style is very interesting because his head is so far down that his nose is almost on the front wheel.

Cav races with a confidence that might have been seen as arrogance earlier in his career. I remember talking to him a few years ago when he was on the train on his way to the final stage of the Tour. He said to me, 'Yes, I think I'll win on the Champs-Élysées today.' And he did. When he's finished with racing, all those victories in Paris will be a source of special satisfaction.

His win in the 2011 world championship in Copenhagen was a proper example of old-fashioned teamwork, with Wiggins, David Millar, Geraint Thomas and the rest really working for him. That's great to see in today's very commercial world. It was an amazing achievement, one of many that we've seen from Cav. And for the next twelve months he wore the rainbow jersey with enormous and very visible pride.

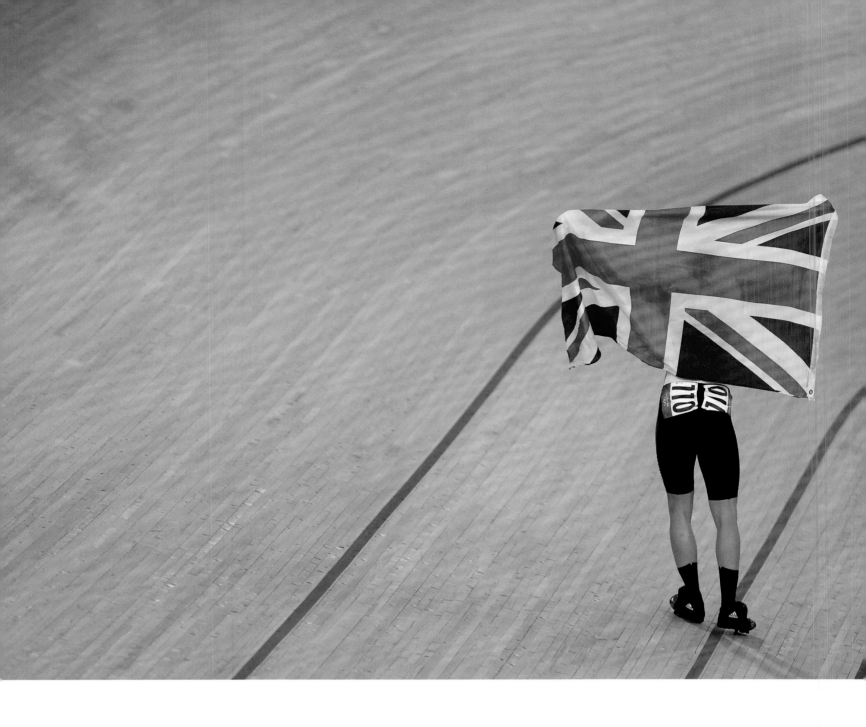

VICTORIA PENDLETON

One day when I was visiting the Olympic velodrome in London to watch the track World Cup, Victoria Pendleton was there, doing the commentary for the BBC. The presenter she was working with told me that when she's analysing a race that's about to start, she says, 'Ah, so-and-so will win.' And she always gets it right.

For anyone who came up through the Athens-Beijing-London era of the Olympics, that was when the traditional emphasis on the health and strength of the athletes coincided with a modern way of thinking. What British Cycling did in order to achieve success in those years was never going to stay a secret, of course. In my business, if I do a catwalk show with a certain look, that look is going to be around the world within eight to twelve weeks. What British Cycling did was seized on by the Australians, the French and others. But while it was all new, Victoria was an important part of it. She had a father who wanted to be a racing cyclist but only did okay. He gave her the motivation to succeed in a career that brought her nine world

championships and three Olympic medals – two gold, one silver. Between 2005 and 2012 she was the woman to beat in the velodrome, even though physically she didn't resemble the majority of sprinters. When I went to watch the track World Cup races, I was surprised by how small Victoria seemed compared to the other athletes. The only big muscles on her were her thighs. Then came Laura Trott, who also showed young women that you don't have to develop a hugely muscular overall physique to succeed on the track.

Victoria's good looks, and the opportunities they open up, mean that she's had to take quite a bit of flak, which I don't think is fair. She often gets clothes from us, and she did a work placement here after she retired from competition. She's got a big name and she's attractive to sponsors. She's already put her name to a line of bikes and climbed into a different kind of saddle to have a go at National Hunt racing, so it's going to be interesting to see where her career takes her.

OPPOSITE: *In the velodromes in Beijing and London, Victoria Pendleton achieved Olympic immortality.*

THIS PAGE: *When you compare her slender physique with those of her rivals, it is hard to see where Victoria's power comes from.*

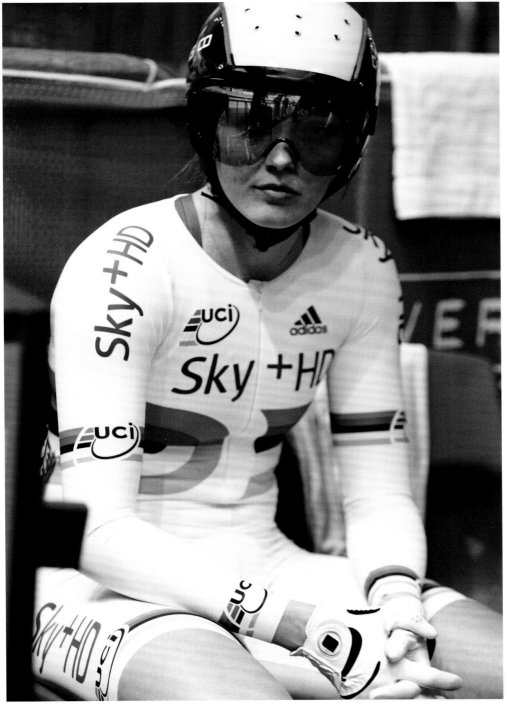

NICOLE COOKE

The sight of Nicole Cooke sprinting through the rain to the finish of the women's road race in Beijing kicked off Britain's rush of gold medals in the 2008 Olympics. It was a thrilling effort that didn't even need the setting, by the Great Wall of China, to make it more dramatic. A few weeks later Nicole capped a magnificent year by winning the world championship road race in Varese, Italy. That made her the first cyclist, man or woman, to have won both those titles in the same year.

Nicole's achievements have been massive, but I've always worried about her because she always seemed to me to be quite isolated within her chosen world. She didn't come up through the British Cycling system but developed outside it, with the support and encouragement of her father. They had strong opinions about how they thought her career should go, and it didn't always make them popular. The fact that she raced for nine different teams in eleven years as a professional suggests that there may have been some grounds for her reputation for not being a natural team player.

But different people go about things in different ways, and Nicole can certainly say that, although some of her career decisions might not have turned out well, what she did was unmatched by her contemporaries who operated within the system. She was a pioneer, and pioneers sometimes don't fit the sort of mould that suits others. The support systems for young riders have definitely been improved since her time, and it would be interesting to know whether things would be easier for her if she were starting out now.

I don't know Nicole well enough to be sure about that. She came to my office with her manager and she was very nice and she sent me a jersey. Since her retirement she's built a platform for a different sort of career by studying for an MBA, which also takes some doing. No doubt she'll continue to live an independent life, and you wouldn't bet against her succeeding at whatever she attempts.

OPPOSITE: *Nicole wears her medal at the finish on the outskirts of Beijing, a few yards from the Great Wall of China.*

ABOVE: *Nicole's sprint to win the Olympic road race in Beijing unleashed a flood of British gold medals.*

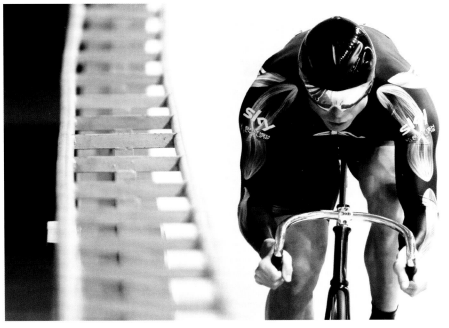

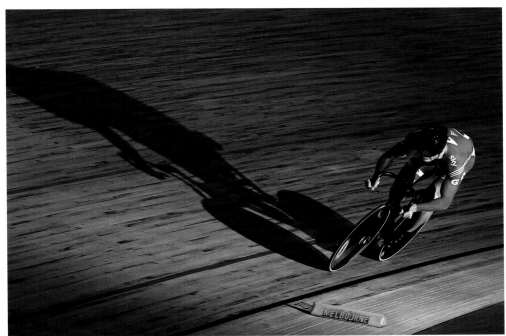

CHRIS HOY

I met Chris Hoy when he needed some clothes and couldn't find anything to fit him, because he's a big lad, especially in the thighs. I don't quite know how it happened, but suddenly one day he was in my office. Then, when he came the next time, he brought his Olympic medals along to show us. How many gold medals has he got? Six? Astonishing.

Chris also brought me one of the team's warm-up tops, and he said, 'Don't tell anybody, because it's in the new material, and it's still secret.' British Cycling is always coming up with something new, from bike frames to clothing. When Simon Mottram, the founder of Rapha, came here and caught sight of that top, he was astonished. We made Chris some suits for his appearance at the 2014 BBC Sports Personality of the Year show in Glasgow, where he was presented with a lifetime achievement award. Since his retirement from cycling he's been competing in sports-car races and has been doing well.

Chris's success was the product of the British Cycling staff's shared passion for fine detail, for making sure that nothing was overlooked. That sort of thing can happen in my business, too: the right people come together at the right time with a set of shared ambitions and values, and somehow they manage to make all their dreams come true.

I couldn't believe how such a big man got through that tiny gap to snatch the keirin in London, the last of his Olympic medals and the one that made him the most successful British Olympian of all time. His bravery was as astonishing as his power and speed.

Chris was like a father to the younger riders in the British track team. He was a mentor and someone who led by example. He was strong with them. He'd tell them off for eating crisps – but in a very nice way, because he's such a nice man.

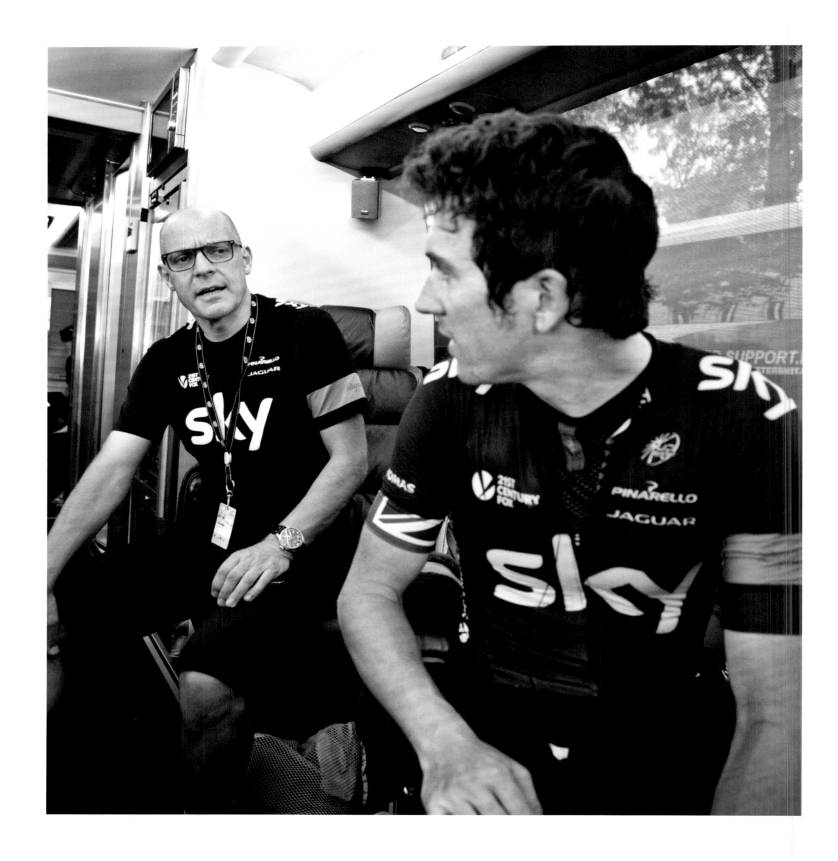

DAVE BRAILSFORD

My relationship with Sir Dave Brailsford is mostly conducted by text message. I've met him in person a few times, but it's usually been at the start of a stage, when he's got a lot to think about and he's trying to concentrate. But his texts are fascinating and often quite profound. They might be only three lines but they're very much to the point.

I don't know him well enough to have any real idea about his personality, but his way of thinking and his strength with the riders have been fantastic. To start a road team from scratch and to tell everybody that you intend to win the Tour de France with a clean British rider within five years, and then to go and do it – that's nothing short of amazing.

I know Brailsford started out wanting to be a professional rider, and went to France and raced quite a lot. Then he came back to Britain, where he got some practical experience in the business by working as an export manager for a bike company. When British Cycling started to get National Lottery money in 1997, he joined it, and six years later he took over the top job of performance director.

Brailsford's achievements with his riders on road and track are staggering: not just the Tour de France and the Olympic gold medals, but also Mark Cavendish's world championship in 2011 and many other race wins for Team Sky. He assembled and encouraged a group of very talented coaches, such as Rod Ellingworth, who ran the academy programme and played a big part in helping Cav develop his talent.

Sir Dave is strongly associated with that famous phrase about 'the aggregation of marginal gains', which means looking at every element of your programme, no matter how small, and seeing how it could be improved through the use of imagination, science and anything smart that somebody else hasn't yet thought of. We can all take a lesson from that.

MY BIKES

Sometimes a visitor will come to my office for the first time
and mistake it for a bike shed. I like having bikes around, and
these are bikes that mean something special to me, either from
my own past or because they've been given to me.

My first racing bike was a Paramount, with a pale blue frame,
a Brooks saddle and derailleur gears made by Simplex, a French
company whose products were popular at the time with people
who couldn't afford the top-end kit from Campagnolo.
Paramount had a shop on Front Street in Arnold, just outside
Nottingham. Years later I discovered that the frame had actually
been made by Mercian over in Derby, and badged as a Paramount.

It was a present from my father for my eleventh birthday. He
got it from a friend of his, Cliff Hunt, who was a fellow member
of the local camera club – and was also a member of Beeston
Road Club. That was what really got me into cycling. Over the
next few years I improved the bike by changing the components
for better ones – adding quick-release hubs and so on.

I rode races and time trials with the club, and I went out every
Sunday on a ride with fellow members, usually into the Derbyshire
dales. There was a lot of nice countryside nearby to ride in, and
plenty of testing hills, and I could get back home in time to have
a bath while listening to 'Pick of the Pops' on the radio.

When I was fourteen or fifteen I saved up and bought a yellow
track bike from Paramount – a proper one, with track ends. I rode
it at the velodrome on the outskirts of Nottingham, the Harvey
Hadden Stadium, in a suburb called Bilborough. It's a sports
centre now, with an athletics track but, sadly, no velodrome. I did
sprints and pursuits. I didn't do very well. I was too lean for the
sprints. I was probably better at pursuits, but still not that good.

Then I had a fixed-wheel Claud Butler in pale lilac, a second-
hand one that I bought from somebody at the club. I used to go
to work on it. I left school when I was fifteen and started work
at a clothing warehouse called Cree and Fletcher in the old
Lace Market in Nottingham. It was 6.5 km from home, and that
became my daily commute, which was good for me. Along
with the experience on the track, that must be the reason I can
still ride a fixed-wheel bike with confidence, as I did with the
British Cycling team at the Manchester velodrome a couple of
years ago.

When I was seventeen I had the accident that changed everything. I'd just set out from home on a training ride one morning when I rode into the back of a car and broke a lot of bones. I think it must have been because I was riding into a very low sun. I was in hospital for about three months, most of it in traction, and when I got out I had to wear a caliper on my leg for a while. Eventually I regained enough movement to be able to ride the Claud Butler to work, but then I met some art students in a pub in the centre of Nottingham, got interested in the things they were talking about, and found my life taking a different direction.

That meant leaving bikes alone for a while. But eventually I came back to them, and I started by buying a very nice second-hand steel Harry Hall frame, which I've had restored and equipped with Campagnolo equipment of the appropriate vintage and a riveted Brooks saddle and so on. It's a beauty, and it's one of the bikes that you can usually see in my office.

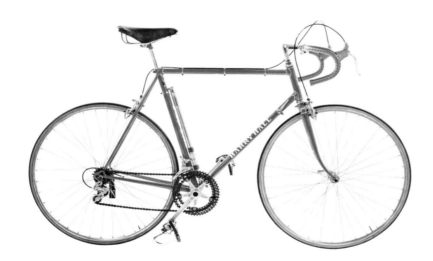

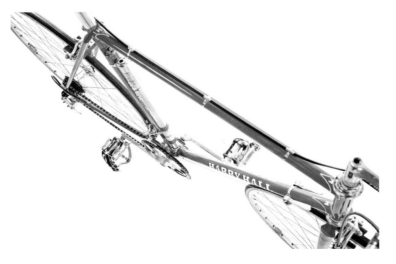

I'd missed cycling a lot. But from the age of eighteen I started working in a local boutique, and I met Pauline Denyer, an art teacher who became my wife and business partner and with whom I started my first shop. I'd always followed the sport, though, and one day I started riding again. The first time out was in Nottingham while Pauline was down in London on business. I came off on some gravel, breaking my wrist and ending up in hospital. I had to get one of Pauline's sons to ring her up and say, 'Mum, Paul's in hospital – he's all right, but he's come off his bike again…'

I've got a tandem, too. Before my big crash I'd started riding tandem with a friend at the club, Chris Whiteman. I remember going for a ride with him one day on normal bikes and I said something that made him laugh so much that he fell off. That was the first time I realized that I had the sort of sense of humour to which people respond.

One day we were out on the tandem and I dropped Chris off at his house. I'd been on the back, where you don't really have to do anything, and now I was on the front and I came off and did my knee in. I got home in an ambulance.

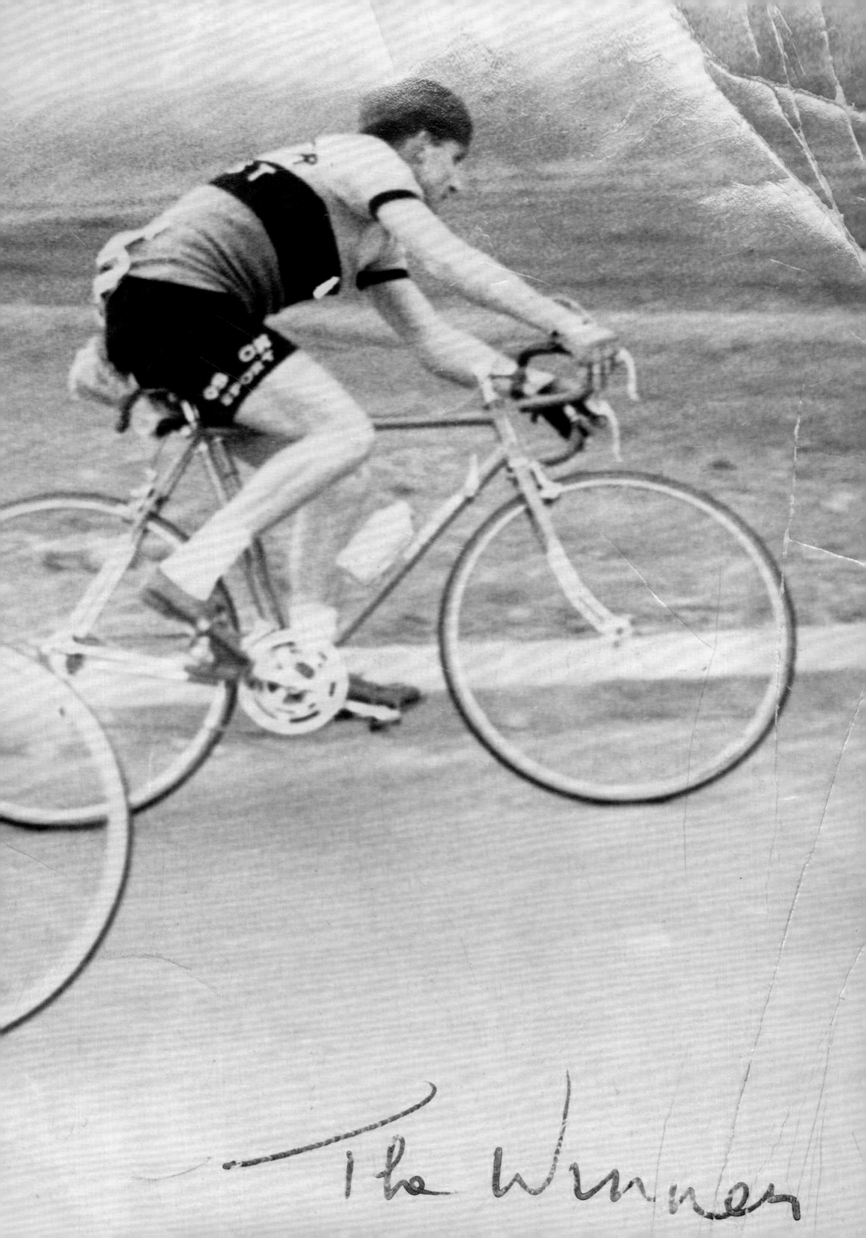

The Winner

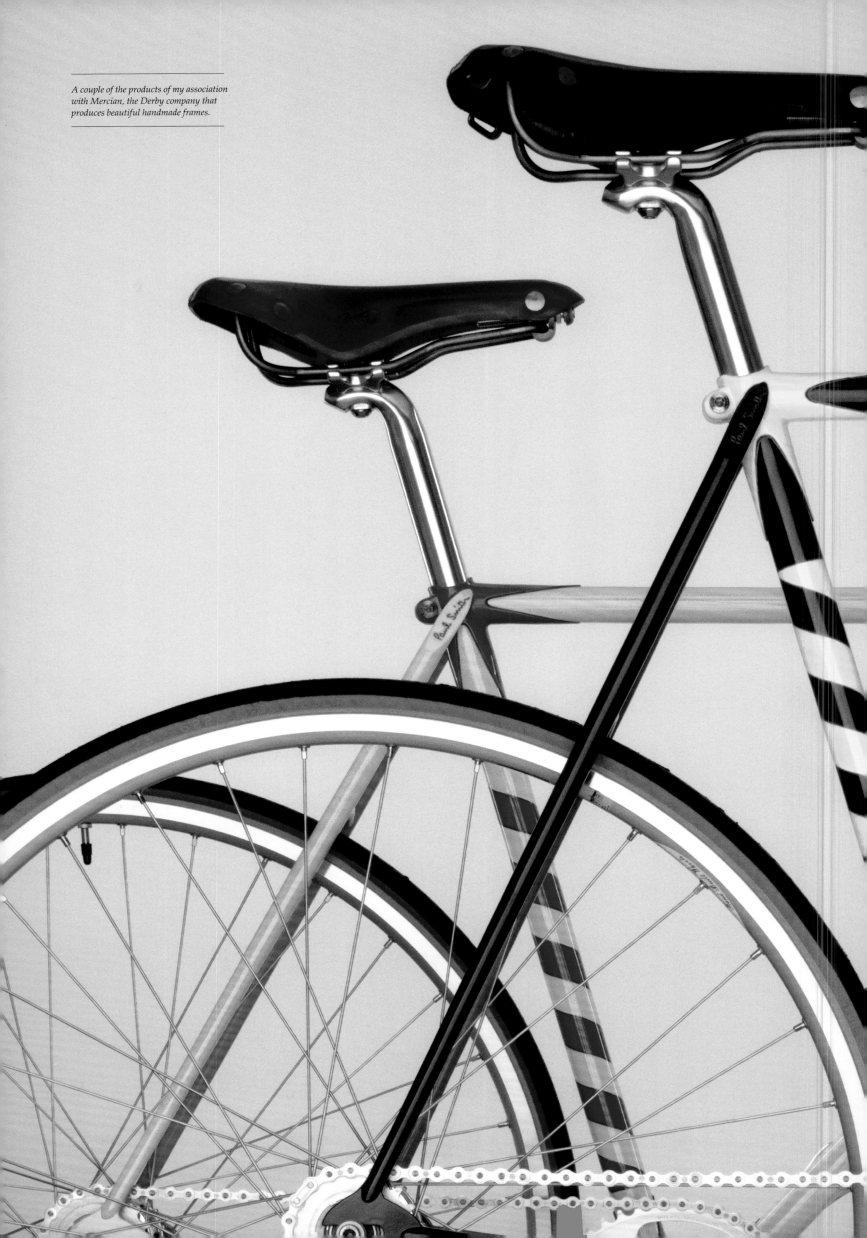

A couple of the products of my association with Mercian, the Derby company that produces beautiful handmade frames.

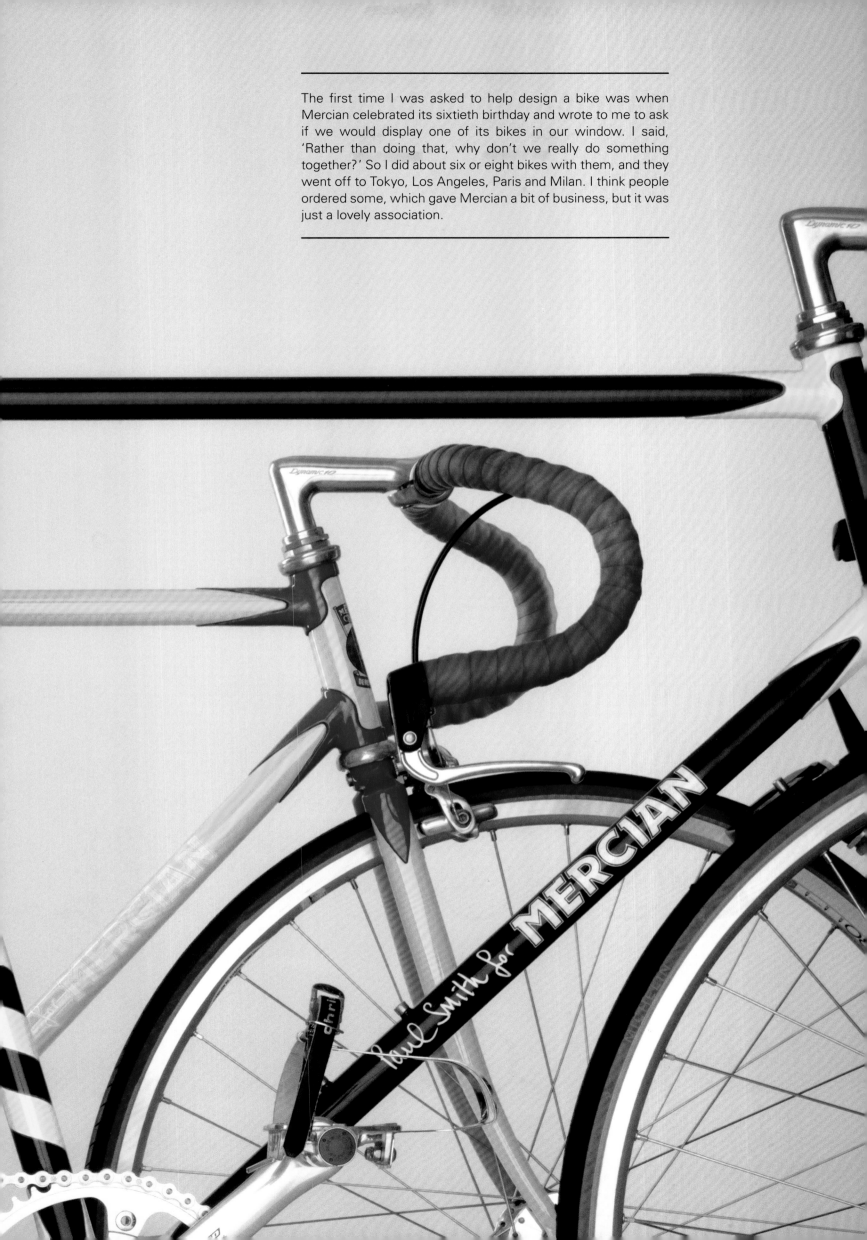

The first time I was asked to help design a bike was when Mercian celebrated its sixtieth birthday and wrote to me to ask if we would display one of its bikes in our window. I said, 'Rather than doing that, why don't we really do something together?' So I did about six or eight bikes with them, and they went off to Tokyo, Los Angeles, Paris and Milan. I think people ordered some, which gave Mercian a bit of business, but it was just a lovely association.

The black single-speed bike was built specially for me by Mercian. I love the combination of traditional skill and modern technology, which somehow seems to mirror my approach to designing clothes: the famous 'classic with a twist' line.

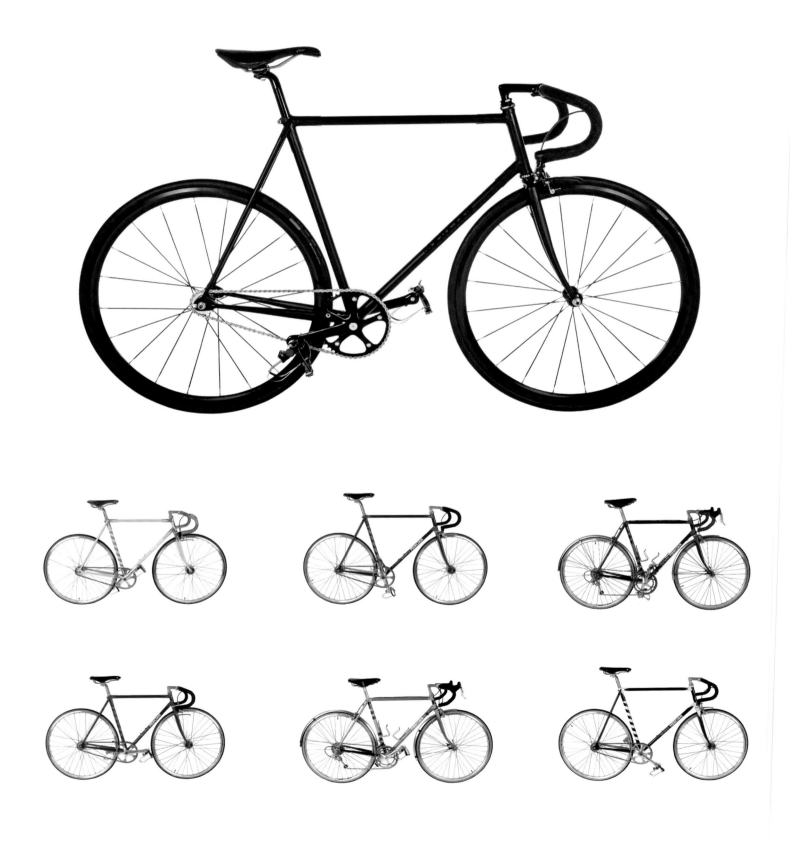

Then Mercian said it would like to give me one, and asked me if I'd like to go along and help make it. The special colour scheme was matt black, and I helped to weld it and choose the components. I keep that one in London, and I've got another of Mercian's bikes to ride in Tokyo. There's also a lovely one with brass filet brazing on a lugless stainless-steel frame.

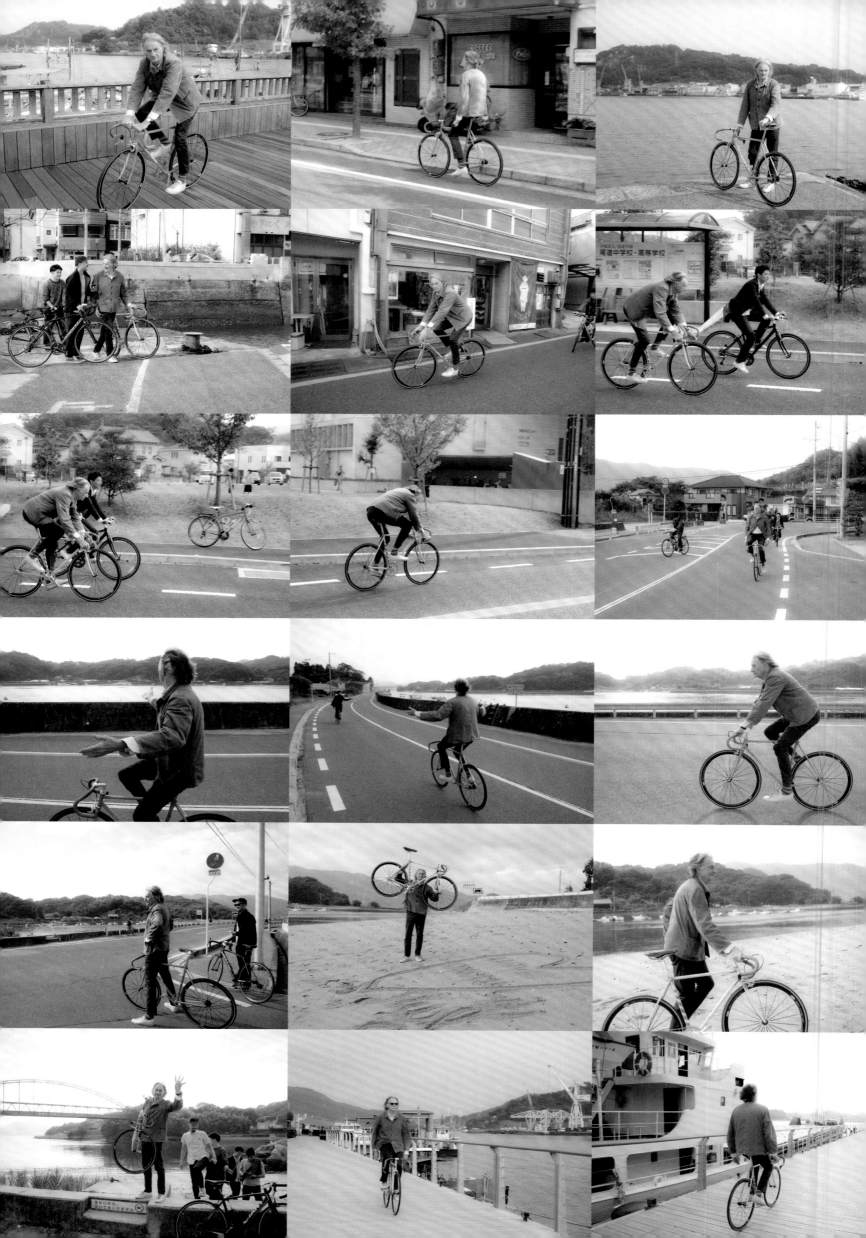

During my travels, I try to ride whenever possible. In these pictures I'm on a bike I keep in Japan.

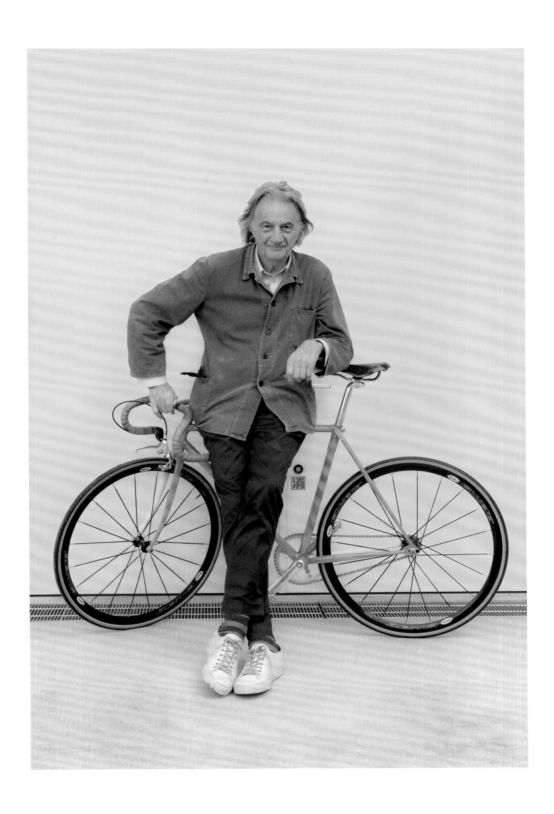

THIS PAGE: *Rapha sponsored Condor's race team for a few years, and this is a bike finished in a design I did for the company, with my stripes inside the front forks and the chainstays.*

OPPOSITE: *I designed this mountain bike for Gary Fisher for a twenty-four-hour race in the United States.*

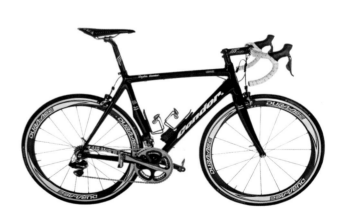

When Rapha started in 2004 I got to know its founder, Simon Mottram. He asked me if we could do something together, so I designed some jerseys and jackets. I also helped the Rapha-Condor team with some promotional events, including one at my shop in Floral Street, London. And I designed a Condor bike with our multi-stripes on it.

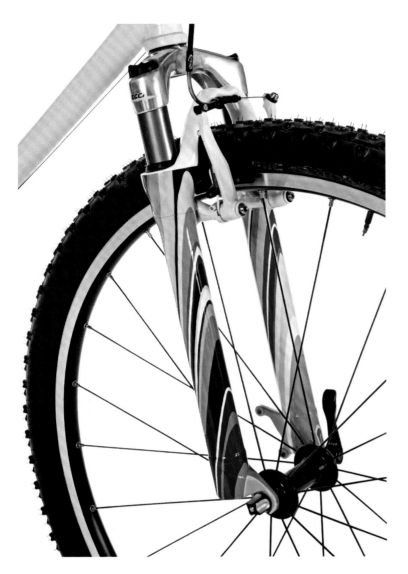

Then I discovered that Gary Fisher, the very successful US mountain-bike builder, was a huge customer at my shops in Los Angeles and San Francisco. He's an interesting guy: he started competing when he was twelve, and when he was sixteen he was prevented from starting a race because his hair was too long and he refused to have it cut. Eventually he became recognized as the founding father of mountain biking, and although he sold his company in 1991, he's still involved on the design and marketing side. He asked if we could meet, and suggested that we do a bike together. He was doing a twenty-four-hour race, so we did a white bike with stripes on the rear forks. The stripes on the Condor bike are a transfer, but on the Gary Fisher bike they're hand-painted. It took this hippie guy in Los Angeles eighty hours to do it.

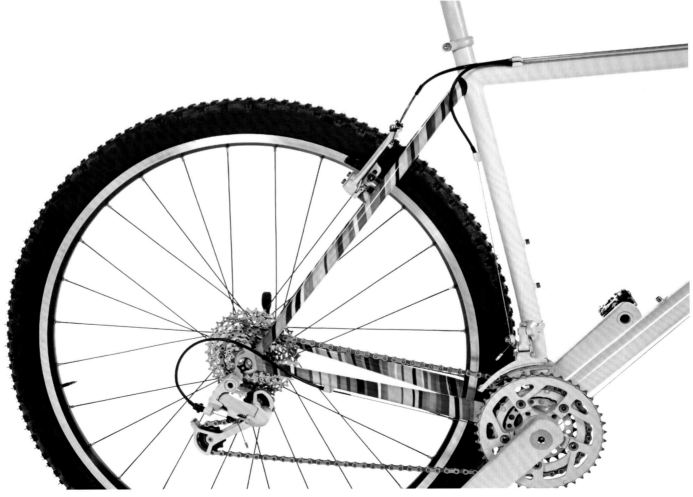

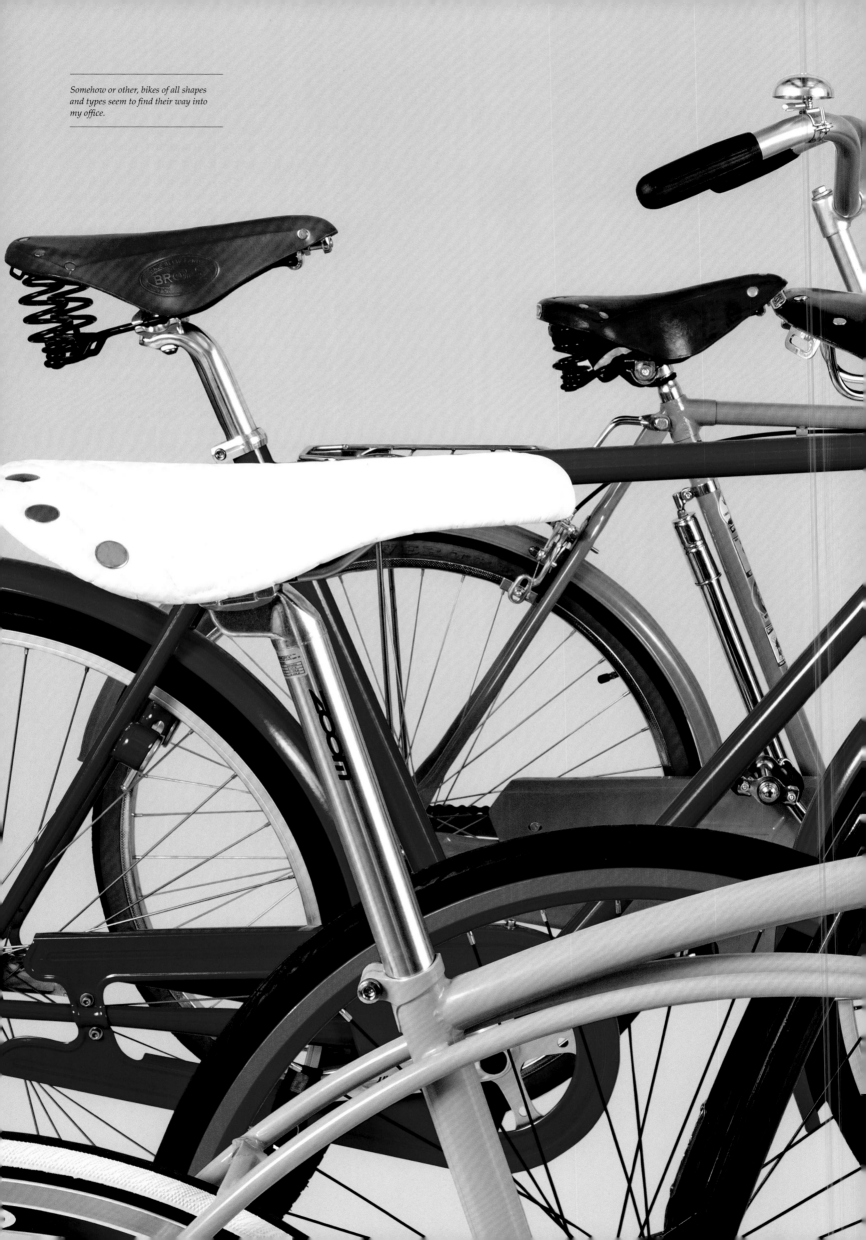

Somehow or other, bikes of all shapes and types seem to find their way into my office.

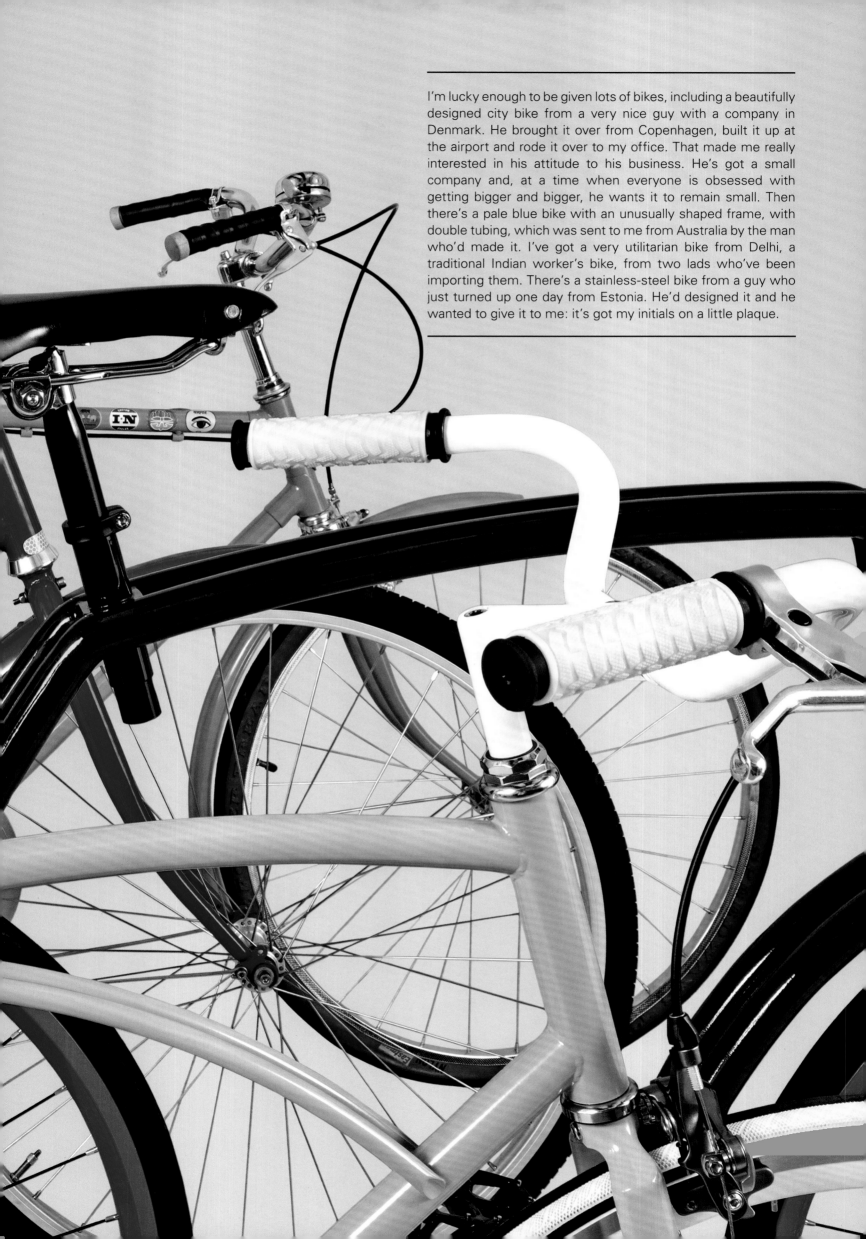

I'm lucky enough to be given lots of bikes, including a beautifully designed city bike from a very nice guy with a company in Denmark. He brought it over from Copenhagen, built it up at the airport and rode it over to my office. That made me really interested in his attitude to his business. He's got a small company and, at a time when everyone is obsessed with getting bigger and bigger, he wants it to remain small. Then there's a pale blue bike with an unusually shaped frame, with double tubing, which was sent to me from Australia by the man who'd made it. I've got a very utilitarian bike from Delhi, a traditional Indian worker's bike, from two lads who've been importing them. There's a stainless-steel bike from a guy who just turned up one day from Estonia. He'd designed it and he wanted to give it to me: it's got my initials on a little plaque.

I've got the Pinarello that Mark Cavendish won the world championship on. He rode it only seven times, and he brought it here for me. The guy who works on reception for me spotted him outside the front door on the CCTV camera, and he rang me up and said, 'I think Mark Cavendish is outside – I recognize his car, but he seems to be building a bicycle on the pavement.' Mark had brought this bike to give me as a present, which was absolutely fantastic.

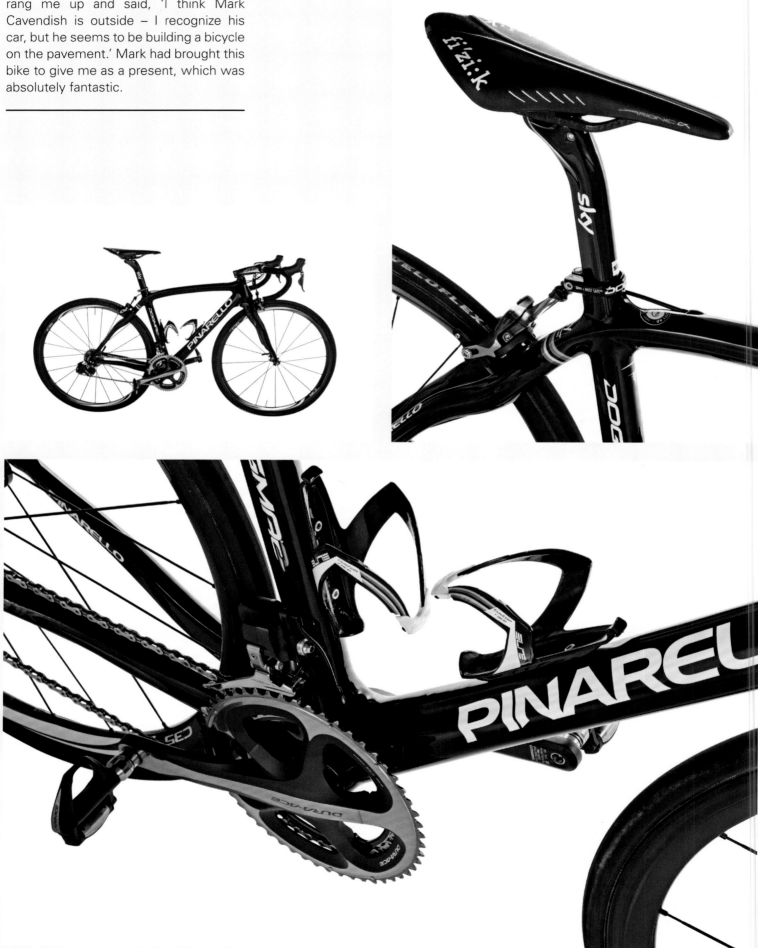

In 2013 I was invited to design the four main jerseys for the Giro d'Italia, which I was really proud to do, and Pinarello asked me if I'd do the same thing but with its bikes. So I did a pink one, a red one, a white one and a blue one. Pinarello made them to order, and I've got a blue one.

OPPOSITE: *Mark Cavendish's world championship Pinarello looks as if it was built for one thing: ultimate speed.*

THIS PAGE: *Pinarello is one of the great names in bike racing, and it was a privilege to put my name – and my stripes – on a Dogma racing model.*

I've got two bikes from Bradley Wiggins. Luckily, he's exactly the same inside-leg size as me, and I keep one of them – his old Giant from a previous team – to ride at my house in Italy. The other is one of his old Pinarellos. I've also designed a Dogma 8 model with Pinarello, using the stripe in a subtle way, again to order.

Bradley Wiggins's Pinarellos are made to very different dimensions from Cav's. This is the aerodynamic F8 (this page). Luckily, Bradley is the same size as me, so I can take these bikes for a ride.

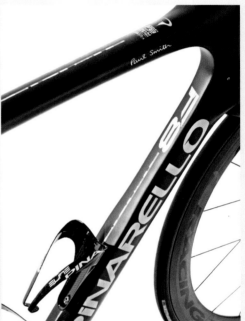

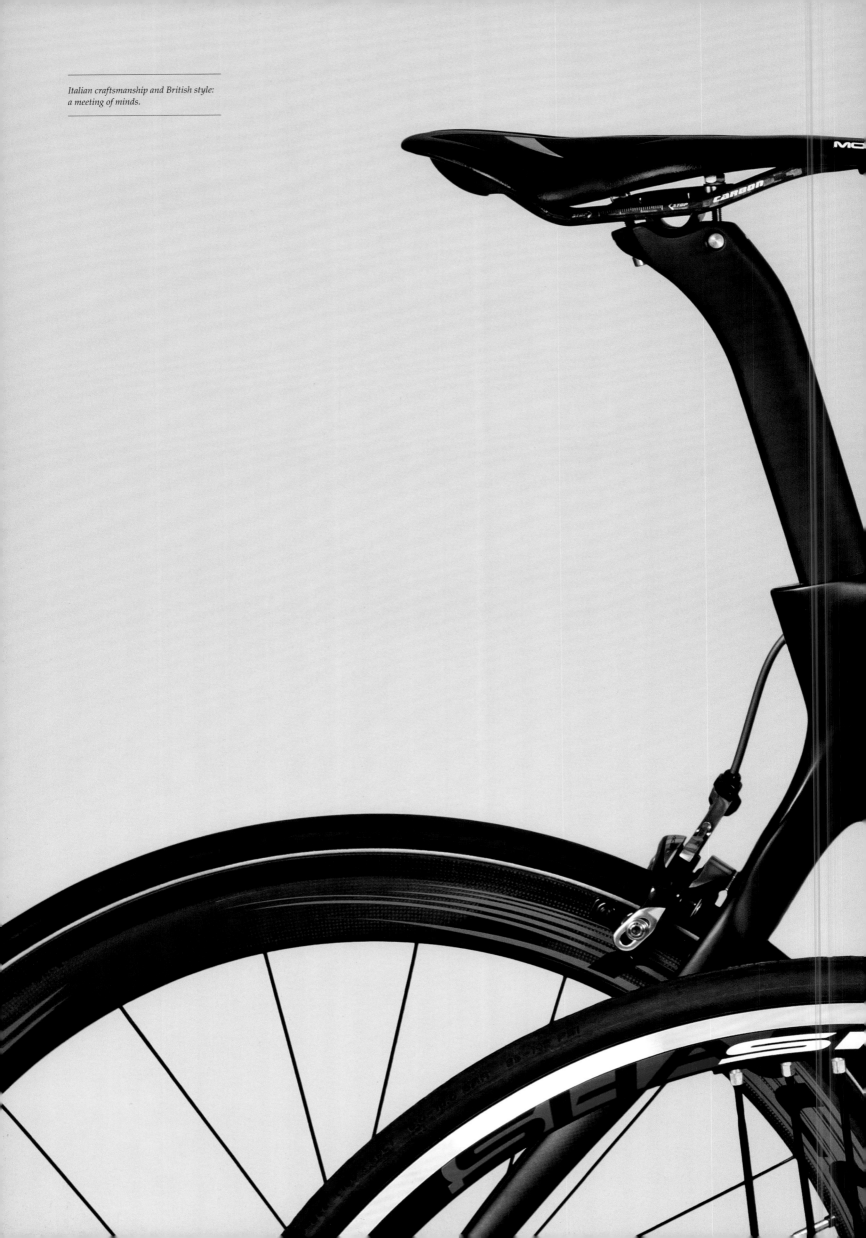

Italian craftsmanship and British style:
a meeting of minds.

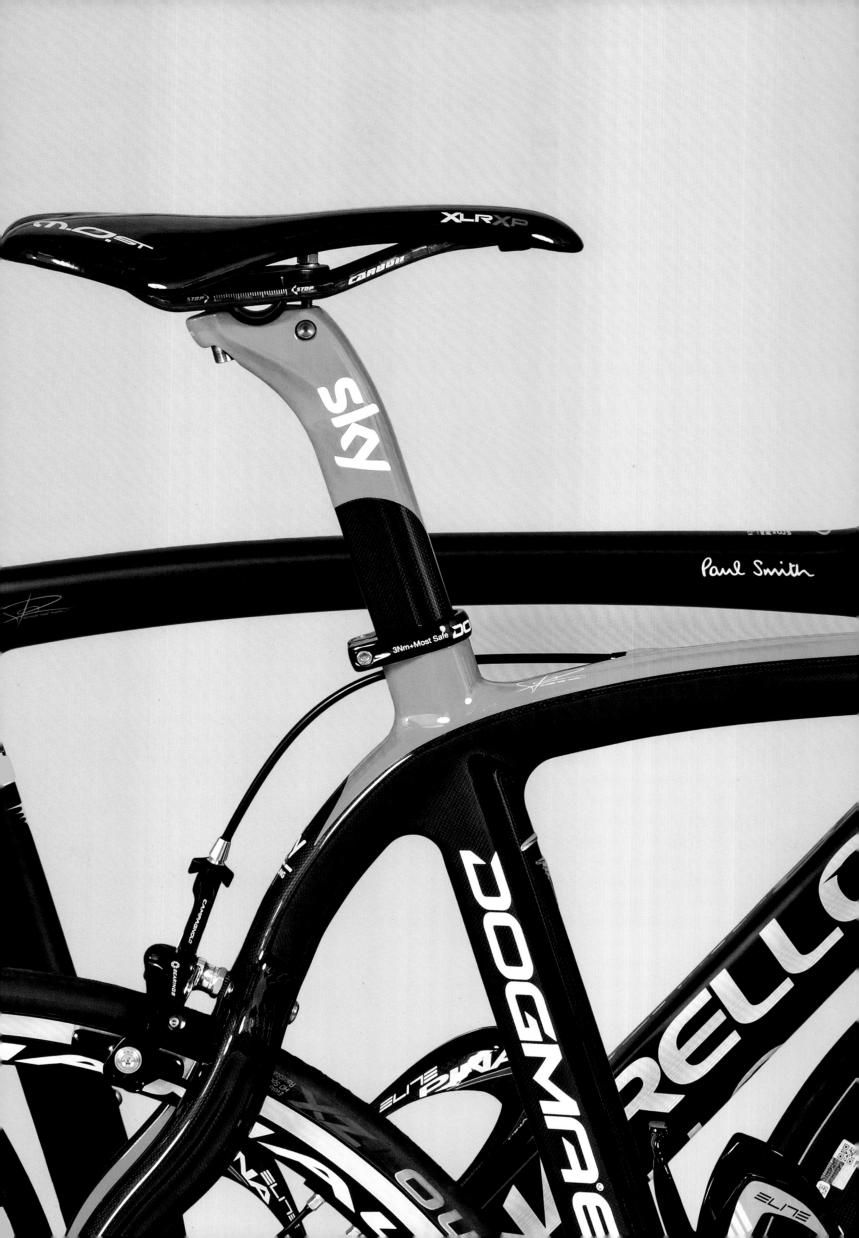

With all these things it's nothing to do with money. It comes from my passion for cycling. One of the nicest bikes is one I designed to help my Danish friend Brian Holm, a very stylish guy who has been Mark Cavendish's *directeur sportif* with the HTC and Etixx–Quick-Step teams. He's very close to a charity for children with cancer in Denmark, and he asked me to help with making a series of limited-edition bikes with a company called Principia. We called it the Flamme Rouge, after the sign that marks the last kilometre of a bike race, because that's when you need your reserves of inner strength and energy to face whatever you've got to cope with. As a thank-you, I was given one of the bikes. It's a carbon-fibre frame, and unbelievably light. In fact, I've got a friend who lifts it up every time he comes into my office, just to check that a full-size bike with all its equipment really can weigh so little – and that it hasn't lost any more weight in the meantime.

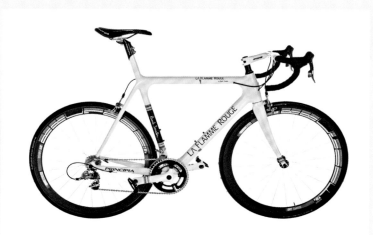

THIS PAGE: *The Principia company made a handful of these bikes for my friend Brian Holm, Mark Cavendish's sporting director, to raise funds for a children's cancer charity. This one is mine. It's unbelievably light.*

OPPOSITE: *By contrast, this Soviet-era Russian bike must be one of the heaviest I've ever come across.*

Of all the bikes I keep in the building, perhaps the most amazing – at least in terms of the story of how it came into my possession – is a Russian bike given to me by a lady whom I'd never met, who arrived at the office on my birthday a few years ago and announced that she'd brought a present for me. It turned out to be a bike made in a factory in Moscow the very year I was born. It's exactly what you might expect from a Soviet-era Russian bike: impressively solid and impressively heavy. She just turned up from Moscow that day, not knowing whether I would be there but wanting to ride it to Covent Garden and leave it for me and then go straight home, which she did. That was very special.

As the slowest of the lot, and probably weighing as much as the rest of them put together, it's a great conversation piece. And it demonstrates that it takes all sorts of bikes to make the world of cycling.

Ricoverato a Capodanno nell'Ospedale di Tortona, Fausto Coppi si spegneva il giorno 2 gennaio 1960, alle ore 8,45, dopo una notte di agonia, in cui le ansiose e devote cure di valentissimi medici non erano riuscite a vincere il mistero di confuse diagnosi.

Egli era nato il 15 settembre 1919 a Castellania — un agreste paese sulle colline dell'alessandrino — da una modesta famiglia di contadini. Là forse avrebbe potuto compiersi il quadro della sua esistenza, in una cornice di tradizionalità, se fin da ragazzo la passione della bicicletta e qualche corsa, vinta in bellezza, non avessero richiamato su di lui l'attenzione dei circoli sportivi e posto le lontane premesse della sua immensa fama.

Però la fortuna del campione Fausto Coppi sarebbe incominciata dopo la seconda guerra mondiale (il fragore delle armi aveva sovrastato l'eco delle sue prime imprese, dal 1940 al 1942), e non subito, perchè il giovane avrebbe dovuto smaltire lo scetticismo e la stanchezza che furono comune retaggio di tanti soldati, caduti in lunga prigionia e restituiti poi a una patria vinta. Dall'Africa ritornò infatti un giovane senza speranza.

La bicicletta dell'adolescenza risanandolo, doveva ripetergli ancora il presagio di una magnifica avventura: già nel 1945 il nome di Fausto Coppi riappare insistentemente sulle pagine dei giornali sportivi e nelle cronache degli altri quotidiani.

Superato il 1946, passa ai trionfi del 1949 attraverso tappe senza respiro, logiche ed entusiasmanti e, a trent'anni, Coppi tocca il vertice della sua gloria. Stupirsi oggi del rimpianto internazionale suscitato dalla sua morte, significa non voler ricordare o non aver conosciuto le proporzioni di quel fenomeno.

Il giovane e insuperabile campione era celebrato da tutta la stampa italiana e straniera, era conteso da potenti gruppi sportivi in Italia e fuori.

Quand'egli non partecipava alle corse internazionali, esse perdevano rilievo. Si faceva anticamera d'ore e si trepidava nei momenti d'incertezza del campione; sulle sue decisioni tornava a splendere il sole, si scatenavano le agenzie e le grandi penne del ciclismo.

Non era più e soltanto il corridore a interessare, ma tutto l'uomo come appariva nei suoi atti buoni e cattivi; e ciò fu certamente un male, frutto di un'epoca tutta impegnata a fecondare la più drogata curiosità.

Il Coppi che chiedeva e comandava quasi tirannicamente era il corridore che in pochi anni aveva vinto cinque Giri d'Italia, due Tours di Francia, un campionato del mondo su strada, quattro campionati italiani su strada, due campionati del mondo inseguimento, cinque campionati italiani inseguimento, cinque Giri di Lombardia, tre Sanremo.

Era colui che aveva tenuto in soggezione tutti i più veloci competitori, lasciandoli alle sue spalle, lontani ed umiliati; mentre con sorprendenti distacchi di tempo tagliava i traguardi, acclamato da folle impazzite che a stento i gendarmi controllavano e contenevano.

Soltanto Gino Bartali, l'altro leggendario vincitore del Tour, gli era rimasto a fianco senza cadere in ombra, in una competizione di valori che giovò ad entrambi ed anche ai giornalisti, i quali finirono per esprimere la gustosa formula dei due « amici-nemici ».

Ma gli anni frattanto avevano macinato stanchezze per la vita di Fausto Coppi, così sottoposto all'usura di una fama senza pause spirituali. Furono la morte del fratello, le cadute, le ferite, le degenze negli ospedali, le dissipazioni del vagabondare, la lontananza dal desco e dai suoi sapori casalinghi, a preparargli quella tormentata notte d'agonia, in cui la sua anima e il suo corpo accettarono il doloroso invito della morte.

Scomparve a quarant'anni, ancora corridore. Nel giro di pochi giorni, dall'ospedale al camposanto, accorsero a Tortona non meno di centocinquanta tra giornalisti, fotografi, operatori di televisione.

Là, tra Tortona e Castellania, in un clima di lutto nazionale, nacquero e vennero irradiate le notizie e gli articoli che coprirono pagine e pagine di giornali: tutta una vita fu rinarrata; per un'ultima volta le agenzie gareggiarono alla ricerca dell'inedito e del sorprendente.

In morte, Fausto Coppi faceva cogliere i « record » alle tirature dei rotocalchi.

Ma la folla che gli ha voluto bene, che gli tributò tanti applausi, non trovò conforto in tutto ciò. Rimase delusa ed amareggiata: « Non è il nostro Coppi! ».

Questa frase riletta tante volte sui nostri tavoli redazionali, scritta sotto diversi cieli, ci ha commossi ed impegnati. In essa trovammo la precisa linea del nostro fascicolo: ridare il Coppi della bicicletta e della grande passione agonistica.

In tale stato d'animo abbiamo incominciato il lavoro di ricerca delle fotografie che sarebbero divenute il testo del nostro documento.

E procedendo nella pietosa fatica, si ritrovavano gli entusiasmi di un lungo corso d'anni, si ritrovavano la stupita gioia degli sportivi e la luminosità di giornate trionfali.

A poco a poco, dalla barriera silenziosa della morte, veniva avanti il vero Fausto Coppi: quello che avevamo visto sulle impervie strade dei passi solitari, con il volto contratto da fatiche inumane, ebbro di sole e di azzurro, di pioggia scrosciante e di neve senza limiti.

Noi congediamo il numero unico dedicato alla memoria di Coppi nella vigilia della Sanremo, la nostra bella corsa, detta del sole; la classicissima che ricomincia a contare gli anni dopo le nozze d'oro del 1959.

Ai corridori che non vedranno più il grande antagonista presentarsi sulla linea di partenza, ai suoi inconsolabili tifosi, questo fascicolo dice di celebrare la memoria di Fausto Coppi con la fedeltà agli ideali dello sport, da lui onorato attraverso l'abnegazione nella lotta, e sino alla vittoria lealmente conquistata.

LO SPORT ILLUSTRATO

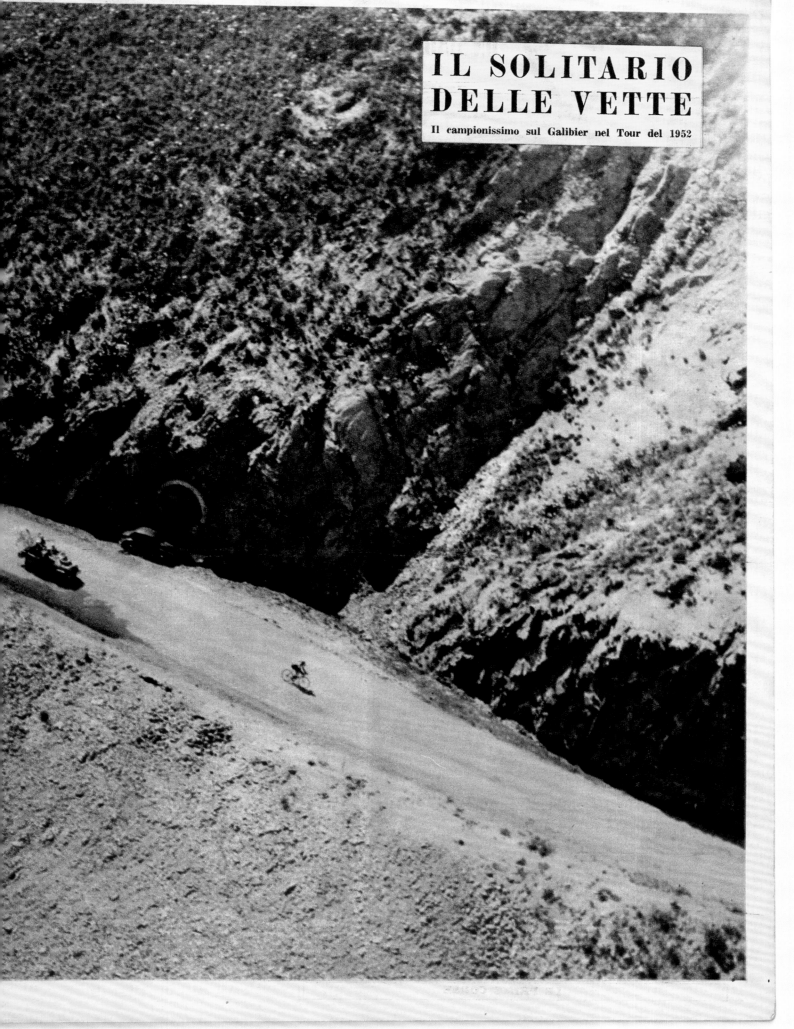

IL SOLITARIO DELLE VETTE

Il campionissimo sul Galibier nel Tour del 1952

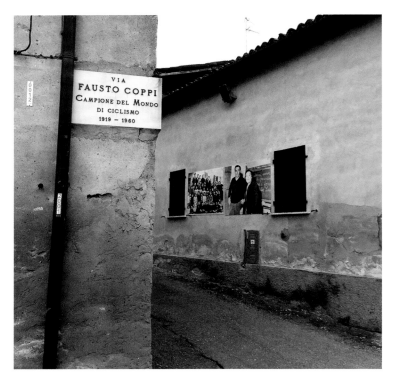

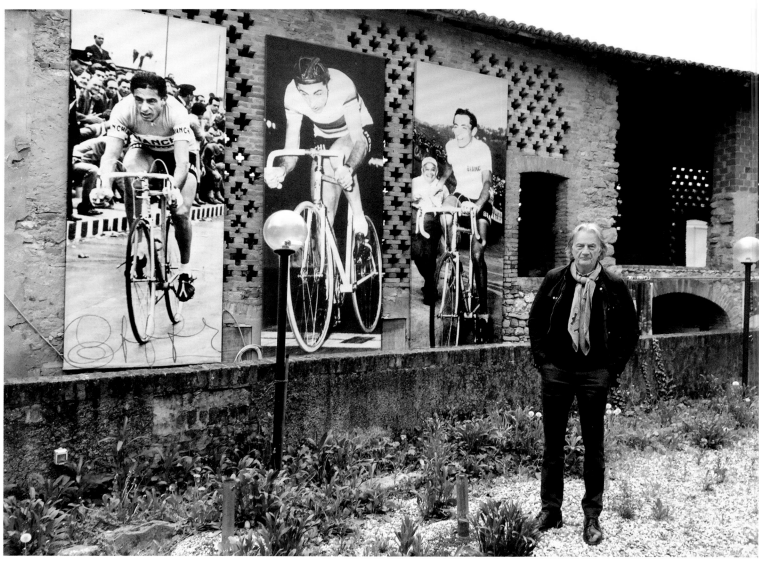

OFF THE BACK

I was sixteen when I first went abroad. I'd been working at a local petrol station at weekends, earning some extra cash to buy parts for my bike. The lady who took the money in the kiosk was connected to the local youth club, which was arranging a trip to Italy. I went with them, on a long trip by train and coach to Cadenabbia, on the western shore of Lake Como. One day we had a trip into Como, where I found a supermarket selling cycling gloves with white leather palms and mesh backs, decorated with the world championship stripes. They also had a leather track helmet – in red! I spent all the money I had for the trip on those two things. Maybe that's where it started, my love of a certain style.

No one embodied that style more perfectly than Fausto Coppi. Half a century after my first trip abroad, I visited Castellania, Fausto Coppi's home village in the Piedmont, 100 km south-east of Turin. It's a tiny place, and its only claim to fame is that it was the birthplace of Coppi and his brother Serse, who was also his teammate. For that reason alone, its name will live as long as bikes are raced. I was thrilled to breathe the air Coppi breathed and to see the environment in which he grew up.

That's what a love of cycling can do to you. On that first visit to Cadenabbia, I certainly noticed that the girls around the municipal swimming pool were very beautiful, but at sixteen I was more interested in my bike. That changed quite a lot, but I never lost my feeling for the sport. And nostalgia – a yearning for the return of the past – has nothing to do with it. It's possible to retain a strong affection for the past while keeping your eyes firmly on the present and the future. That's certainly what I've always tried to do in my work.

Somebody told me that the American writer William Faulkner wrote, 'The past is never dead. It isn't even past.' Perhaps that's one of the suggestions made in this book: the idea that nothing really separates Coppi from Cavendish. To love one is to love both. And the more you learn, the deeper and richer your appreciation becomes. You might expect someone in the fashion industry to say that change isn't something to be scared of. But you can bet that back in 1903 the riders in the first Tour de France were looking for small adaptations that would give them marginal gains, and it's possible that by the time you read this the riders in the Tour, the Giro and the Vuelta will be using disc brakes. The world moves on, and bike racing moves with it. The invention of stretch fabrics changed my world; at the same time, they were making life much more comfortable for men required to ride 3,000 km in three weeks. Somehow, as I hope these pages have shown, the essence of a great sport survives it all.

PAUL SMITH

ACKNOWLEDGMENTS

Special thanks from Paul:

To Richard Williams, who edited the book
To Alan Aboud, Jo Woolhead and Jamie Register for the design
To Karl Kopinski for the paintings
To David Millar for the foreword

To Lucas Dietrich and Bethany Wright at Thames & Hudson
To Clare Alexander at Aitken Alexander Associates

To Roger St Pierre and all the other people who have helped to build the collection of books, magazines, newspapers, bikes, jerseys, caps and other cycling-related stuff over the years

To all the editors, photographers, writers and designers who contributed to a golden age of cycling publications in the 1950s and '60s (another golden age is happening right now...)

And to all my cyclist friends.

CREDITS

INDEX

Note: italics indicate images.

RIGHT: *Raymond Poulidor, the darling of the French cycling public, and Julio Jiménez, three times a winner of the Tour de France's King of the Mountains award, probably wish the cameraman would just disappear as they grind it out in the oven-like conditions of the Mont Ventoux's upper slopes, doing their suffering in public.*

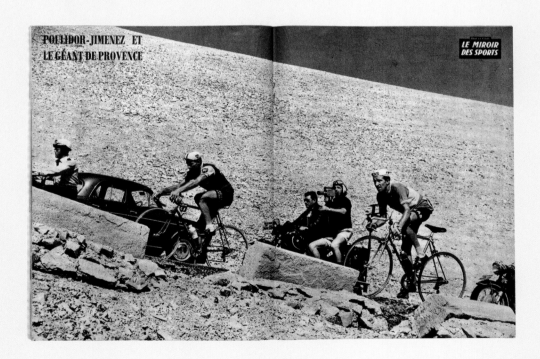

POULIDOR-JIMENEZ ET LE GÉANT DE PROVENCE

LE MIROIR DES SPORTS

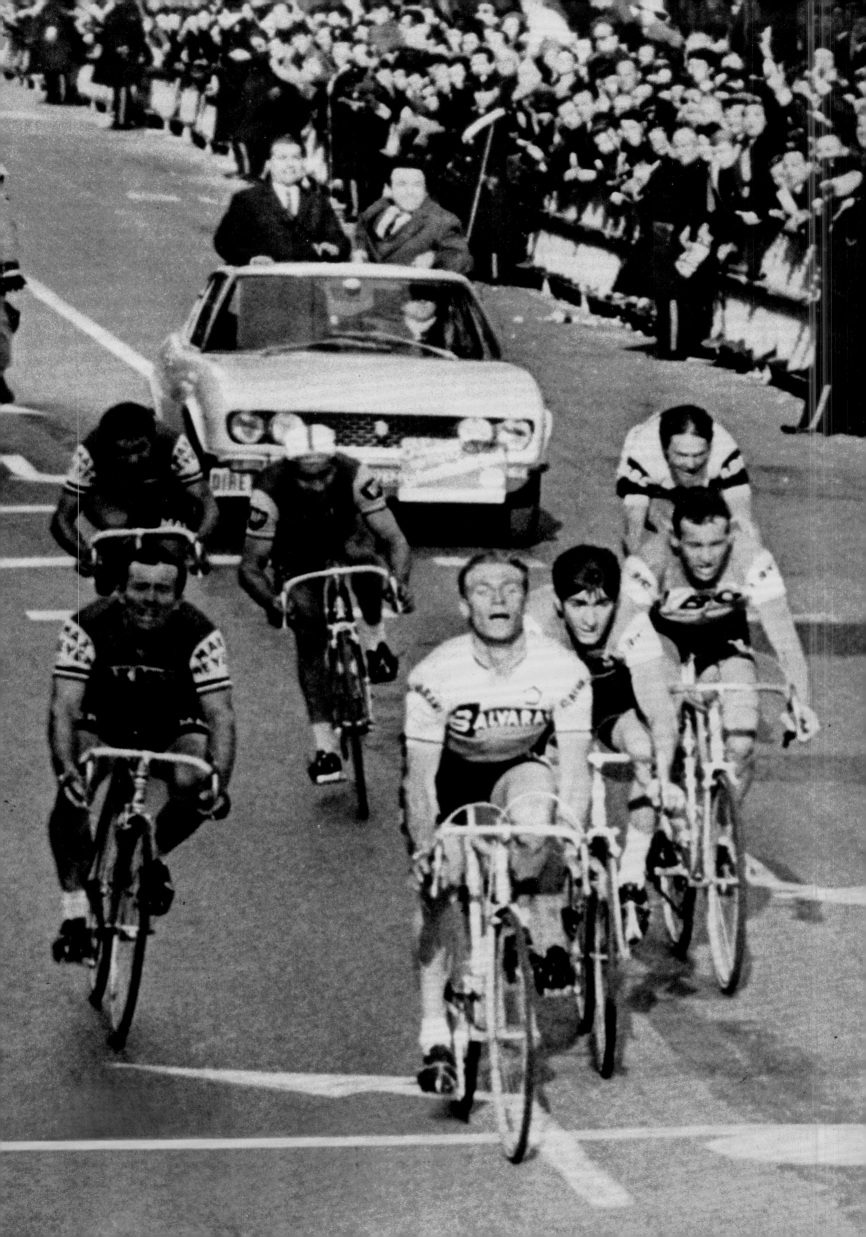